STANFORD
WHITE

Stanford White Architect

SAMUEL G. WHITE ELIZABETH WHITE

PHOTOGRAPHS BY JONATHAN WALLEN

RIZZOLI
NEW YORK

Half-title page:
Stanford White bookplate

Title page:
Venetian Room, Payne Whitney
House (pp. 198–209).

Page 352:
Stanford White's great grand-
sons, photographed on the
piazza of the Newport Casino.
Photograph by Toni Frissell,
1966.

First published in the United States of America in 2008 by
RIZZOLI INTERNATIONAL PUBLICATIONS, INC.
300 Park Avenue South
New York, NY 10010
www.rizzoliusa.com

ISBN-13: 978-0-8478-3079-4
Library of Congress Control Number: 2008922995

Photography (except when otherwise noted
throughout book) © 2008 Jonathan Wallen
Text © 2008 Samuel G. White and Elizabeth White
© 2008 Rizzoli International Publications

Distributed to the U.S. trade by Random House, New York

Designed by Marcus Ratliff

Printed and bound in China

2008 2009 2010 2011 2012/ 10 9 8 7 6 5 4 3 2 1

PROLOGUE

Stanford White, c. 1890.

He was a personality of enormous power, a man of phenomenal force. He affected every one he met ... I always think of him as the embodiment of a particular period in New York life—perhaps in American life—a period of effervescence and of the sudden coming of elements that had long lain in solution and came together with a certain emotional violence.

*I*N THIS posthumous tribute, John Jay Chapman's characterization of Stanford White's personality was inseparable from the chronological and physical context in which he lived. Chapman was a legendary essayist on American arts and letters as well as White's contemporary. There was nothing unintentional about his choice of words. Stanford White lived extravagantly and had died sensationally, and familiarity with both circumstances would have colored anyone's perception of the architect's professional accomplishments. The passage of time since White's death in 1906 makes it easier to move White's celebrity towards the background and to focus instead on the enduring and extraordinary quality of his work.

Stanford White was born in New York City on November 9, 1853. White's mother, Alexina Mease, came from Charleston. His father, Richard Grant White, was a journalist, editor, and Shakespeare scholar whose professional and intellectual circle was centered around the magazine *The Nation*. Richard Grant White never achieved the financial success he thought was his due, but he was able to provide his son with introductions to figures such as Frederick Law Olmsted, John La Farge, Richard Watson Gilder, and William Cullen Bryant. Stanford White grew up with access to America's cultural and intellectual elite.

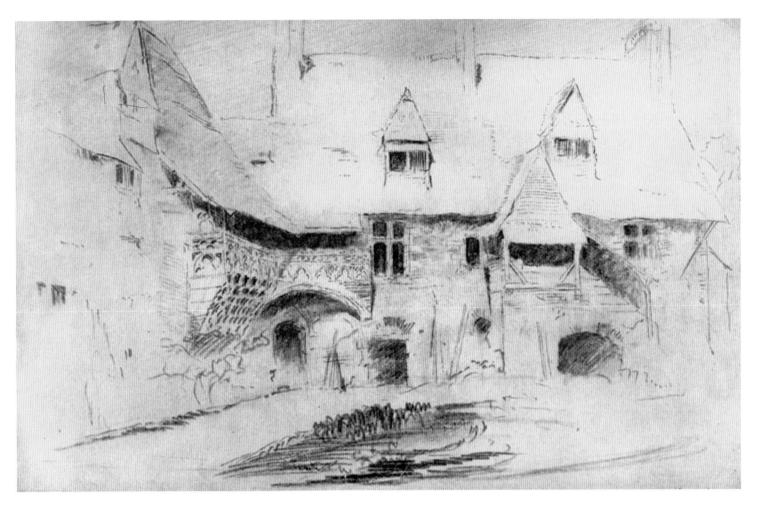

Sketch of a French courtyard,
1878–79.

White's talent for drawing and watercolors was evident from an early
age. He intended to make his way as an artist until La Farge warned him
of the financial precariousness of that career and advised him instead to
consider architecture. An introduction was arranged with Henry Hobson
Richardson, who had opened an office in New York after returning from
the Ecole des Beaux-Arts. By the spring of 1872 White was an apprentice
in the office of Gambrill & Richardson on Hanover Square.

There were probably less than a handful of practices in New York that
could have met La Farge's artistic and professional standards, including
Peter B. Wight, Russell Sturgis, and George B. Post. Richardson and
Richard Morris Hunt were the first two American architects to have grad-
uated from the Ecole des Beaux-Arts in Paris. Charles Follen McKim was
the third. When White arrived in Richardson's office, McKim was prepar-
ing to leave to open his own practice after a two-year apprenticeship in

which he had assisted Richardson with the competition drawings for Boston's Trinity Church. McKim set up shop at 57 Broadway and soon shared the space, and eventually the practice, with William Rutherford Mead, an alumnus of Sturgis's office and of the Accademia in Florence.

White could not have had a better teacher nor Richardson a more qualified assistant. Training at the Ecole had given Richardson the ability to design buildings with clear diagrams, powerful forms, and elegant ornamental details. On the basis of an initial sketch and regular oversight he could establish the direction and control the development of the plan and massing, but not all of his intentions could be as easily communicated. The abundance of original ornament in his designs meant that Richardson needed to work closely and continuously with a skilled delineator and as Mead would later say, White "could draw like a house on fire."

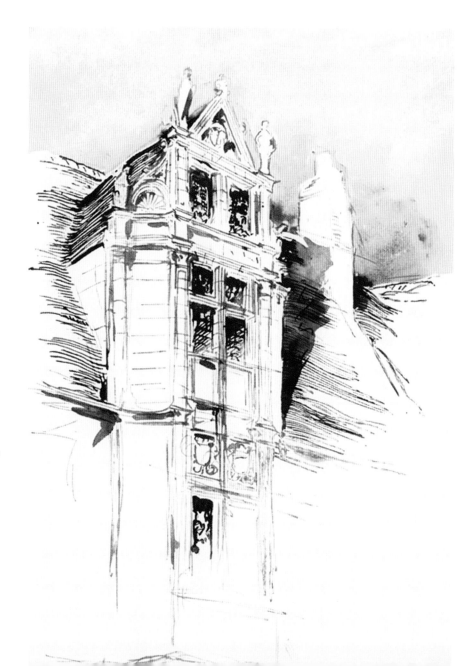

Sketch of a dormer window on the roof of a French chateau, 1878–79.

During his six-year apprenticeship White assisted Richardson with the New York State Senate Chamber, the Oliver Ames Library in North Easton, Massachusetts, and houses in Newport for William Watts Sherman and James Cheney, but his first job was to help realize the winning entry for Trinity Church. White became Richardson's amanuensis, studying every aspect of the building from redesign of the tower to the smallest details. White's experience with Trinity Church defined his apprenticeship, exposing him to the elements of design, the mechanics of construction, and even the choreography of artistic collaboration.

In 1878 and with the encouragement of his employer White left Richardson's office for Europe. He was based in Paris, traveling around the continent to satisfy a nearly insatiable appetite for medieval architecture and filling dozens of sketchbooks with evidence of a keen

Stanford White, c. 1880.

eye and a remarkable hand. He saw first-hand the art and architecture that Richardson had taught him to admire, became familiar with the culture that he would soon translate into an American idiom, and discovered the artifacts that would form the raw material for his decorative expressions. For fourteen months White virtually inhaled Europe; then, shortly before returning to America, he received a letter from McKim and Mead with an offer to join their practice.

By circumstance, and possibly by inclination, Stanford White's formal schooling had stopped before college, but by the time he returned to New York he was the beneficiary of a rigorous, diverse, and comprehensive architectural education. Working under the tutelage of one of America's greatest architects he had helped to design and build some of the most important buildings constructed since the Civil War. He was a talented artist, a likeable personality, and a seasoned European traveler. He had

broad interests, cultivated tastes, and strong enthusiasms, and thanks to his father was reasonably well-connected in New York City. The core elements that would make up Stanford White's artistic and professional persona were in place when he arrived at 57 Broadway in September 1879 to begin working on the Newport Casino. At twenty-eight White still had a lot to learn, but he was extraordinarily well prepared. He was also energetic, optimistic, and highly gregarious, with a circle of friendships that defined much of what followed. His life-long friendship with sculptor Augustus Saint-Gaudens helped to change the course of American sculpture, while partnership with McKim and Mead evolved into the largest and most famous architecture office in the world.

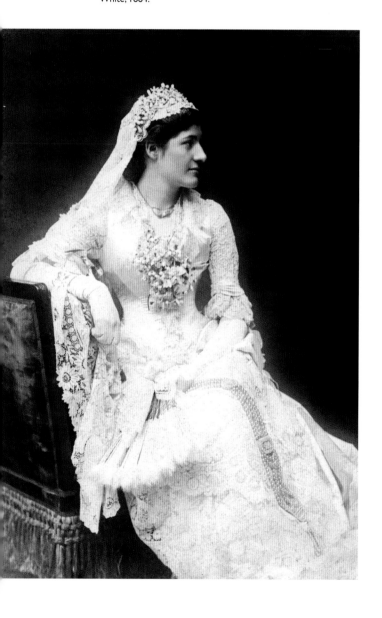

Wedding portait of Bessie Smith White, 1884.

By 1879 the American economy had finally emerged from its postCivil War doldrums. Traditional enterprises such as coal, steel, railroads, banking, real estate, and journalism were joined by new services such as streetcars, savings banks, and life insurance to generate enormous fortunes. The rising tide of wealth created ambitious clients looking for offices, houses, libraries, universities, churches, and clubs. If money was in supply, architectural talent was in demand. New York was the financial capital of the country, but the northerly half of Manhattan was still largely undeveloped. The lower regions were a sea of brownstone rowhouses in the "neo-Renaissance" style, a catch-all phrase to describe a dreary and illiterate collage of vaguely classical elements. The countryside was even emptier until train service initiated the rise of the garden suburb and weekend retreats were suddenly accessible by overnight boat. Newport was poised to explode as a resort, but fashionable houses built since the Civil War had been realized in soon-to-be-rejected hybrids such as the French Second Empire. Into this vacuum

came McKim, Mead & White, armed with an appreciation of the past, a clear understanding of the present, and a brand new architectural idiom—the shingle style, which they called the modern colonial.

The office consumed White, so much that it is hard to locate the boundaries of his personal and professional lives. He was in a constant hurry, rushing between meetings, job sites, parties, concerts, dinner at one of his clubs, and buying trips to Europe or restorative escapes to his beloved Ristigouche Fishing Club in Canada with Robert Goelet, friend and one of his most faithful patrons. Goelet headed the building committee of the Metropolitan Club and was an investor in Madison Square Garden, Sherry's Restaurant, and the Imperial Hotel, among many real estate ventures. An 1892 letter from White conveys the spirit of their friendship and the range of their shared interests:

Detail of a settee designed by Stanford White for the Cheney family, c.1890.

Wadsworth Atheneum and Museum

> My general health is perfectly good, but the little buzz-saw inside of me is still going on in an unpleasant manner. I have not taken a mouthful of food except dairy farm milk for the last seventeen days and I am visibly wilting under the treatment; going to Egypt; must settle Club first. The Club is the chief reason. I must get that completely settled before I go or Henry Taylor will never forgive me. Everything is all right as far as we and you are concerned at Sherry's and at the Imperial. We expect to open the Vaudeville in style on the 9th. I wish you were here.

Stanford White met Bessie Smith on a site visit with McKim and married her in 1884 after what he referred to as "a protracted siege." With the match came material advantage. Bessie's mother was one of the heirs of her aunt Cornelia Stewart, widow of A. T. Stewart, dry-goods king and at one time the richest man in America. Ultimately, Bessie's share was in the order of $5 million. Much of that eventually disappeared into

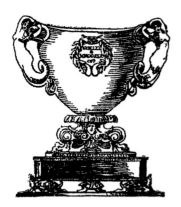

Goelet Schooner Cup, 1890s.

poor investments and financial reversals, but a lot went to support her husband. She owned their country house outright, and she was a major stockholder in the Madison Square Garden Company.

White's output dissolved the boundaries between architecture and related arts. He was a visionary decorator as well as an enterprising dealer in antiques. He designed jewelry, furniture, book covers and even sailing trophies like the massive Goelet Schooner Cup, executed by Tiffany's. He is still famous for his picture frames, which capture the energy and spark of his imagination, his ability to combine traditional and contemporary ornament, and his infatuation with gold leaf. The dining rooms in his early houses feature built-in sideboards inspired by Newport cabinet-makers while his last design, Payne Whitney's Venetian Room, occupies an enchanted middle ground between architecture and furniture.

White was celebrated as a tastemaker. He advised wealthy clients like Oliver Payne on their art collections and would bid on their behalf. He organized parties ranging from family weddings to celebrations of a civic scale. His directions to New Yorkers for celebrating the anniversary of Columbus's discovery prompted *Harper's Weekly* to declare that he should be appointed Commissioner of Public Beauty. It is no wonder Chapman could not discuss the man apart from the time and place, could only describe them in highly charged terms, and suggested in his characteri-

Cooper Hewitt at Box Hill, 1902.

zation that nothing with that much sheer energy could go on forever.

A photograph in Bessie White's guest book from a weekend in late September 1905 recalls White's trajectory in somewhat bittersweet terms. The scene appears to be a picnic. Stanford White and Charles McKim sit on a blanket on the north lawn of Box Hill, the Whites' country house in Saint James, Long Island. Augustus Saint-Gaudens is in a rocking chair next to Bessie, the effects of illness clearly showing in his sunken expression. In 1878 the

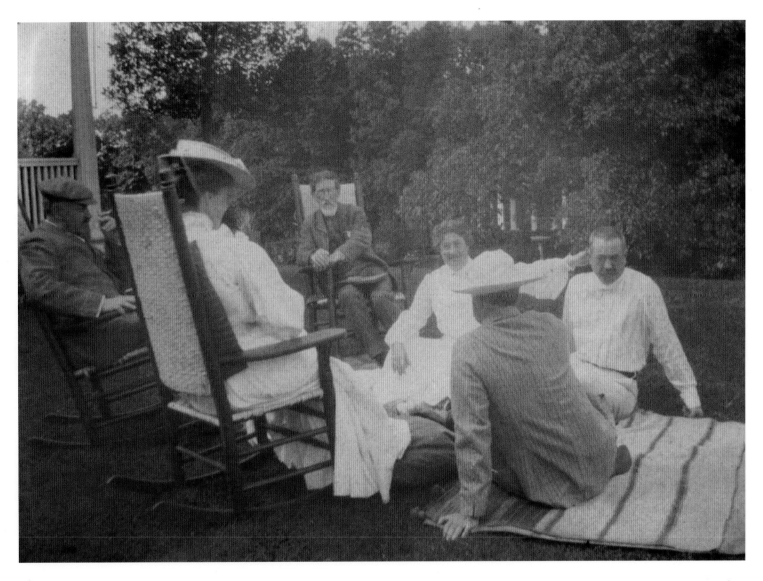

Augustus Saint-Gaudens, Bessie and Stanford White, Charles Follen McKim (back to camera), and other guests at Box Hill, September 1905.

three young men had taken an extended holiday to look at Romanesque architecture in the South of France, an excursion that White recorded in a series of highly entertaining letters to his mother. Now they were at the top of their professions. Saint-Gaudens was redesigning the coinage for the United States Mint. McKim had just been awarded the gold medal from the Royal Institute of British Architects. White was probably the most celebrated architect in the country. The three men had defined a period of unprecedented creativity in this country and created some of the most beautiful objects in America. Less than one year later White would be the victim of an assassin. Within two more years Saint-Gaudens would succumb to cancer and McKim, it is said, to the shock of White's death.

The Architect as Client

T HE TRAJECTORY of an architect's career can be measured in many different ways, but Stanford White's can be based on where he lived at any particular time and what he was doing to improve the property. Stanford and Bessie White lived in a number of different houses in New York City; during the warmer months Bessie moved out to Saint James, a village on Long Island's North Shore about fifty miles east of New York, and her husband joined her on weekends. Progressive expansions of the Saint James house probably coincided with installments of Bessie's inheritance as much as with peaks of White's

Stanford and Bessie White at Box Hill about 1904.

professional success. These home improvements stretched over a twenty-year period, and the major stages were based on the campaigns of 1892 and 1898–99. At precisely those two moments, Stanford White was implementing a parallel action to upgrade his principal residence in New York City.

By the early 1890s, White's professional accomplishments were impressive. A list of works in progress prepared for the office in advance of one of his many European trips included more than sixty projects in various stages, from preliminary design through construction. The number of guests visiting his Saint James house during the 1892 season suggests an equally complex social life. Everyone seemed to want something from Stanford White. These demands are suggested by a letter to a friend in which he complained, "I work all day and then have to dress up and do the society thing every night." The space between work

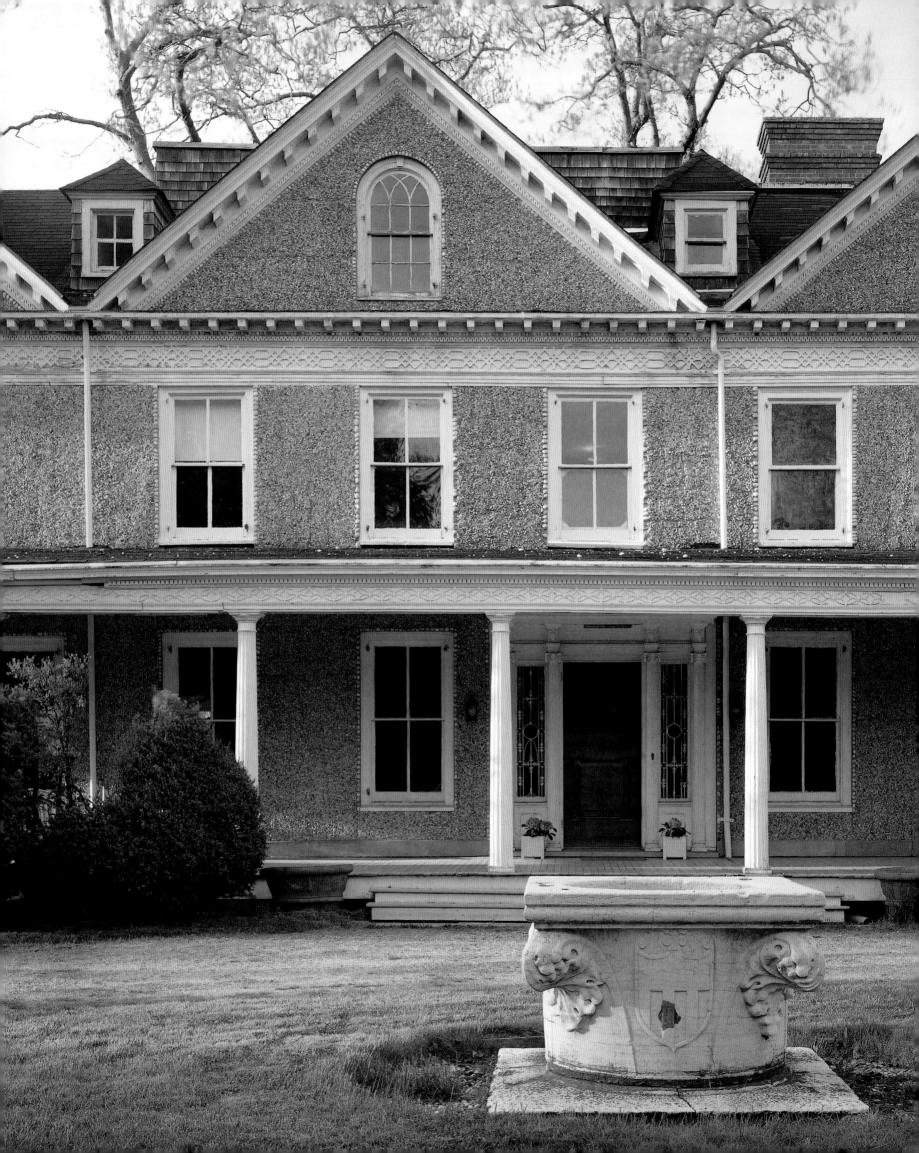

and play was similarly oversubscribed. White had just been appointed to the Advisory Committee for the Arts of the upcoming Columbian Exposition; a generation of American painters and sculptors relied on his judgment and his frames as well as his generosity; and he was regarded as a ready source for a host of favors, ranging from club memberships to box seats for the National Horse Show at Madison Square Garden. White had every reason to think that he was just as worthy as his illustrious clients and that he and Bessie should live as their equals.

Box Hill

For more than half the time the Whites occupied the house eventually called Box Hill, its buildings and grounds were the subject of a nearly continuous program of expansion, renovation, and redesign. White had access to three exceptional resources: his own considerable talent; the interest and support of his able partners; and his wife's timely inheritance. In transforming a cottage into a country seat, White was able to satisfy three separate agendas. For his wife, he created a place for assembling and entertaining her friends and family. For his partners, McKim and Mead (who each lived only in rented quarters in the city), White's country house was a laboratory for testing architectural ideas. For the firm of McKim, Mead & White, Box Hill was a critical component for developing residential commissions. It was an accessible, accommodating, and entertaining venue for nurturing social contacts and the perfect setting for their flamboyant partner Stanford White to demonstrate his conviction that "an architect must live better than his clients."

The story of Stanford White at Box Hill begins with his partner Charles McKim. In the 1870s McKim was asked by his college classmate Prescott Hall Butler to design a modest weekend retreat in Saint James. The property overlooking Stony Brook Harbor had been transferred to Butler from his father-in-law, Judge J. Lawrence Smith, whose ancestors had settled that part of Long Island more than two hundred years before. "Bytharbor" was completed before White joined McKim's practice, but Butler and his wife, Nellie, had a growing family that required a near-endless

The original farmhouse is legible in the pitch of the roof, the off-center front door, the shape of the attic window, and the two-over-two sash below.

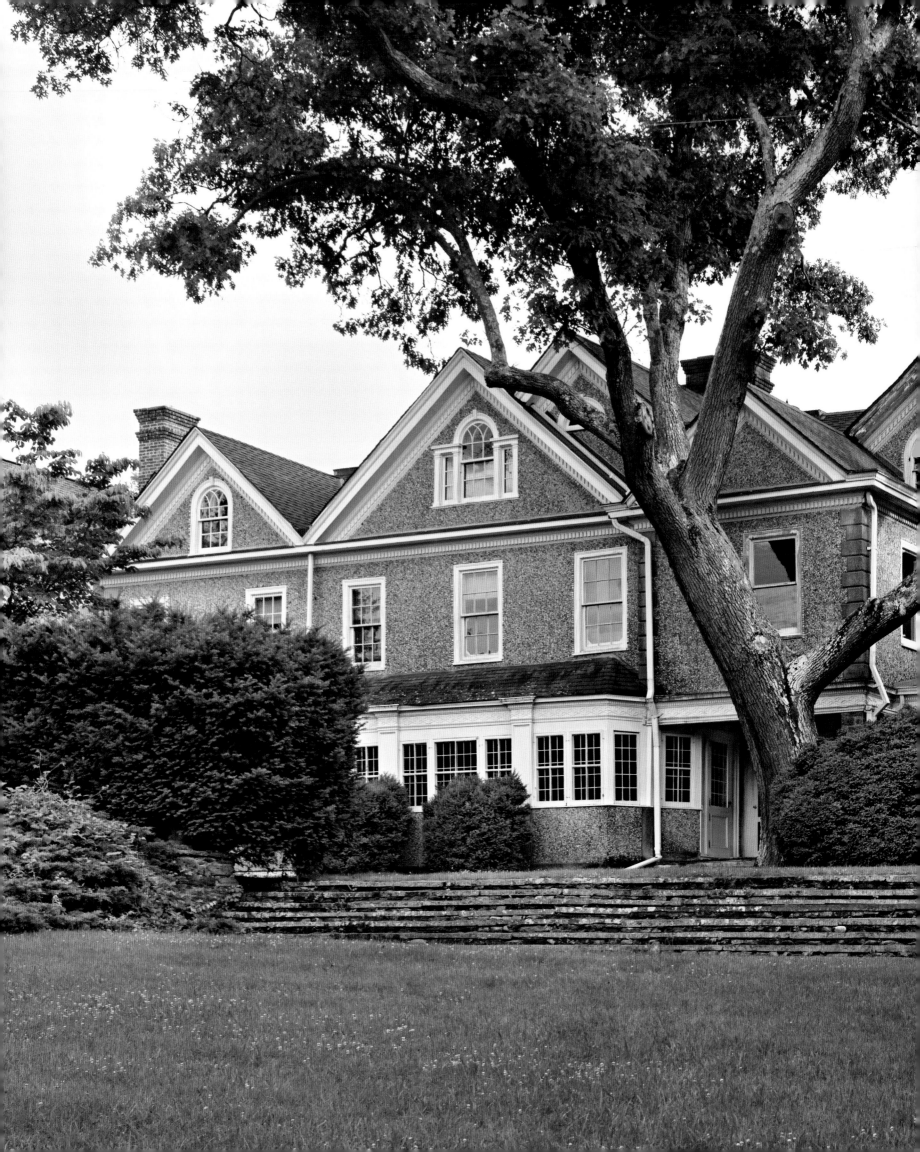

The rear elevation reveals the incremental nature of expansion but almost no trace of the original house.

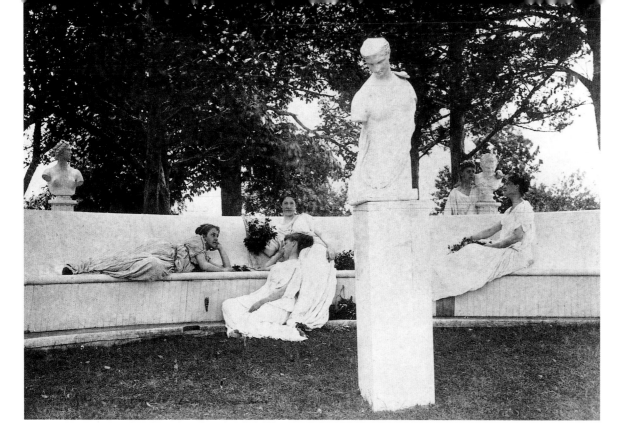

Bessie and her sisters pose on the wood exedra that White built at the top of the hill. The architect's interest in classical architecture dated from his honeymoon in Greece.

series of expansions. In the course of serving his congenial classmate, McKim introduced White to the other members of the Smith family, including Nellie Butler's youngest sister, Bessie Springs Smith. Stanford White and Bessie Smith were married in February 1884, and one year later the couple rented Carmen's farm, next door to the Butlers, owned by Mrs. Lewis Atterbury. Years later Bessie would recall her attachment to the site:

> In driving to the harbor, just before we reached the Cordwood Path, I used to get out and run across the fields to look at the view from Carmen's Hill and then join the others down the hill at the Harbor where we had our bath-houses. This view became a passion with me, so much so that later when I married, my Father told Stanford he was sure I would never be happy or content to live anywhere else but on top of Carmen's Hill. So we bought this hill and after nearly 50 years I am still living there.

The principal structure on the property was a two-and-a-half-story cottage in a dreary neo-gothic vernacular. A center hall and straight stair divided three small living rooms on the first floor and four even smaller bedrooms on the second. The rent was $900 a year.

A photograph of the living room from the 1880s shows a comfortable

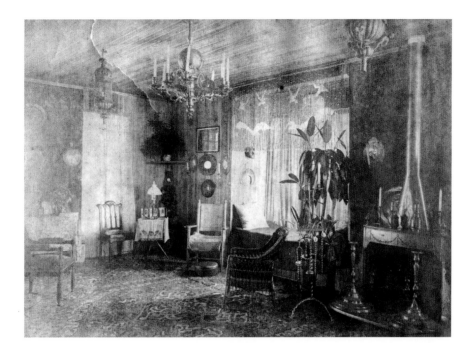

The living room in the original farmhouse transformed by the taste of Stanford White. The walls and ceiling are covered with bamboo or cane. The fabric over the bay window is a design by Candace Wheeler.

if cluttered interior with an exceptionally varied collection of decorative objects representing a range of cultures—American colonial, Dutch, Medieval, and Islamic. The embroidered gauze casement over the bay window and the fabric panels screening the back door suggest the designs of Candace Wheeler, one of White's collaborators of the Veterans Room at the Seventh Regiment Armory. The carpet on the floor anticipated

White expanded one corner of the porch to the size of a room with a view over the formal garden and out to Long Island Sound.

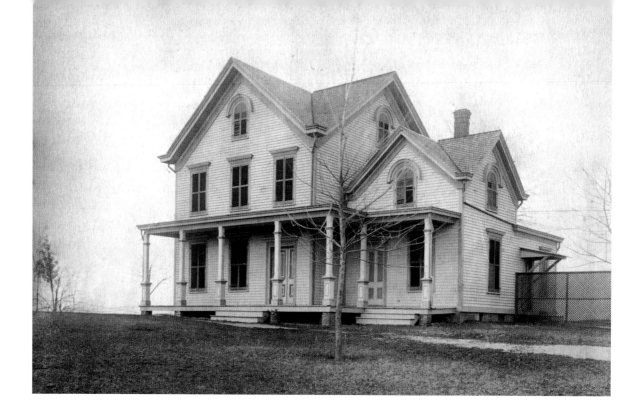

White's reputation for high standards in that department. The walls and
ceiling appear to have been completely covered with reed matting, which
would have enveloped the room in an even wash of warm light.

In 1892 Mrs. Atterbury offered to sell the house for $25,000. For the
first time in his life Stanford White had access to capital in the form of
his wife's inheritance. Bessie, who would always be ambivalent about the
city, was more than happy to invest in Saint James.

White's impulsive enthusiasm for this opportunity was reflected in an
early scheme for the expansion of the cottage. With its pretentious cyclo-
pean windows and ornamental swags, the design was characterized more
by indiscriminate decoration than by architectural discipline. Fortunately,
another scheme was selected. Building on the existing gable as the irre-
ducible unit of expansion, White extended the living room to the west,
achieving its present dimensions with the help of steel beams. The treat-
ment of the walls and ceilings continued the reed covering from the orig-
inal installation. The enlarged room was filled with White's growing col-
lection of furniture, carpets, and extraordinary objects.

Even with his powers of visualization and unlimited access to drafts-
men, White's execution of the design was not completely linear. A con-
struction photograph overdrawn in pencil (probably in White's hand)
illustrates a late change to the porch, which was then implemented. By

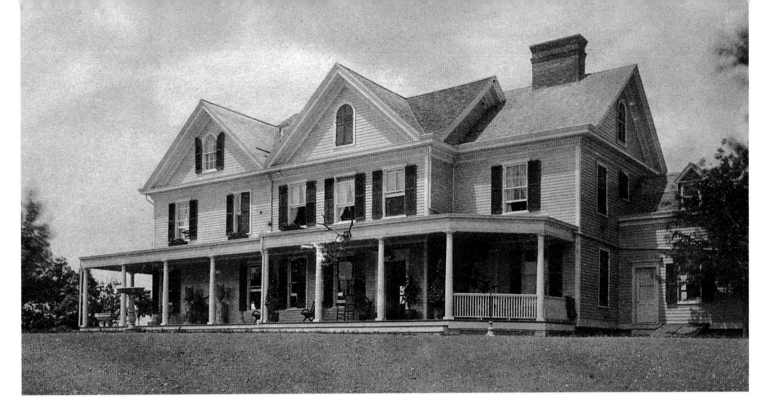

Box Hill after the first major expansion around 1893. The original house is in the center. The clapboard walls were painted pale yellow.

summer 1893 the house was finished. Clad in pale yellow clapboard with white trim and green shutters, the handsome building represented an astonishing transformation of the original farmhouse as well as a beautiful and original variant on a federal idiom.

One of White's early, unbuilt schemes for expansion. The original farmhouse is on the right. The two-story porch would have faced west.

Avery Fine Arts and Architectural Library, Columbia University

The expansion of the house was accompanied by a parallel set of landscape improvements. White regraded the original cow pasture to create a level parterre around the house. A formal garden was laid out at the

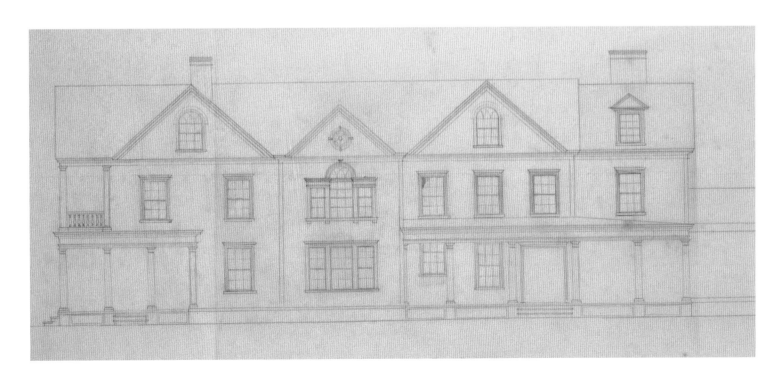

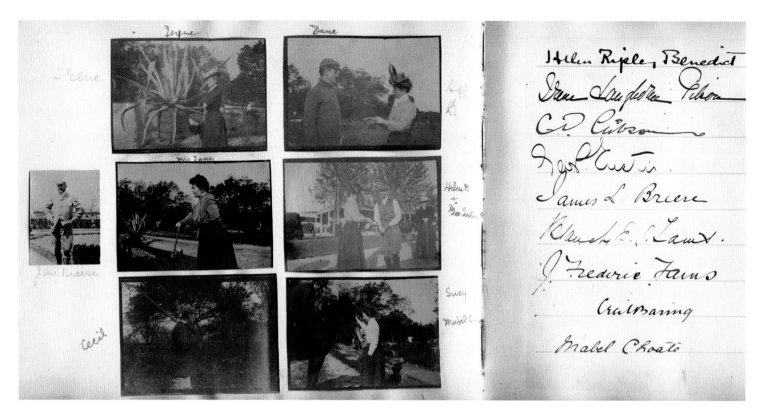

A page from the guest book for October 1898 documents visits by clients, family, and friends. Bessie White was usually the photographer.

western end with a fountain in the center and a pergola at the back. The remaining open fields were adapted (probably without much effort) to accommodate a nine-hole golf course.

Bessie kept a guest book, which recorded visits from Bessie's family, neighbors, the occasional English lord, and multiple connections to the firm, suggested by the signatures of McKim, Mead, James Breese, Cooper Hewitt, Tessie Oelrichs, and Charles Dana Gibson. She illustrated the album with photographs showing her guests enjoying a full range of seasonal activities. The increasing proportion of clients to family members suggests that the business of running a country seat was beginning to assume a more significant role in White's professional life.

By 1898 the house must have started to seem inadequate, since White began to explore alternative formal strategies for a second major expansion. Three drawings record his thinking.

In the fall the center of outdoor life moved to the south porch. White always kept horses, which soon shared the barns with automobiles.

26

The first shows the twin gables concealed by a two-story porch, a design similar to the firm's house for James Breese in Southampton. A second proposes a monumental south gable along the lines of the house for Ruth Livingston Mills in Staatsburgh. A third scheme drawn over a photograph of the 1893 house shows—in pencil and possibly in White's hand—the ghostly outline of a third gable linked to the first two. There was precedent for this approach as well: twelve years earlier White designed a three-gable house for Edward Dean Adams in Seabright, New Jersey. By 1899, and following the now-usual course of midconstruction adjustments, the third gable was in place. The expansion allowed White to add the large dining room, with its opposing walls of leaded glass and Delft tile, and enlarge the

The grounds surrounding the house were laid out with a nine-hole golf course for the amusement of the guests and their host, who is pictured above and below.

entrance hall to incorporate a generous new staircase in green-glazed Guastavino tile. Upstairs were additional bedrooms on the second and third floors for guests and staff. A fourth gable, set apart from the main block by a hyphen, accommodated the kitchen on the ground floor and even more bedrooms above. The completed house had more than twenty rooms.

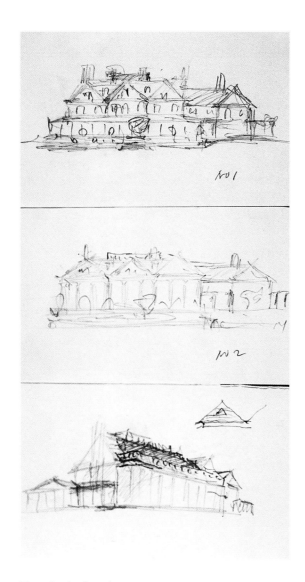

Three sketches from about 1898 outline White's options for a second major expansion.

Avery Fine Arts and Architectural Library, Columbia University

The three linked gables defined the image of the house from the south, but the formal consequences of this simple and seemingly inevitable gesture translated into almost unworkable complexities on the north facade and roof plan. The problem was resolved only with a collage of overlapping gables and lots of flashing, but at least one of Bessie's letters to her husband asks him to do something about the leaks.

Inexplicably, White seems to have lost faith in his design as soon as he had completed it. A finished drawing dated 1899 illustrates a proposal for a massive reconstruction of the south front, burying the three gables behind a monumental south porch capped by overscaled dormers and supported by two-story columns, which White had acquired from a dismantled church in Connecticut. The effect was elephantine and fussy; one can be grateful that it was never implemented. The major change that was carried out around 1899 involved covering the yellow clapboard siding with pebbledash, a coat of cement stucco into which the workmen pressed beach pebbles from Long Island Sound, outlining window openings with larger stones and framing the corners of the gabled sections with cement quoins. The architecture of the house was complete.

Landscape improvements continued in a similarly nonlinear fashion. In 1900 a new pergola replaced the original, which had been destroyed in a storm. One drawing shows caryatids as structural supports. That idea was not implemented, but White was able to incorporate the caryatids, which were probably architectural salvage, as pilasters on the orangerie he built to store the legions of boxed ornamental trees that decorated the grounds. The back of the one-story orangerie and an adjacent icehouse were set into the crest of the hill at the highest point on the property,

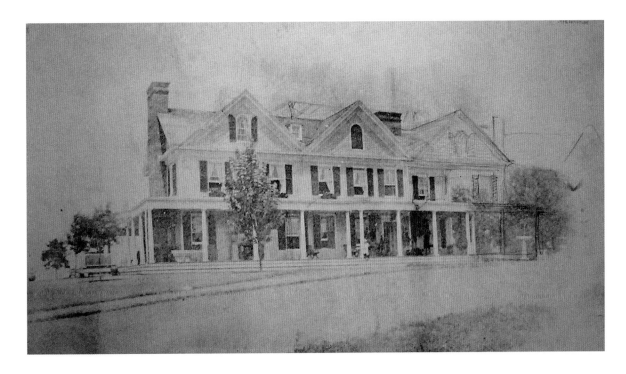

where White erected a flagpole, visible to boats in the Sound for miles. He also constructed—first in wood and then in concrete—a curved bench based on measured drawings made during his honeymoon in Greece. At the focus of the curve he placed a fragment of antique sculpture, later replaced by a cement cast of the Diana that Augustus Saint-Gaudens had created for Madison Square Garden in 1889.

The barns and stables were rearranged and expanded. An earlier scheme for a picturesque water tower and gardener's cottage had not been

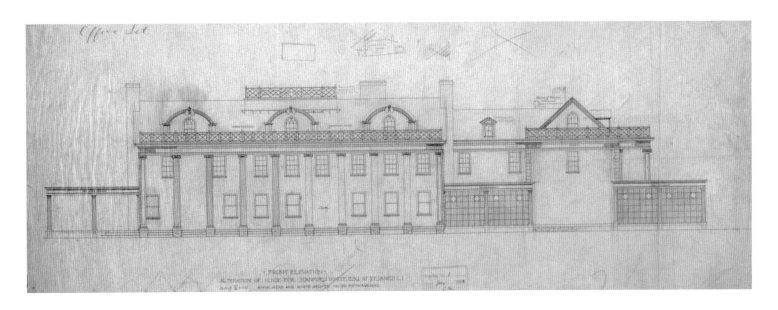

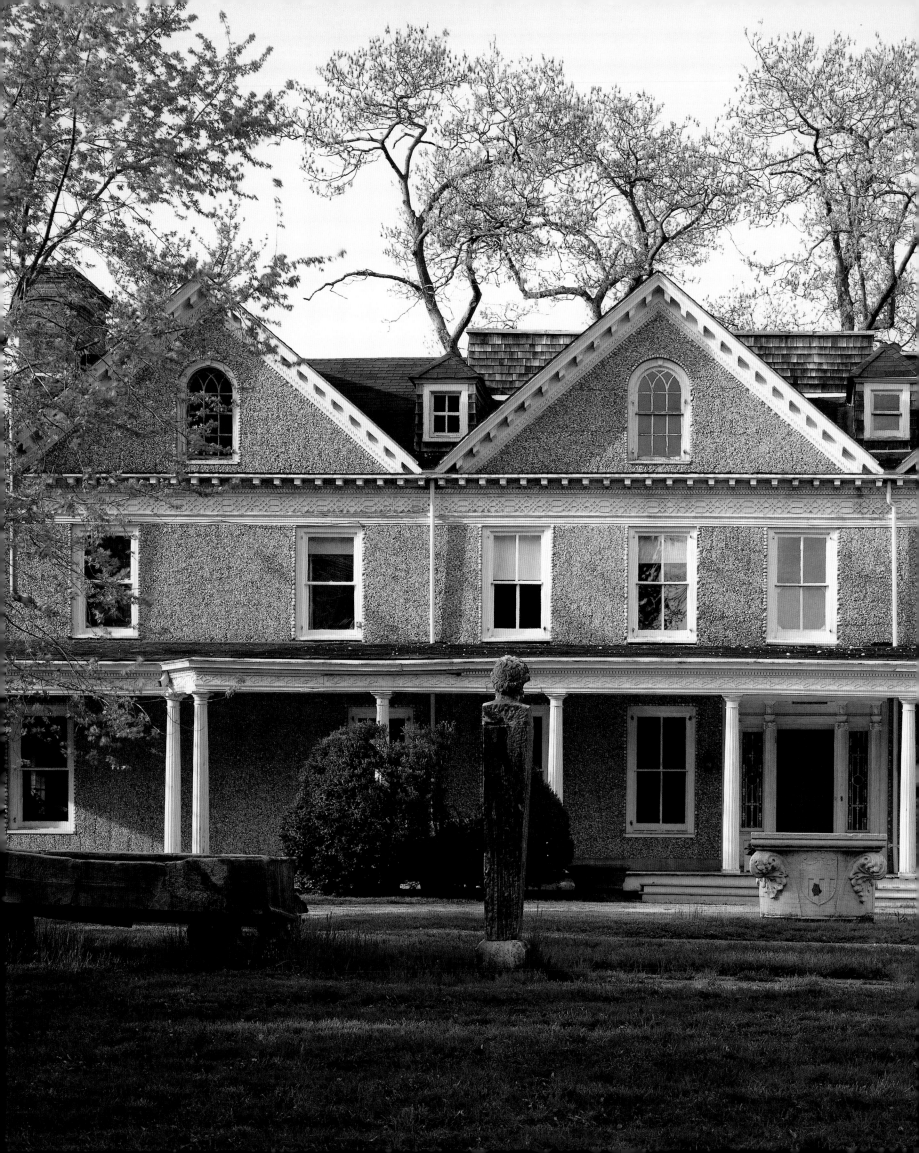

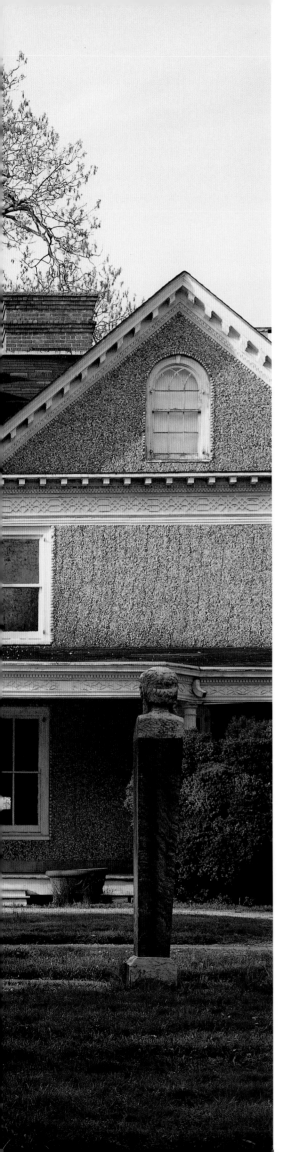

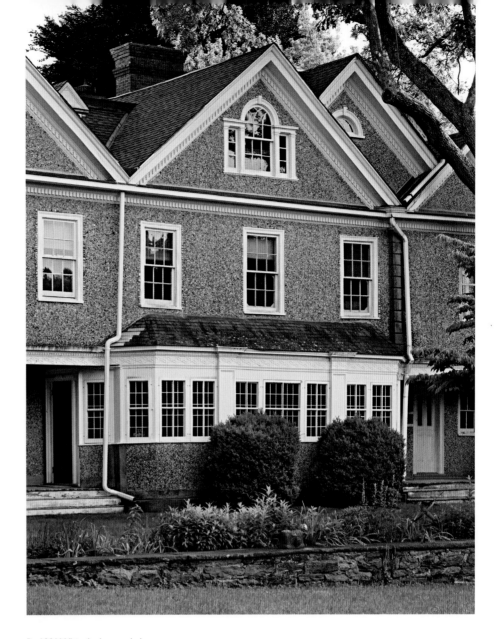

By 1901 White had expanded
the dining room on the north
side, laid out the entrance court
on the south, and covered the
yellow clapboard with pebbledash.

The formal garden to the west
was centered on a *Crouching
Venus* in a reflecting pool. White
tinkered with the design of the
pergola but never implemented
a major change.

The staircase, a creation of the second expansion, is covered in green tile from Raphael Guastavino. The walls are split bamboo.

implemented, but a simpler tower was constructed to store water that was pumped by steam engine from a spring at the base of the laurel-covered hill. On a small saddle halfway between the house and the harbor White placed a circular temple with a thatch roof and baseless Tuscan columns. This folly was a critical component of the landscape, creating a picturesque focus for the middle ground and establishing an intermediate layer of natural landscape that separated the manicured precincts surrounding the house from the awesome views over Long Island Sound.

The processional sequence of arrival was carefully controlled. Piers laid up in smooth glacial rocks framed separate driveway entrances that

The mantel in the stair hall came from White's warehouse. The portrait by Julian Alden Weir is of White's father, Richard Grant White.

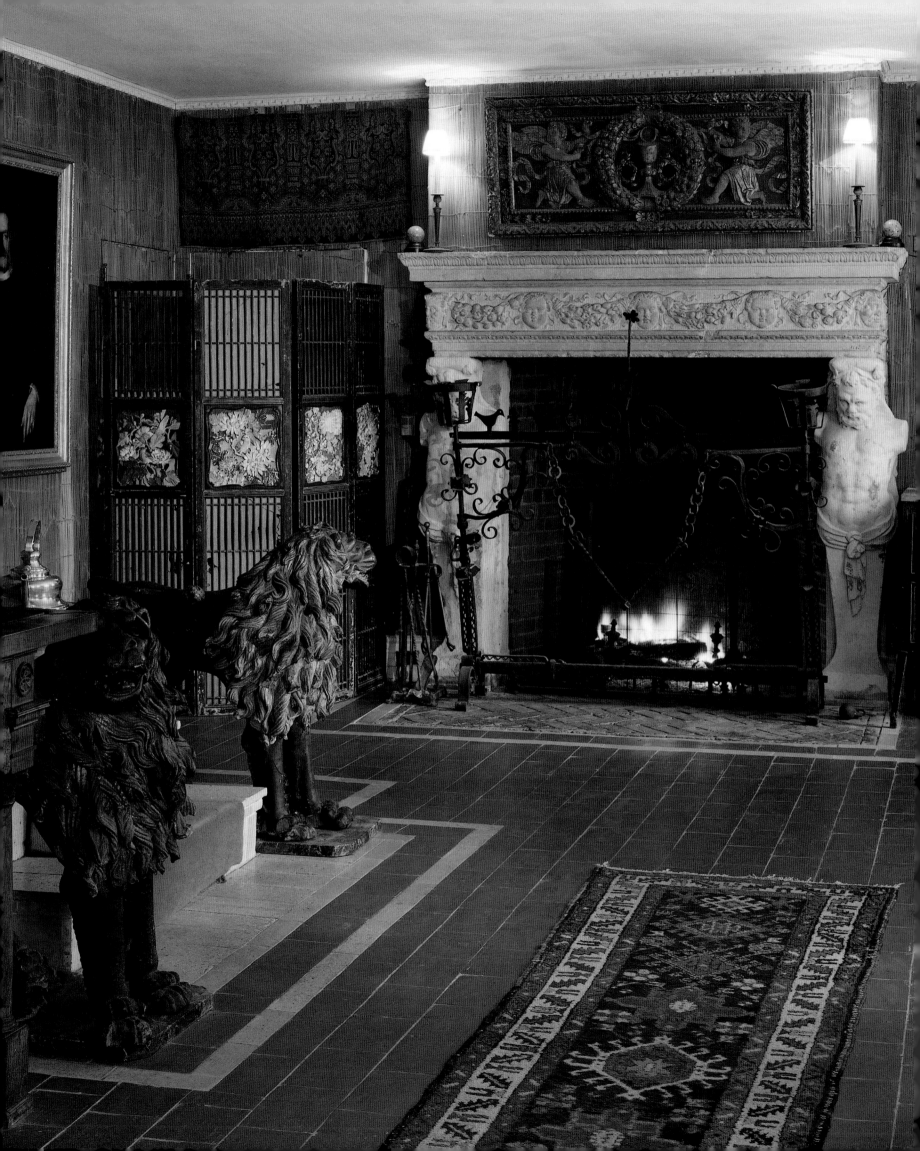

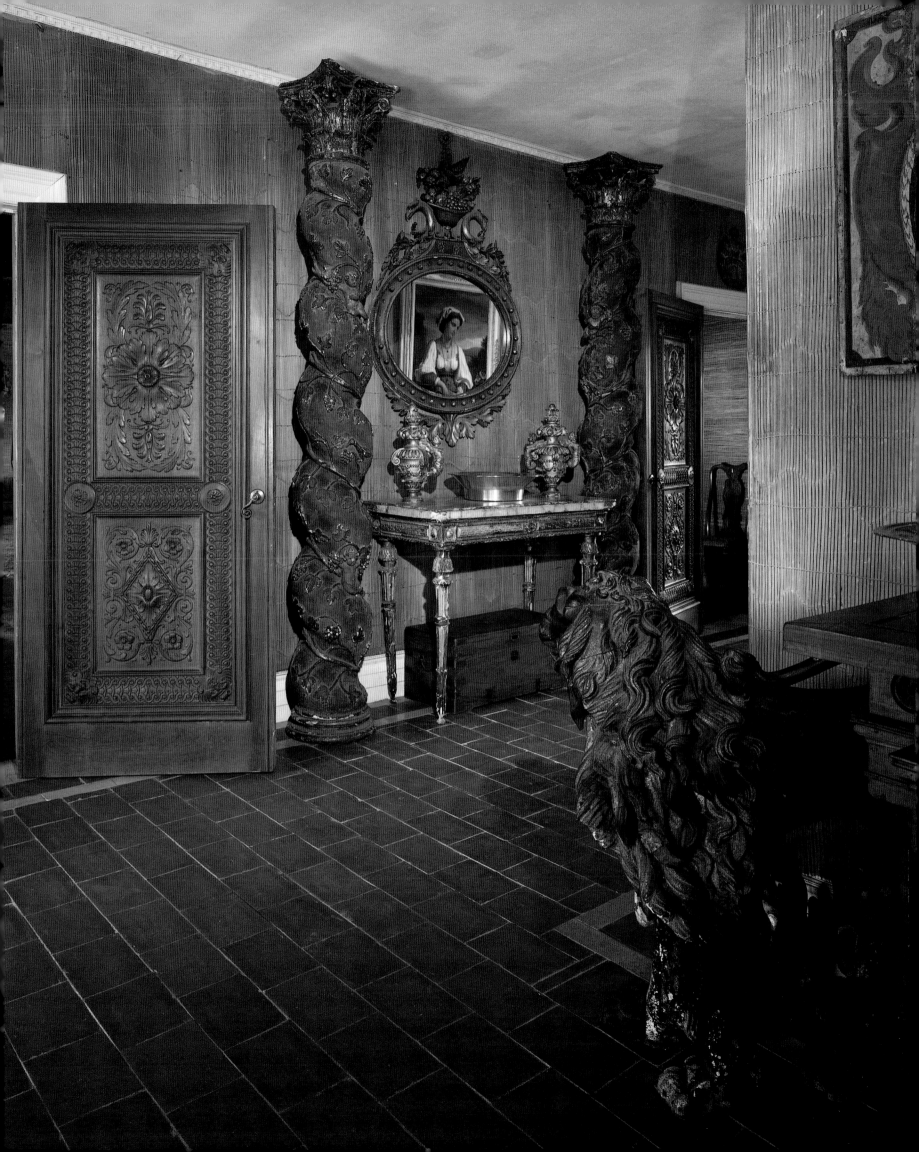

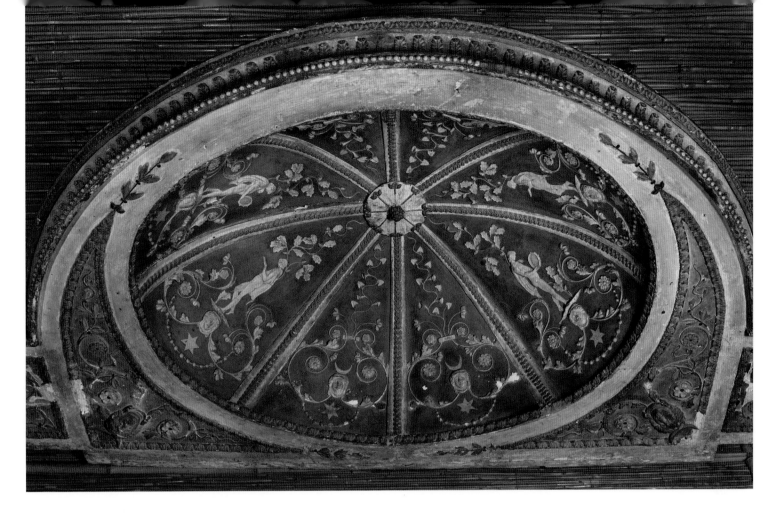

Gilded baroque columns and a neoclassical baldachino are juxtaposed with split bamboo and reed matting on the walls of the hall and living room.

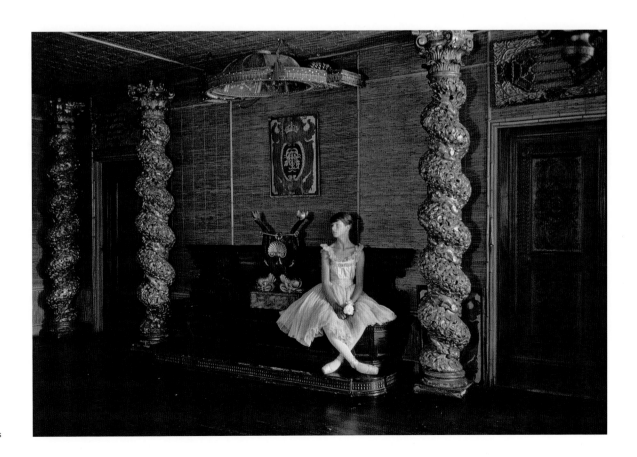

One of White's great granddaughters poses under the baldachino in the living room.

Toni Frissell, Library of Congress

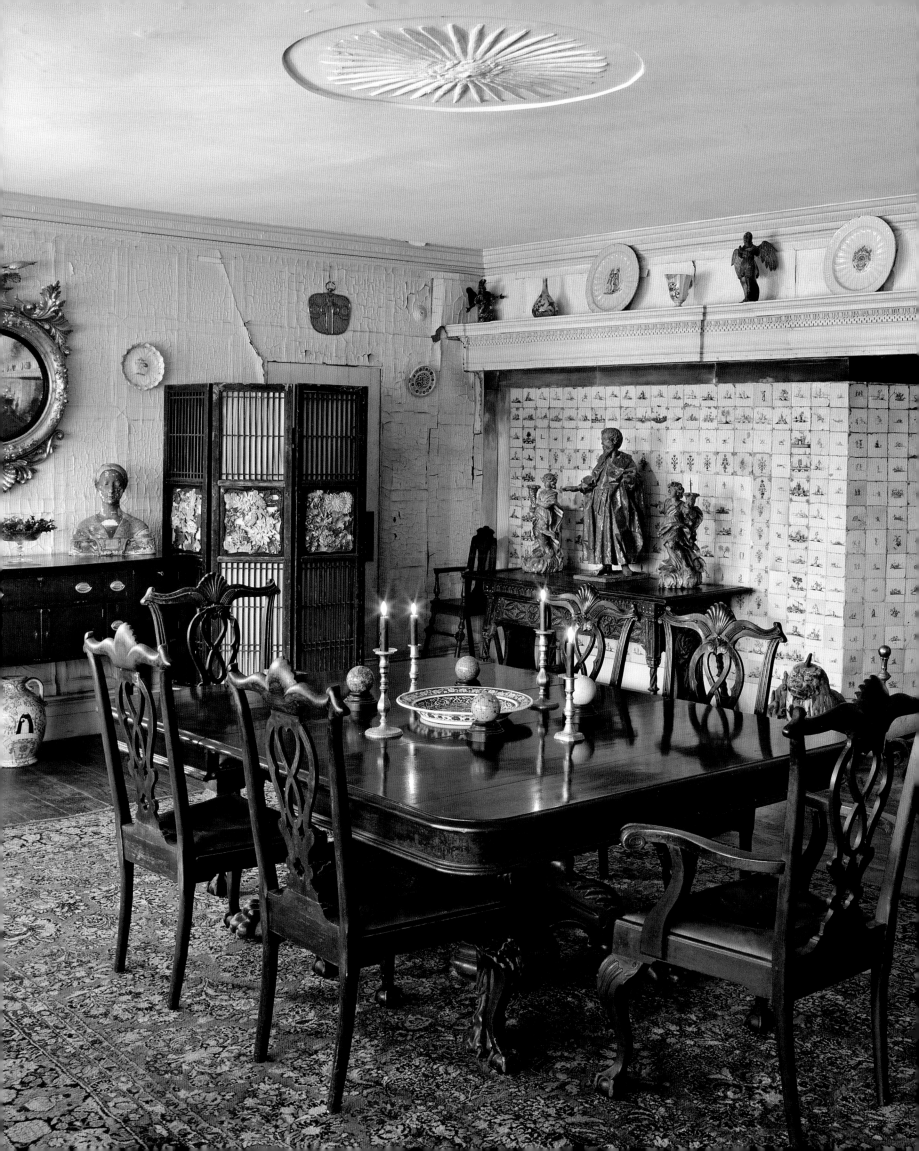

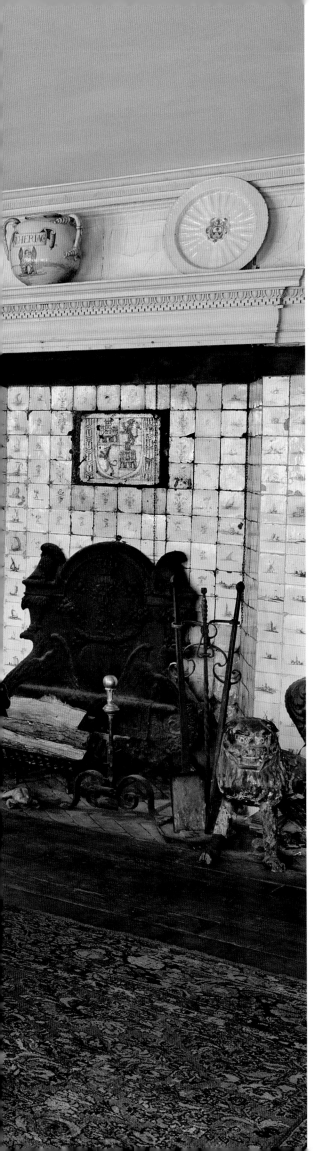

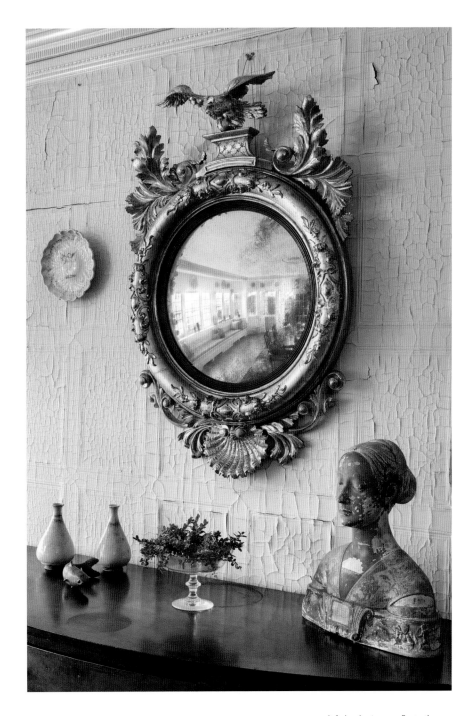

A federal mirror reflects the
wall of glass facing north.
The short walls were covered
in Lincrusta, a manufactured
product that simulated paneling.

The mask of Apollo, inspired
by Louis XIV, is the only
ornament in the ceiling of
Box Hill, although White used
it frequently in his other
designs. The fireback actually
came from Versailles.

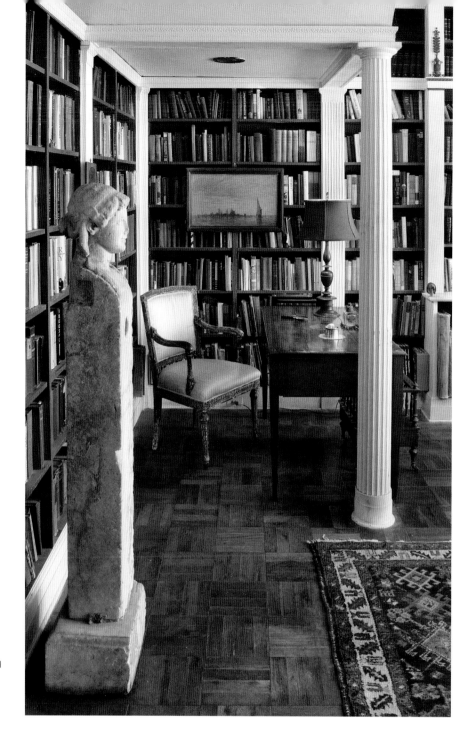

Lawrence Grant White designed the library, which is furnished with pieces from his father's collection. The painting is by William Gedney Bunce.

allowed for a variety of shortcuts, but the principal entrance from Moriches Road had a more formal character. In 1900 White relocated the entire driveway about twenty feet to the south to align its component parts. He planted rhododendron on each side of the drive for half of its length, creating a tight floral tunnel that would explode into the open space of the lawns around the house, to be closed down again by the lines of box bushes that flanked the entrance court. In 1901 he reconfigured that courtyard, framing an oval carriage turn with low stone walls and marble statuary. The entire composition was centered on a large white

The porches on either side of the dining room were cut back to allow light at the sides of the bay. The high chair was designed by William A. Delano.

marble wellhead, said to have been purchased under informal circumstances from the mayor of a town in Italy.

White continued to tinker with the main entrance to the property, and by 1906 he had arrived at a composition worthy of baroque urban design. It combined a curved peristyle and four driveways (two active, two rhetorical) around an oval enclosed by rhododendron. The ingenious geometry of his *"rond point"* made a formal processional event out of an irritating bend in the main axis that had existed since Bessie's sister Kate Wetherill had refused to sell her an additional twenty-five feet of frontage

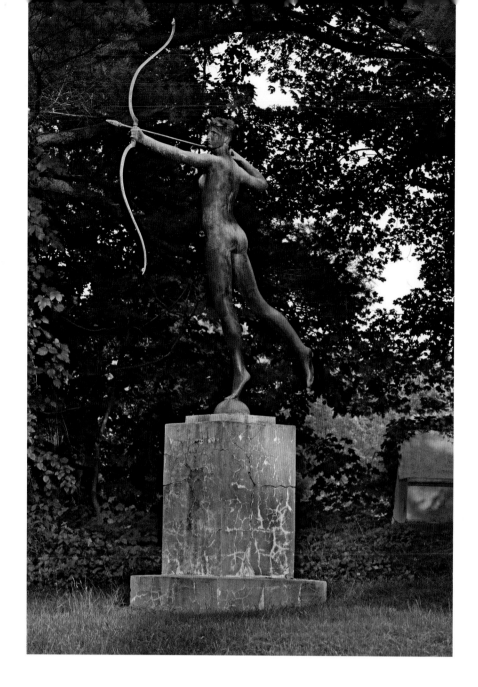

Diana, created by Augustus
Saint-Gaudens for White's
Madison Square Garden,
points toward Long Island
Sound from the highest point
on the property.

on Moriches Road. The design for the peristyle also created a home for
the salvaged two-story columns that a few years earlier White had been
so eager to apply to the south facade of the house.

Some of the artifacts that went into the project were less controversial
but no less interesting. When the Fifth Avenue Reservoir at Forty-second
Street was being dismantled to make way for the new public library,
White secured cartloads of granite rubble and thick bluestone copings to
construct the low walls and broad steps that frame the gardens, berms,
parterres, and entrance. At about the same time, the demolition of A. T.
Stewart's house liberated quantities of white marble slabs, which White
reused as paving stones in the entrance court. The elaborately carved

Renaissance doors to the living room had been rejected by J. P. Morgan, who thought that Carpathian walnut was not sufficiently noble for his new library.

White's abilities as a decorator were as much in evidence at Box Hill as his skills as an architect and landscape designer. Because the house was unheated and would be closed for the winter, the finishes were mostly sturdy and simple but characteristically unusual. Reed covered the walls and ceiling of the living room; plain plaster ceilings and walls of split bamboo defined the stair hall on both floors; and white-painted Lincrusta (simulating wood paneling) was applied to the walls of the dining room. Some aspects of the décor were astonishing, such as the exposed steel beams that hold up the ceiling of the living room or the entire wall of Delft tile in the dining room. Unlike most of the houses that White designed for his wealthy clients, the emphasis on the architectural finishes at Box Hill stressed their visual qualities rather than their provenance or evident cost. White bought the tile for the main stair from Raphael Guastavino for fifty dollars; the Delft tile in the dining room could not have cost much more.

As the country house was designed to feature the pleasures of the outdoors, the decorative emphasis was on the gardens, including sculptures and ornamental plants, and on the porch, furnished with wicker seating, oriental rugs, and Moroccan incense burners that had been converted to lamps. The furniture inside consisted of English, American, Italian, French, Spanish, Dutch, and even Japanese design. Many of those pieces were reproductions, but the mantels, mirrors, lamps, fireplace accessories, ceramics, and carpets were mostly genuine. All of the furnishings had been selected to illustrate White's conviction that it was possible to combine objects from vastly different visual cultures.

A capital from Madison Square Garden, salvaged when the building was demolished in 1925.

Gramercy Park

At the same time that White was making major improvements to Box Hill, he was upgrading his residence in town. While Bessie's first allegiance may have been to the rural landscape of Saint James, White considered New York City his principal residence. Since 1885 he and Bessie (and eventually their son plus White's widowed mother) had been living at 56 West Twentieth Street. In May 1892 the Whites moved a few blocks to 119 East Twenty-first Street, a four-story brownstone with a high basement and a front stoop.

Their landlord was H. A. C. Taylor, a well-to-do banker with extensive connections in New York and Newport, who lived next door. Taylor was part of a multigenerational chain of McKim, Mead & White clients. His father, Moses, had given McKim one of his first important commissions in 1876 for a country house in Elberon, New Jersey. In 1909 the firm would build a house at 680 Park Avenue for Taylor's son-in-law Percy

121 East Twenty-first Street after White's renovation. The solarium marks the original location of the front door. The music room and painting gallery are on the far right.

Museum of the City of New York. McKim, Mead & White Collection

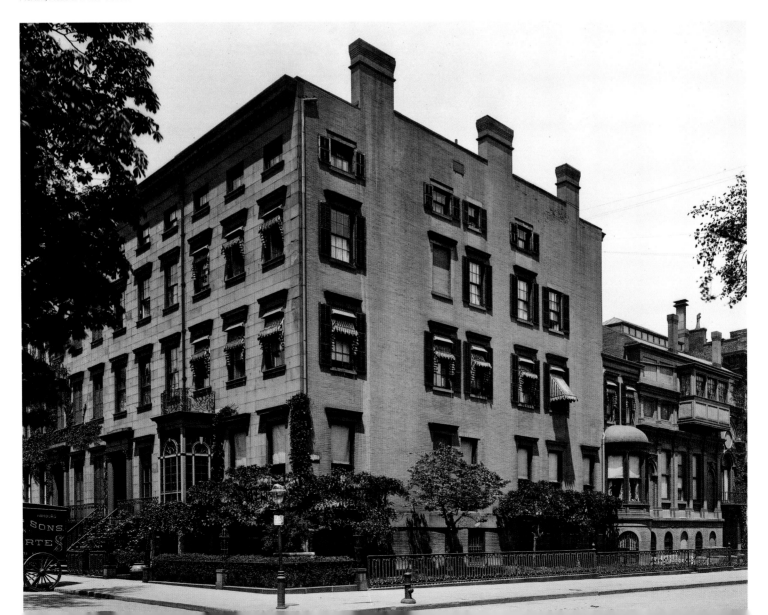

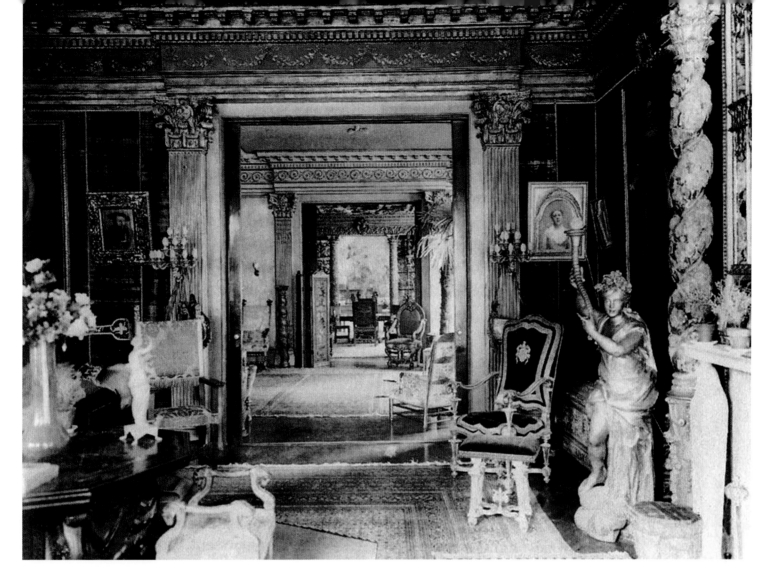

Pyne. For Taylor himself the firm built a striking colonial revival house in Newport, a mausoleum at Woodlawn Cemetery, and town houses for Taylor and his two children. The house that White rented from Taylor was on the north side of Gramercy Park, a midblock urban garden laid out by Samuel Ruggles in 1831. The Whites lived there for seven years without making any major improvements to the property.

By the mid-1890s White was looking for a bigger house in the neighborhood. Without capital he would never be in a position to buy, but the income from a successful practice could support a significant rent. His opportunity arrived in 1896, when Taylor moved uptown and put both of his Gramercy Park properties on the market. By 1898 White persuaded Taylor to rent 121 and to reassign the lease on 119 to Kate Wetherill.

The five-story house at 121 East Twenty-first Street was on a corner lot with twenty-six feet of brownstone frontage facing Gramercy Park, returning 131 feet along Lexington Avenue. A previous owner—possibly

Taylor himself—had added a ballroom wing to the north of the main block, expanding the kitchens at ground level and creating a carriage entrance that led to the stable at the rear of 119. Once he had an agreement with Taylor, White lost no time on design. By August 2, 1898, the office had produced plans for an expansion and total renovation that added a third floor over the ballroom, replaced the high stoop with a ground-floor entrance, transformed the old front door into a solarium, and reconfigured all interiors from top to bottom. The graphic record—a combination of office drawings and autograph sketches—illustrates the organizational muscle of the largest architecture office in the world at the service of an impatient client. Sketches in White's hand over neatly drafted working drawings suggest that he continued to refine the design after construction had started.

Changes in plan and section allowed White to create a dignified entry at the ground floor. He had spent the fall re-studying the design for the entry hall itself, eventually arriving at a geometrically simple but highly nuanced scheme to thicken the back wall into an apsidal curve that enclosed the staircase, allowed passage to the kitchen, concealed a powder room, and centered the double doors leading to the reception room. The low ceilings—a remnant of the former basement—were kept deliberately plain, a strategy that shifted the focus to the surface of the walls and the objects that filled the space. Large potted plants brought the foliage of the park indoors.

On the second floor White created a suite of four formal entertaining rooms, intended to be revealed in a specific sequence. The stair hall came first. Its height was a release from the compression of the floor below, and its plain ceiling sharpened the impact of a highly enriched cornice, fluted Corinthian pilasters, and a tall stone mantel. With virtually no wall surface, the effect was akin to an exterior pavilion.

Identically framed openings connected the stair hall to the drawing room overlooking Gramercy Park and the dining room in the middle of the house. In contrast with the flat-ceilinged hall, each of these chambers featured an elaborate antique ceiling. In the drawing room a curved, gilded frame surrounding allegorical panels was supported by an unusually deep

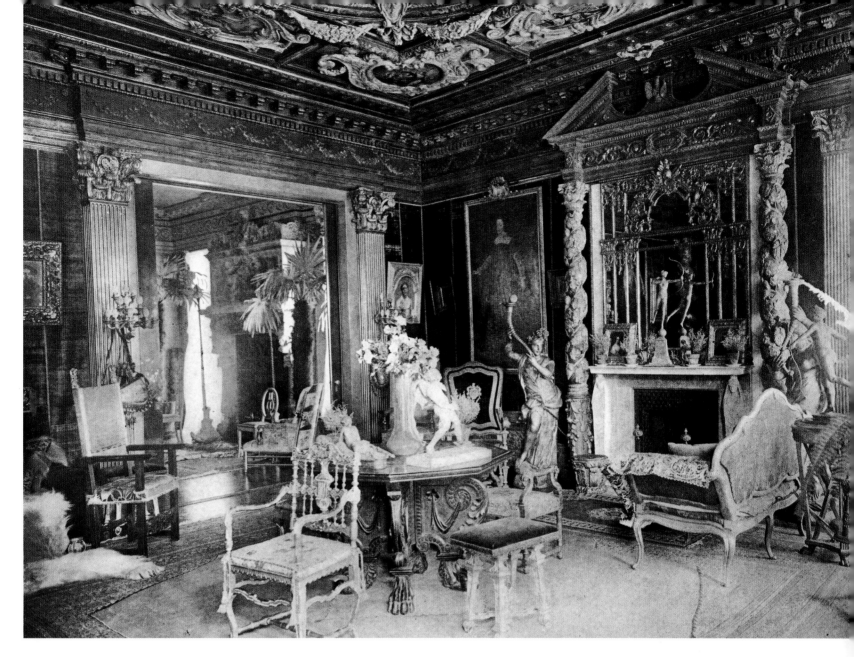

The walls of the drawing room were covered in antique red velvet, establishing a background for a collage of fittings that ranged from a baroque doorway to an Egyptian-inspired mantel.

Corinthian entablature. Walls of antique red velvet covered with paintings established an atmosphere of old-world respectability, while the fittings and furniture created a riot of contrasting scales.

The pitch of the dining room was practically perfect. The space itself was asymmetrical, reflecting the combination of two smaller rooms, but the irregularities of the plan were held together by the ceiling from a Venetian palazzo. The character of the dining room arose not from the forced placement of architectural elements but from their extraordinary texture, which blended into a continuous, animated surface.

From the dining room guests could pass through a large opening sub-divided by Renaissance columns, leaded glass, and more potted plants, to the even-taller music room. White retained the layout of Taylor's original

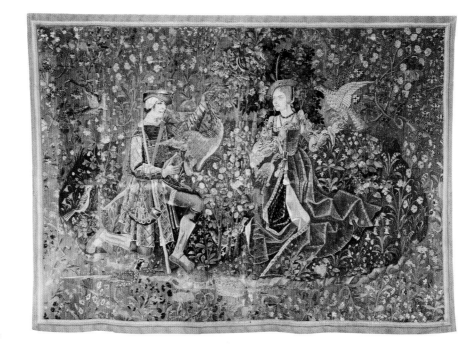

Huntsman Presenting a Captured Heron to a Lady Falconer, a tapestry from White's impressive collection.

Metropolitan Museum of Art

The walls and draperies in the dining room were pale rose, giving the room a memorable tone and color to match its extraordinary texture. The statue on the mantel is a reduced cast of MacMonnies's *Bacchante*, the figure that was rejected by the Boston Public Library.

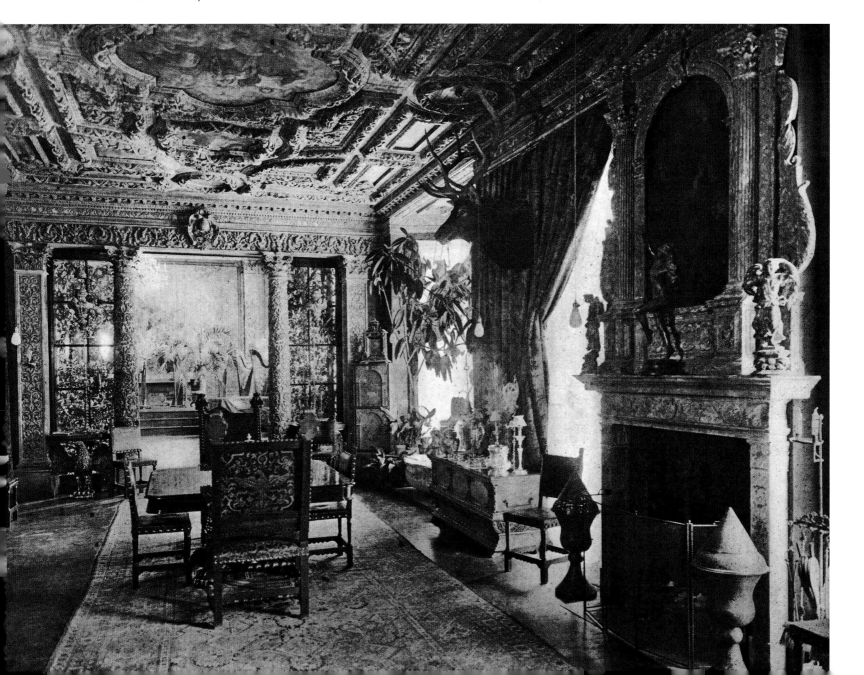

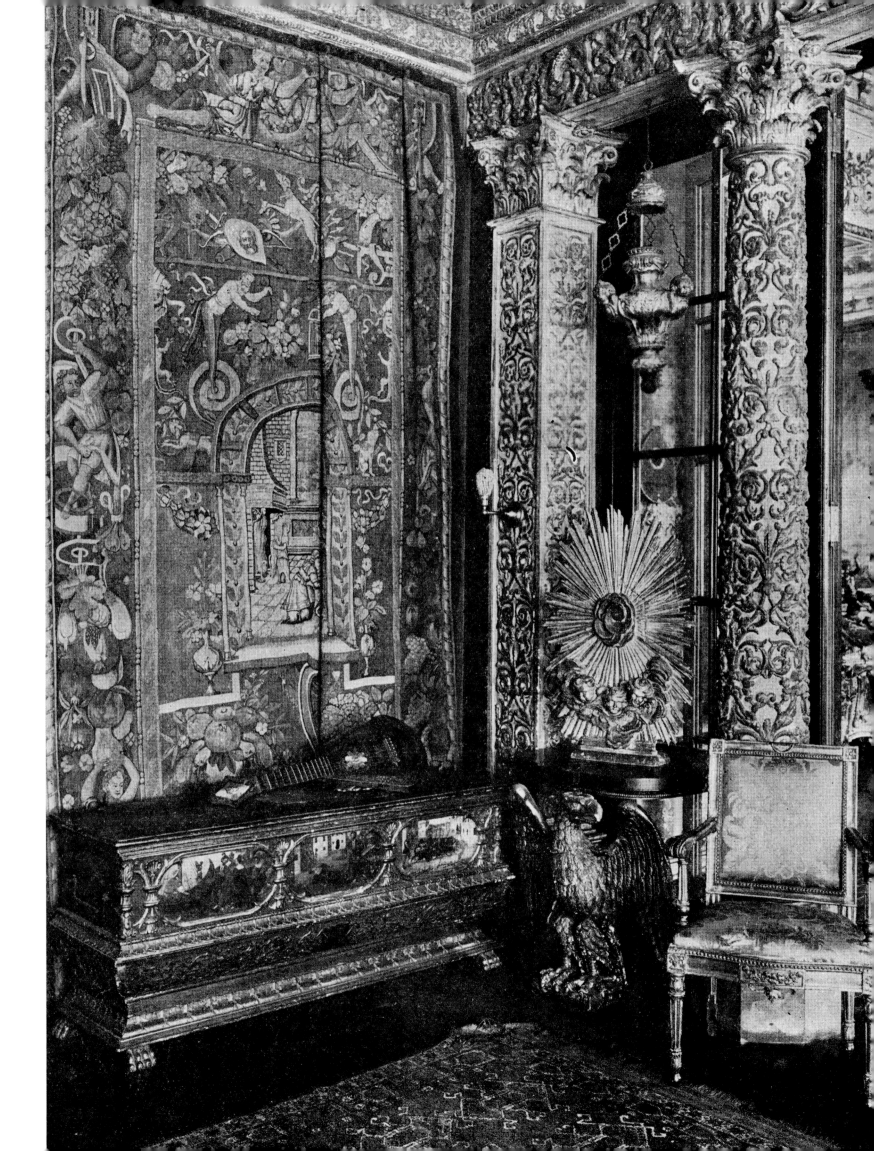

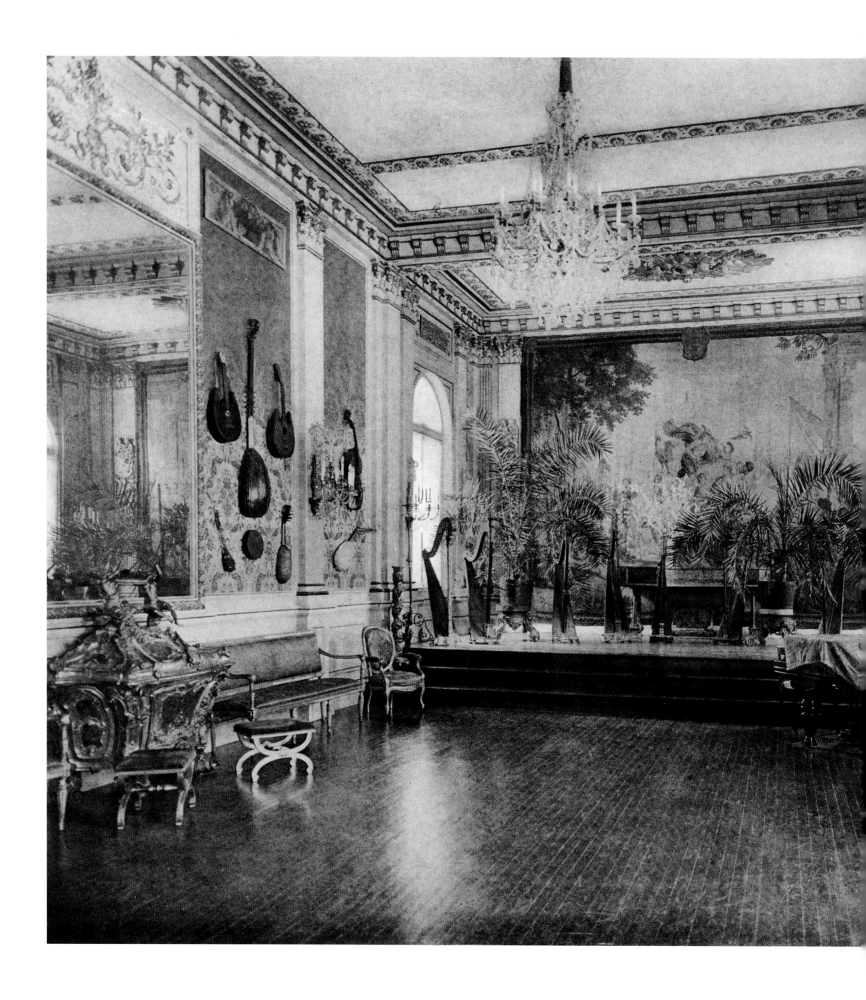

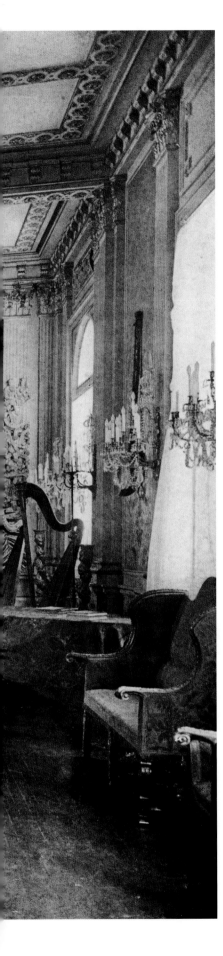

The elegant music room was
the site of parties, recitals,
and even the first exhibition
of a motion picture show in
a private house in New York.
The harpsichord is visible
on the stage.

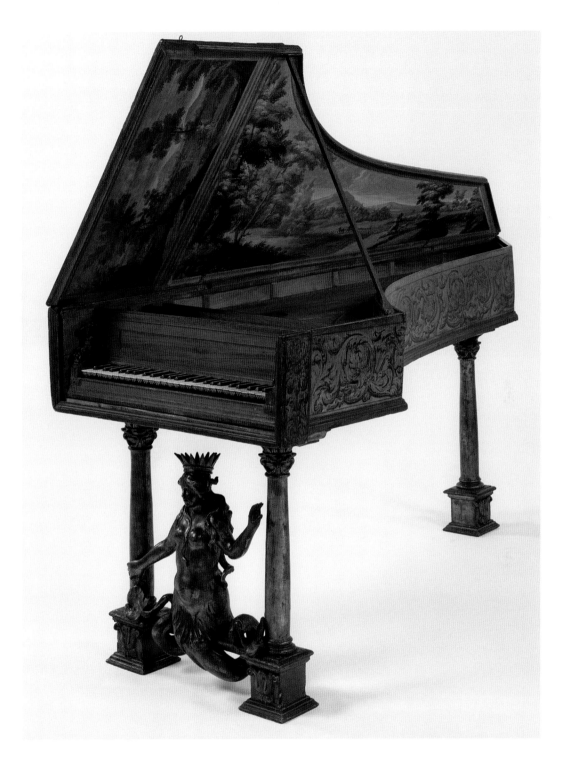

Harpsichord, Italian,
eighteenth century.

Metropolitan Museum of Art

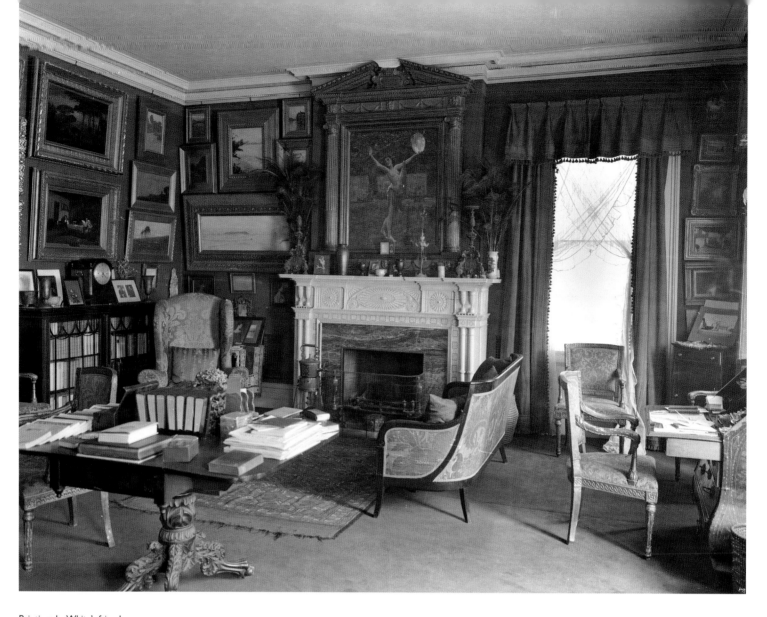

Paintings by White's friends and contemporaries hung in his study. The gold frames, many of White's own design, must have been particularly striking against the green walls.

Museum of the City of New York. McKim, Mead & White Collection

ballroom and added the delicate modillioned cornice, bands of rosettes framing the flat ceiling, and panels of silk damask between unfluted Corinthian pilasters. The walls were decorated with exotic musical instruments, both real and in gilded relief. The raised stage was populated with harps and pianos, while the gentle focus of the room was suggested by fluted pilasters framing an enormous tapestry over the stage. The space was lit by a crystal chandelier (the only one in the house) and matching sconces, all wired for electricity. The color scheme was white, cream, and gold.

The music room was so attuned to its purpose that the instruments in the original photographs appear as if they are about to spontaneously burst into song. Mrs. Winthrop Chanler, a frequent guest, said, "When there was music they seemed to listen and vibrate." Music was important to White. Organized concerts of chamber music were a regular feature of his professional and artistic friendships, particularly in his bachelor days,

and the house at Gramercy Park allowed him to weave that pleasure into his family-based social life as well. His father, an amateur cellist, had been the music critic for *The Nation,* and it was said that Stanford White was the only man in New York who went to the opera to hear the music.

On the third floor White laid out connecting bedrooms and separate bathrooms for himself and Bessie, with additional family bedrooms above. White reserved the front room for his study, which a former employee of the office described as "a lair." Its green walls were packed tightly with gilded frames of White's design, enclosing paintings by contemporary artists who were invariably his friends as well. The room was fitted with his favorite objects: Italian armchairs, a neoclassical sofa, and an elaborate Georgian mantel. A draftsman's sketch among White's papers illustrates the design for a new table in a Renaissance style, set against a couch in which the master himself is reading, or more likely dozing.

At the rear of the house White constructed a top-lit picture gallery flanked by deep window seats set in projecting bays. Photographs show a rather heavy interior rendered in a "masculine" medieval idiom, a space so unlike the music room below that it may have been built to impress potential clients more than to please the owner. Trunklike beams framed

A draftsman at the office added a cartoon of White to this sketch for a table.

Avery Fine Arts and Architectural Library, Columbia University

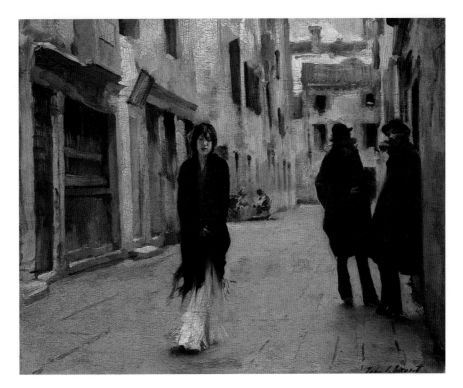

John Singer Sargent's *Street in Venice*, 1882, was a gift from the Chanler sisters, for whom White had renovated Rokeby in Barrytown, New York.

National Gallery of Art, Washington, D.C.

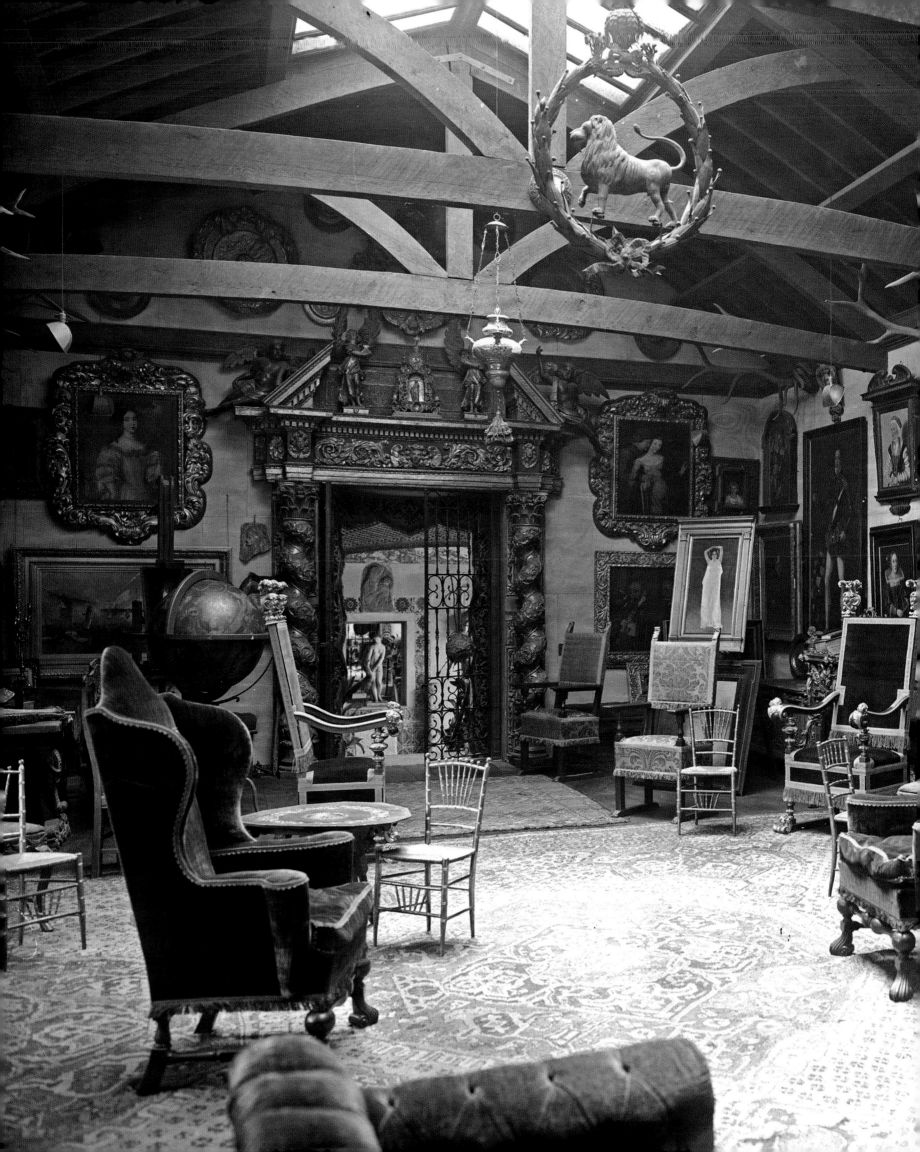

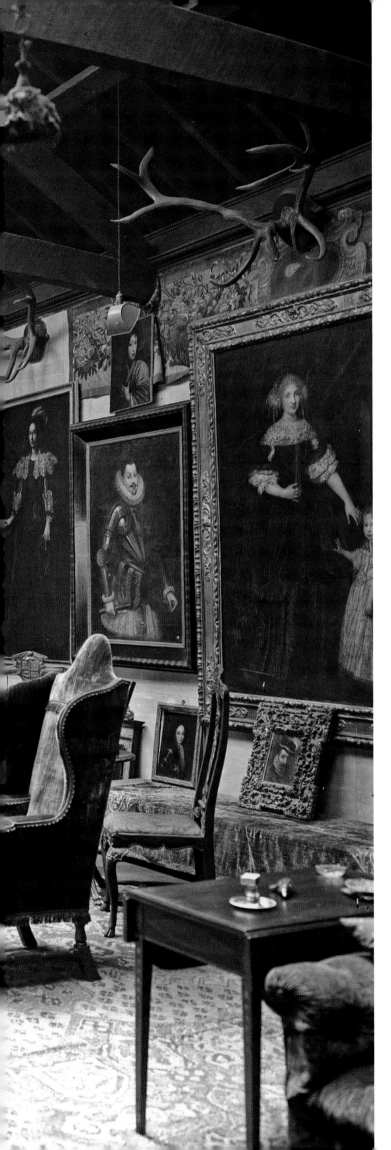

White added the top-lit picture gallery to the third floor. The tiled vestibule is visible through the baroque doorway.

Museum of the City of New York. McKim, Mead & White Collection

White's vision for the vestibule to the picture gallery depended on the precise arrangement of the tiles themselves. He continued to make sketches long after his office had finished the working drawings.

Avery Fine Arts and Architectural Library, Columbia University

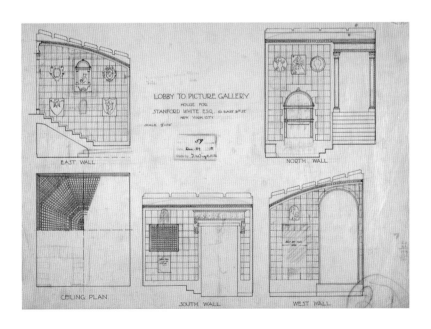

the ceiling; enormous bearskin rugs and Jacobean chairs covered the floor; and the walls were dominated by an oversized Jacobean stone mantel plus full-length portraits of titled Europeans. A careful look at the photographs reveals something of the Stanford White from downstairs. The entrance door was framed by a Renaissance portal—probably a mixture of authentic and reproduced elements—and there are some good paintings between the more static images of barons and duchesses.

To maintain the high ceiling of his music room, White had to raise the picture gallery half a level above the third floor. He wrestled with the connecting space throughout the entire fall, finally designing a tall, square vestibule that was the most original room in the house. Pie-shaped panels of lattice created a dome set under a roof monitor, transforming the sky into a sparkling canopy of daylight that danced across walls covered in Turkish tile. White made multiple sketches for the tile pattern and was rumored to have purchased "an entire mosque" to obtain the tiles. A fountain and a Renaissance votary relief were set next to a short flight of stairs covered in more tile. Marble balusters alternated with tiled risers, endowing the short flight of steps with unexpected monumentality.

The house on Gramercy Park was celebrated as a venue for a great deal of entertaining. Mrs. Chanler recalled a house "full of beautiful and interesting things collected in many lands: pictures, statues, tapestries, old furniture, rich spoils of the past. There was much old Italian gilded carving on twisted columns, and elaborate picture frames."

After White's death, the contents of the house were sold at auction by the American Art Association. A series of sales took place in April and November 1907, and once the property was dispersed, the *New York Times* described the collection as:

> An interesting reflection of the varied interests and tastes of this man who must be regarded as the foremost connoisseur that this country has produced. It is indeed a modest use of the word to call this collection unique. Never before has anything at all comparable with it in beauty been shown here, and it is quite unlikely that it will be matched in value or importance by any other private collection.

The vestibule to the picture gallery. White changed the pattern of the ceiling lattice from the octagon shown on the working drawings to a square.

Museum of the City of New York. McKim, Mead & White Collection

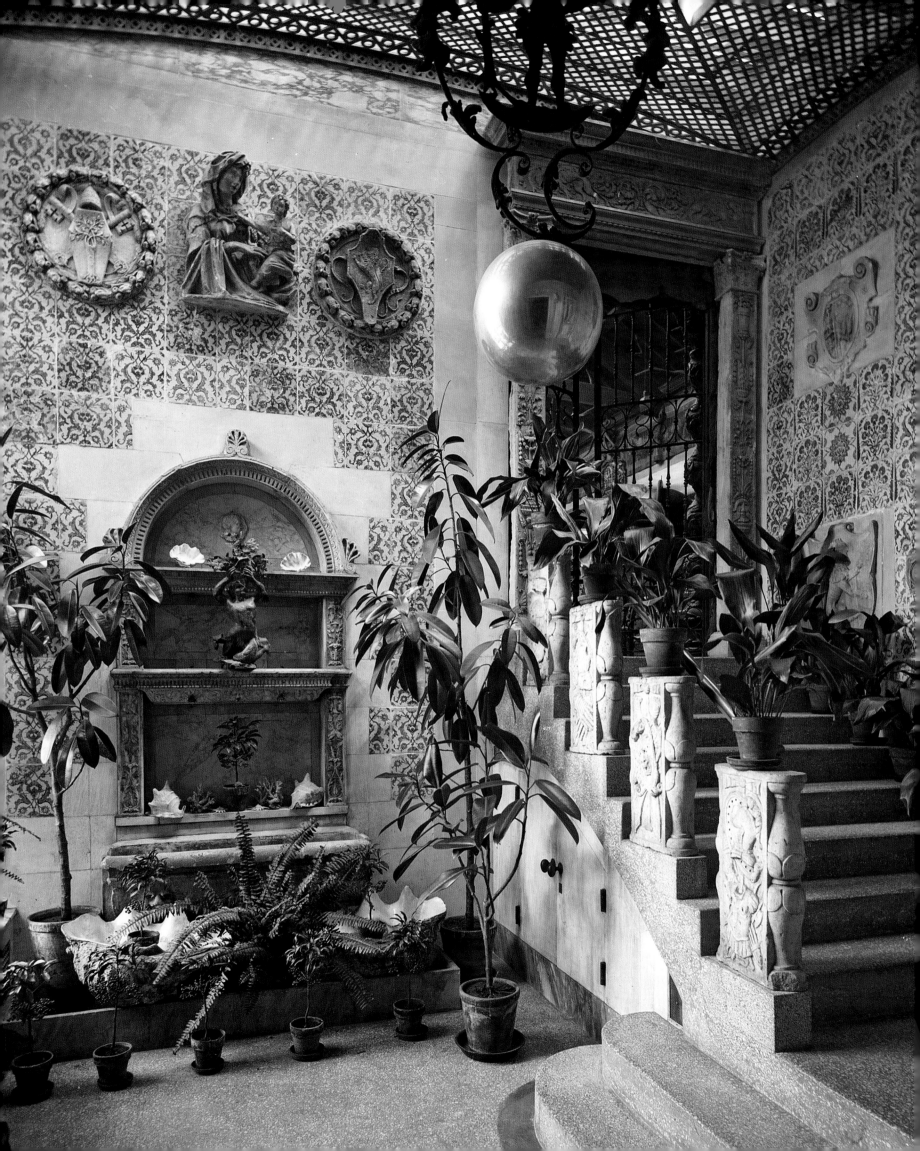

Collaboration

T HE RENAISSANCE ideal of the collaboration of architects and artists, filtered through the principles of the Ecole des Beaux-Arts in Paris, was first implemented in America in the mid- to late-1870s at Trinity Church in Boston. There, under the direction of H. H. Richardson, a team of artists led by John La Farge and including Augustus Saint-Gaudens created the memorable interior with murals, carving, and stained glass. White and McKim both worked on the project, McKim preparing the competition entry and White developing the design and supervising the construction. In addition, McKim had attended the Ecole des Beaux-Arts and Mead studied at the Accademia in Florence. As a result, the partners were deeply committed to the idea of collaboration, both within their firm and with contemporary artists who contributed to their work. The McKim, Mead & White office has been described as "a council chamber where men could meet to discuss the renaissance of American art," frequented by leading artists of the day including La Farge, Saint-Gaudens, John Singer Sargent, Thomas Wilmer Dewing, John Alden Weir, Edwin Austin Abbey, William Merritt Chase, and Frank Millet.

White had personal connections to these artists, having met some of them (including La Farge, who discouraged him from a career as a painter) through his father, Richard Grant White, and knowing others through the Century Association, the Tile Club, the National Academy of Design, and other arts organizations. Saint-Gaudens and Dewing were particularly close friends of White's. Both made portraits of Bessie, and White designed frames for them and for many other

Augustus Saint-Gaudens, shown in bearded profile on the left, created this medal to commemorate the 1878 trip down the Rhone River with White (center) and McKim (right).

Metropolitan Museum of Art

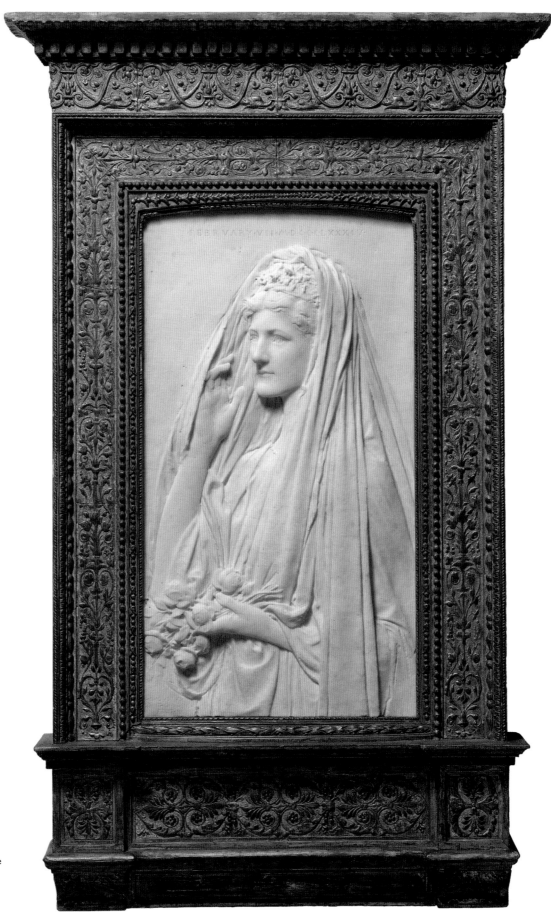

The wedding portrait relief of Bessie by Saint-Gaudens was a present to the Whites from the artist. Stanford White designed the frame.

Metropolitan Museum of Art

works by these artists. According to Lawrence Grant White, the Dewing frame was based on the patterns in a tortoiseshell comb; other designs were based on antique lace, of which Bessie was an avid collector. Dewing was also a muralist who painted the ceiling in the hall of the Charles Osborne house in Mamaroneck and the frieze in the drawing room of the Garrett Jacobs house in Baltimore as commissions from White.

Given White's talent as a draftsman and colorist, and his innate sociability and curiosity, collaboration must have seemed a very natural process to him. As his stature in the art world grew, his correspondence was peppered with requests for introductions, support of exhibitions, and offers of new work. In 1892 he wrote to Sargent explaining that it was

The architectural setting that frames Saint-Gaudens's *Standing Lincoln* in Chicago suggests a powerful psychological drama as well as a respectful distance.

Joan Craig

unlikely that he could persuade Robert Goelet to lend the portrait of his daughter to an exhibition: "I had the devil's own time to get him to send it to the American Society's Exhibition, but as that was on Fifth Avenue where he could see it, if he chose, every day and as I told him the scandalous lie that the building it went in was fireproof, he let it go."

White's earliest independent architectural collaboration was with Augustus Saint-Gaudens. The two are said to have met in 1875 when White followed the sound of a voice singing the Andante from Beethoven's Seventh Symphony up to Saint-Gaudens's studio in the German Savings Bank building. Their earliest project, the monument to Union Admiral David Glasgow Farragut, began about a year later, even before Saint-Gaudens signed the contract for the work. Saint-Gaudens modeled the figure in Paris, with White in New York working on the siting in Madison Square, the design of the base, and even the negotiations with John J. Cisco, a member of the Farragut Monumental Association. Dozens of letters from White survive, recording progress and setbacks, all written with the immediacy and energy that characterizes his correspondence.

In this project and those that followed, White worked with Saint-Gaudens to develop a setting for the sculpture, not a base alone.

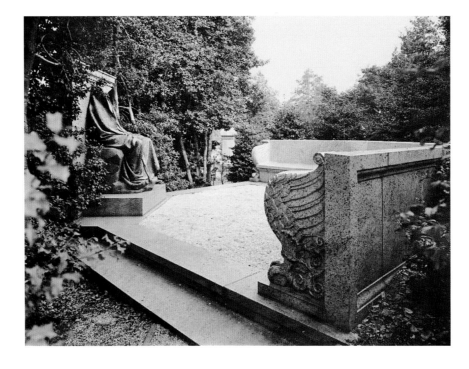

White's design for the Adams Memorial employs dense planting and rigorous geometry to establish an intense intimacy between the visitor and Saint-Gaudens's hooded figure. The bench, steps, and base are polished red granite.

Library of Congress

Approaches and paths to the site and plantings were specified to enhance the viewer's experience of the sculpture. The exedra, used as the base for the Farragut, becomes a framing element for *The Puritan*, the Deacon Chapin monument in Springfield, Massachusetts, and for the *Standing Lincoln* in Chicago. The most carefully considered design was that of the memorial for Marion Hooper Adams, the wife of the noted historian Henry Adams, in Rock Creek Cemetery in Washington, D.C. The

Saint-Gaudens's first version of *Diana* included flowing drapery that appeared to move with the wind as the sculpture turned on the top of the tower.

Museum of the City of New York

shrouded figure sits on a granite base across from an exedra that invites contemplation, and the whole site was originally enclosed with tall evergreens that concealed it from view.

White's best-known collaboration with Saint-Gaudens was the *Diana* for the tower of Madison Square Garden. Envisioned as an ornament to the festive structure, the idealized nude figure perched on one foot, her arrow poised and her cloak fluttering behind. Unfortunately, the original eighteen-foot statue was too large—McKim teased his partner: "That's a very beautiful pedestal you have made for Saint-Gaudens's statue, but I thought he was making a finial for your tower"—and to some critics too explicit. Ultimately the statue was replaced with a thirteen-foot version, and the larger figure was shipped to Chicago, where it crowned McKim, Mead & White's Agriculture Building at the World's Columbian Exposition.

Early in his career, White was involved with the Associated Artists, a group led by Louis Comfort Tiffany and Candace Wheeler that created scenographic interiors based on opulent materials and intricate craftsmanship. For the commission for the Veterans Rooms at the Seventh Regiment Armory, Tiffany enlisted White to "superintend the architectural arrangements," working with a group that included Wheeler, Samuel Colman, George Yewell, Francis Millet, and Lockwood de Forest. Today it is difficult to identify specific contributions in the profusion of ornament and materials. As a contemporary observer commented with remarkable understatement, "It will abundantly appear that the Veterans have steered clear of conventionalisms in the ornamentation of their quarters." White is believed to have designed the mantelpiece and woodwork in the principal space and the adjoining library.

Within the partnership of McKim, Mead & White, McKim and White brought distinct preferences and skills. McKim was principally interested in form, looking for elements to organize structure and tie the composition together. In contrast, White was fascinated with visual effects, the play of light on surfaces, the procession from dark to light, color, and the combination of materials. Ultimately, the strengths of each informed the other, enabling White to design the formal composition of

the Gould Library for New York University and McKim to produce the opulent interiors of the University Club and the Morgan Library.

In the early projects, however, two independent hands are often in evidence. Kingscote was one of the first designs to be finished by the new partnership. The project consisted of a dining room addition to a Newport villa originally designed by Richard Upjohn. McKim conceived the solution of inserting the new dining room between the service wing and the main block of the house, and the exterior massing illustrates his proclivity for stable, balanced forms. The interior, with its rich combination of tiles, marble, stained glass, and metalwork, comes from the imagination of Stanford White. Neither McKim nor Mead had ever designed anything remotely resembling Kingscote's dining room, with its exotic materials, voluptuous colors, and sleek finishes. The cork ceiling, the cabinetry that is both furniture and architecture, and the tableau of a colonial spinning wheel surrounded by export china and Persian carpets

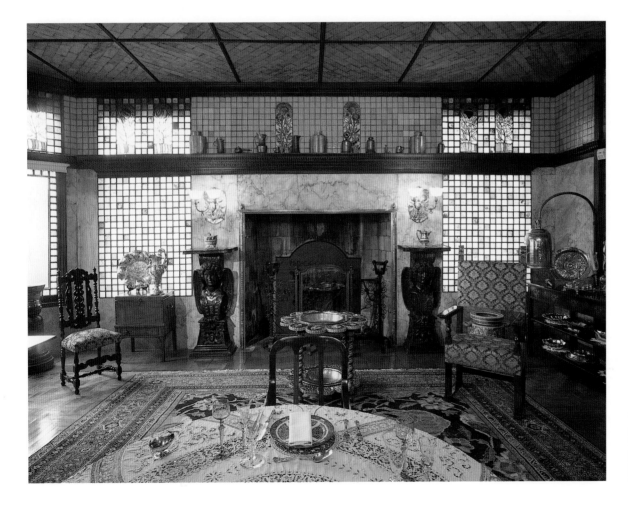

The dining room at Kingscote was a collaboration between White and his partners, but the glass blocks and tile suggest a possible contribution by Louis Comfort Tiffany.

must all be attributed to White, but the deep wooden cornice that holds the composition together is certainly the suggestion of McKim. It gives the room a resolution missing in the Veterans Room, where even the enormous fireplace and its brilliant Tiffany tiles cannot hold the focus against the dazzling ornamented surfaces.

A similar collaboration is evident at the Newport Casino, where McKim developed the rigorous symmetry of the facade with its distinctive triple gable, relieved by the lively shingle patterns and carved panels that White contributed. On the interior court, the Romanesque tower is a favorite motif of White's, and the turned screens and sgrafitto panels that enclose the piazza appear in many of his houses of the 1880s.

The Villard House complex, which established McKim, Mead & White's reputation in New York, is perhaps the best example of collaboration both within the firm and with participating artists. In the early 1880s Henry Villard, a visionary businessman whose risk taking drove him to bankruptcy twice, became the firm's most important and demanding client. Referred to as "his royal highness Mr. Villard" by White in a letter to Bessie, Villard commissioned a series of hotels to be built in the major cities along the route of his railroad lines in Oregon and Washington. In New York, Villard acquired the block front on Madison Avenue between Forty-ninth and Fiftieth streets, which he proposed to develop as his own residence with five additional houses to sell. Initially, White was in charge of the project, proposing a chateau-style mansion, but Joseph Morrill Wells, the chief draftsman in the office, developed the final design. The handsome structure, with a central block and two wings enclosing a courtyard, revolutionized design in America. In form and details, the building drew its inspiration not from the Gothic or the Romanesque but from the Italian Renaissance, specifically the Palazzo della Cancelleria and the Farnesina in Rome. On the interior White remained in charge, commissioning sculpture from Augustus and Louis Saint-Gaudens, paintings from Francis Lathrop, and stained glass from Tiffany and La Farge. He also oversaw the installation of intricate marquetry, mosaic, and marble decoration. Financial reverses prevented Villard and his family from occupying the house for more than a few

Sidney V. Stratton, who shared the office with McKim, Mead, & White, obtained the commission for the Church of the Atonement in Quogue, New York, but the fish scale shingles suggest that White was at least co-designer of the interior.

Joseph Morrill Wells may have been the advocate for the Renaissance lanterns that appear on the Villard houses in New York and the Garrett-Jacobs house in Baltimore, but White would use them in other designs.

months. It was subsequently bought by Whitelaw Reid, publisher of the *New York Tribune* and ambassador to France, and redecorated by White in a more French idiom, with paintings commissioned from La Farge and Edwin Austin Abbey. White himself described the Villard houses as "The beginning of any good work that we may have done . . . designed on simple and dignified lines, which we have ever since endeavored to follow."

As the firm matured and commissions grew more complex, the collaboration began to focus on sharing information with a partner who was traveling and on support during difficult projects. Struggling with the design of the Boston Public Library, McKim proposed a trip to Paris to seek fresh inspiration, a move that his partners vehemently opposed. Mead replied with characteristic candor: "I tell you, with your temperament, you are in great danger of getting in doubt about the design and suggesting all manner of changes, even thinking that you have an altogether better scheme, if you leave it for a moment. You are in a good position now, and we are all ready to back you . . . I say all I have said because I want the library to be a success and I know that it cannot be left in other hands without great danger." Design critiques could be equally pointed. Assessing the drawings for the Robert Gould Shaw

Five separate houses are presented as a single palazzo. Villard retained the south wing for himself and offered to sell the others to his friends.

memorial in Boston, White warned McKim: "You will make the biggest blunder of your life if you build the main monument surrounding St. G relief with the fore and aft entasis that you have on it. I send you a tracing."

Nevertheless, the overall relationship of the three partners was exceptionally collegial. Writing in the December 1906 issue of *The Brickbuilder* memorializing White, Albert Ross recalled early evenings with the partners in the library of the office, as the tensions of the day receded: "Then did McKim 'go fishing,' as he was pleased to call pouring over old volumes of Roman masterpieces and then did they admire or aid with criticism each others work."

Public monuments and churches, with their narrative and symbolic potential, offered exceptional opportunities for collaboration. At McKim's St. Paul's Church, in Stockbridge, Massachusetts, White designed the baptistry, where his architecture encloses a dedicatory marble panel flanked with angels sculpted by Louis Saint-Gaudens and stained glass

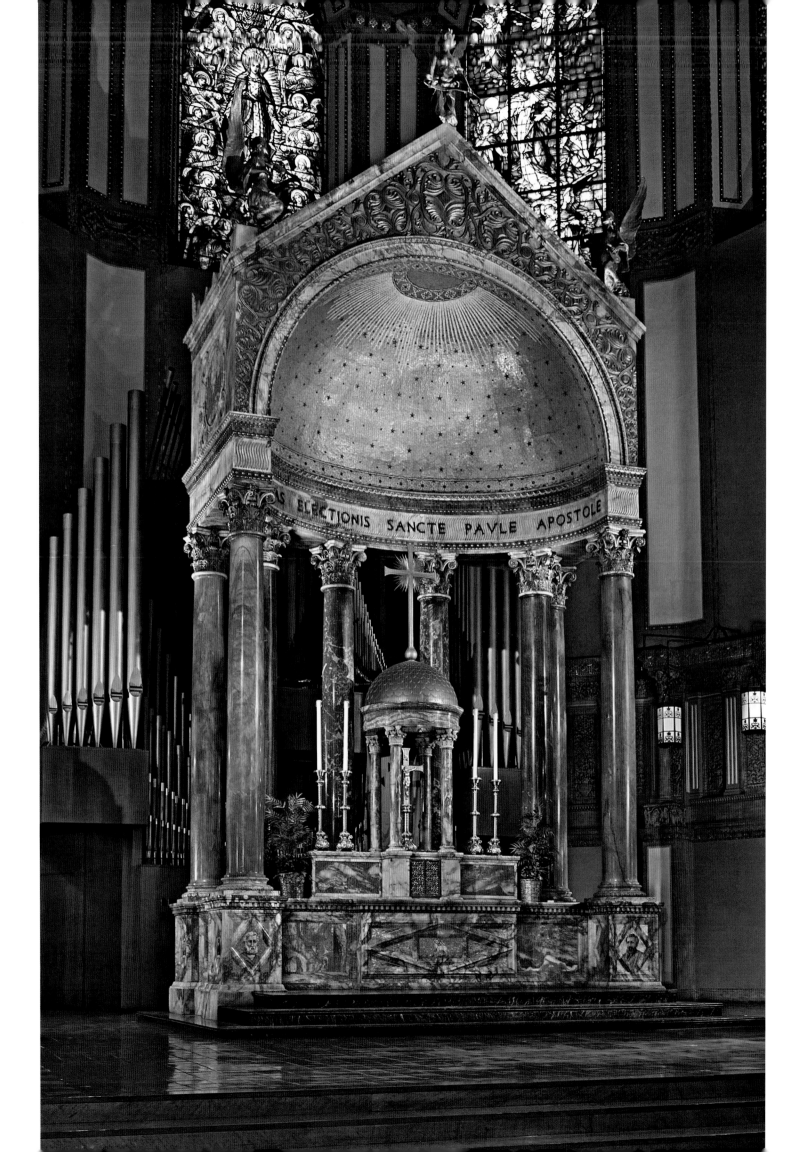

by Tiffany. On a larger scale, his design for the altar at the Church of the Ascension created an illusionistic gilded Renaissance frame for La Farge's monumental mural of the Ascension. Intricate marble mosaics enriched with a pair of angels in high relief by Louis Saint-Gaudens formed a base for the painting. The altar was also the focus of White's work at the Church of St. Paul the Apostle. There he designed a freestanding altar made of marble he had found in a Sienese monastery within a magnificent baldachino inspired by that of Santa Maria Maggiore in Rome. Made of porphyry, onyx, and alabaster with incised gold leaf, the baldachino dominated the chancel of the vast sanctuary. Angels by Frederick MacMonnies and a sanctuary lamp by Philip Martiny completed the ensemble, with stained glass by La Farge behind and ceiling murals by Robert Reid above. A team of sculptors including Henry Adams, Martiny, and Daniel Chester French worked with White on the porch of St. Bartholomew's Church. commissioned in 1902 by Mrs. Cornelius Vanderbilt as a memorial to her husband. The triple arch was based on that of St. Gilles du Gard in Arles, which White had seen on his European trip in 1878 and described as "the finest piece of architecture in France." The sculptural program, executed in bronze, limestone, and marble, tells the story of Christianity. First installed on James Renwick's church at Madison Avenue and Forty-fourth Street, the seventy-five-foot span was incorporated as the main entrance to Bertram Grosvenor Goodhue's Byzantine masterpiece at Park Avenue and Fifty-first Street.

The process of collaboration is one of negotiation, and White's engaging manner was essential to the successful outcome of these discussions.

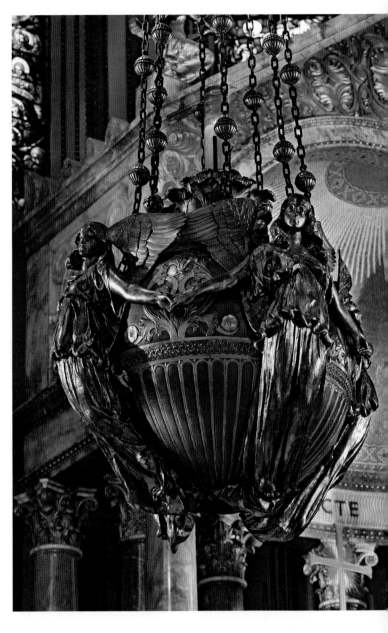

The influence of Augustus Saint-Gaudens on an entire generation of American sculptors is evident in Philip Martiny's design for the sanctuary lamp.

White's baldachino for the Church of St. Paul the Apostle made the altar legible within one of the city's largest interiors. MacMonnies was the sculptor for the three angels on the roof.

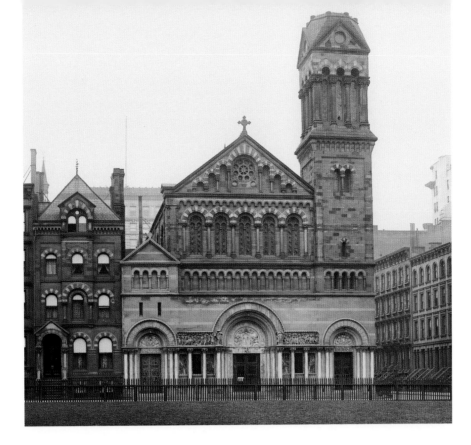

White's portal for St. Bartholomew's Church was a welcoming addition to Renwick's neo-Ruskinian building.

Museum of the City of New York.

Both he and McKim enjoyed working with Frederick William Mac-Monnies, a talented apprentice in Augustus Saint-Gaudens's studio, whom they supported as a student at the Ecole des Beaux-Arts and as a newly independent artist. Young and ambitious, MacMonnies could be more responsive than the fully established Saint-Gaudens, but his instincts were not always correct. Responding to sketches for the spandrels of the Washington Memorial Arch, White wrote: "The arch as you know is a very severe classical design and it strikes me that the character

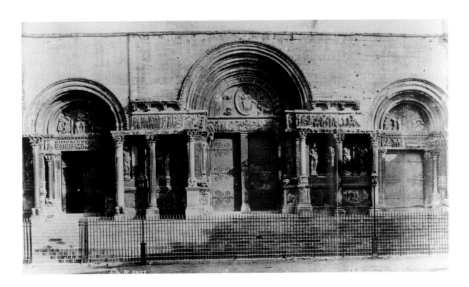

West portals of the Cathedral of St. Gilles du Gard, the model for St. Bartholomew's.

The allegorical figure occupying one of the spandrels in the Washington Memorial Arch was based on Bessie White.

of the sketches belong rather to something in the style of Louis XIV or Louis XV. Of course you must take everything I say *cum grano salis* because I am an Architect and it may be bad taste in me but I would really like here a thoroughly quiet severe and architectural treatment of these sculptures." The self-deprecating tone of this criticism persuaded MacMonnies, who not only revised the figures to classical winged victories but also incorporated the features of Bessie White in the figure with the trumpet.

White greatly valued these artistic collaborations and his friendships with painters and sculptors. His personal collection included reduced casts made especially for him of MacMonnies's *Bacchante*, famously rejected by hyper-moral trustees of the Boston Public Library, and of the controversial original Diana. Paintings by Dewing, Childe Hassam, George Inness, John Singer Sargent, Weir, and other artists hung together in his study in the Gramercy Park house; an extensive collection of young female nudes was discreetly hidden from view.

Fifteen years after White's death, when the scandal had abated, Lawrence Grant White led a group of artists in creating a pair of memorial bronze doors that were installed at Gould Library on the University Heights campus of New York University. Panels were modeled by Herbert Adams, Philip Martiny, Andrew O'Connor, and Adolph Weinman. Janet Scudder designed the inscription. At the dedication, art critic Royal Cortissoz noted that the doors were a particularly fitting tribute to White, who was always opening doors for others, doors into the world of art, and described his spirit of collaboration:

> It was a spirit of glowing comradeship. He put his heart into the men with whom he worked. Merely to have White with him was, for an artist, half the battle.

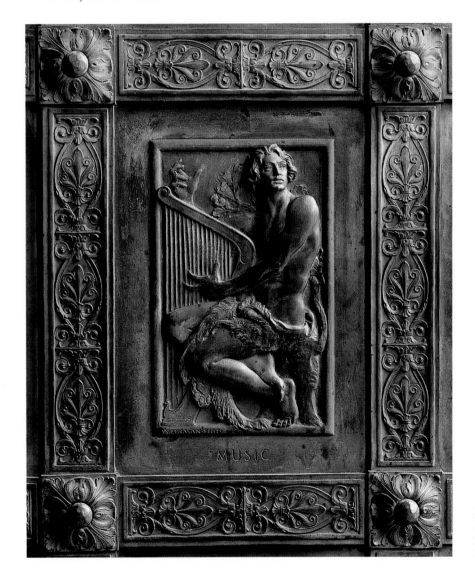

Allegory of Music by Adolph Weinman from the memorial bronze doors at Gould Library, New York University (now Bronx Community College).

ADMIRAL DAVID GLASGOW FARRAGUT MONUMENT

*T*HE EARLIEST collaborative work of Stanford White and Augustus Saint-Gaudens honors the Civil War hero David Glasgow Farragut, whose victories at the battles of New Orleans and Mobile Bay reopened the Mississippi River to Union forces and ended the Confederate blockade of the Gulf of Mexico. Such a prestigious public commission, to be erected in a New York City park, could launch the careers of a young sculptor and architect, and the process of designing the figure and base and siting the monument reflected both their awareness of the opportunity and their creative synergy, as well as their inexperience in negotiating with clients, contractors, and city agencies.

White and Saint-Gaudens worked most intensively together on the project during the fall of 1878 and winter of 1879, when White lived in Saint-Gaudens's studio in Paris. They prepared a full-scale paper mock-up in February 1879, with the figure mounted on a horizontal, curved seat. Over the next two years, the artists worked to strengthen the connection between the base and the figure by refining the proportions and incorporating iconography related to Farragut on the seat. Their concept of a fully integrated sculpture and base that invited the viewer to approach was a radical departure from the traditional solution of a remote figure on a high, vertical pedestal.

White sailed for New York in August 1879, joining McKim and Mead in practice on September 6, just a few days after he landed. Plunged into an active architectural office, White nevertheless eagerly consulted H. H. Richardson, Frederick Law

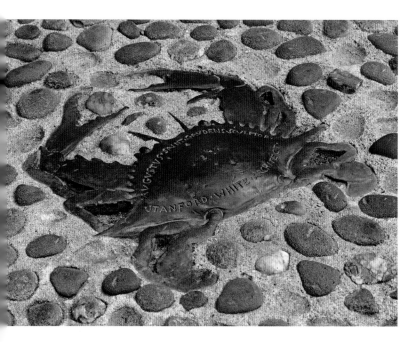

White and Saint-Gaudens signed the crab set in pebbledash at the base of the exedra. White later designed a necklace for Bessie with two gold crabs clasping a baroque pearl.

The cast of Farragut is original, but the pedestal was replaced in the 1940s with granite. The original bluestone base was relocated to the Saint-Gaudens home and studio in Cornish, New Hampshire.

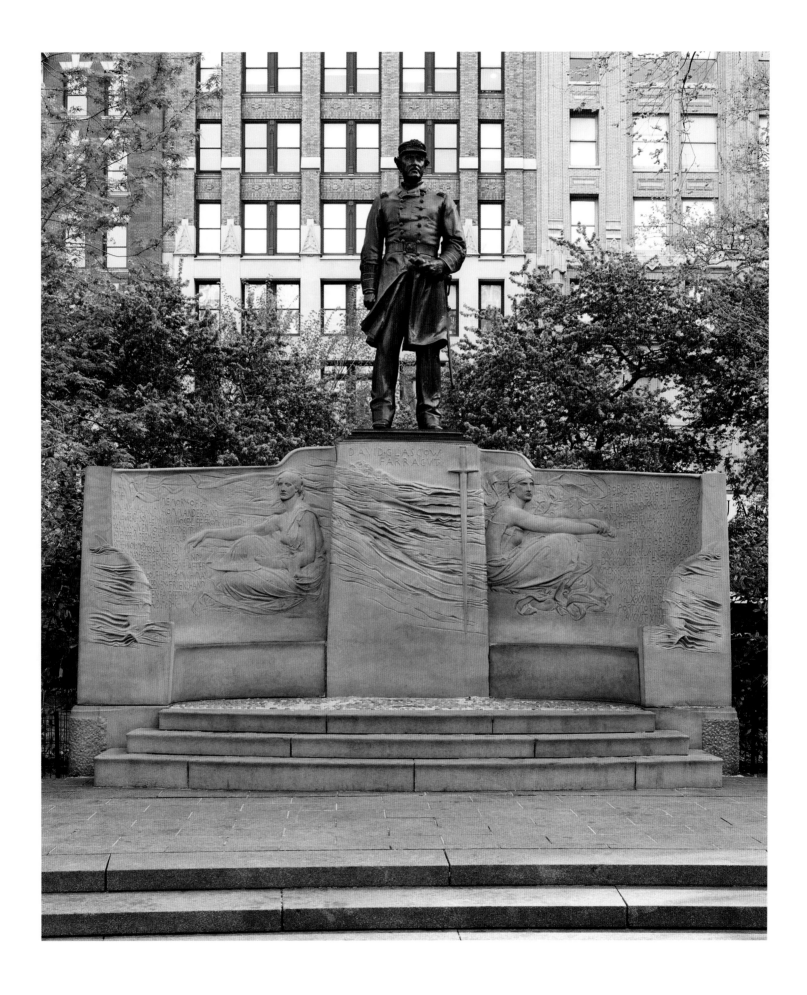

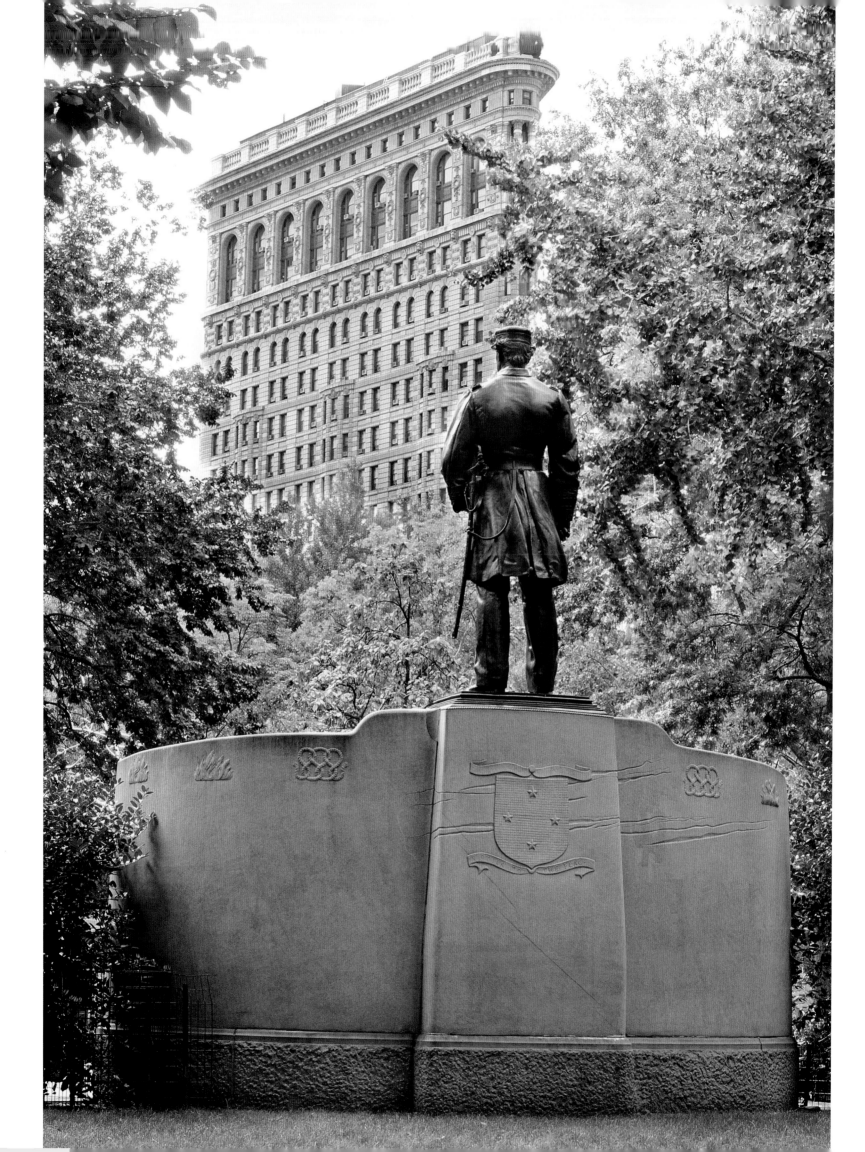

The height and the slight rise in the line of the base—elements that gave White particular anxiety—now appear correct and even inevitable.

Olmsted, John La Farge, and George Fletcher Babb on the design of the Farragut. Confronted with a series of inevitably conflicting opinions, he was relieved by McKim's assessment: "You've got a good thing. Why don't you stick to it?" White returned from Paris with a letter from Saint-Gaudens authorizing him to make all the arrangements for the installation of the monument, from site selection to negotiation with the Farragut Monumental Association over the extra cost of the base. The smooth and uniformly colored bluestone White advocated was significantly more expensive than the granite called for in the original contract. No additional carving by the sculptor or any architectural fees had been anticipated. In the end, White waived his fee, and Saint-Gaudens accepted a token increase.

White studied a number of locations, including one at the north end of Union Square and several options in Madison Square, incorporating sketches of possible approaches and landscaping in his letters to Saint-Gaudens. The final site at the corner of Twenty-sixth Street and Broadway was set back within Madison Square, allowing for paths leading to a pebbled terrace in front of the monument itself.

The Farragut Monument was unveiled on May 25, 1881. Just a month earlier, the national monument to Farragut—a Congressional commission executed by Vinnie Ream, a young woman who had previously sculpted the marble statue of Lincoln in the Capitol rotunda—had been dedicated in Washington. Comparison of the two points to the new direction forged by White and Saint-Gaudens in New York, where the stance of the figure and the generosity of the base give the monument an immediacy totally absent from the Ream version.

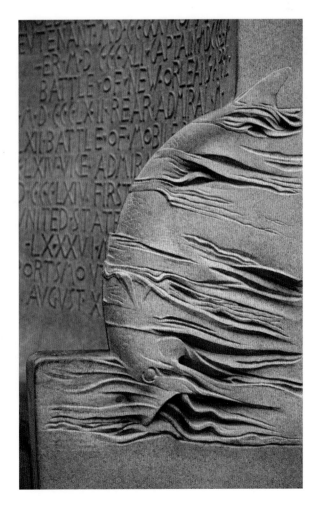

Diving fish form the arms of White's exedra. The architect's father, Richard Grant White, provided the text carved into the back.

VETERANS ROOM AND LIBRARY

SEVENTH REGIMENT ARMORY

NEW YORK

1879–81

\mathcal{A}s a group, the Veterans Room, library, regimental offices, and company rooms of the Seventh Regiment Armory are considered the most important extant interiors of the American aesthetic movement. The most prestigious design firms and cabinetmakers of the period—Herter Brothers, Pottier & Stymus, Robinson & Kunst, Alexander Roux, Kimball & Cabus, and Louis Comfort Tiffany—were commissioned by the Regiment, its individual companies, and the Veterans Association, in genial competition with each other, for the new armory at Park Avenue and Sixty-seventh Street.

The Seventh Regiment, celebrated both for its distinguished service

Trophy cases have replaced bookshelves in the library, but almost everything else is intact. The windows are among Tiffany's earliest designs in that medium.

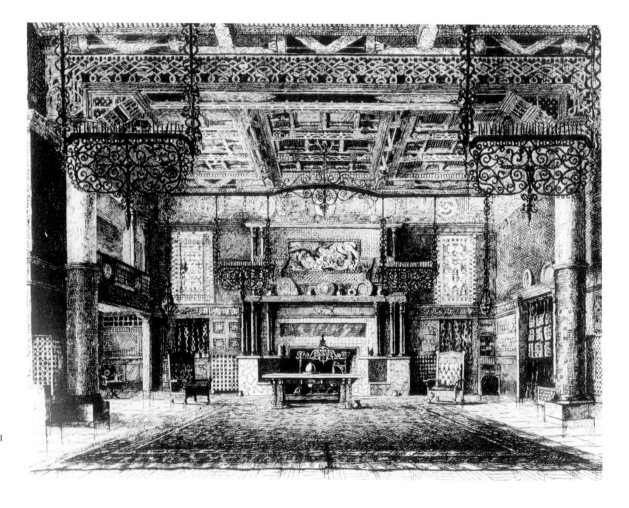

A magazine illustration shows the open balcony in the corner of the Veterans Room. Louis Tiffany's table and chairs are still in the Armory's collection, but Candace Wheeler's portieres have disappeared.

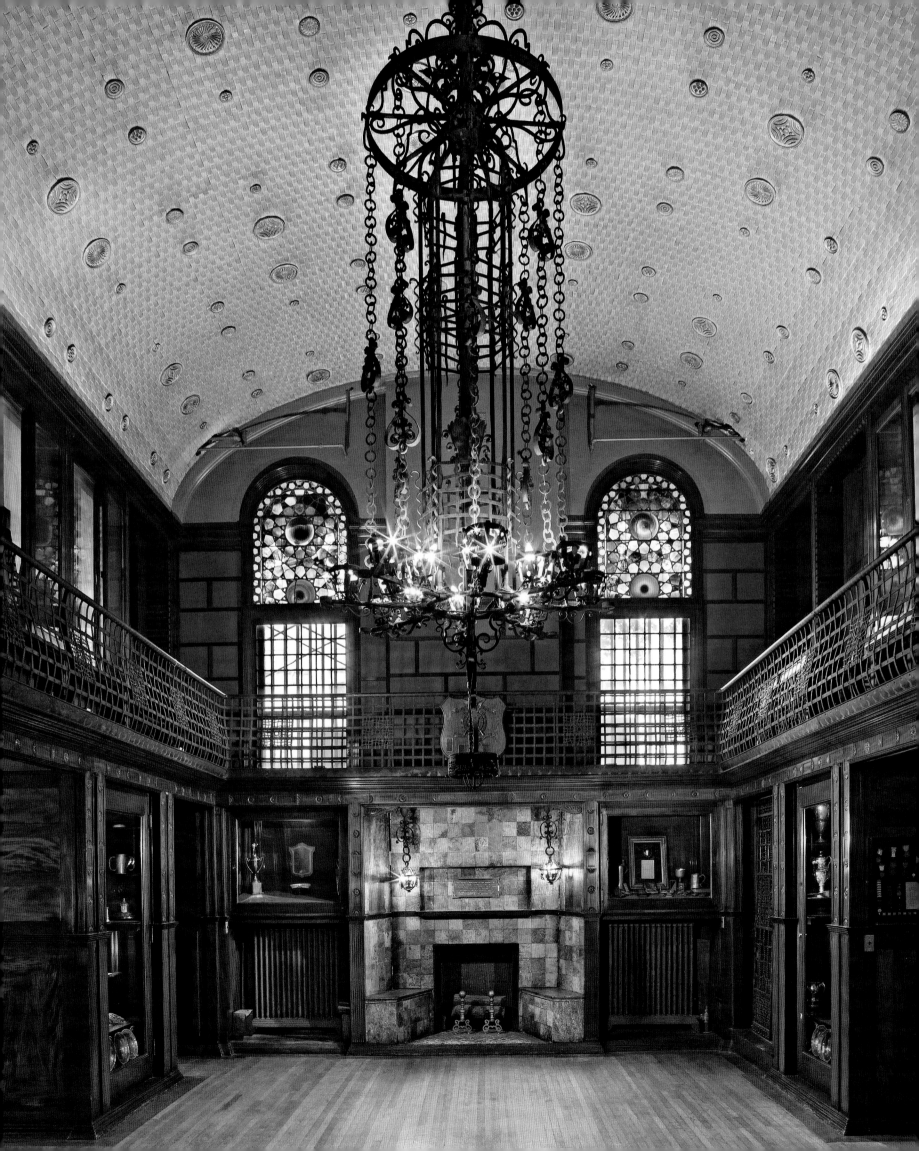

Copper spiderwebs on the library's balcony railing suggest White's taste for bizarre creatures. The tongues of fire below anticipate his design for the ceiling at Lovely Lane Church.

in the Civil War and for its roster of members from the highest ranks of Knickerbocker society, had advocated allocating public funds for the construction, but the severe depression of the mid-1870s persuaded the courts to exempt the project from the legislation that had been enacted. The Regiment embarked on a fund-raising campaign, with contributions from private individuals—Messers Cooper and Hewitt—and corporations including Standard Oil and Arnold Constable, duly reported in the *New York Times* over the next two years. Once the shell of the building was completed in the fall of 1879, the regimental companies organized a spectacular two-week New Armory Fair, opened by President Rutherford B. Hayes, that raised more than $140,000 for the decoration of the interiors.

The most sumptuous of these is the Veterans Room, conceived by Louis Comfort Tiffany working in collaboration with Stanford White, Candace Wheeler, and the painters Francis Millet, Samuel Colman, and George Henry Yewell. Described as "Greek, Moresque, and Celtic, with a dash of Egyptian, Persian, and Japanese," the decorative scheme was a

A gate of chains safeguarded the books on the library balcony, a screen of carved beads illuminated the stair, and a panel decorated with upholstery tacks provided access to storage.

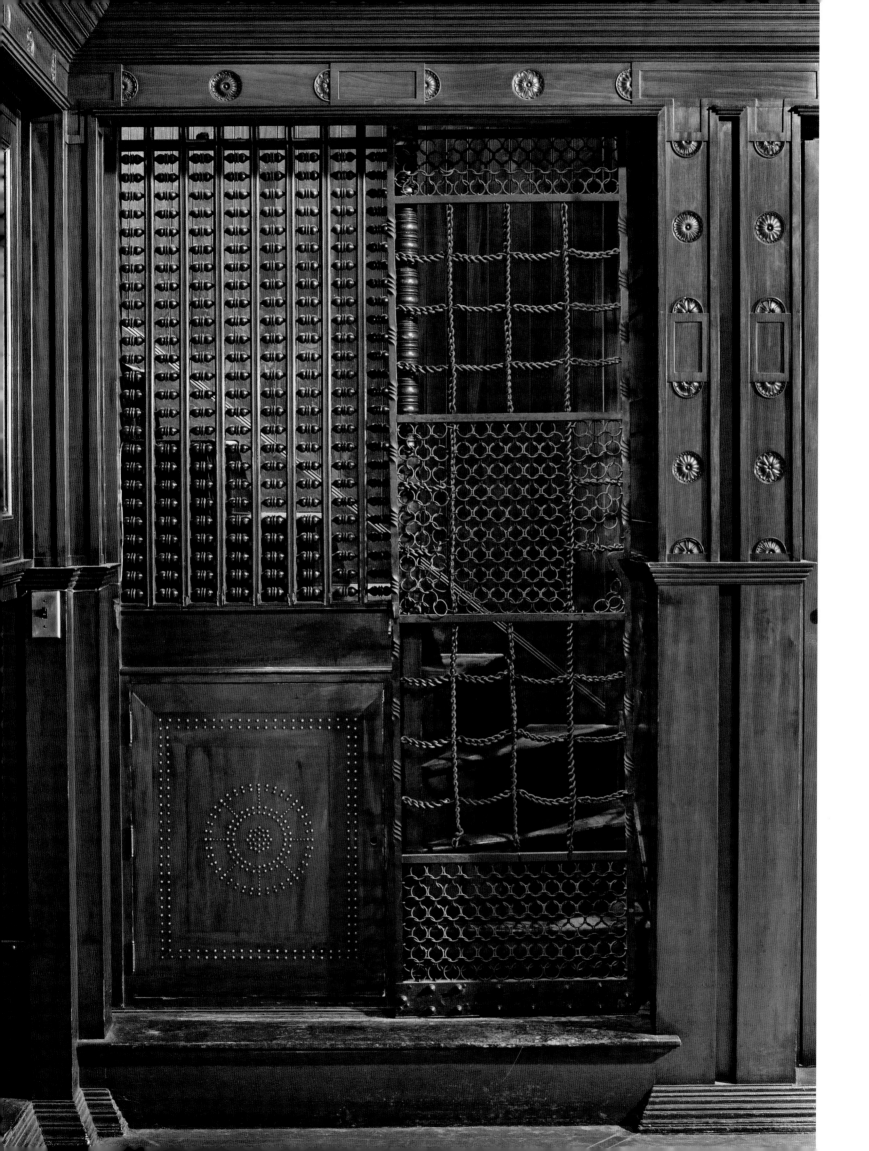

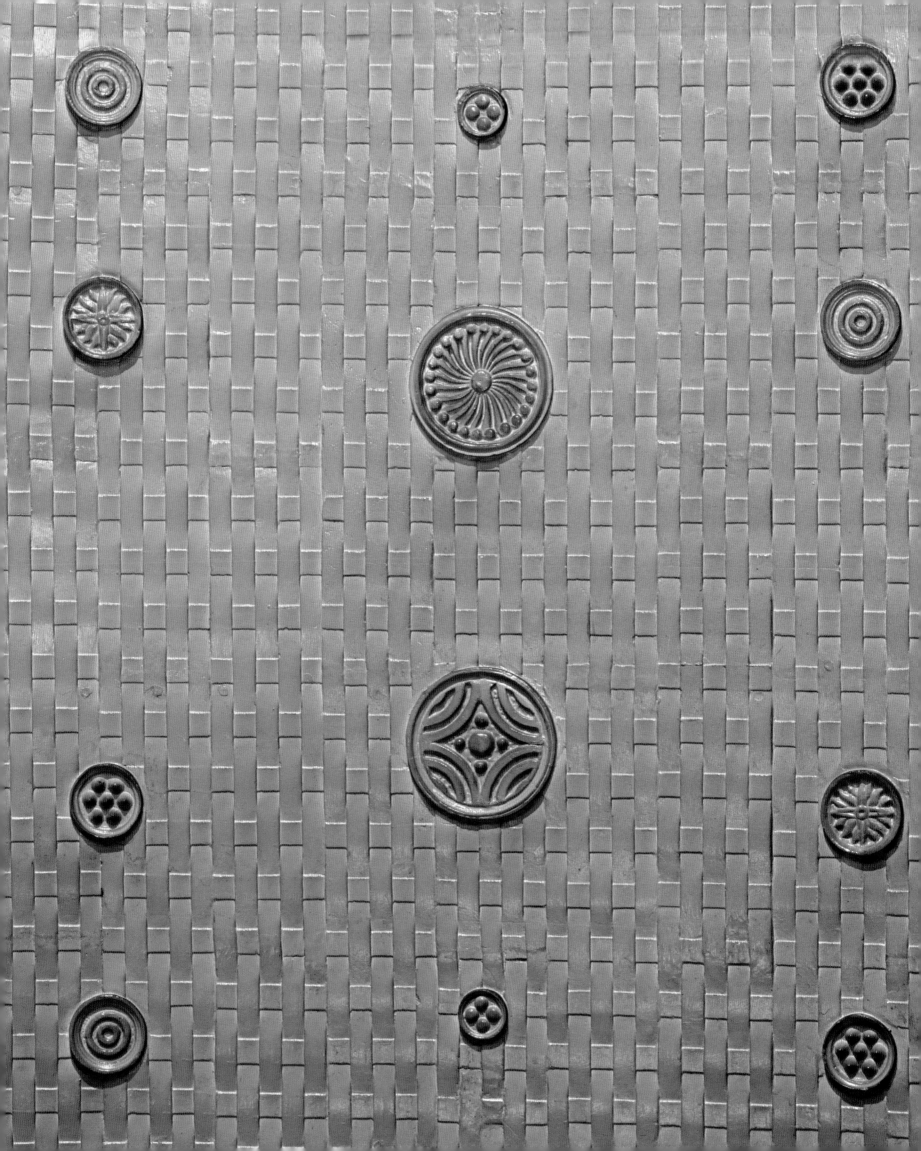

The basket-weave pattern on the library ceiling is constructed of cast plaster blocks, each about eight inches wide and three feet long. Small circular motifs were popular decorative features of the aesthetic movement.

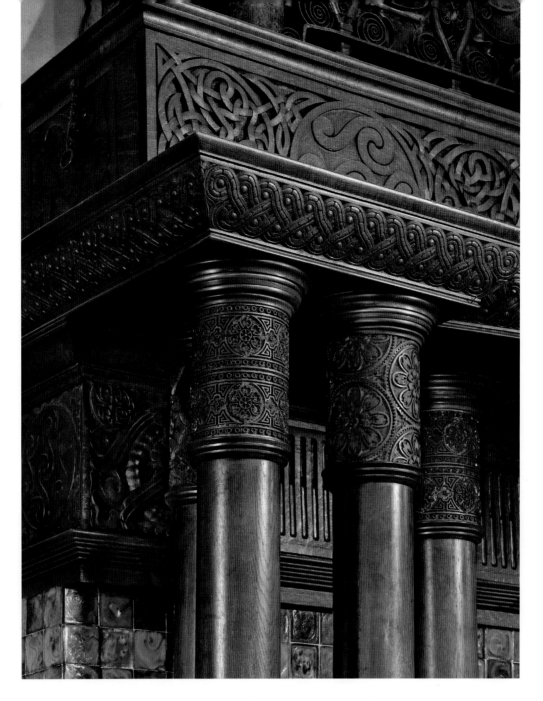

The mantel in the Veterans Room incorporates column capitals made from wooden blocks originally carved to print wallpaper.

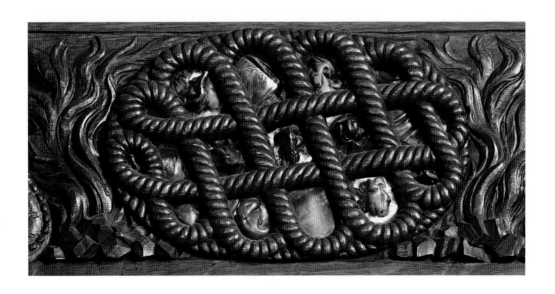

The high dado is punctuated by endless knots, which are filled with chunks of colored glass when the dado passes in front of a window.

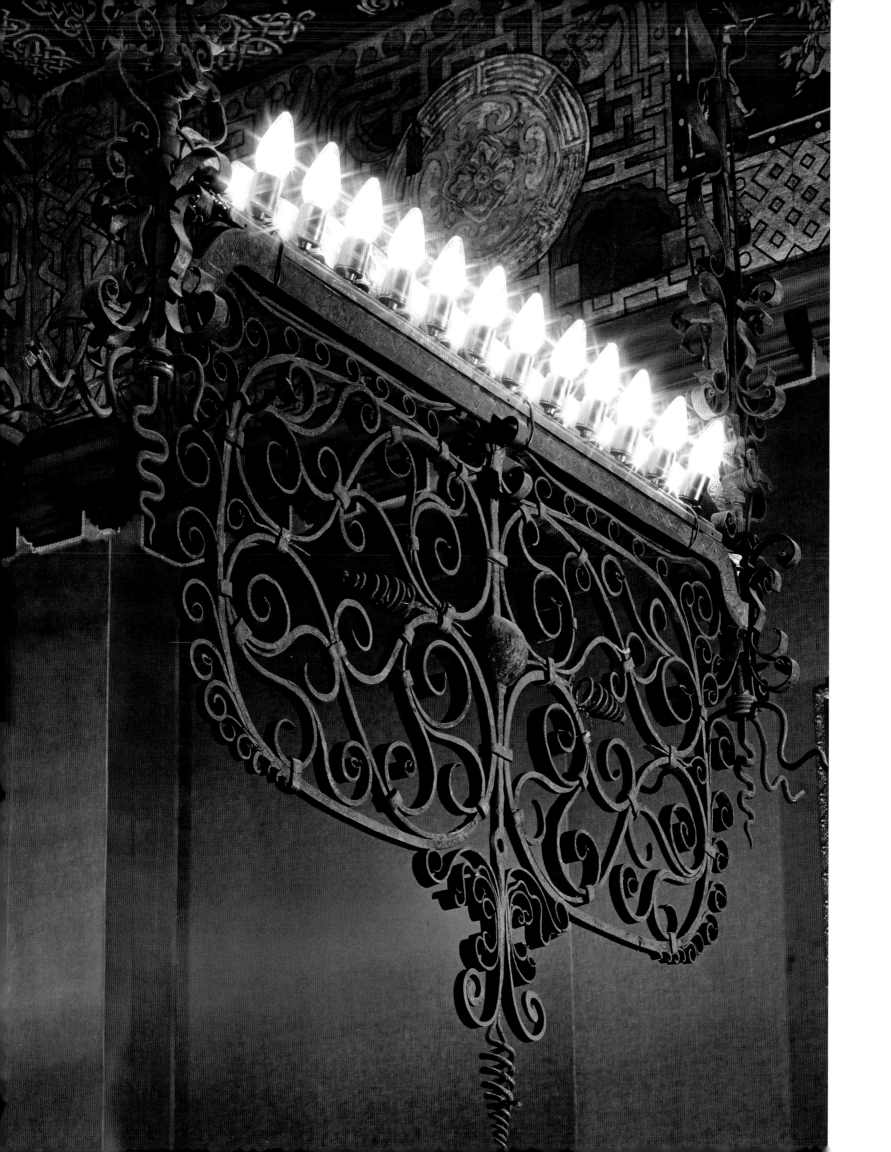

tour de force in adapting military iconography and materials to ornamental use. Massive columns were tightly wrapped in chains; clusters of bosses were embedded in the wainscoting; and a frieze composed of panels depicting the history of warfare from antiquity to the Civil War, alternating with roundels of military emblems set in a continuous band of Celtic tracery, surrounded the room just below a ceiling of rough-hewn beams originally multicolored and covered with silvery stenciling. Richly carved wood, intricate wrought-iron lighting fixtures, Tiffany stained glass, and brilliant blue tiles heightened the effect.

White contributed the architectural framework for the space, developing the high oak wainscoting with built-in seating, originally covered in leather up to the level of the chair rail, and probably designing the massive mantel supported by clusters of columns resting on pink marble piers, also with built-in seating. To compensate for the irregularity of the room, which projected under the corner tower, White introduced screens at the plane of the wall and created a niche with a balcony above.

Adjacent to the Veterans Room is the regimental library, intended to house two thousand volumes. The two rooms connect through double pocket doors, allowing those still on active duty to glimpse the splendor accorded to the veterans. Tiffany and Associated Artists were awarded the commission, but the room is thought to be primarily the work of White. The barrel-vaulted ceiling was executed in a basket-weave pattern incorporating medallions that was used in a number of residential projects and at the Newport Casino Theater. Here the original color scheme was salmon pink with silver medallions, in contrast to the cream and gold found in other projects. The mantel is a typical White design, incorporating a shallow shelf and inglenook seating on either side of the hearth. In scale and material, it is virtually identical to the mantel in the study at Alden Villa, which White designed a year or two later. Unique to this room is the balcony railing, an undulating openwork lattice in copper inset with squares in an abstract spiderweb pattern. The base was decorated with tongues of fire, similar to those that ring the dome at Lovely Lane Church in Baltimore.

A pendant light fixture in the Veterans Room. Both Tiffany and White designed similar metalwork throughout their careers.

The lower half of the columns in the Veterans Room are wrapped in common chain, with studs originally burnished gold.

Overleaf
Veterans Room.

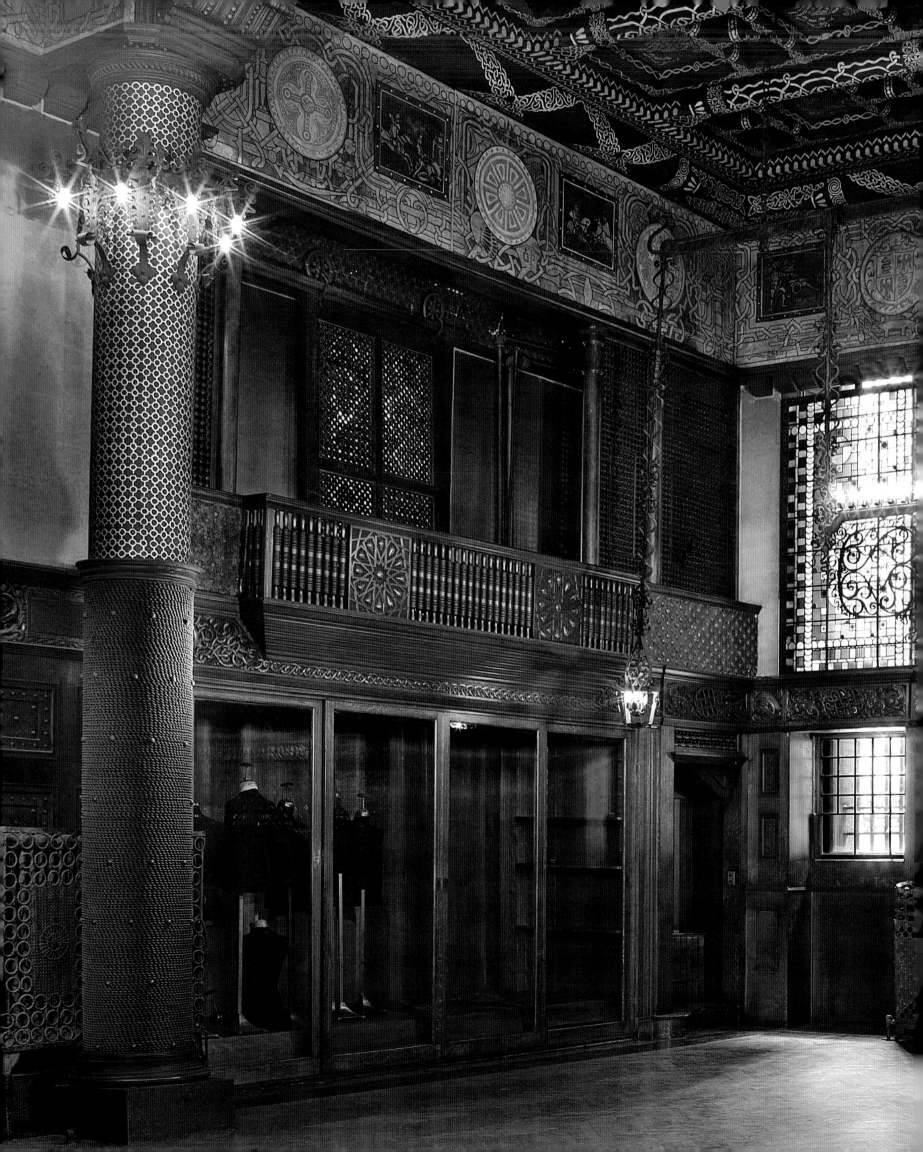

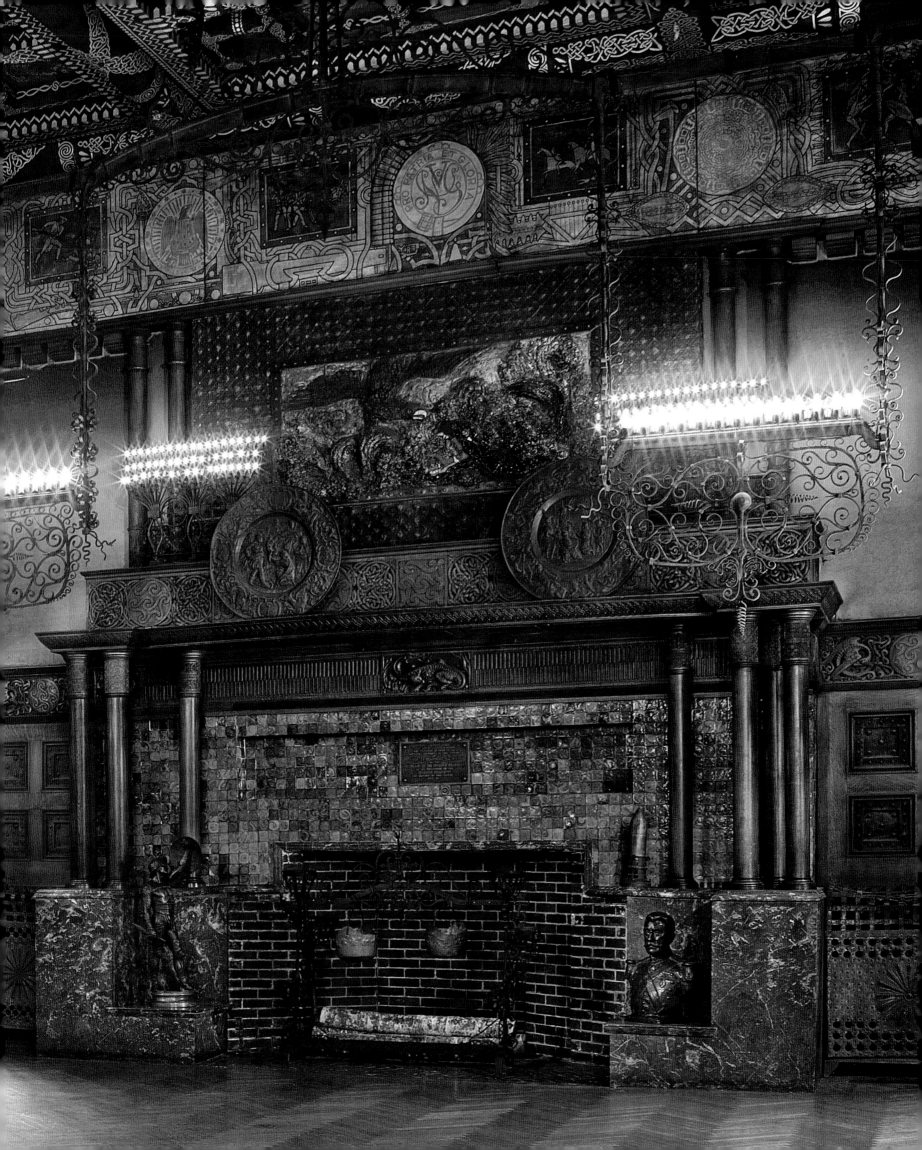

VILLARD HOUSES

NEW YORK

1881–85

I N APRIL 1881 Henry Villard purchased the land along the east side of Madison Avenue between Forty-ninth and Fiftieth streets and commissioned McKim, Mead & White to build six houses on the site, one for his own family and the others for sale to a select group of friends and colleagues. The firm had personal and professional ties to Villard. His brother-in-law was married to McKim's sister, and the partners had already completed renovations to the Villard country house in Dobbs Ferry, New York. In tandem with the design of the Madison Avenue townhouses, White and McKim worked on speculative hotel projects along the route of the Northern Pacific Railroad, of which Villard was the majority shareholder.

The Villard complex was a collaboration within the drafting room and

The intricacy of the ironwork over the gate suggests why Stanford White's nickname in the drafting room was "Cellini." Henry Villard's front door is visible on the right.

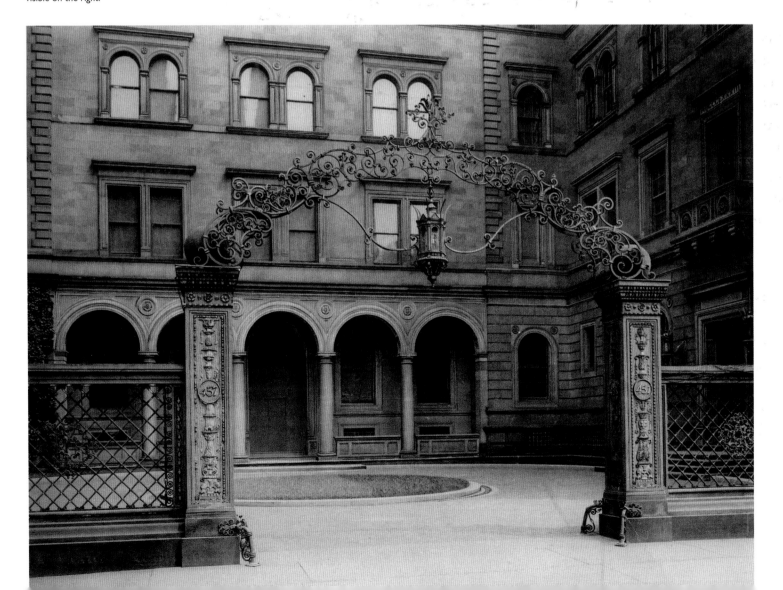

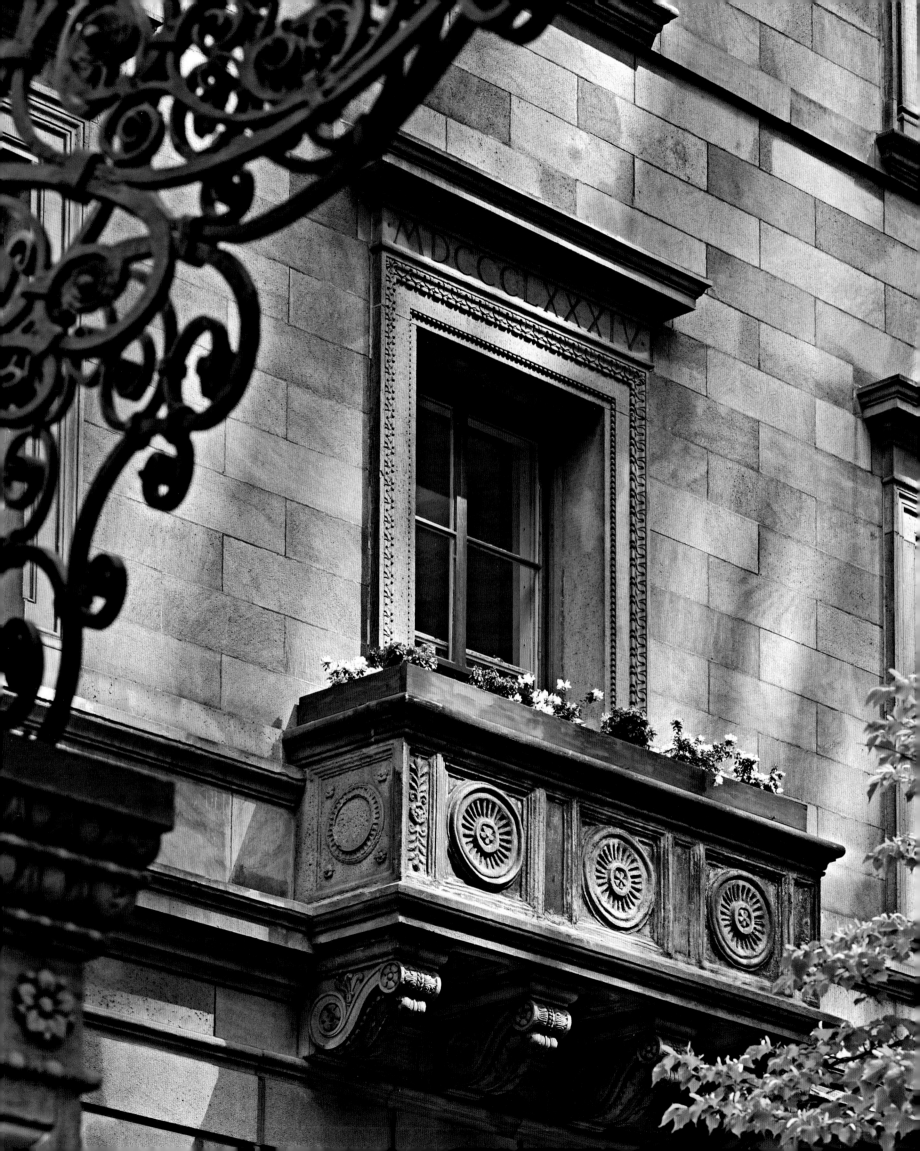

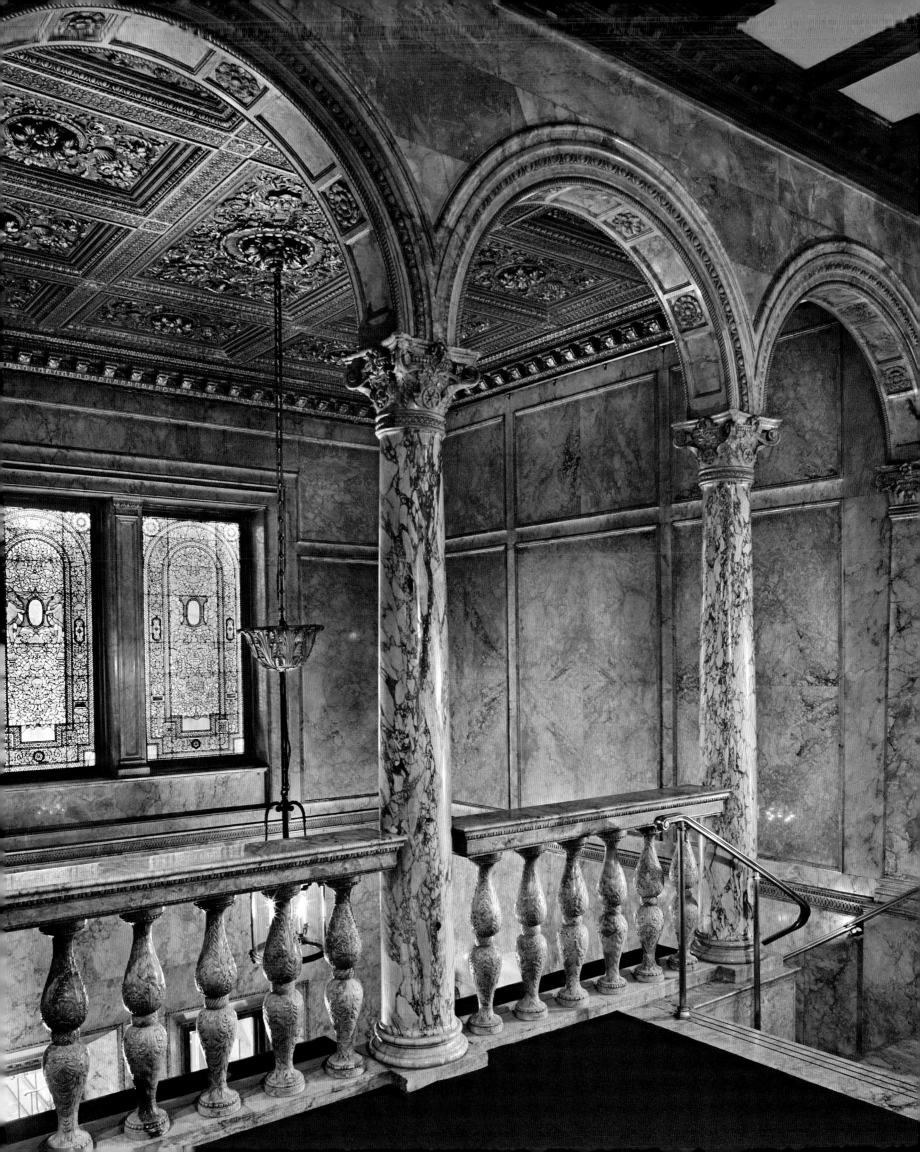

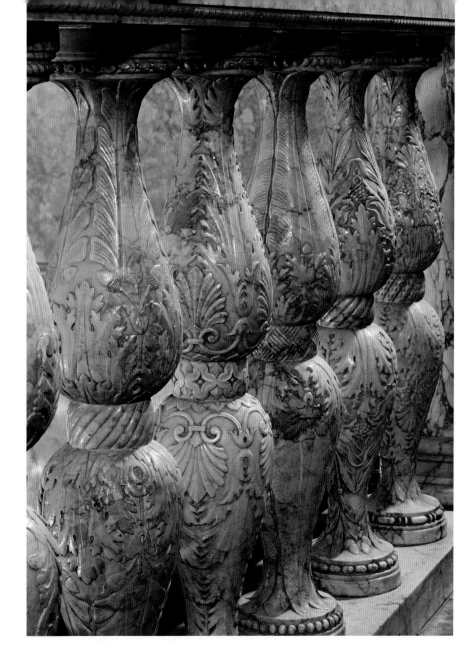

Each baluster in the railing overlooking the stair hall is a unique design.

within the community of artists and artisans with whom White had begun to work regularly. No drawings survive of White's initial scheme, said to have been in the French chateau style of Richard Morris Hunt's houses for William Henry Vanderbilt and his two sons. This scheme was abandoned by the spring of 1882, when White went to New Mexico to help his brother. A tracing of a sketch filed with the New York City building department reflects the basic configuration of the completed building based on the Italian Renaissance precedents advocated by Joseph Morrill Wells.

For the Villard residence White designed a suite of public rooms decorated at a level that was virtually unprecedented in New York. The walls of the entry, living hall, and stairwell were sheathed in marble panels inlaid with decoratively patterned strips and trimmed with

Highly figured marble columns almost disappear in the visual abundance of the stair hall.

93

White redecorated the public rooms when Whitelaw Reid took over the house from Villard, but he did not alter the entry hall. Details include thick chunks of glass alternating with thin sheets of onyx, suggesting the possible contribution of Tiffany or LaFarge. The mosaic contractor was Pasquali & Aeschlimann.

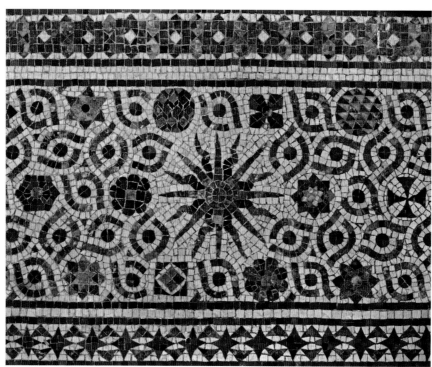

Overleaf
The vaulted ceiling of the entry hall is covered in mosaic in a foliate pattern, possibly designed by Maitland Armstrong. There is no firm attribution for the Pax relief.

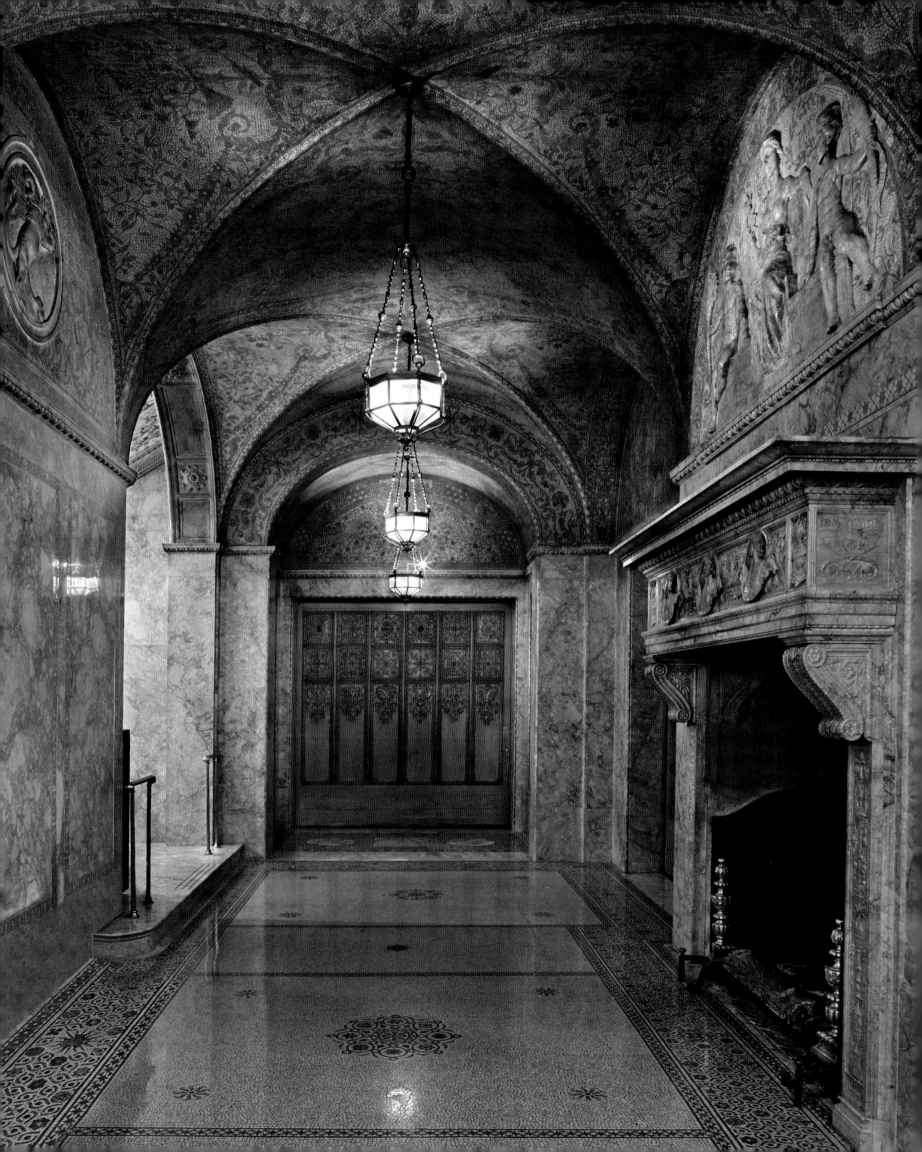

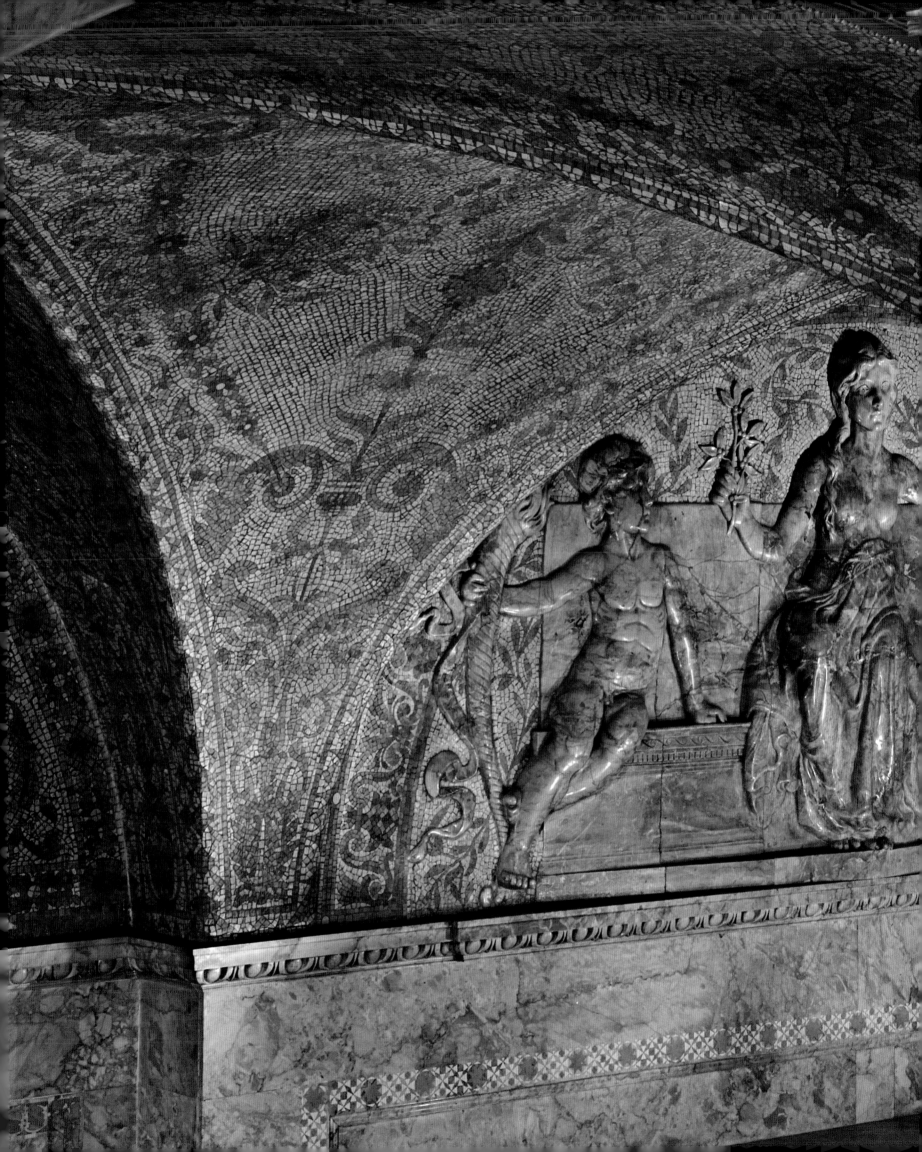

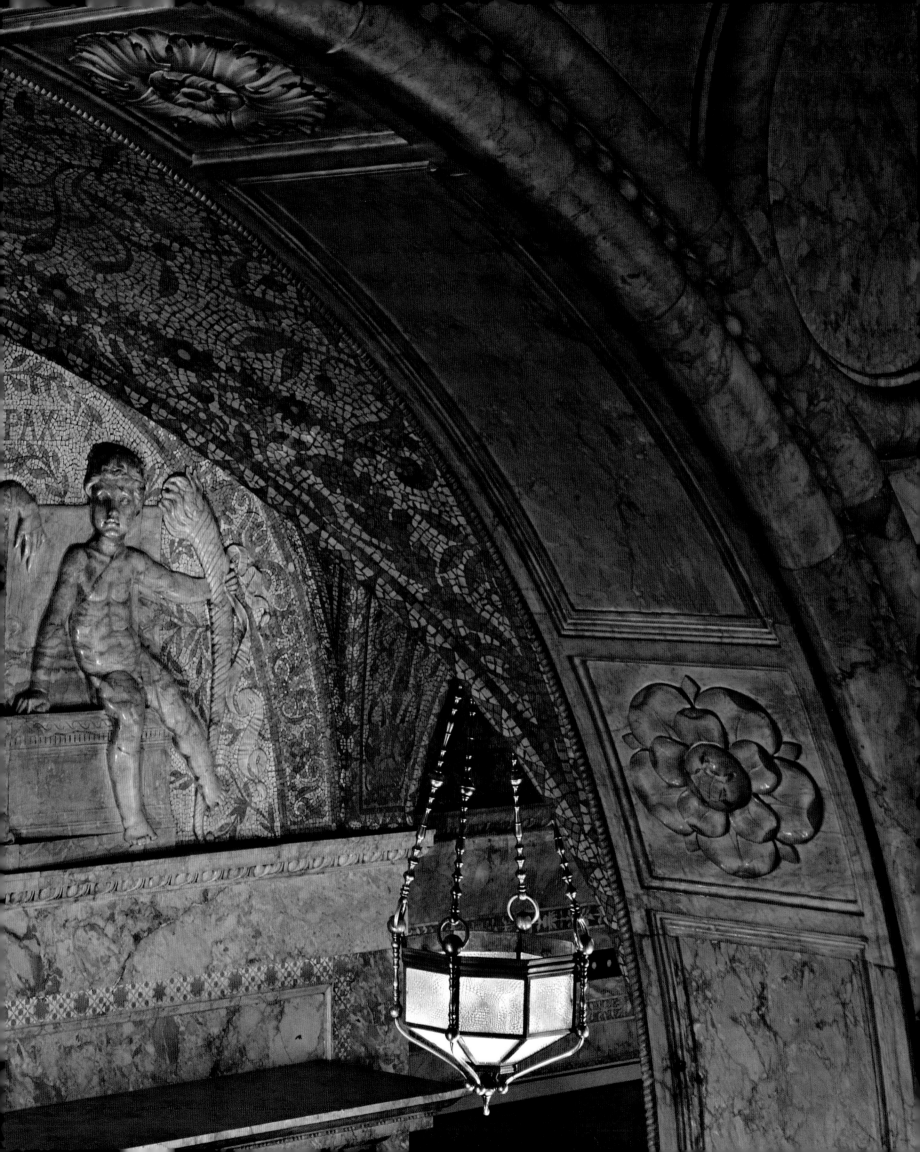

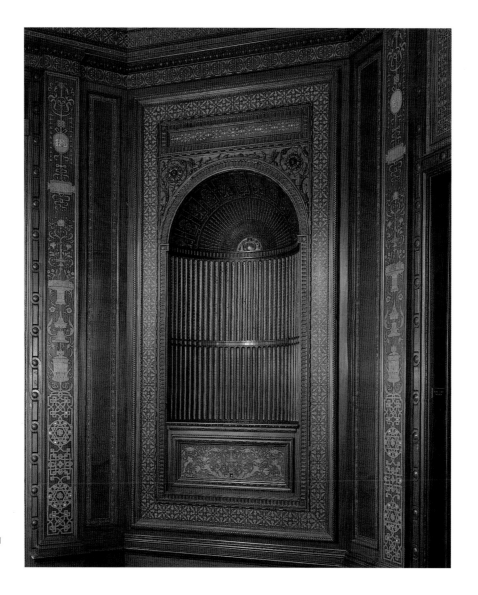

classical moldings. Mosaics in elaborate patterns covered the floors and vaulted ceilings. Augustus Saint-Gaudens contributed the monumental fireplaces in the living hall and dining room as well as the figures for the zodiac clock White designed for the stairwell. The triple parlor, arranged in an enfilade across the Madison Avenue facade, was covered with an exotic, densely figured marquetry of dark and light woods and mother-of pearl supplied by Joseph Cabus, a cabinetmaker on whom White frequently called. The dining room was finished in richly carved wood, but the music room was treated differently. Its walls and barrel-vaulted ceiling were painted a light color and enriched with bas-relief panels of musical instruments and a cast of Luca della Robbia's *Cantoria*.

The redesign of these rooms for Whitelaw Reid and his wife,

Marble and gold leaf form the core of the redesign for the drawing room. White retained the original location for the niches but translated them into a more classical idiom.

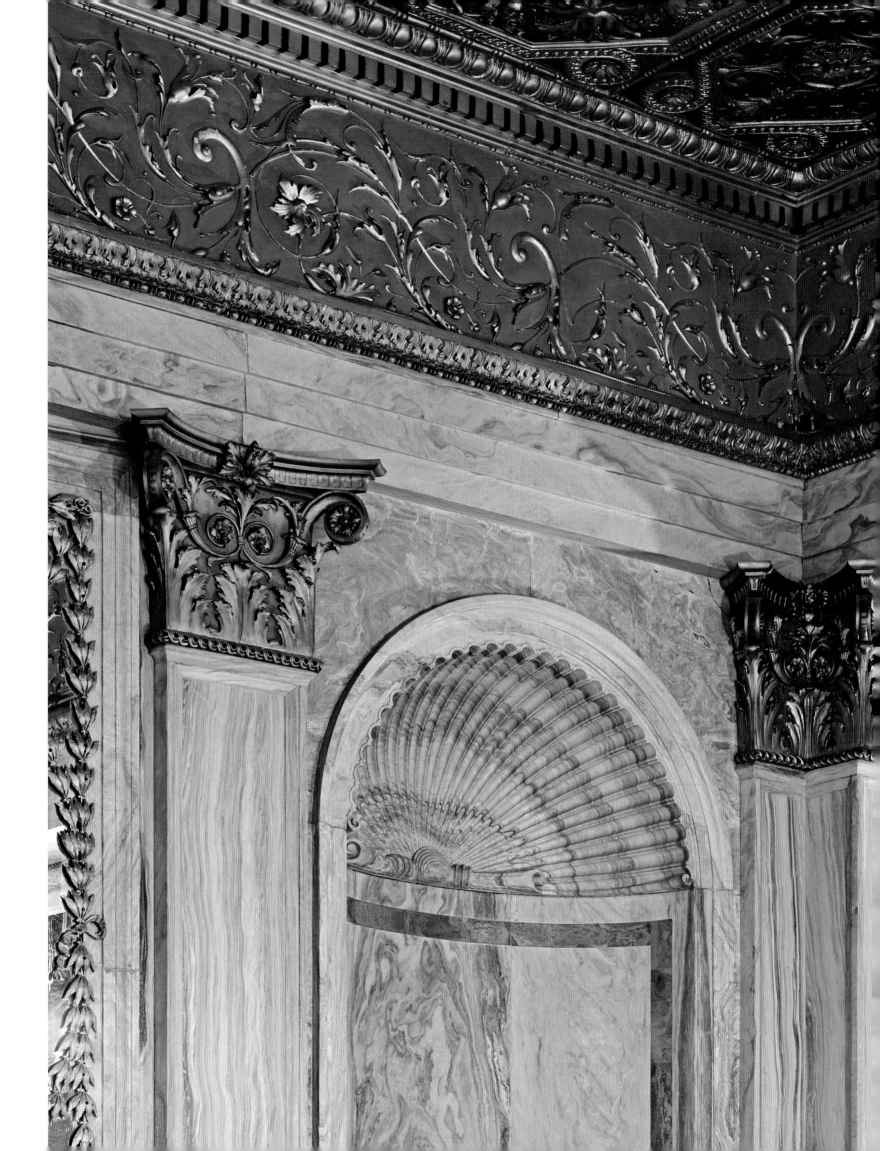

The drawing room as redesigned in 1887. It must have looked stunning with the furniture that Ambassador Reid brought back from France.

White's capitals for the second floor stair hall display the power of an imagination that was only lightly restrained by an established classical vocabulary.

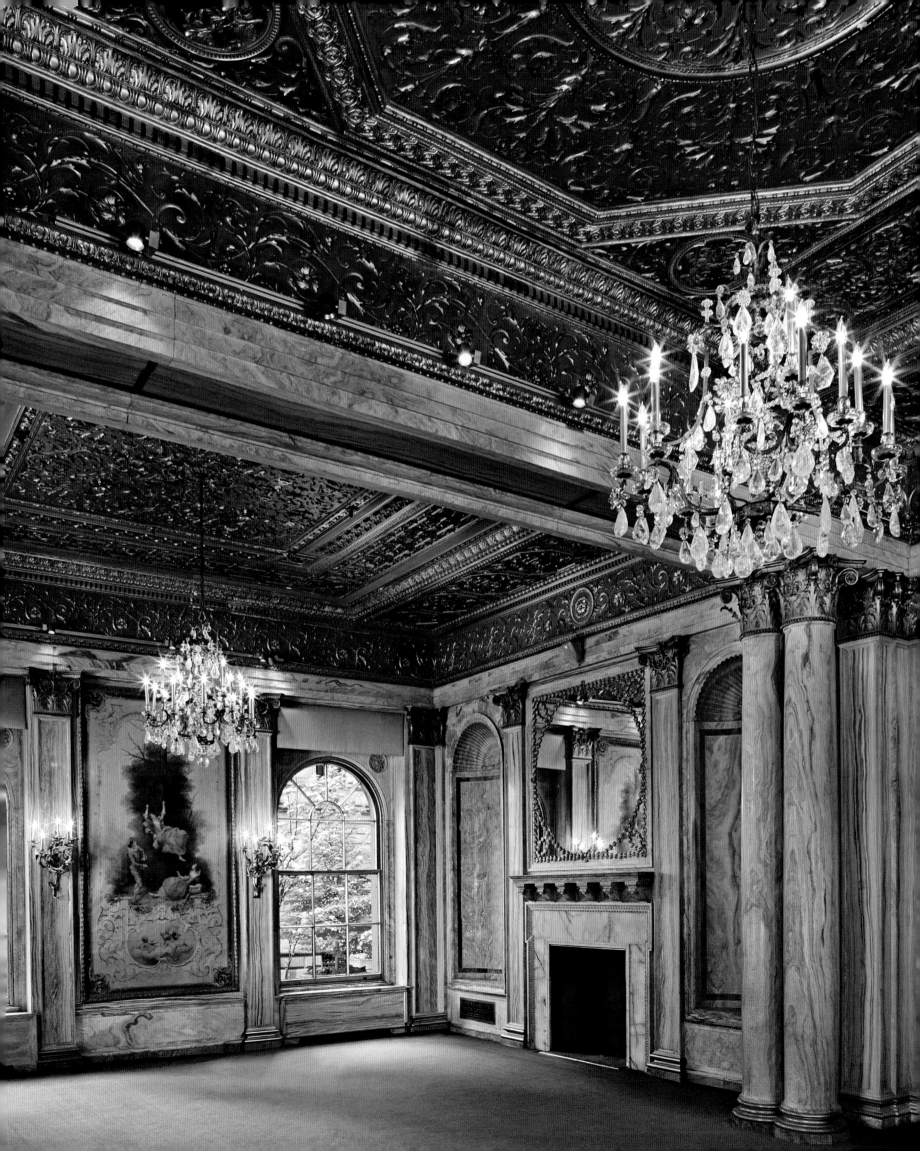

White and Saint-Gaudens collaborated on the zodiac clock in which the marble reliefs are separated by flush bronze bands. The sun figure at the center of the dial is particularly characteristic of the architect's designs.

Elisabeth Mills Reid, begun in 1887, reflected both the clients' sophistication and a more general shift in taste toward classical ornament. The triple parlor became an imposing entertaining space, clad in pale green Callacatta marble under a gilded Renaissance ceiling supported by columns with gilded Corinthian capitals. Inset into the walls were paintings in the rococo style by P. V. Galland, who "had decorated grand drawing rooms from Paris to Petersburg." The plain surfaces of the music room were completely covered with gilded ornament, and lunette paintings by John La Farge were inserted at either end of the room above the della Robbia panels.

The music room was created for Villard, but the gilded decoration was installed for Reid. Reproductions of della Robbia panels from the *Cantoria* were in use in the New York school art curriculum and readily available in the city.

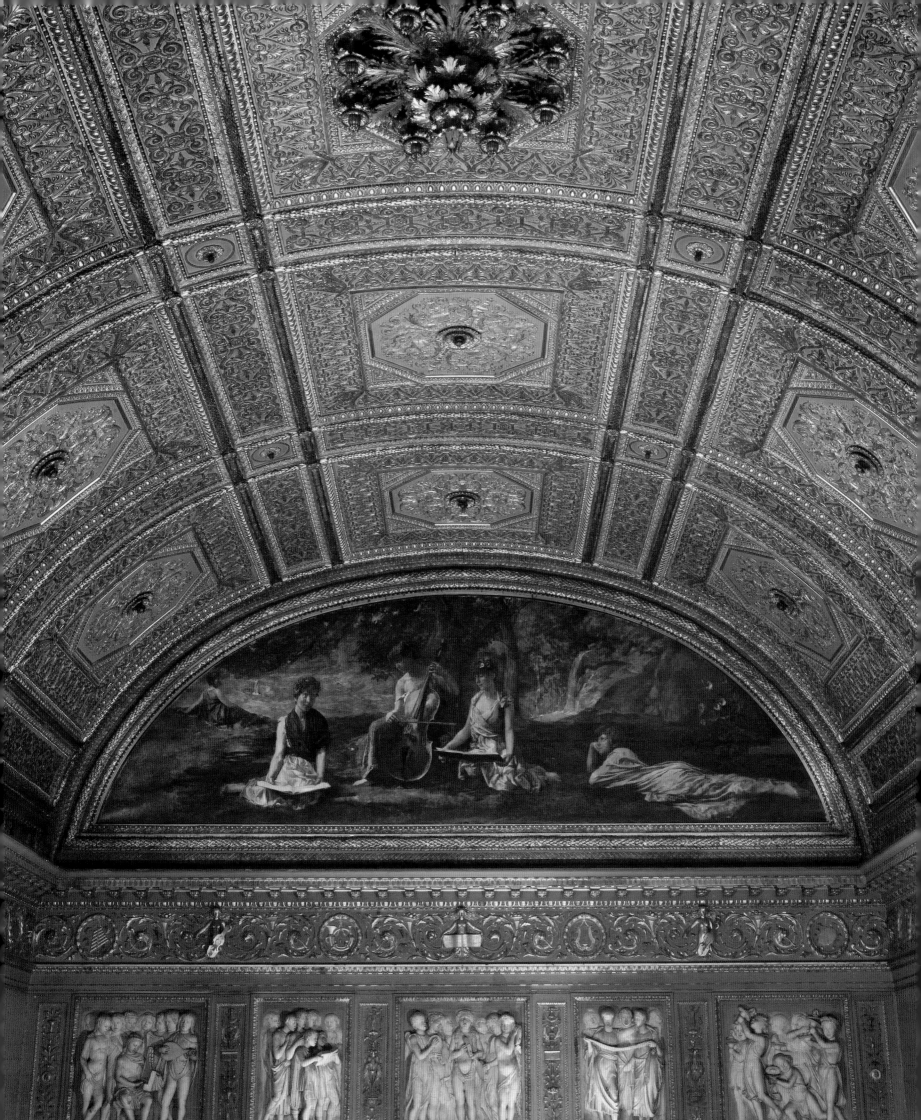

CHURCH OF THE ASCENSION

NEW YORK

1885–88

The medallion in the pulpit designed by McKim.

The setting for La Farge's mural incorporates White's palette of decorative elements—panels of Siena marble, intricate mosaics and sculptural reliefs— found also in the entry hall of the Villard houses.

*R*ICHARD UPJOHN designed the Church of the Ascension on Fifth Avenue at Tenth Street in the 1840s. While the Gothic revival exterior, executed in newly fashionable brownstone, was typical of his work, the interior was compromised by the decision to omit the chancel and terminate the space with a flat wall pierced with a lancet window. The idea, initiated by the low-church congregation and the rector, was to forestall the introduction of high church ritual around an altar, but the result was "one of the ugliest churches inside that were to be found in New York, which is saying a good deal," according to Maitland Armstrong.

In the mid-1880s, when the more worldly Reverend E. Winchester Donald became the rector, he persuaded the congregation, and specifically the Rhinelander sisters, to reconsider the decorative scheme under the direction of Stanford White. Since there was still no enthusiasm for physically creating an chancel, White devised a plan to extend the space visually. The focal point was the mural of the Ascension proposed by John La Farge. He introduced an uncharacteristic but successful landscape of receding mountains behind the figures. The illusion of depth was supported by the forced perspective of the Renaissance frame White designed for the painting, similar to the one for the Baptistry at St. Paul's Church in Stockbridge but here in richly ornamented and gilded plaster and on a monumental scale. Below the painting is a Siena marble panel inlaid with intricate mosaics by Maitland Armstrong, including a pair of Giottesque angels at the left and right. At the center, two angels sculpted by Louis Saint-Gaudens support a chalice. All elements are executed in golden materials that harmonize but do not compete with the frame.

To improve the proportions of the nave and reveal the stained-glass windows, White removed the balconies on the left and right. New windows by La Farge, Armstrong, Frederic Crowinshield, J. Alden Weir, Joseph Lauber, and Frederick Wilson were installed over the years,

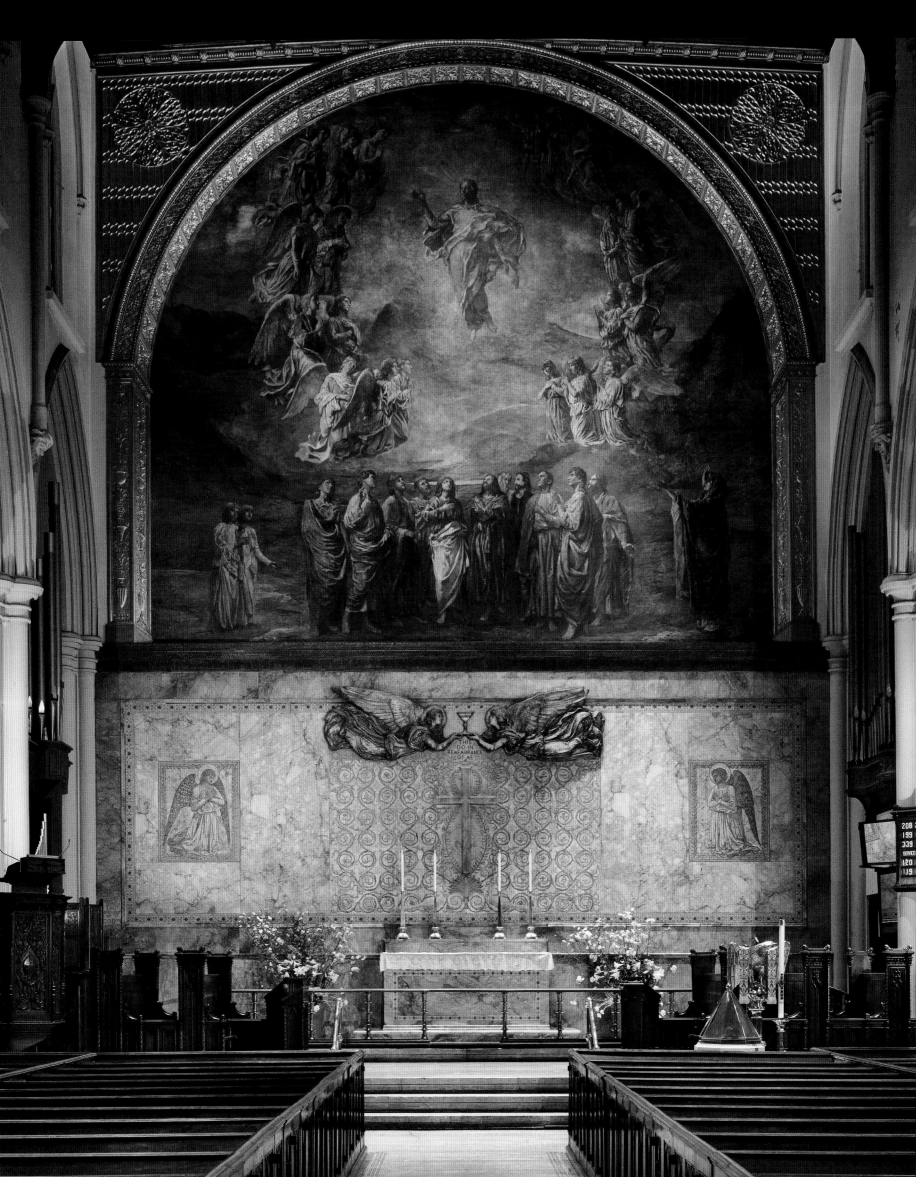

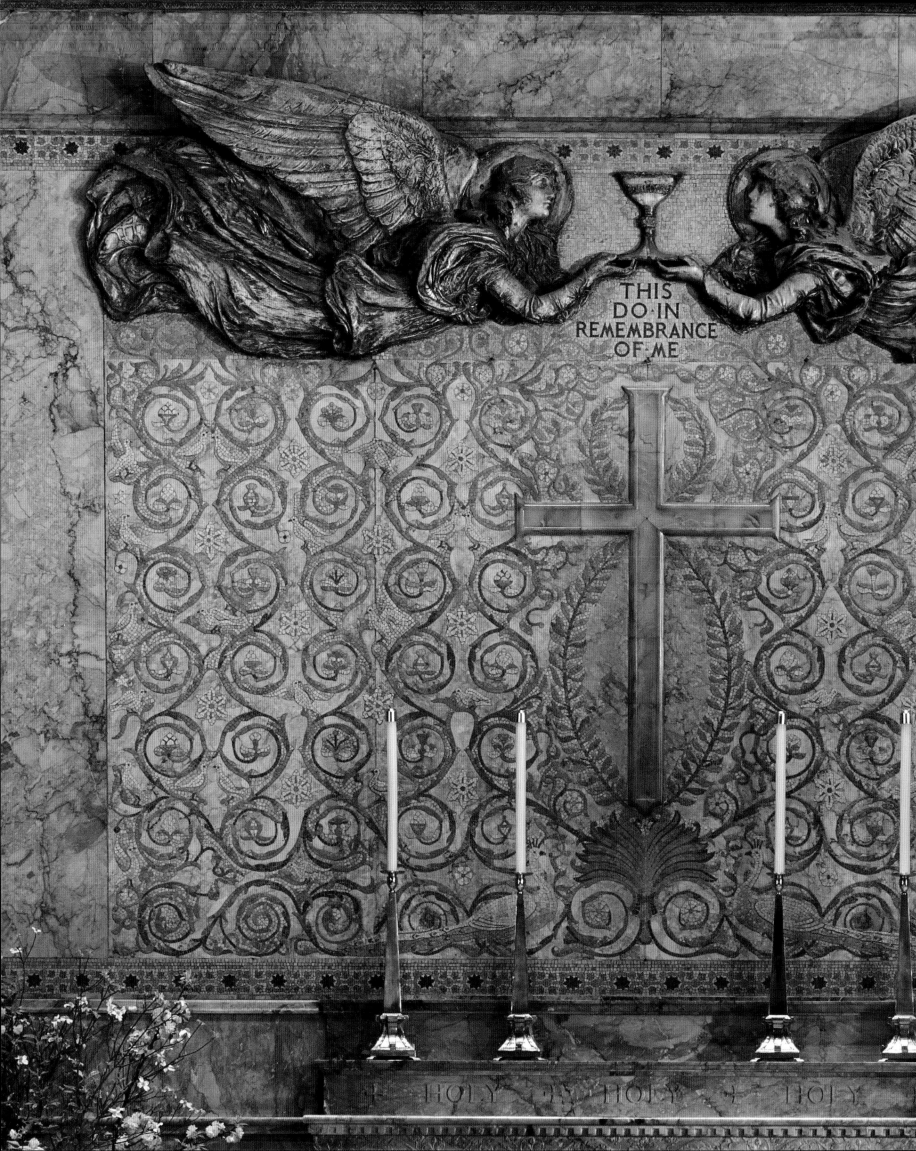

A medallion at the end of one
of the choir stalls, also designed
by White.

The angels appear to be carved
in the round, particularly when
compared to the border and
foliate pattern that are inlaid
flush with the marble.

107

White teased McKim that the commission for the pulpit would make the older partner rich.

making the group collectively "one of the supreme achievements in American stained-glass art." Charles Follen McKim designed the handsome French walnut pulpit, inspired by a medieval panel he had found in Paris. The handsomely carved choir stalls flanking the altar are also the work of the firm.

McKim, Mead & White continued to work with the church, completing the Parish House on Eleventh Street in 1889. This modest five-story row house connected to the church through the rear reflected its combined institutional and residential use in the details of the overscaled arch at the entrance and Tudoresque leaded-glass windows.

Stanford White considered the Church of the Ascension his parish church. His son, Lawrence Grant White, was baptized under La Farge's mural in 1889.

A detail of the fiddlehead design over the altar shows mosaic songbirds concealed within the branches of the foliage.

CHAPTER THREE

Houses

STANFORD WHITE was a natural residential architect. McKim had a reputation for persuasion and probity, and Mead for New England common sense, but White's name was associated with living and specifically with living well. He had superb taste and got along with everyone. White understood the problem of residential design both in terms of the activities and relationships that houses needed to accommodate and in terms of the status and ambition that they were intended to express. While he may have complained privately about "small hells that encircle us on every side—women who want closets!" White was intimately familiar with his clients' operational and social requirements. These could be significant in the case of Ruth Livingston Mills, Teresa Fair Oelrichs, or Katherine Duer Mackay, all chatelaines of grand houses for lavish entertaining. Other clients might not have articulated their aspirations as forcefully as those three, but White learned to anticipate unspoken agendas. He radiated confidence, delivered solutions that were ingenious and beautiful, and possessed a boundless imagination.

White's early houses nearly exploded with invention; the novelty of his later work was sometimes concealed behind historical precedent. His portfolio represented an overlay of multiple cultures and styles: American colonial and federal revival; French from Norman to Louis XVI; English ranging from the Tudors to the brothers Adam; and Italian Renaissance. The range of his interiors, which included references to Islamic, Spanish, Dutch, and Japanese decorative arts, was even broader. White was an acute observer of the language of style, but he was also fearless in his disregard for conventional usage. He was said to have a phenomenal memory for architecture, and he was always looking for the right model, but he was never a copyist. Even those houses displaying identifiable formal or decorative characteristics of a specific culture and period were trans-

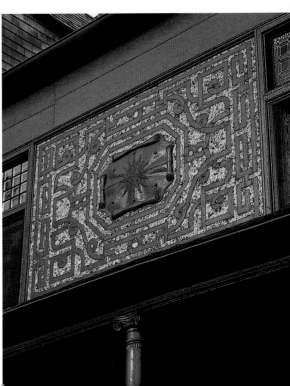

formed in his hands into original works of architecture.

Throughout his career White had designed built-in fittings that seemed to occupy an enchanted middle ground between architecture and furniture. The carvings in the early houses, often the work of local craftsmen, were finished with a coat of clear varnish. The interiors of later houses achieved their refinement with a profusion of mirrors, gesso, and gilding, plus decorative objects from European palaces and churches that had to be skillfully integrated with new carvings to create doorways, mantels, and ceilings. To achieve the requisite level of literacy and detail, White collaborated with decorating contractors staffed by highly skilled European craftsmen. The Parisian firm of Allard et Fils assisted White on many of these commissions, including Rosecliff and Harbor Hill, houses for Robert Wilson Patterson and two generations of Whitneys, and his own town house at 121 East Twenty-first Street. Allard advertised themselves as tastemakers, but when working for White, their job was to realize his vision.

Finances are a danger zone for any residential project, and White's were no exception. In the initial stages, he was scrupulous about estimating potential construction costs, literally scribbling on the back of an envelope to calculate the area and volume of even the most preliminary pencil sketch. Once the project got underway he must have had a harder time maintaining that perspective. He valued beauty, craftsmanship, and rarity. He encouraged his clients, escorting them on shopping trips to Europe, sending them streams of letters and telegrams in response to their constant questions, and collaborating with them on every detail. The trouble arose when White's expectations exceeded his clients' since it was their money that he was spending.

White's houses can be divided into three groups: shingle-style designs of the early and mid-1880s, transitional, experimental projects of the late 1880s and early 1890s, and mature designs from the mid-1890s onward. For the most part, the early designs were active collaborations with his partners. White was twenty-five when he joined the firm following a six-year apprenticeship with H. H. Richardson and a fourteen-month tour of Europe. McKim and Mead, half a decade his senior, had

the advantage of formal education, training in a number of different offices, and experience that translated into financial acumen, technical ability, and an emerging client base. But as Mead observed, White could "draw like a house afire." Stanford White was an alchemist with a pencil, and his wizardry had an instantaneous impact on the firm's output.

Early Houses

The Kingscote dining room was one of the first designs to be completed under McKim, Mead & White's new arrangement. Newport society dined in the new space during the summer of 1881, the first full season that the casino was open. The triumphs of the dining room and casino quickly led to commissions for new houses in the summer colony, and the young firm was ready with a particularly apt response. Together with other progressive architects of this period, including Peabody and Stearns and William Ralph Emerson, McKim, Mead & White had been developing a design vocabulary for wooden structures that is now called the shingle style, but which the architects themselves referred to as "modern colonial." The new style was based on an amalgam of details from eighteenth-century New England federal and nineteenth-century English Queen Anne houses, wrapped around a ground-floor plan that featured a generous, comfortable living hall with a fireplace, a broad staircase, and built-in seating and cabinetry. Richardson's 1876 Newport house for William Watts Sherman was the first coherent essay in the new idiom. White had been Richardson's principal assistant, responsible for developing the interior and exterior details. McKim had been experimenting with the shingle style ever since he left Richardson's office in 1872 to set up his own practice.

The novelty and invention in these early houses allows us to see into the artistic minds of the two design partners and the nature of their collaboration. McKim's interest in broad gables, balanced asymmetry, and compressed planes can be seen in the massing of the Samuel Tilton, Isaac Bell, and Robert Goelet houses in Newport. White's contributions are found in the half-timbering columns that imitate bamboo shoots, waves

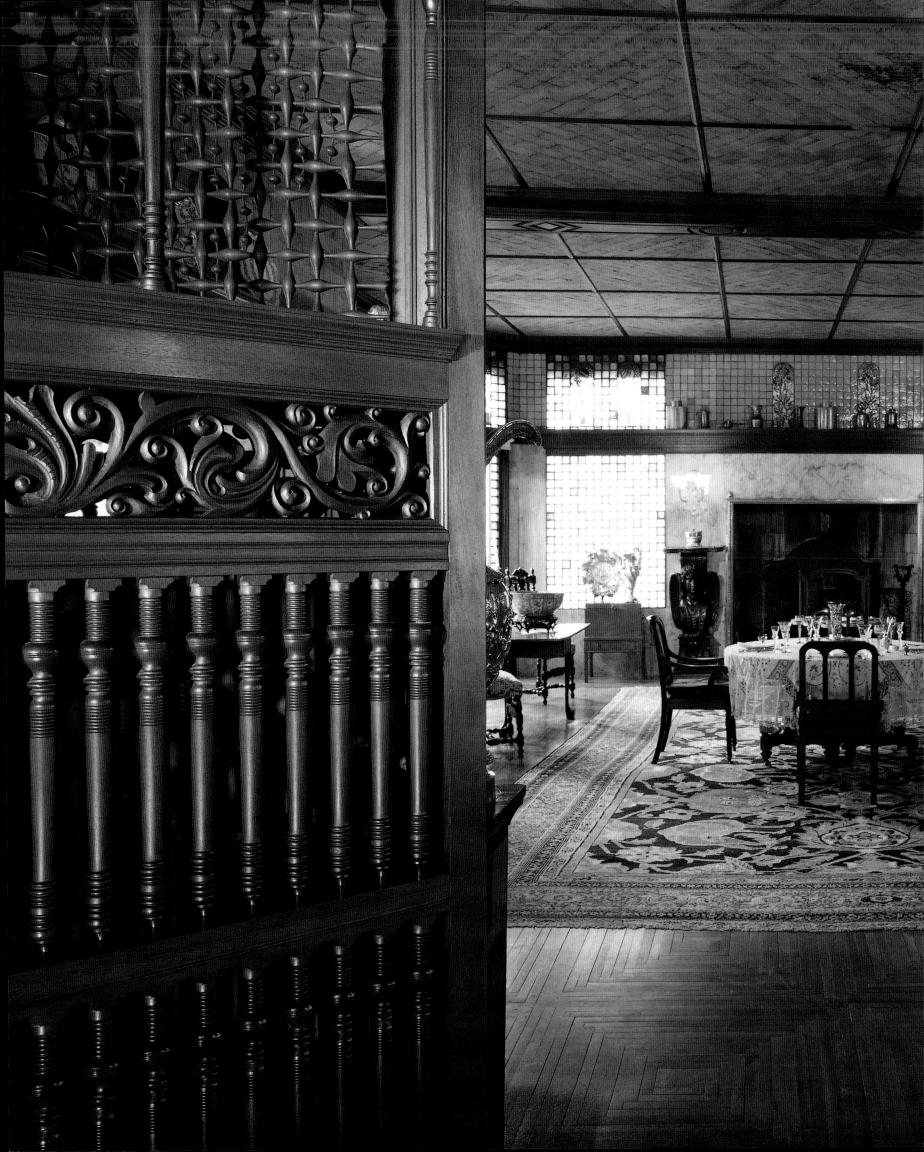

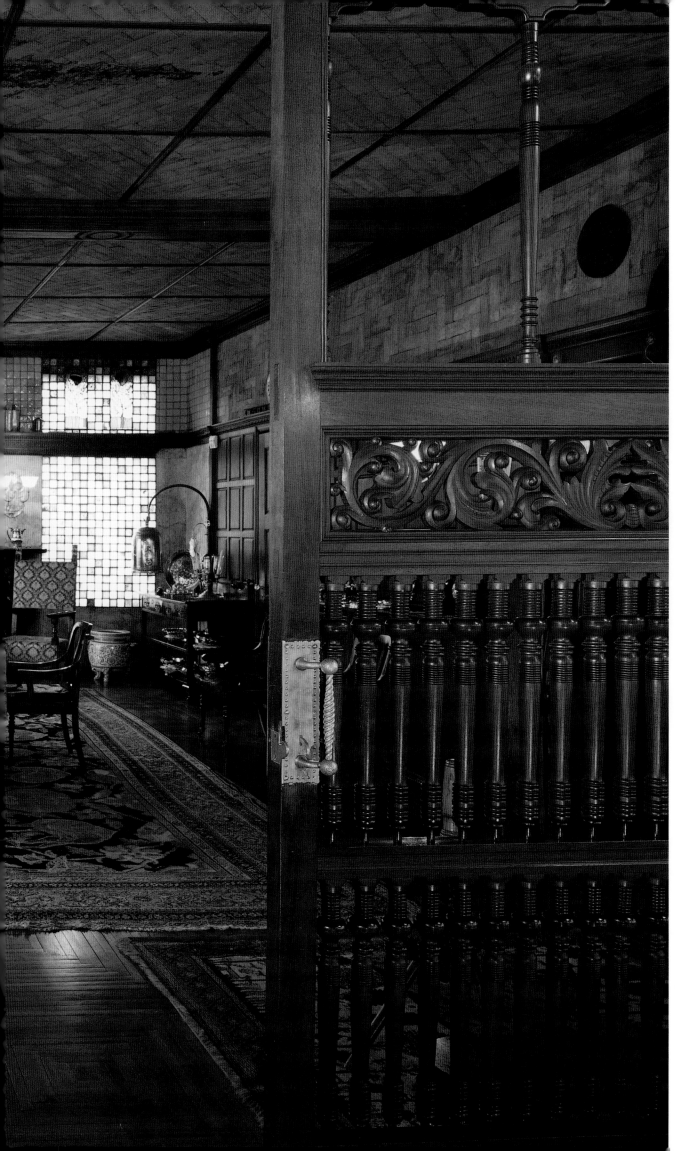

White's mastery of light, color, and material was fully revealed in the dining room at Kingscote. The geometric rigor may represent the influence of his more experienced partners.

White was Richardson's principal assistant for William Watts Sherman's Newport villa. One of his first commissions in partnership with McKim and Mead was to redesign Sherman's library.

of shingles, and stucco panels decorated with seashells, beach pebbles, and broken glass. The plans of these houses were dominated by McKim's paradigm of space flowing horizontally in all directions through broad doorways from the central living hall, but White was the magician behind the interiors. Pine was transformed into an array of textures and patterns; fishnet was glued to ceilings and wicker to the walls; tendrils of brass grew from cabinet hinges; and panels of silver foil concealed behind beaded medallions reflected light from every source.

The Baltimore house for Ross Winans shows how White and McKim could translate their shingle-style idiom into masonry. The collage of crisp gable roof, meandering stone base, and off-center stair tower is held together by the same broad, unornamented horizontal band that contains the Goelet house in Newport. The wavy copper cheek walls of Winans's dormers recall White's virtuosity with wood shingles, but the brick and slate of the house are more appropriate to its downtown location.

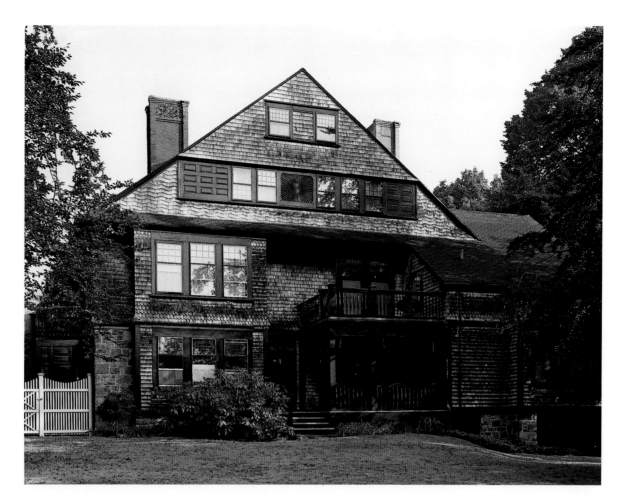

McKim controlled the massing and most of the exterior details on the Samuel Tilton house. White's influence was limited to the rear elevation and interiors.

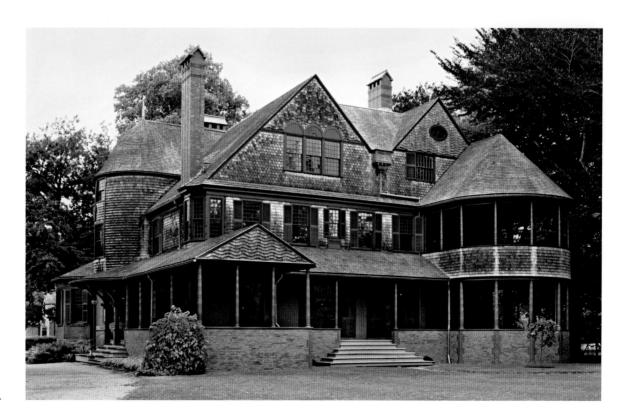

The complex massing and imaginative details of the Isaac Bell house illustrate White's increasing influence in the early collaborations with his partners.

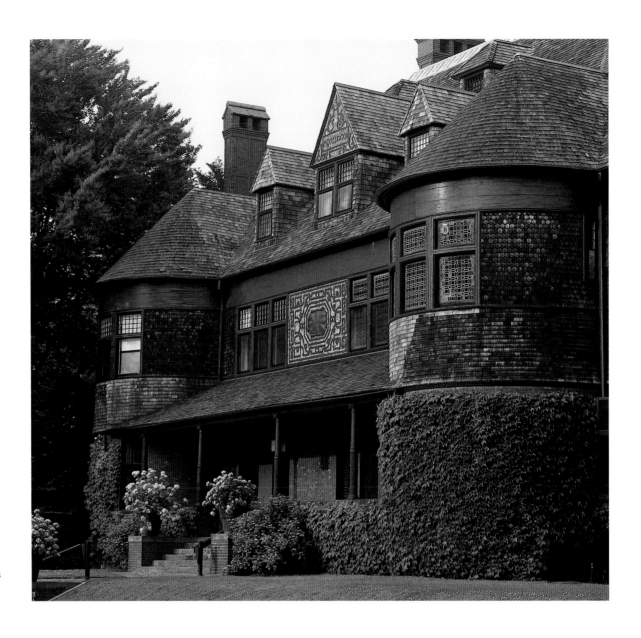

Ochre Point, designed for Robert Goelet, combines the firm's shingle style vocabulary with signature White elements such as the decorative panel over the porch.

The interior plan is based around McKim's classic living hall, while the woodwork shows how White's details could be urbanized with a heavy coat of varnish.

A number of early houses deviated from this paradigm of dual authorship. The firm's records give White design credit for Charles L. Tiffany's town house at Seventy-second Street and Madison Avenue in New York, but evidence suggests a broader collaboration. The rough-cut bluestone walls, massive arches, and tall gable roofs suggest that both McKim and White were still influenced by Richardson. A preliminary sketch by Louis Comfort Tiffany suggests that the client's son was at least an equal partner in the design of the exterior, and the younger

The forms and details of the shingle style could be translated into masonry. The essence of the vocabulary is particularly apparent when the Ross W. Winans house in Baltimore is compared to the Goelet house.

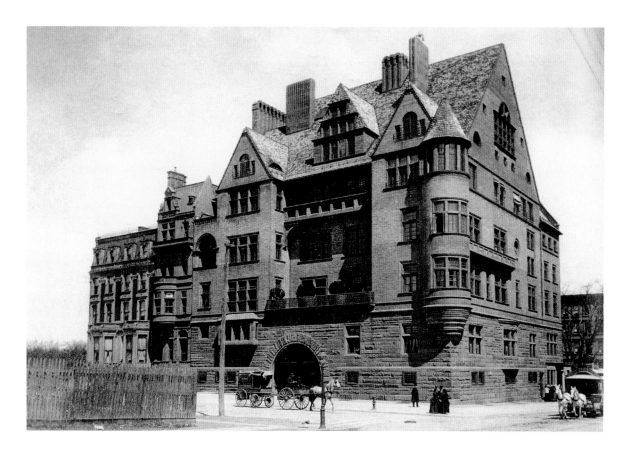

The triple house for Charles L. Tiffany included a lofty studio for Louis Comfort Tiffany in the attic. The muscular Romanesque of the bluestone walls testifies to Richardson's influence on his former employees.

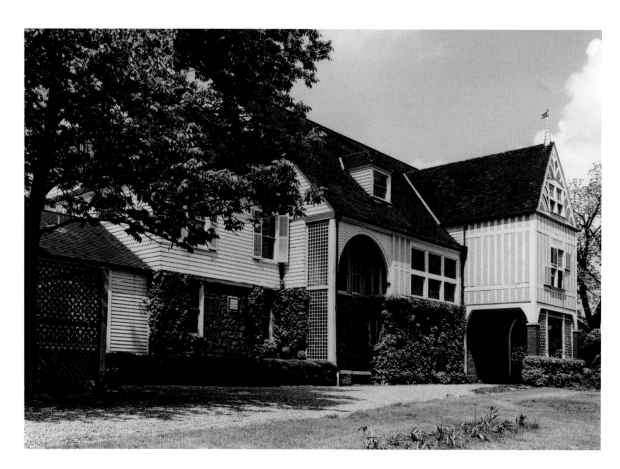

The main approach to Percy Alden's villa presented this view of a great lattice arch. The slight backward tilt of the gable end above the porte cochere was a deliberate anachronism.

New-York Historical Society

Tiffany's design for his own studio in the attic makes White's most imaginative visions seem repressed.

Alden Villa in Cornwall, Pennsylvania, seems to be pure Stanford White. The architecture—inside and out—is much closer to White's designs in the Queen Anne style under Richardson than to the new firm's shingle style. The double-width house on fashionable Mount Vernon Place in Baltimore for Robert Work Garrett suggests a division of labor between White and Joseph Morrill Wells, his older, acerbic, and exacting employee. The rhythm, proportions, and detailing of window openings, medallions, entrance porch, and cornice reflect a thoughtful study of Renaissance prototypes, an approach that was initially associated with Wells. The interior design has a vigor and immediacy that could be attributed only to White.

Charles Osborne's house in Mamaroneck, New York, summarizes all facets of White's training to date: his years with Richardson, his sketching

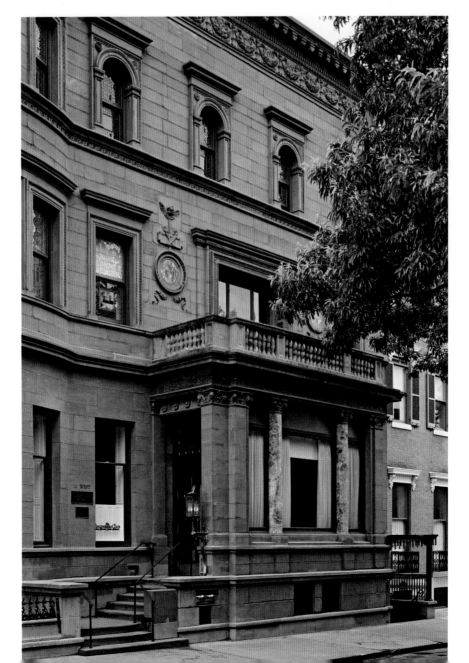

The Garret-Jacobs House in Baltimore illustrates the firm's shift towards a Renaissance vocabulary. Arched window surrounds based on the Palazzo della Cancelleria are representative of these early efforts.

Rough stone walls emerge from the rocky site of Charles Osborne's house overlooking Long Island Sound, giving the Loire Valley idiom an intensely regional flavor.

tour in Europe, and his four years in partnership with McKim and Mead. The main house was a great Norman pile stretched along on a rock overlooking Long Island Sound. Three massive stone arches separated four stone turrets with conical roofs to frame the corners of the main block, while a rambling service wing extended into the distance. A covered carriage drive ran through the entire house, separating the billiard room and Osborne's winter bedroom from the principal living rooms, the exceptionally large hall, and the broad staircase. White was responsible for the main house, which was destroyed in a fire, and the matching gatehouse and picturesque shingled stable block. Begun in 1882 and finished by 1885, the Osborne house can be seen as the completion of White's apprenticeship.

Transitional Houses

By the mid-1880s, wealthy clients interested in large houses were becoming dissatisfied with the inherent modesty of the shingle style. This development gave Stanford White an opportunity to broaden his residential vocabulary, but the evidence of the houses he designed over the next five or six years suggests that he did so with somewhat mixed results. The transitional houses were characterized by an experimental quality, and the range of images White created suggests that he was searching for an appropriate model to represent the ambitions of an emerging class of Americans. While aspects of the transitional houses may have been tentative or unresolved, the designs for these transitional houses were extremely ambitious. White saw them as an opportunity to synthesize a set of conflicting and in some cases irreconcilable paradigms. Although they were uneven as a body of work, the transitional houses included some of White's most interesting designs.

Naumkeag, the house for Joseph Hodges Choate, a distinguished lawyer and ambassador to the Court of St. James, was among the earliest transitional designs. Learned, traveled, and highly sophisticated, Choate must have imposed a number of preconceptions on his architect. White's design suggests the broad range of Choate's agenda, from pride in his Yankee origins and his Anglophilia to his insistence on a family house with conventional living rooms. The interiors of Naumkeag are among the firm's most livable, with a generous living hall extending through the house to a porch overlooking the Berkshires and ample bedrooms, all with mountain views.

The elevations achieve a high level of conviction but with less overall coherence. The asymmetrical brick entrance facade suggests a picturesque Cotswolds cottage, while the rear incorporates familiar shingle-style elements—gables, projecting bays and porches, dormers—in a more linear arrangement.

The transitional country houses included some great successes, the most dramatic of which was the Newport residence of Edwin Dennison

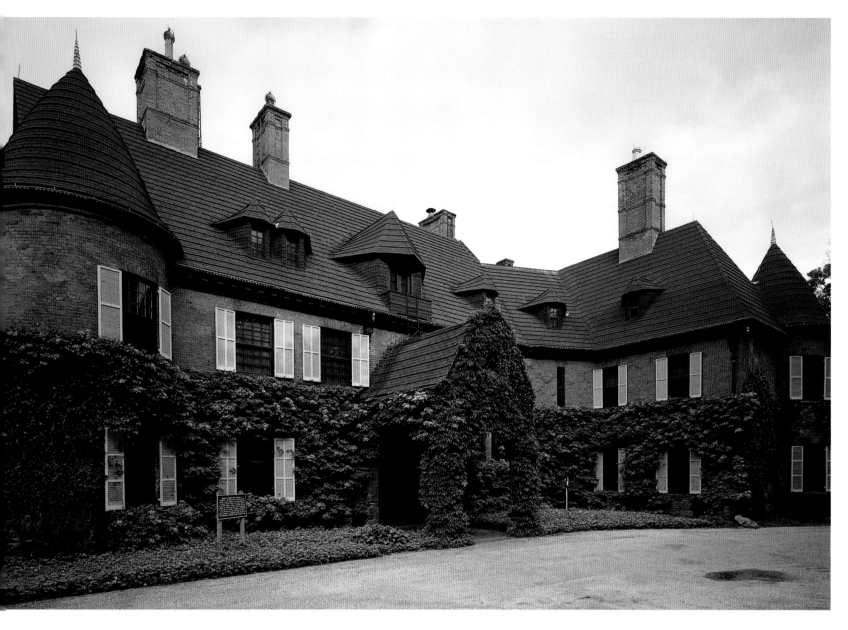

Naumkeag combined Joseph Choate's nostalgia for medieval Europe with a house that would accommodate contemporary family life.

Morgan. The plan shows great skill at manipulating axes and twisting geometries to create a complex processional route inside the house while fitting the building on a difficult site. At Beacon Rock, the primitive character of the setting was represented by rubble stone walls descending into the water, while the distinguished lineage of the client was reflected in the classical order of the two pavilions framing the deep entrance court. Here the fusion of conflicting paradigms was brilliantly accomplished; the image of Beacon Rock overlooking Newport Harbor is one of the most memorable of the firm's designs from any period.

McKim, Mead & White's most enduring contribution to country

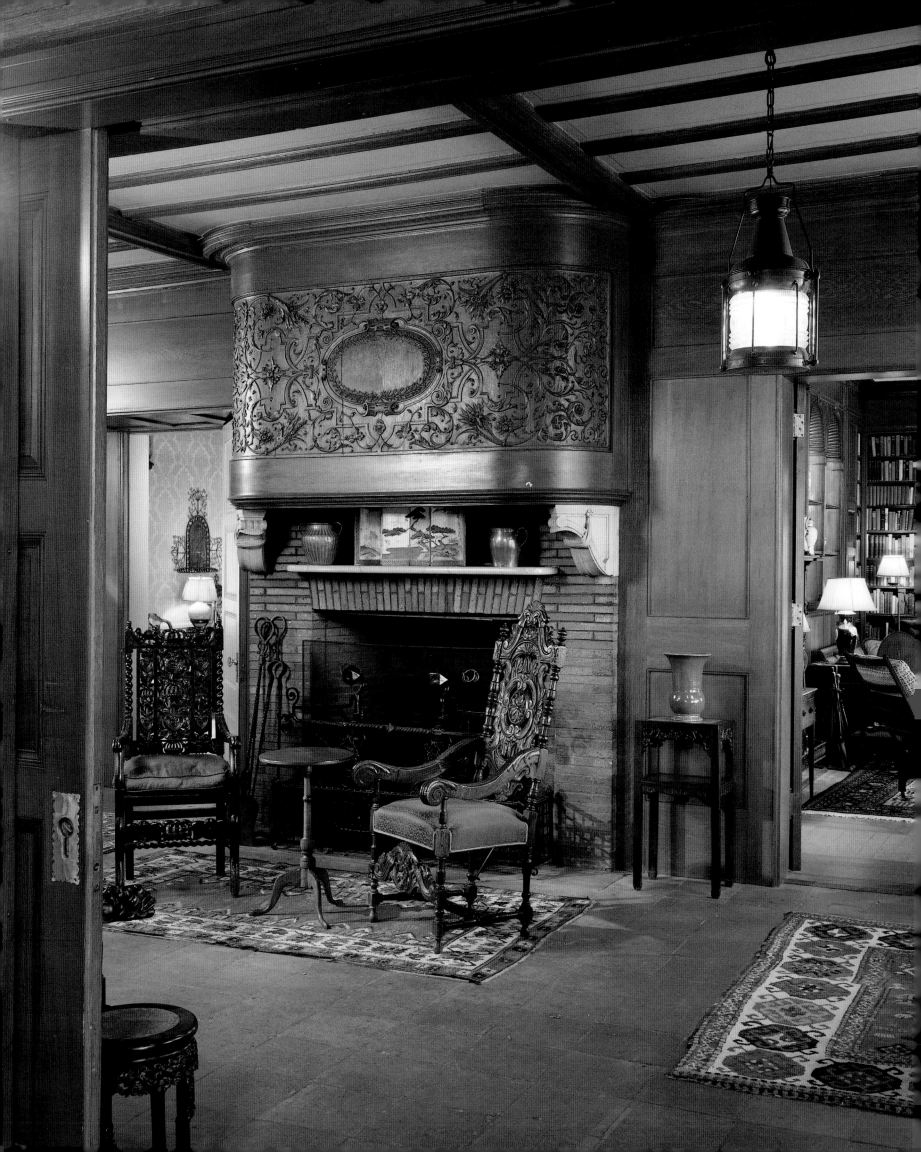

house design—the combination of simple shingles and federal-style detailing now known as the colonial revival—was developed in White's transitional designs. White and his partners first attempted to combine an elegant classical vocabulary with vernacular wall construction in the Samuel Parrish house in Southampton, New York. This approach was perfected at Head of the Harbor, designed for White's sister-in-law Kate Wetherill, as an octagonal villa overlooking one of the prettiest bodies of water on Long Island. For more than one hundred years, architects have continued to decorate the Eastern seaboard with houses designed in a civilized, summery vocabulary of plain shingles, robust classical moldings, and pure white trim.

Mature Houses

Stanford White's reputation as the architect of legendary palaces is based on the commissions he received after the World's Columbian Exposition in 1893. The late 1890s coincided with important economic and cultural developments on a national scale. America was experiencing a period of unprecedented prosperity, with enormous wealth concentrated in a very small percentage of the population. Following the success of the White City in Chicago, the classical vocabulary was adopted as the appropriate style for the important buildings of the New World—public and private—and the palaces of Europe were seen as expressing just the right level of status for their socially ambitious builders. American architects had been working in a classical vocabulary for more than one hundred

White's inventory of columns and mantels purchased in Europe was recorded on large measured drawings, which were updated as he sold pieces to clients.

Avery Architectural and Fine Arts Library, Columbia University

years, but the enormous size of these houses and the complexity of their programs presented a new architectural problem.

Richard Morris Hunt arrived at a highly visible solution working for William H. Vanderbilt in Newport. Hunt adapted a Genoese palace to accommodate Vanderbilt's notionally republican program. When the Breakers was completed in 1893, it established the gold standard for the image of a rich man's house.

By 1894 the firm of McKim, Mead & White was celebrated as architects for the Boston Public Library and contributing designers of the Chicago exposition. Stanford White was the partner to see about a new house. His client list featured several dozen of America's wealthiest families, including a Vanderbilt, a Lorillard, and a Whitney. His reputation for commissions at this level could only have been enhanced by the white marble palazzo on Fifth Avenue that he had just completed for the millionaire members of the Metropolitan Club.

White took advantage of this unprecedented opportunity to create a remarkable body of work. These houses are great designs, possibly unmatched in the history of American architecture. They gave the widest range to his knowledge of historical precedents, and they demonstrated his exceptional ability as a decorator, his command of details, and his access to European dealers. White kept drawings that documented his personal inventory of such architectural elements as columns and mantels, which he could consult to flesh out the interiors of these designs.

These houses were settings for performances as well as for decorative arts, and they illustrated White's interest in translating social rituals into processional architecture. Movement toward, around, and through these houses became the primary language for reading their design. Most were intended as venues for great parties and show that Stanford White was without peer among his countrymen as the architect of celebration.

Staatsburgh for Ogden Mills, one of the first commissions of this mature period, reflects all of these attributes. Mills, whose father founded the Bank of California, was married to Ruth Livingston, establishing a dynasty that combined his limitless wealth with her unimpeachable Knickerbocker lineage. Ruth Mills's ambition was to succeed Caroline

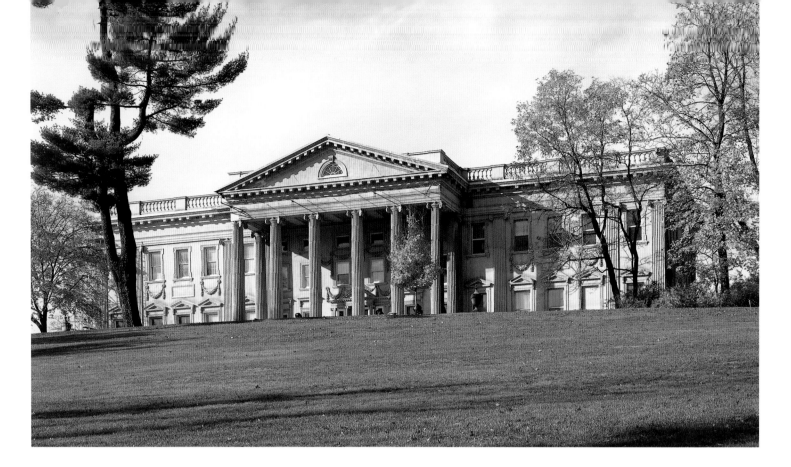

Schermerhorn Astor as doyenne of New York society; the image of their house suggests that her husband aspired to be president of the United States. In the service of both agendas, White expanded an older structure, transforming it into a stage for entertaining at a lavish scale as well as a residence capable of accommodating the intricate choreography of a country house in the Victorian era. The rituals of a formal dinner allowed the hosts to parade guests from one end of the vast house to the other and then back again, passing through a suite of reception rooms of imperial grandeur. Houseguests discovered the ingenious arrangement of stairs and corridors that enforced an immutable separation of genders by class and marital status. Edith Wharton, who had a keen eye for such distinctions, used a fictional Staatsburgh for the critical weekend in *House of Mirth*.

White's city houses of this period were celebrated as venues for great entertaining in the colder months. His Madison Avenue town house for Mrs. Stuyvesant Fish was said to have the biggest ballroom in New York. That legend is hard to reconcile with the geometric realities of a central staircase and a thirty-by-one-hundred-foot plot, but the exterior, with highly charged details set off by smooth yellow walls, promised an exceptional degree of festivity. White conjured up similar expectations for

Radiating power and cultural literacy, the Payne Whitney house illustrates White's paradigm for a town house for entertaining.

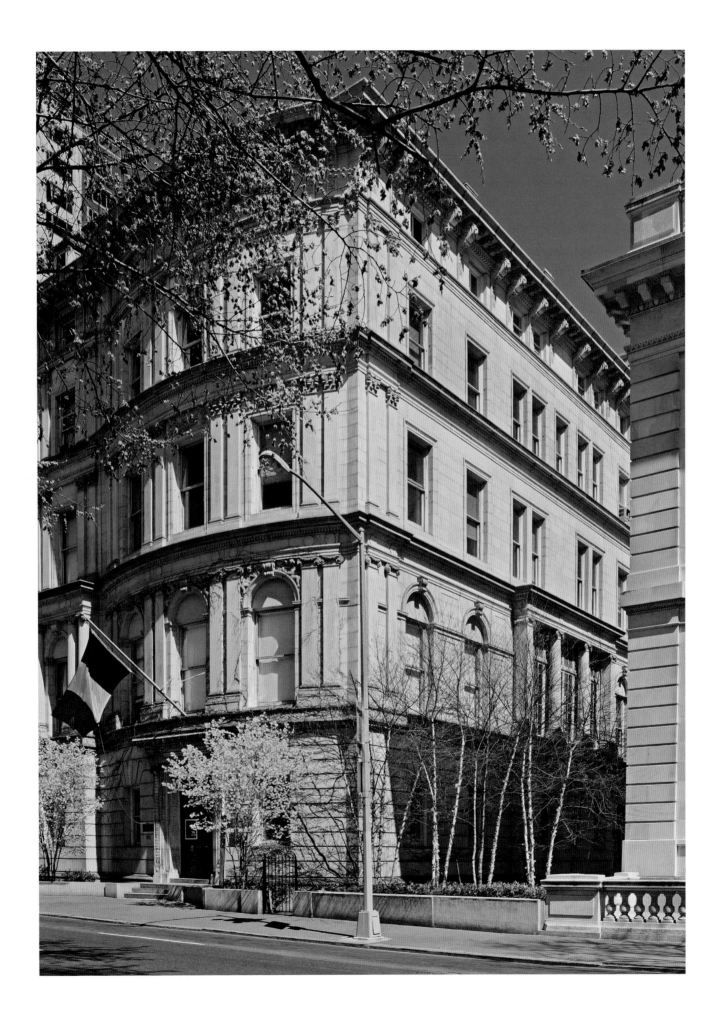

Washingtonians invited to the house of Robert Wilson Patterson. An all-white palette of marble slabs and terra cotta angels established the tone on the facades. The interior was revealed through a formal processional sequence of passage and arrival, compression and release. Patterson's guests would proceed from the semiprivate court off Dupont Circle to the reception hall and staircase, ascending to the second-floor ballroom that celebrated their arrival with a gilded confection of mirrored walls and crystal chandeliers.

Both Rosecliff in Newport and the Payne Whitney house in New York reflect that White was at the peak of his abilities, as the master of decoration and the knowledgeable interpreter of precedent. For the entry

The welcoming facade of the Robert Wilson Patterson house established expectations that would be fulfilled by the time guests reached the second-floor ballroom. Wealthy Americans built grand houses in Washington to take advantage of the capital's more accessible social structure.

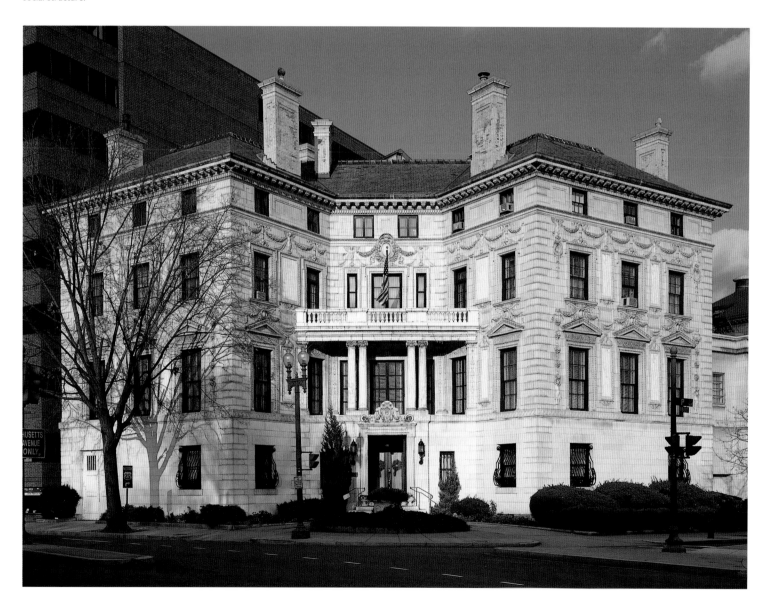

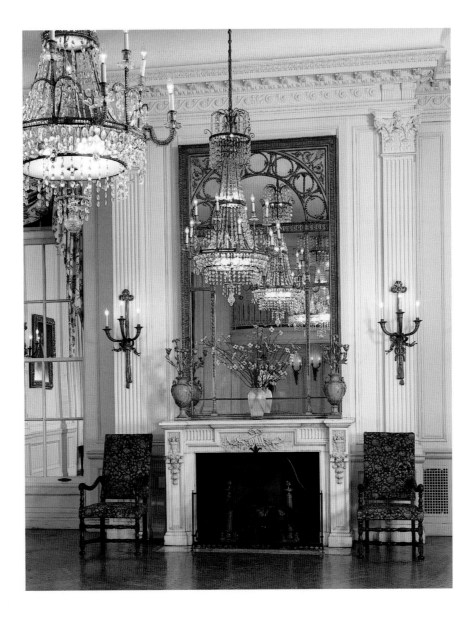

The details of White's interiors were always informed by decorative arts. For the Pattersons' ballroom he drew on the neoclassical idiom of the chandeliers for the mirror over the mantel.

hall in New York he was inspired by the Villa Giulia, a papal summer retreat. In Newport he evoked the absolute power of Louis XIV by adapting the Grand Trianon to a white palace by the sea.

Katherine Duer Mackay, wife of Clarence Mackay, an heir to the Comstock Lode fortune, identified as her paradigm the Chateau de Maisons, a mass of pure intimidation completed in 1650 for a well-placed member of the French nobility. With an enormous budget and three years of hard work, White was able to transform Francois Mansart's baroque monument into Mrs. Mackay's country seat overlooking Long Island Sound, but the visual and written record suggests that the whole enterprise was more to her taste than to his.

Overleaf
Rosecliff confirms White's ability to translate the operational and psychological essence of his client's program into architecture.

François Mansart's Chateau de Maisons was the inspiration for Harbor Hill. Both Harbor Hill and Rosecliff were built with profits from the same silver mine.

White's learned adaptations of historical styles could be realized with considerably less drama than Harbor Hill or Rosecliff. Sherrewogue, the country seat of his brother-in-law Devereux Emmett, was an enlargement of an early-nineteenth-century farmhouse. Showing the greatest respect for the vernacular idiom of the original, White extended the structure to create the main living room, a waterside porch, and bedrooms above, giving the house the character of a Georgian country seat of modest stature. White enclosed the property with a fence and gates worthy of a Charleston estate. A similar pair of gates frames the entrance to the Orchard, the Southampton house of his close friend James L. Breese. Like Sherrewogue and White's own country house, the Orchard was a skillful expansion of a nineteenth-century cottage. Its plan replicates an extended Palladian villa. Trellised hyphens link white clapboard pavilions that enclose a rose garden, establishing a modest and distinctly regional grandeur and creating a great country house assembled from the simplest of elements.

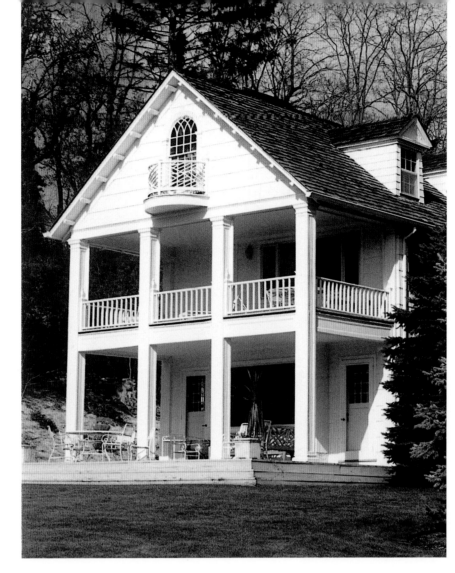

At Sherrewogue, White doubled the length of a small nineteenth-century farmhouse. The two-story porch recalls one of White's unbuilt schemes for Box Hill.

White designed the portico that transformed a nineteenth-century cottage into an homage to Mount Vernon for James L. Breese. The slender proportions of the columns contrast with the unusually wide spacing of the painted cypress shingles covering the walls.

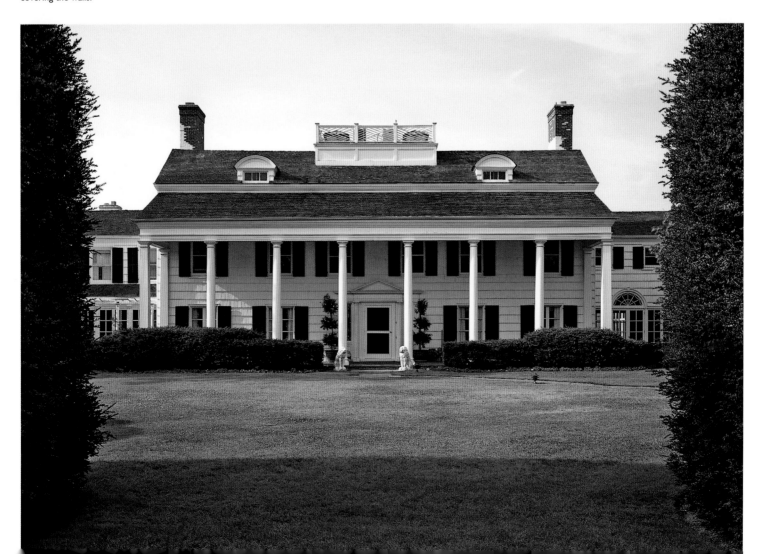

Crisp masonry openings and restrained ornament characterize Charles Dana Gibson's town house. The center arch and sidelights on the parlor floor form a highly abstracted Palladian window, topped by a solitary keystone.

For the illustrator Charles Dana Gibson, White created a town house with a street facade based on chaste federal prototypes. The palette was restricted to white marble, brick, and iron trim, plus double-hung windows with divided lights. Light entered the *piano nobile* through a three-part Palladian window, enlarged to monumental size and severely abstracted. The facade of White's town house for publisher Joseph Pulitzer—a synthesis of the details from two Venetian palazzi by Baldassarre Longhena—is equally learned but considerably less abstracted or restrained.

Many New York City commissions were renovations to existing town houses. The original structures were typical row houses, built with the

The implied canal entrance of the Venetian palazzo for Joseph Pulitzer is only two blocks west of Gibson's federal revival porch. The evolving streetscape of New York could absorb both images.

high stoops that the early Dutch settlers developed to separate service spaces on the ground floor from living rooms above. The stoop was an effective strategy for internal zoning, but it compromised the parlor floor with proximity to the front door and its choreography of entrance and departure. White's favored approach was to remove the stoop, relocating the entrance (including the powder room, coat closets, and waiting rooms) to the basement and dedicating the *piano nobile* to formal entertainment. Because he had to work within the constraints of the existing floor levels, White used the low ceilings of the basement entry as a foil to the more generously proportioned rooms above, into which he could place furniture and fittings originally scaled to the palaces of Europe. White employed this strategy with his 1886 renovation of the Abram Hewitt house at 9 Lexington Avenue and continued to rely on it throughout his career, including on projects within a radius of a few blocks: his transformation of Edwin Booth's Gramercy Park town house into the Players Club; the house for Thomas Clarke at 22 East Thirty-fifth Street; and his ambitious combination of two town houses for Henry William Poor. Poor's house sat directly across Lexington Avenue from the town house at 121 East Twenty-first Street, which White had de-stooped for himself one year earlier.

Stanford White never stopped designing houses. Papers left on his desk at the time of his death included a rough scribble for an unidentified residential project, accompanied by preliminary calculations of area, volume, and cost. That year he was completing the town house for Payne Whitney, altering an existing town house at 32 West Fifty-second Street for Philip Lydig, and beginning to design a new city residence for Mrs. William K. Vanderbilt Jr. Her house at 666 Fifth Avenue, completed after White's death, would employ the same idiom as the Loire Valley chateau one block to the south that Richard Morris Hunt created for that lady's fearsome mother-in-law, Alva Smith Vanderbilt. White's deference to Alva's house was highly appropriate. Hunt, acknowledged as the dean of American architects, was the first to adapt the palaces of the European aristocracy to satisfy the self-esteem of America's emerging class of wealthy industrialists. In their separate fashions, both Charles

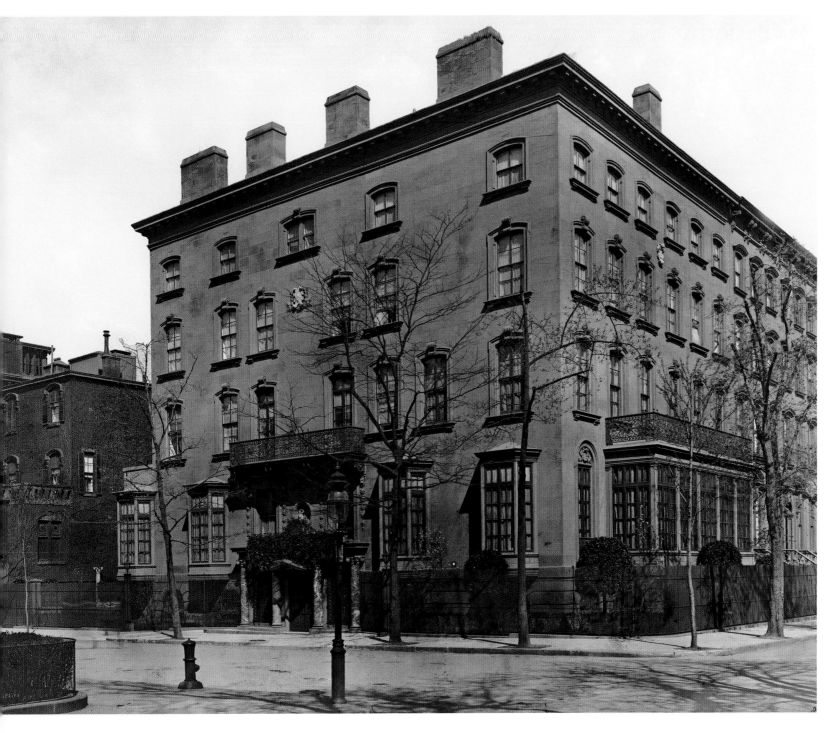

White removed the stoops from two town houses to give Henry Poor a double-width bay overlooking Gramercy Park. White's own house was directly across Lexington Avenue behind the low fence on the left.

Museum of the City of New York

McKim and Stanford White were Hunt's heirs. McKim would eventually be seen as the dean of American architects, largely on the basis of his institutional designs. By focusing so much of his exceptional energy, imagination, and artistry to realize the more personal ambitions of his wealthy clients, Stanford White created some of the most beautiful houses in America.

ALDEN VILLA

CORNWALL, PENNSYLVANIA

1880–84

*T*HE COMMISSION from Robert Percy Alden arrived in 1880 through McKim's connections. In early 1879 the partnership of McKim, Mead & Bigelow began to design Fort Hill, a rambling villa on Lloyd Neck on the north shore of Long Island, for Percy's mother, Anna Coleman Alden. That project may have come to McKim through his New York City landlord, who was Mrs. Alden's son-in-law. The Coleman-Alden family may have preferred New York City, but their money came from iron mines in central Pennsylvania. Following his marriage, Percy Alden decided to build a new family seat complete with manor house, barns, and superintendent's cottage on a plateau in Cornwall, just within view of his profitable smokestacks.

Possibly because he was the junior partner, Stanford White was assigned the trips to site, and he may have worked out the design during long train rides back to New York. The massing of the main house is quite different from the young firm's more representative shingle-style work of the period and much closer to White's designs in the Queen Anne style under Richardson, particularly the unbuilt house for James Cheney. Details of the elevations relate closely to White's European travel sketches as well as to his contributions to the firm's shingle-style vocabulary, including half-timbering, decorative shingle patterns, lattice screens, delicate iron finials, stained-glass windows, and sgraffito panels. Other details demonstrate the role of observation in invention. The elaborate concave door surround at the living room may have been based on a federal house near Gramercy Park that was

Tight eaves, simple crown moldings, and inventive shingle patterns characterize the firm's earliest work. White's personal vocabulary included decorative reliefs such as the wreaths at the peak and the nearly invisible date of construction just below.

Candlesnuffer tower roofs, effervescent metal crestings, Tudor chimneys, and scalloped shingles reappear throughout the early designs, but the muscular flex of the porch columns is unique to Alden Villa.

The lattice arch encloses an outdoor bench and two floors of service windows while contrasting walls of half timbering, waves of shingles, and simple clapboard are organized by the high stone base.

reproduced in *The Century Magazine*. The lopsided overhang that creates a particularly interesting asymmetry on the east elevation may have been inspired by vernacular Pennsylvania icehouses.

Within the house, the area devoted to formal circulation is exceptionally compact, particularly the entry sequence. The Dutch door at one side of the porte cochere opens into an entry hall that doubles as circulation to the dining, living, and drawing rooms. Nonetheless the small space delivers a substantial punch. Walls of pulvinated bead board rise from a tall, unadorned base to support a broad frieze carved with sunflowers and tight geometric patterns. Daylight from stained glass placed high in the stairwell is filtered through *mashrabia* screens and supplemented by hanging mosque lamps in exotic colors. The entry ceiling is finished in gold leaf overlaid with wood battens in a pattern that White might have based on plate 143 of J. Bourgoin's *Les Elements de l'art arab*, published in Paris in 1879.

The interiors of Alden Villa introduce almost every decorative detail that would reappear in the firm's early designs, including fireplaces with inglenooks; panels of checkerboard marquetry; rattan wall covering; reeded moldings painted in ivory paint flecked with gold; and colonial- and federal-inspired cabinetwork that is part furniture, part architecture, and animated with the brass tendrils of exotic hardware. The ceiling of the dining room was covered with dried fishnet, a detail White employed in the Samuel Tilton house in Newport at about the same time.

In place of the omnidirectional living hall with its easy flow of space, the plan set up a more axial sequence of events. Movement through the house has a taut, spring-loaded quality, an early manifestation of White's interest in processional architecture. White also replaced the shingle style's constraining horizontal planes with a dramatic section, culminating in the three-story, barrel-vaulted living room, the gable end of which recalled his sketches of medieval architecture at the same time that it anticipated the drama of modern glazing.

The compact entrance hall is an encyclopedia of White's interior design vocabulary of the period.

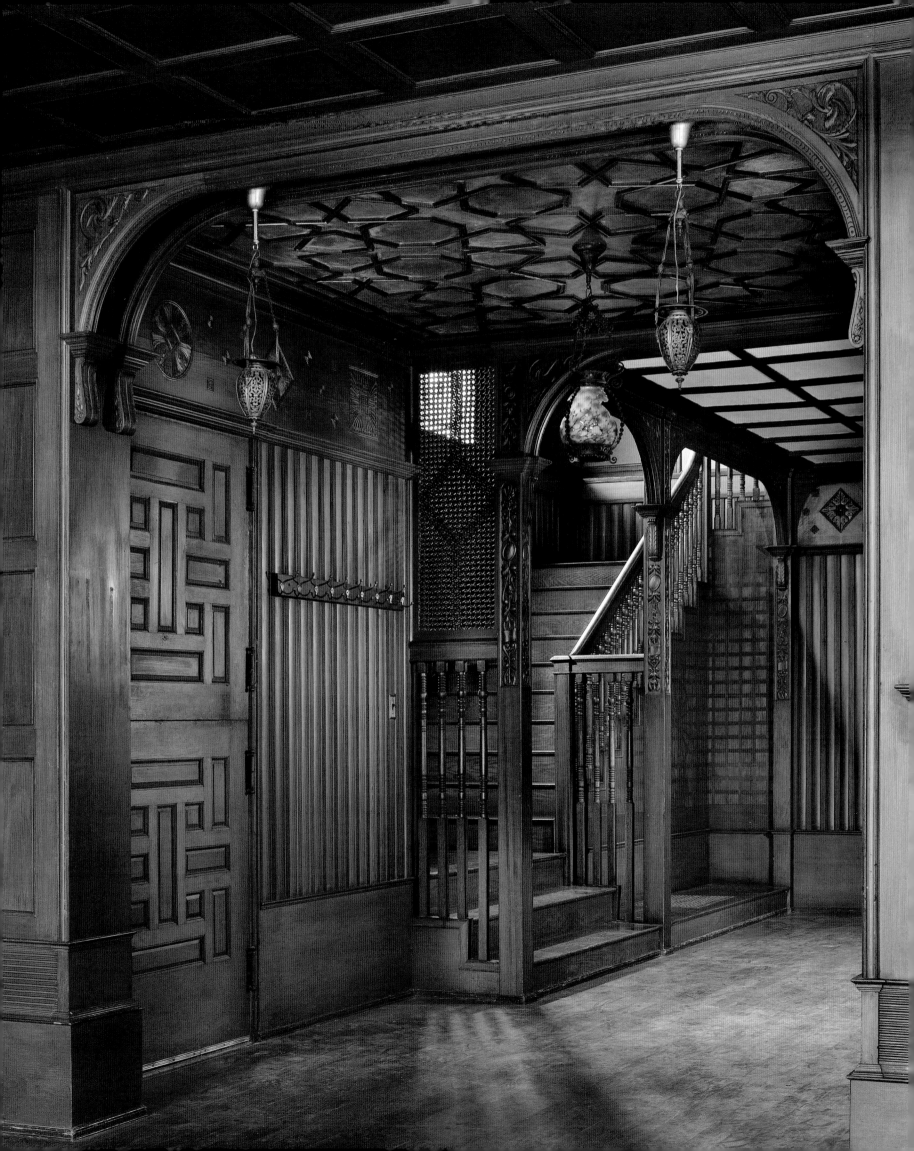

Third Floor

Details on top of details include shells on a bracket supporting the living room balcony, gold on the ceiling of the entry hall, and every component of the main staircase. All millwork was furnished by J. A. Skinner, the general contractor for the house.

Second Floor

First Floor

On the plan, the double-height living room is on the right. Guests entered through the porte cochere at the center of the house or directly from the garden.

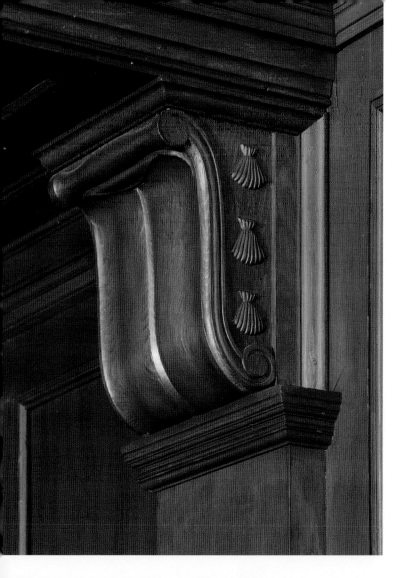

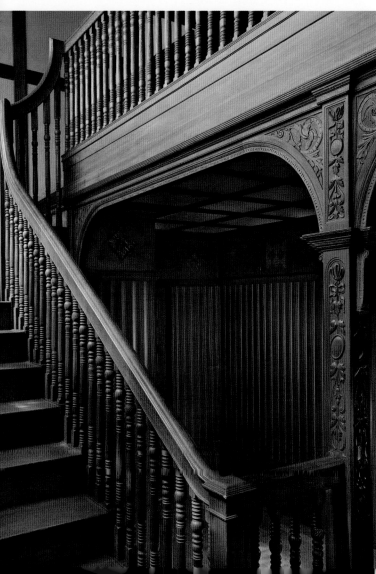

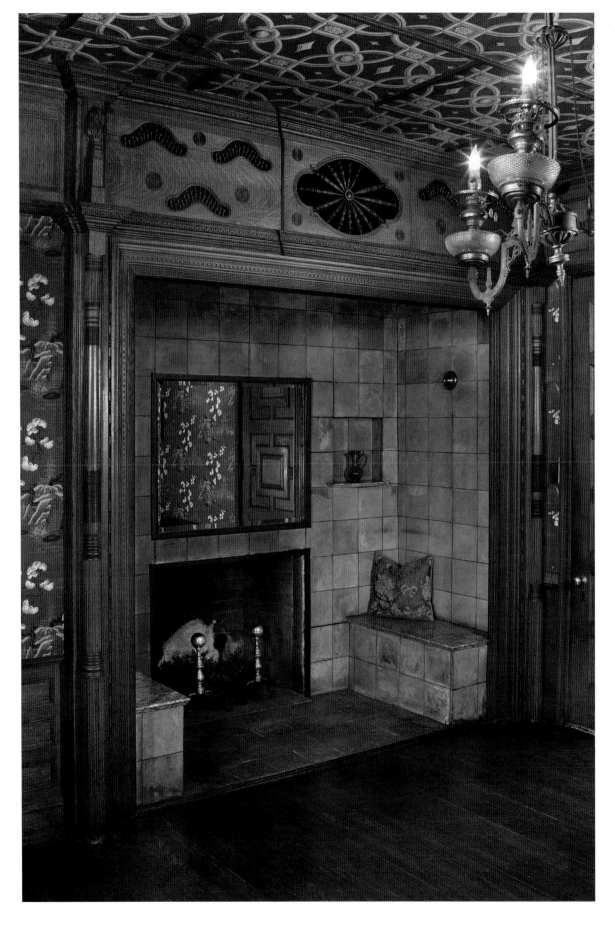

Light from windows concealed in the chimney illuminated wood screens over the library inglenook. Details of the mantel and seats relate to White's contemporary fireplace design in the library of the Seventh Regiment Armory.

Both the impact and coherence of the two-story living room are established by the huge studio window of leaded glass, the monumental chimneypiece, and the barrel-vaulted ceiling. The decorative treatment of the walls consists of remarkably dissimilar horizontal layers, including the slightly coved panel of Lincrusta at mid-height.

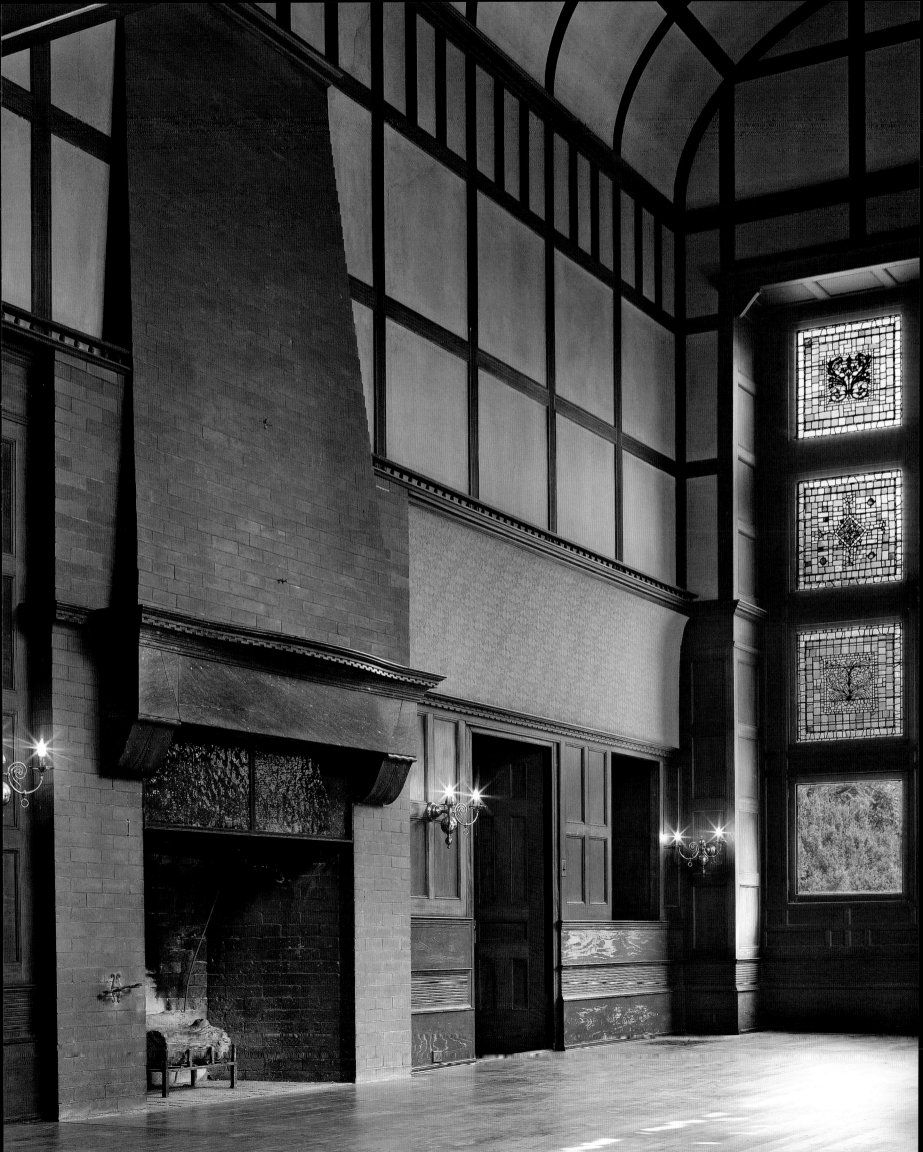

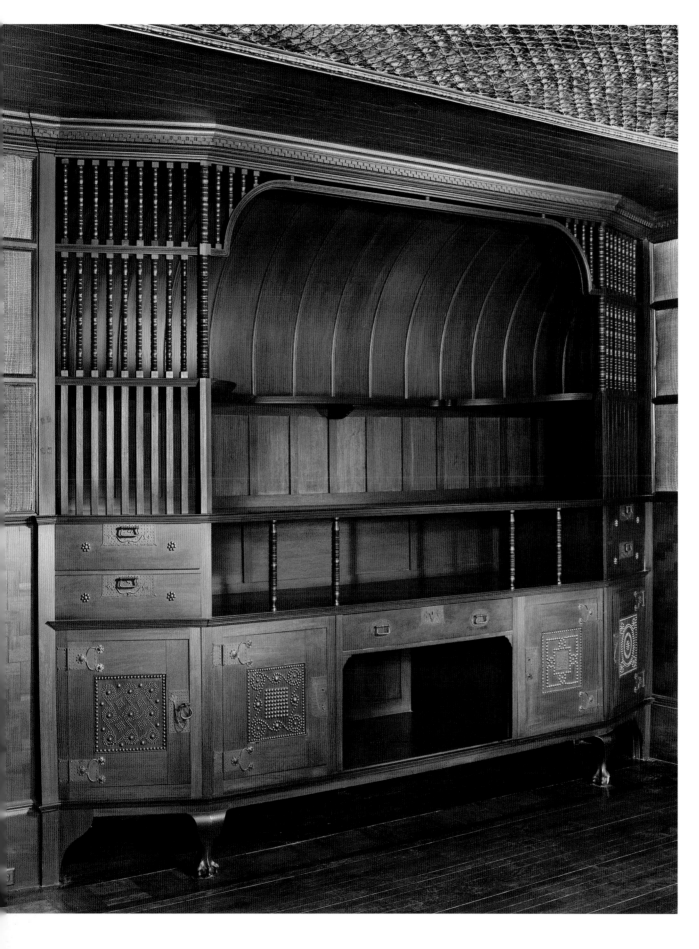

Many of White's early dining rooms featured dowelled screens, patterns of upholstery tacks, panels of woven cane, exotic hardware, and a built-in sideboard with ball-and-claw feet. Fishnet glued to the ceiling was also used at the Tilton house, but it survives only at Alden Villa.

The compact character and contrasting scale of the Villa's plan is apparent in this view. A compressed niche separates the entry hall from the painted drawing room, which is in turn separated from the dining room by a sliding pocket door.

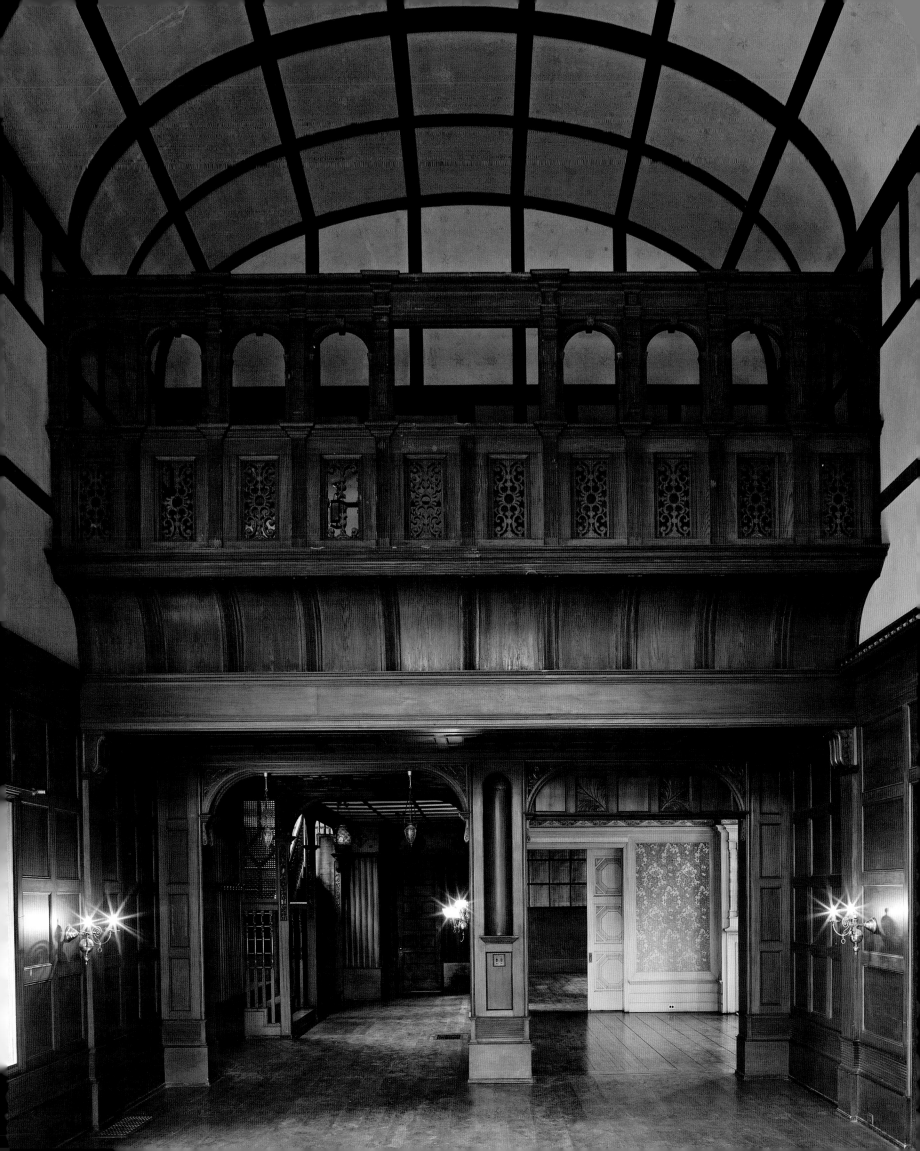

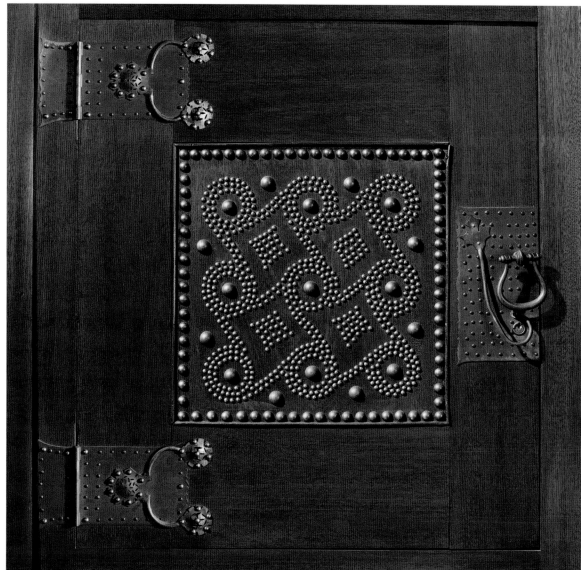

Inventive patterns were an integral component of White's early designs, including the gold stenciling on the wall (above). Cabinet hinges and nail heads decorate the sideboard (below).

White's taste for graphic ornament included the exteriors of his early houses. At Alden Villa a collage of painted wood leaves and nuggets of anthracite overlooks the north lawn (below). White himself may have applied the broken glass and colored pebbles to the stucco panel on the south facade (above).

ISAAC BELL HOUSE

NEWPORT, RHODE ISLAND

1881–83

*T*HE ISAAC BELL house illustrates Stanford White's role within the close collaborations that characterized the partnership's early work, particularly their houses in the shingle style. McKim's houses before 1879 reveal many of the individual elements of that vocabulary, but it was not until White joined the partnership that the ingredients fused into a vibrant whole.

White's contributions to the exterior of the Bell house include the decorative vignettes that animate McKim's highly stable collage of simple geometries. To White's imagination we can attribute the combination of bamboo columns with leaf-spring capitals, the hanging globe that marks the entrance as well as the benign sea-monster brackets that frame it, the waves of tightly wrapped shingles that even encase the pole emerging from the cap of the engaged tower, and the brick chimney tops reminiscent of dovecotes.

McKim and Mead had been principally attracted to White on account of his strength with interiors. White made Bell's living hall the decorative heart of the house, beginning with the chestnut inglenook that he assembled from fragments of French provincial furniture. The backs of the panels were covered with foil to reflect light, introduced directly to the inglenook through small openings with cut-glass panes and indirectly through the oversized leaded-glass window at the landing of the stair. The dark wood of the inglenook established a foil to the lighter natural finish of the vertical boards, which were milled with a unique profile and used to clad the lower walls of the living hall and stairway. Other finishes and details that were unusual for the time but typical of White's early vocabulary included the rattan wall covering in the dining room, which was divided by strips of wood

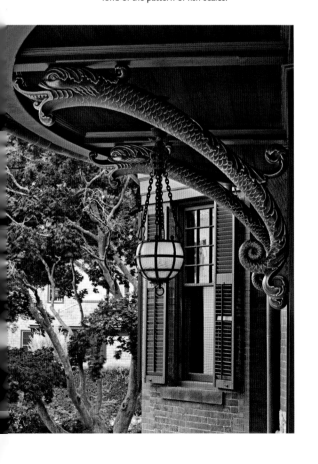

Fantastic creatures support the roof at the entrance to the porch. White was particularly fond of the pattern of fish scales.

Bamboo columns supporting the porch, glass panes the size of shingles, and a medieval English rainwater collector testify to White's love of texture, juxtaposition, and surprise. At the same time, the Bell house displays McKim's taste for balanced asymmetry, taut surfaces, and eighteenth-century colonial details.

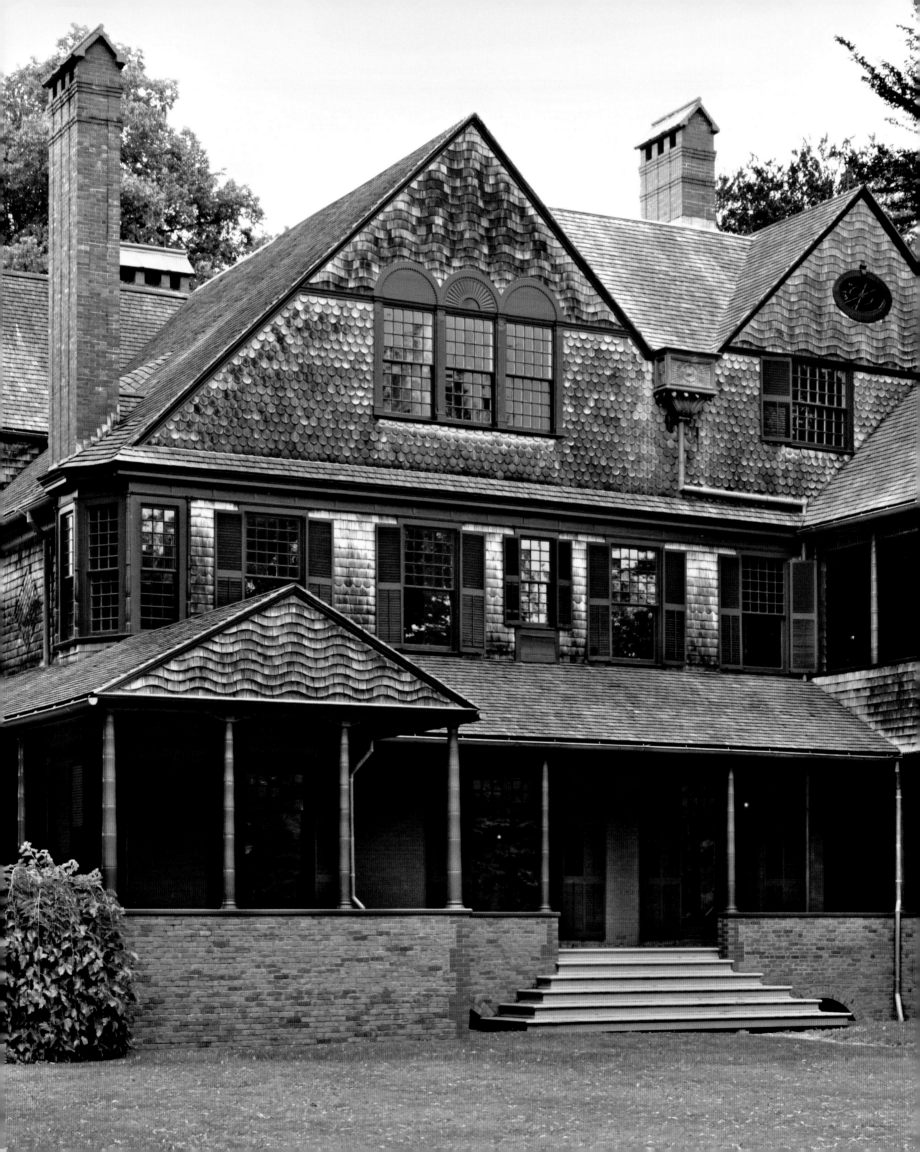

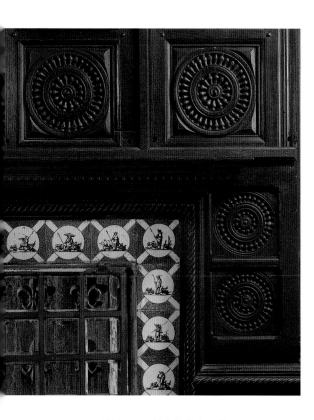

White assembled the inglenook from elements of medieval French furniture, Dutch tiles, and beveled glass. Originally silver foil behind the circular beaded panels reflected light back into the room.

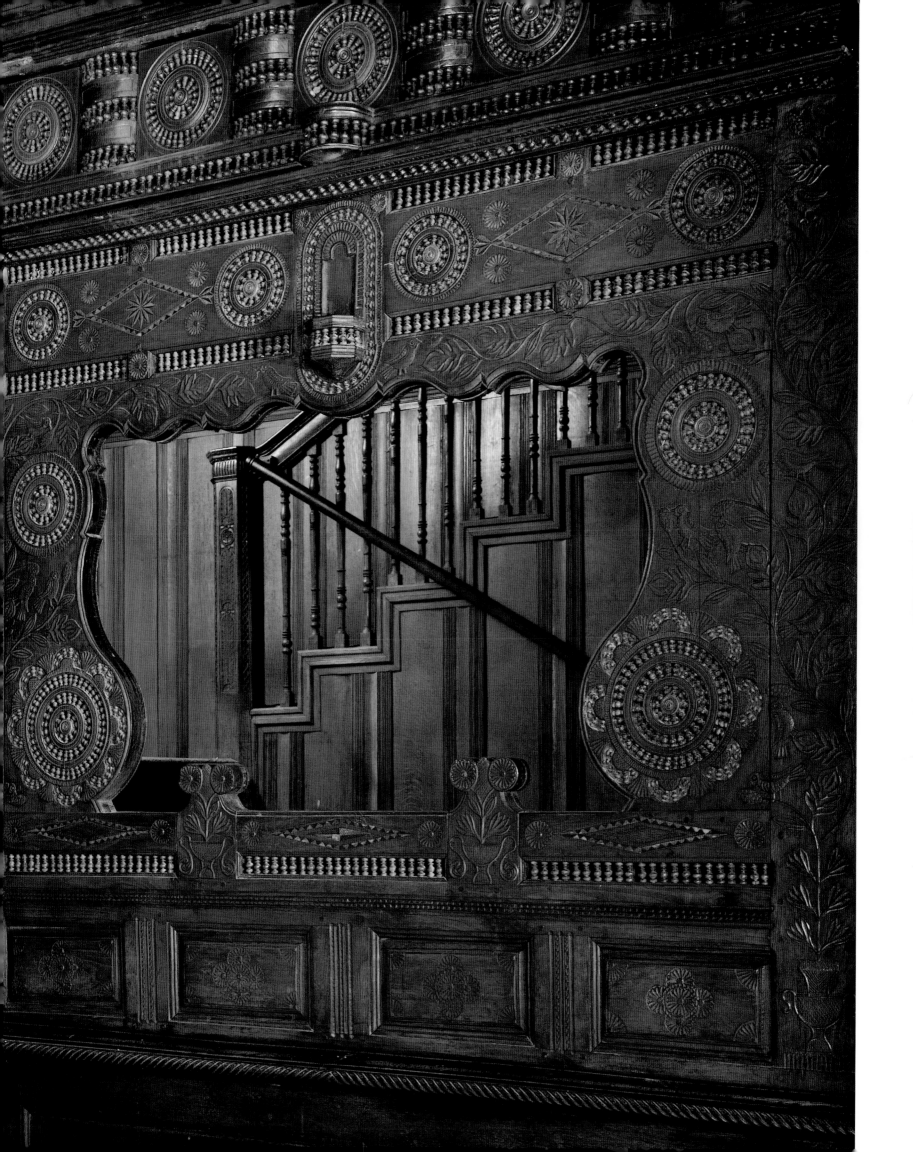

into panels that surrounded medallions created from the pierced copper lids of bed-warming pans.

Other decorative motifs reflected the larger context of the aesthetic movement, particularly the taste for Japonism. The oversized sliding doors to the drawing room may have been a reference to the Japanese pavilion of the 1876 Centennial Exposition, a connection that was further suggested by the chrysanthemum motif stamped on the hardware. The pavilion and contemporary publications illustrating Japanese architecture introduced observant Americans to new concepts of interconnecting space, varieties of screening devices, and a decorative motif called a "kamoi" that organized interior elevations around a continuous datum set a few feet below the ceiling. Every one of these strategies appears in the Isaac Bell house.

White also specified more conventional decorative materials. Through his exposure to leading decorators such as Herter Brothers, he was familiar with French and English fabrics and wallpapers. The upper walls of Bell's living hall featured an embossed paper in simulated gilt leather manufactured in England. The walls of the drawing room were upholstered in pale green watered silk, which complemented the pale ivory ceiling and picked up on the sprinkles of gold dust embedded in the plaster. The adjacent waiting room was finished in a pale stencil pattern that repeated the ivory and gold palette.

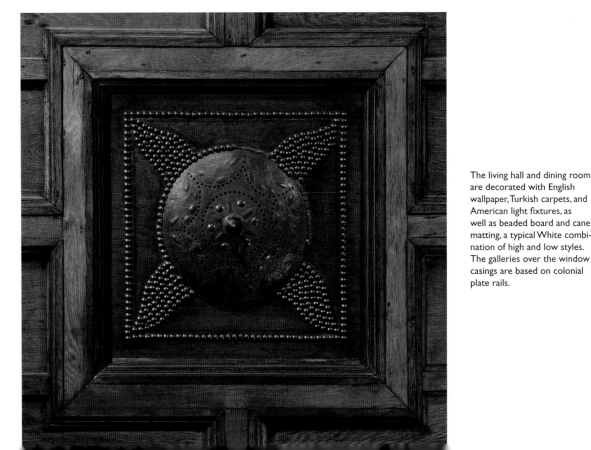

The central element in the wood-paneled ceiling of the living hall may have originally been the lid of a colonial bed-warming pan.

The living hall and dining room are decorated with English wallpaper, Turkish carpets, and American light fixtures, as well as beaded board and cane matting, a typical White combination of high and low styles. The galleries over the window casings are based on colonial plate rails.

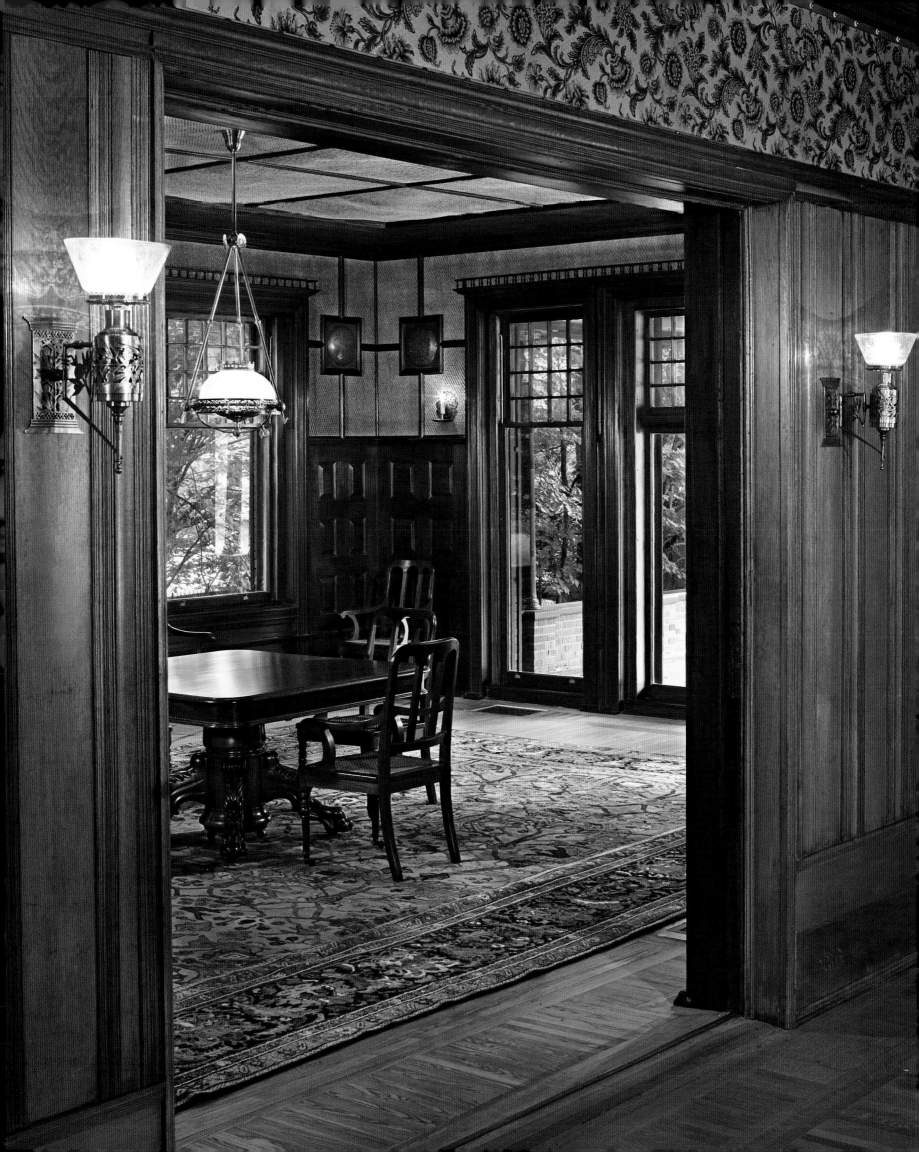

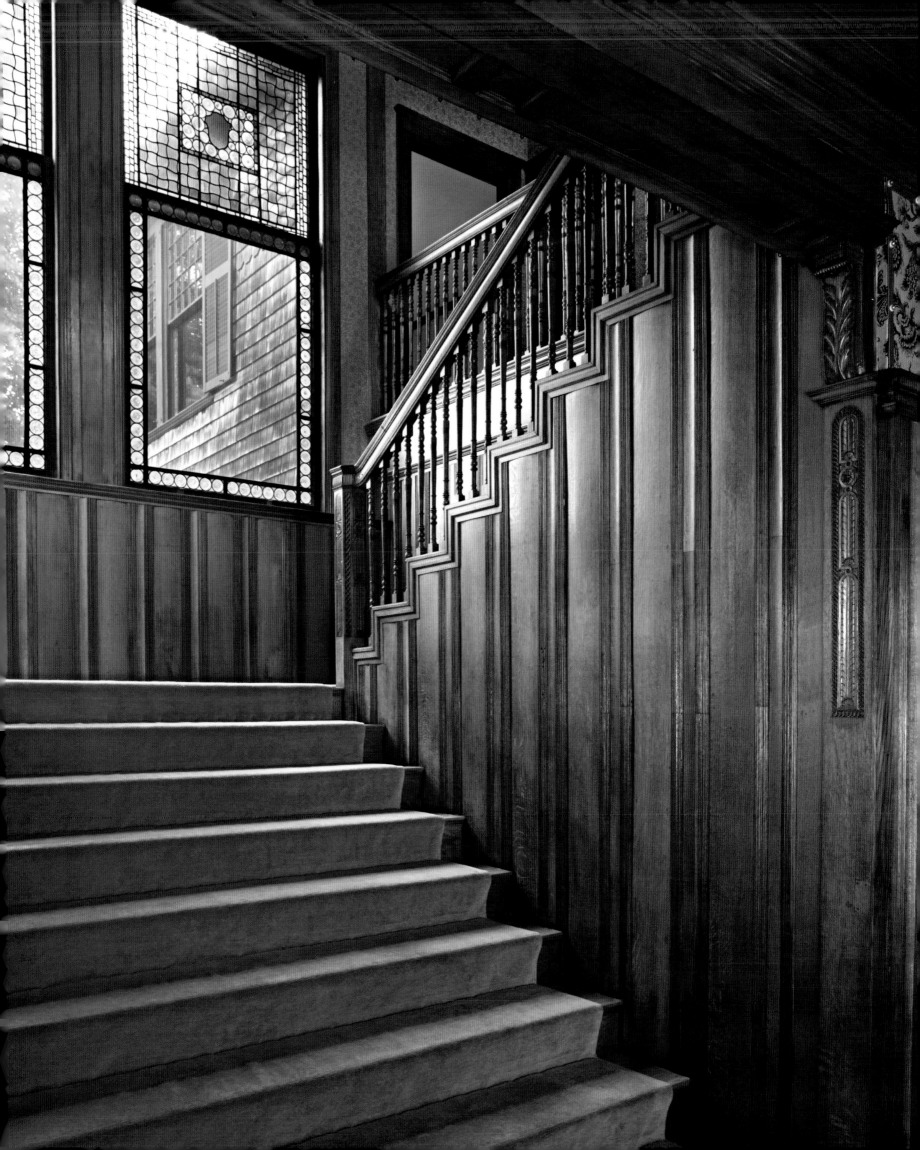

The overscaled beaded board and sinuous leading of the stained glass introduce vertical thrust and animation to the stair hall. The abstract zigzag of treads and risers appears in staircases throughout White's portfolio.

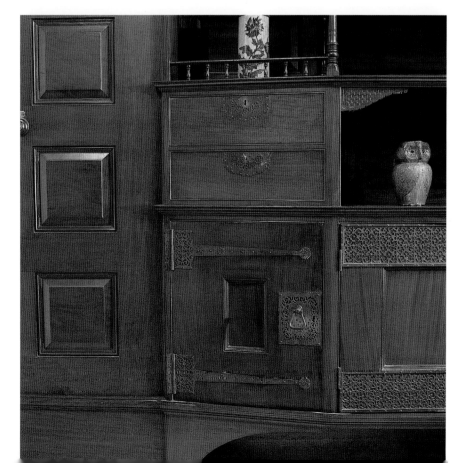

McKim's appreciation for traditional Georgian cabinet-work was transformed by White's taste for imaginative combinations, as seen in details from the mantel in the parlor (above), and the dining room sideboard (below).

GARRETT-JACOBS HOUSE

BALTIMORE, MARYLAND

1883–87

*I*N 1872 John Work Garrett bought a four-story 1860 brownstone at 11 Mount Vernon Place. The house was probably a wedding present for his son, Robert, who had just married Mary Sloan Frick, the daughter of an equally distinguished Baltimore family.

Ten years later the younger Garretts bought the town house next door and hired Stanford White to combine them. With her husband managing the family businesses, Mary Frick Garrett would manage the architect. Known in the newspapers as "the Mrs. Astor of Baltimore," Mrs. Garrett may have had unerring social instincts, but she was less sure of herself in the role of client. The design took years to construct and entailed numerous changes, for which Mrs. Garrett was not always willing to pay.

The interiors reflected a wide range of styles. Within a few steps of the front door, visitors were transported from the mosaics of Pompeii past the baronial halls of Tudor England to the helical staircase of Blois. Mrs. Garrett could survey the entry hall from her lookout on the second floor, concealed behind a decorative wooden screen patterned on Moroccan *mashrabia*. Lavish materials were furnished by the same New York artists and craftsmen who had collaborated on Henry Villard's house. Herter Brothers fabricated an oak stair, the mosaics came from the firm of Pasquali & Aeschlimann, W. H. Jackson supplied the fireplaces, Joseph Cabus made the doors, the gas lights came from Archer & Pancost, and Allard provided the furniture. White's friend, Thomas Wilmer Dewing, painted the frieze in the drawing room. James S. Ingle's Jacobean woodwork in the dining room must have been a specific request from the client.

Joseph Morrill Wells probably assisted White on the exterior. The elegance and restraint of the cornices, stringcourses, window surrounds, and other enrichments testify to a distinct preference for Italian Renaissance details—quite different from the more inventive idiom of the nearby Ross

Details in the vestibule include a classical bench and rope mold column bases. White specified the same Siena marble in the Villard house and used the same mosaic contractor for both houses.

Contemporary critics admired the restrained elegance of the brownstone facade, but neighbors objected to the porch's projection beyond the building line.

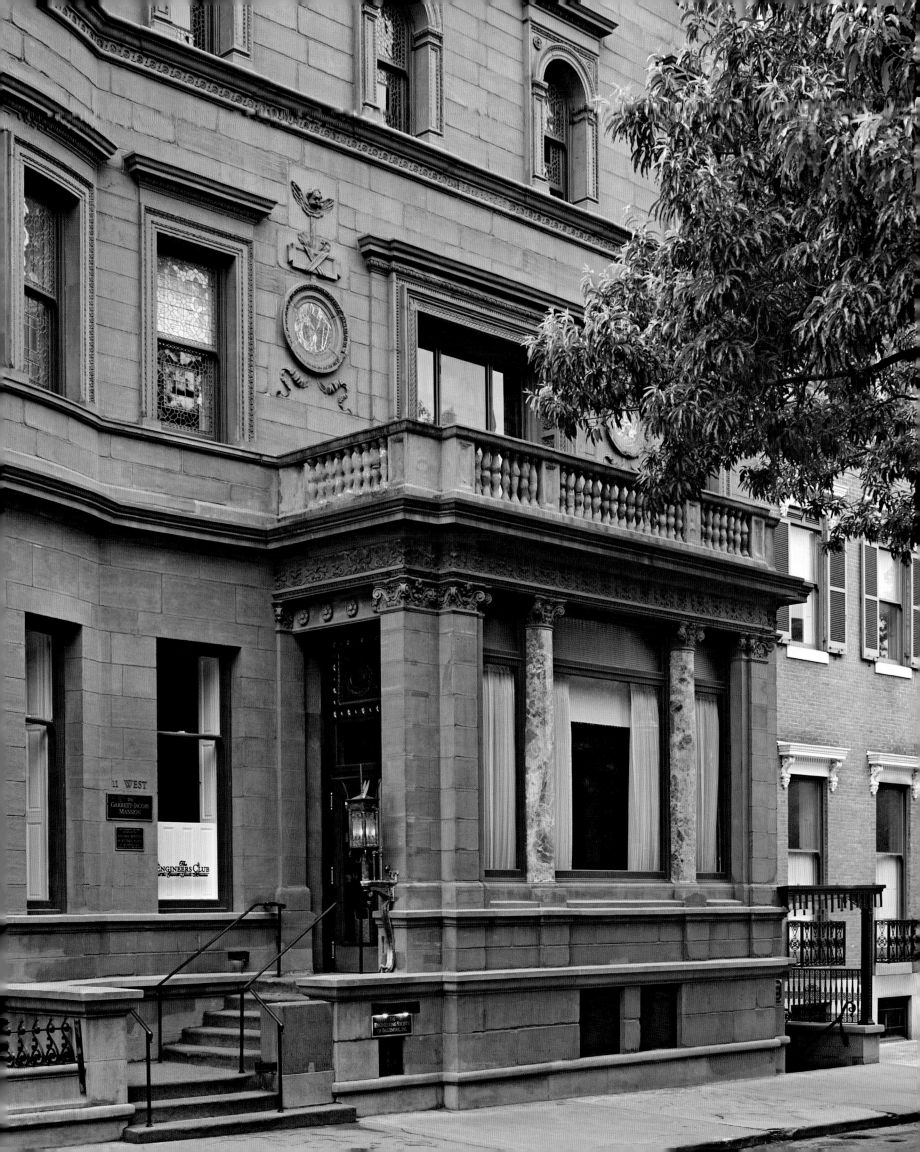

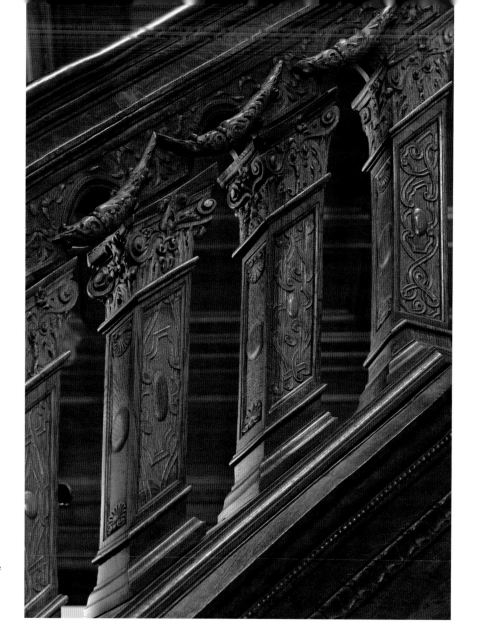

Sea shells and Jacobean strapwork, frequent motifs in White's early interiors, decorate the balusters. Herter Brothers fabricated the current stair as a replacement for White's first design.

Winans house that White had designed two years earlier. Not everyone appreciated the evolution of taste. One neighbor claimed that the Garretts' new one-story porch encroached on his light and air, although he probably objected to the architectural vocabulary that was being imposed on Baltimore's most conservative block. In the course of the lawsuit, several local architects appearing for the Garretts stated that the house exemplified the best style then prevailing in New York.

McKim, Mead & White sent a final bill in March 1887, but in the early 1890s Mrs. Garrett developed a second wind. Her focus was on the double-height entry hall, and Louis C. Tiffany's monumental stained-glass window may date from this campaign. Herter Brothers fabricated a second staircase, this time in mahogany. As with many of White's clients, time lost on indecision was soon forgotten; Mrs. Garrett expected the

The staircase is said to be based on the famous spiral at the Chateau de Blois.

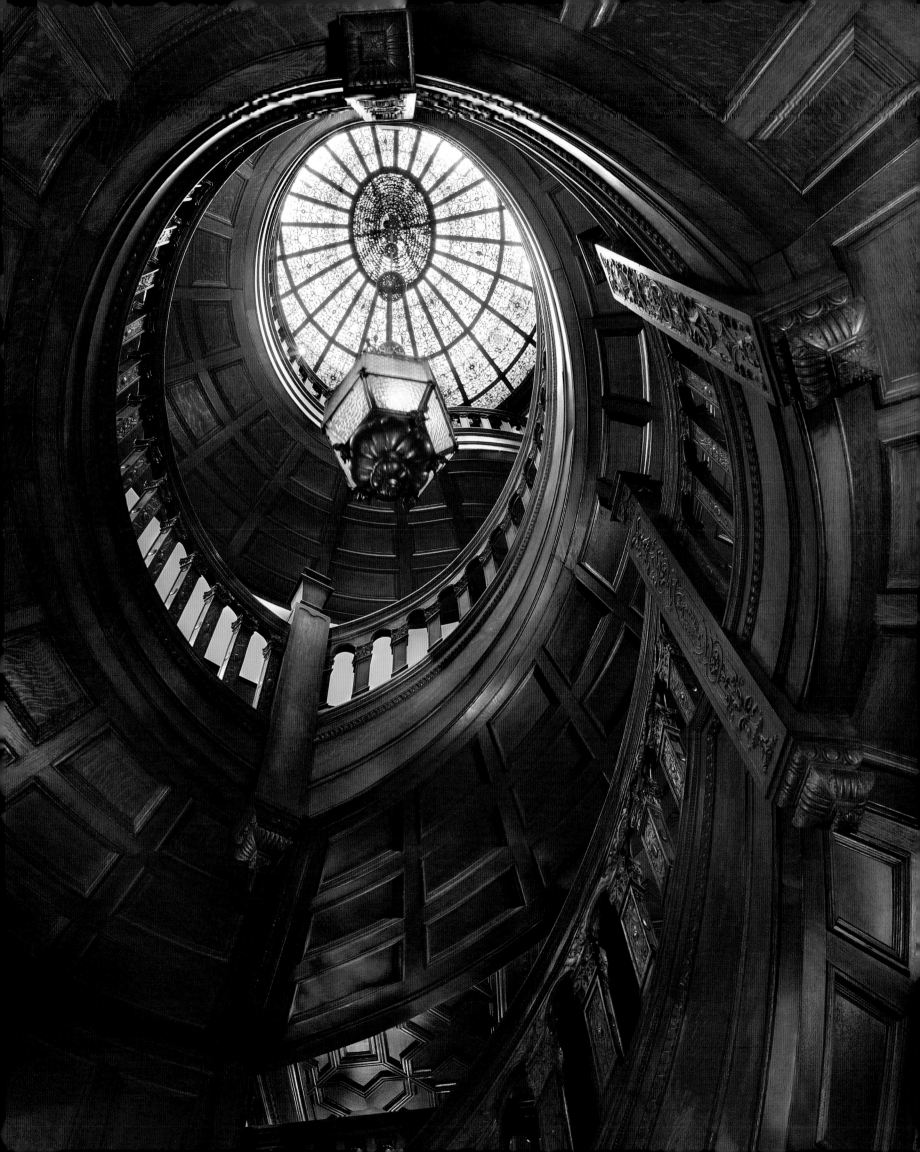

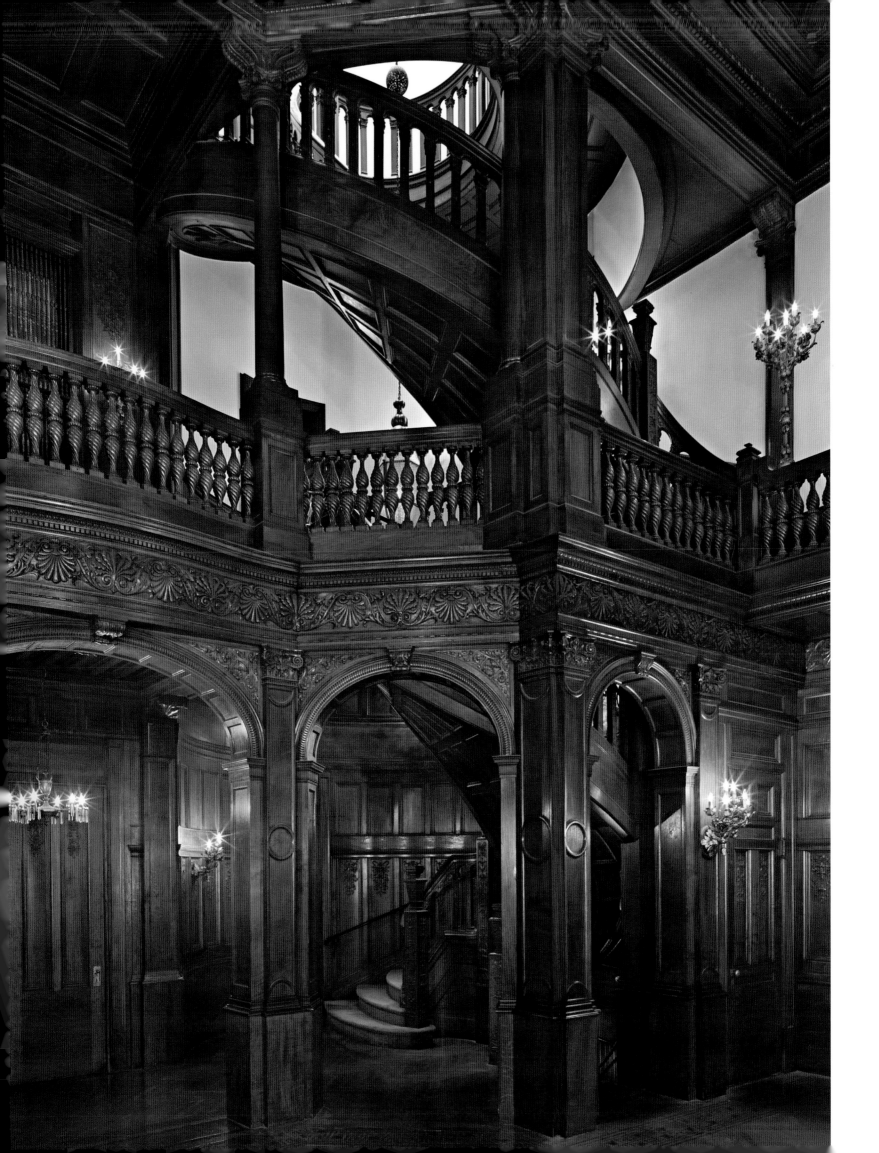

Mrs. Garrett could survey the hall from her second-floor office, located behind the screen on the left.

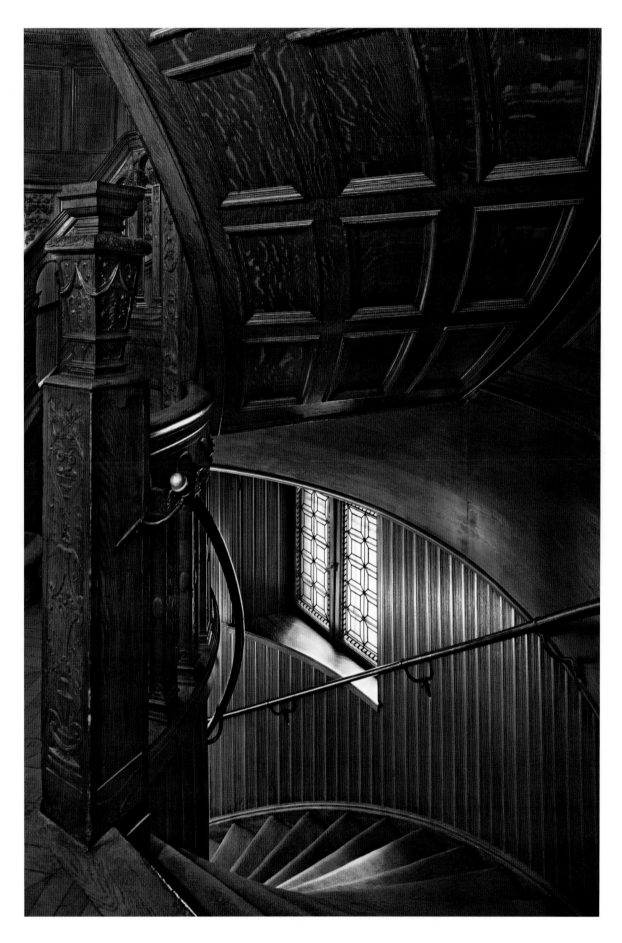

A change from paneling to beaded board signals the transition from the formal precincts of the entry hall to the more discreet stair leading to the gentlemen's cloakroom in the basement.

hall to be ready when she returned from the country. The state of affairs at 11 Mount Vernon Place in November 1892 can be imagined from the letter that White sent to Herter Brothers: "I must insist that you place more men there and drive the work day and night until completion."

Between 1905 and 1916, Mary, who had been widowed and was now married to Barton Jacobs, acquired the properties on either side and expanded her house with John Russell Pope as her architect. Pope's extension of White's facade was highly respectful of the original, while the new interiors reflected a larger and more ritualized social program. By 1905 White may have been too busy for another renovation project, but there is a possibility that he and his former client had simply worn each other out. Years earlier White had left instructions with his office saying that if Mrs. Garrett called she was to be informed that "Mr. White has gone fishing."

Millwork details in the vestibule at basement level demonstrate that service areas can possess exceptional elegance.

Splayed Renaissance benches in the front hall suggest a nominal welcome in the context of an intimidating interior. White's vocabulary of ornamental details combined Greek anthemion in the frieze, Roman arches on Jacobean pilasters, Renaissance relief panels, and baroque balusters.

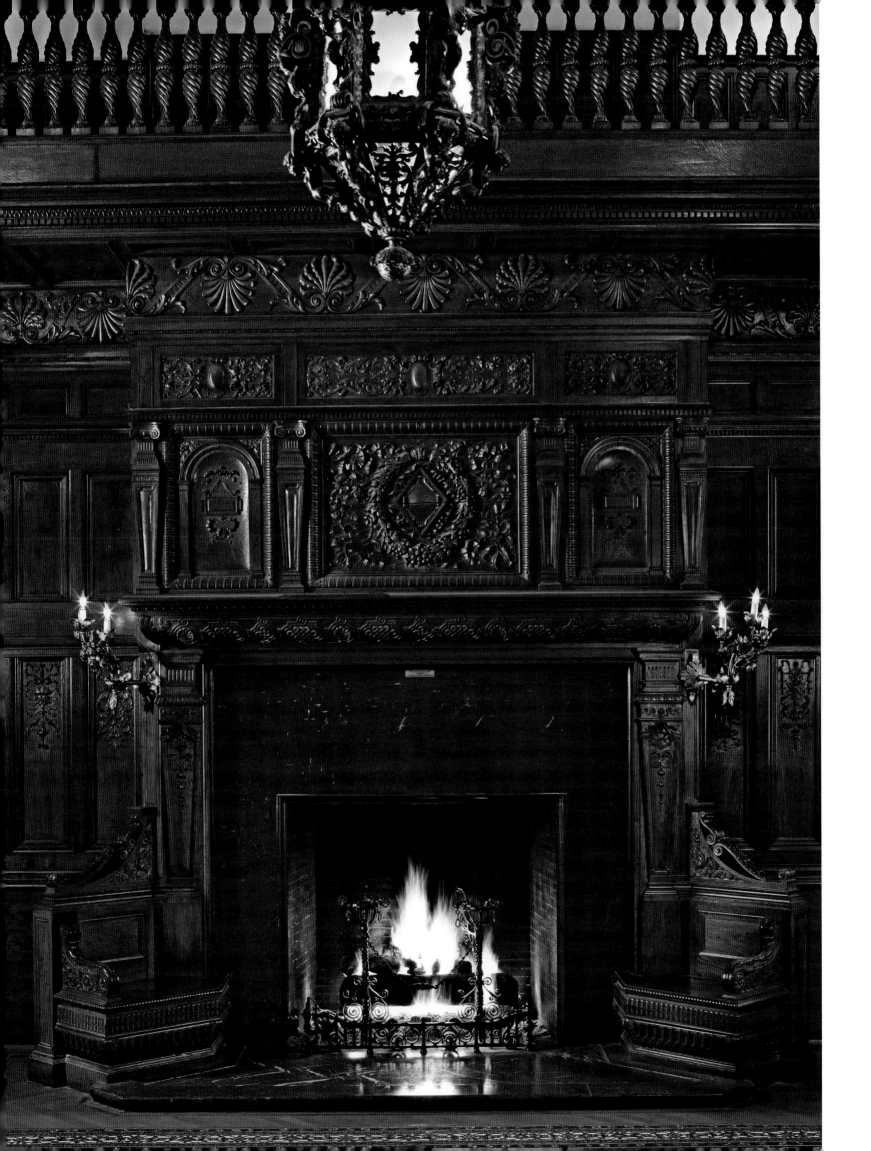

HEAD OF THE HARBOR

MRS. JOSEPH BLOOMFIELD WETHERILL HOUSE

SAINT JAMES, NEW YORK

1894–95

I send you plans of your house and a perspective giving you a fair idea of how it will look. I know of no house like it in this country, although there are some in "Old England," but I feel very certain that it would look well perched up on the hill and of course it would look equally well from all sides.

NOTWITHSTANDING references to "Old England" in his letter of November 13, 1893, Stanford White's design for Head of the Harbor represents a successful resolution of his search for a regional idiom to replace the shingle style, which had become distinctly unfashionable by the late 1880s.

This opportunity was provided by White's sister-in-law Kate Wetherill, widow of the Episcopal minister who married Stanford and Bessie in February 1884. As one of Bessie's eight siblings, Kate received the same inheritance from Cornelia Stewart, and like Bessie and their sister Ella Emmett, Kate transformed a portion of her windfall into waterfront property and a house designed by Stanford White.

The site she selected had more character than utility—the top of a hill with land falling steeply away on all sides. White must have appreciated the drama; his letter suggests that he welcomed the opportunity to design a house in the round. The plan at ground level is a cruciform circumscribed by an octagon; the residual space allows for multiple porches with separate views. The upper floors fill out the octagon, with a steeply pitched gable at each face. This pinwheel is anchored to one side by a service wing.

Exterior walls were clad with uninterrupted courses of square-cut shingles with straight lines replacing the more animated patterns and intricate shapes of the shingle style houses a decade earlier. The design also subdued the rubble masonry of the earlier work. Fieldstone laid up

Head of the Harbor illustrates White's mastery of the shingled colonial revival style. Details from ancient Greece, Renaissance Italy, and Federal America are combined with ordinary shingles and a modern wrap-around porch to create a thoroughly American idiom.

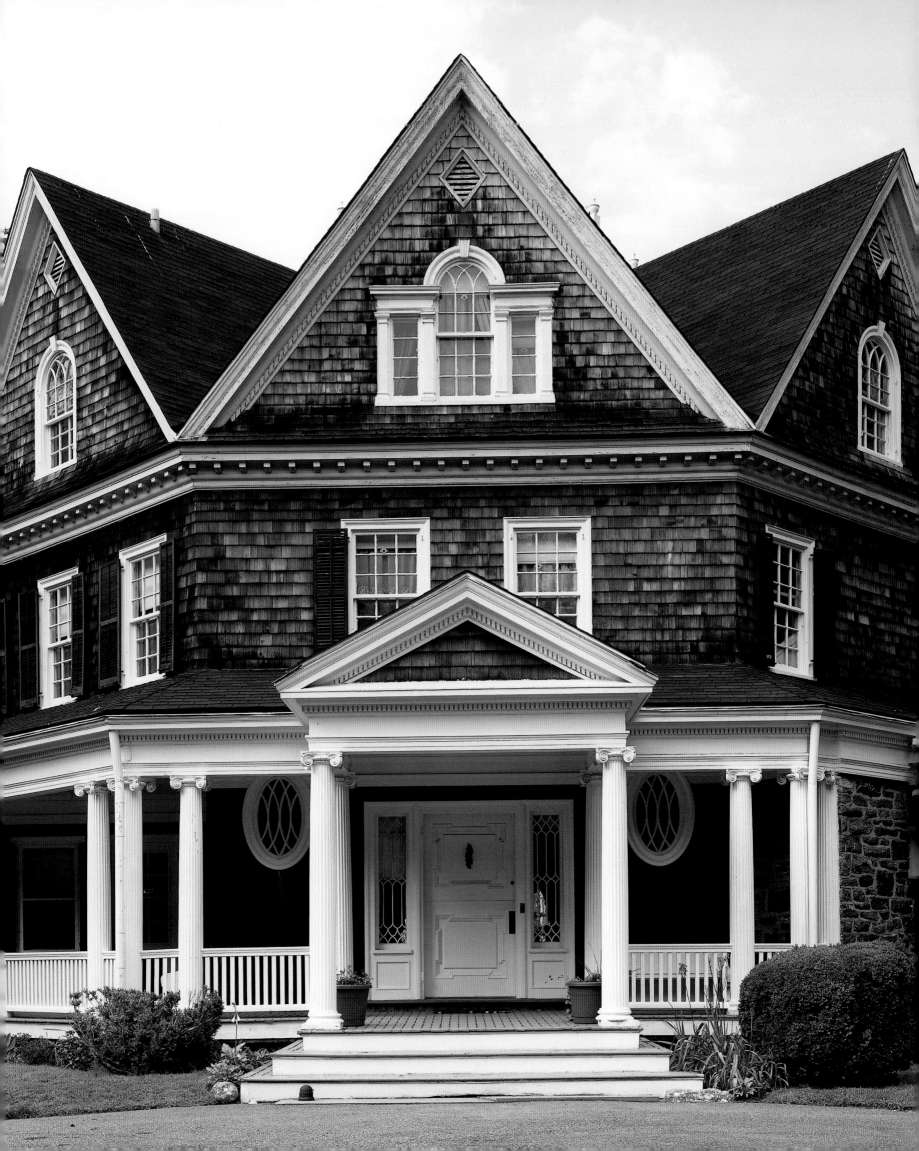

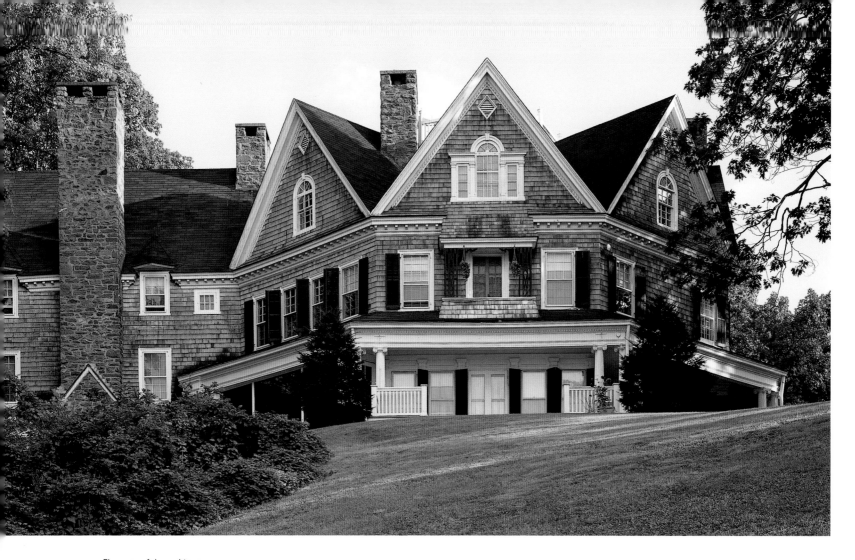

Elements of the architecture
suggest active engagement with
the dramatic site. A second-
floor porch overlooks Stony
Brook Harbor, while a widow's
walk marks the peak of the roof.

Roman Ionic capitals and an
oeil-de-boeuf window suggest
the literacy and cultural
ambition of the architecture.
Perfect proportions establish
the authority of the design.

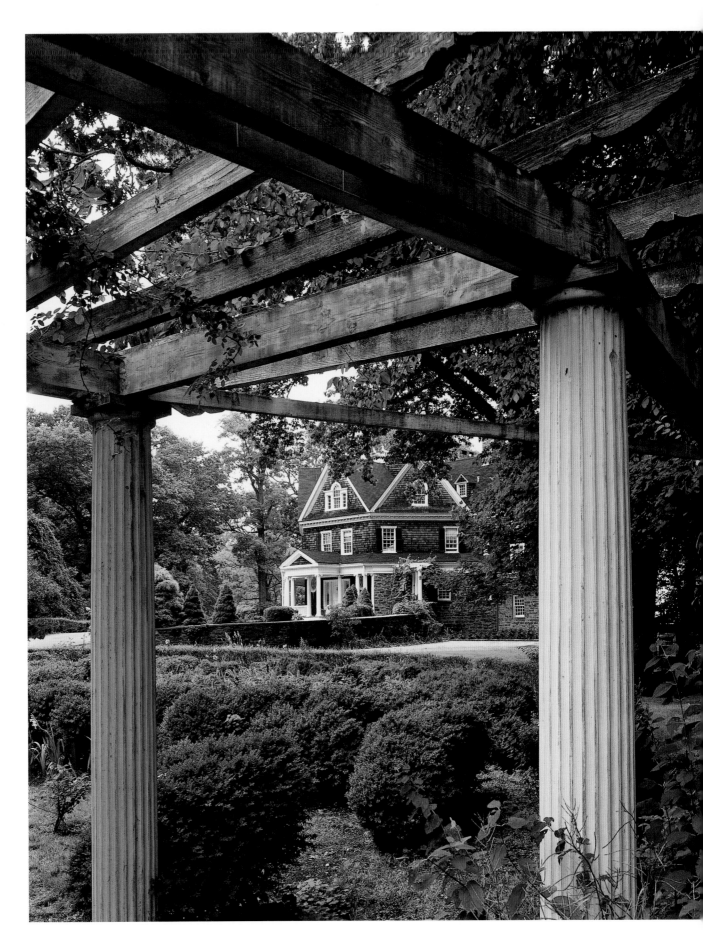

The compact site required some unusual adjustments. The driveway overlooks the formal garden before arriving at the front door. A thin line of hedge separates the service court on the right.

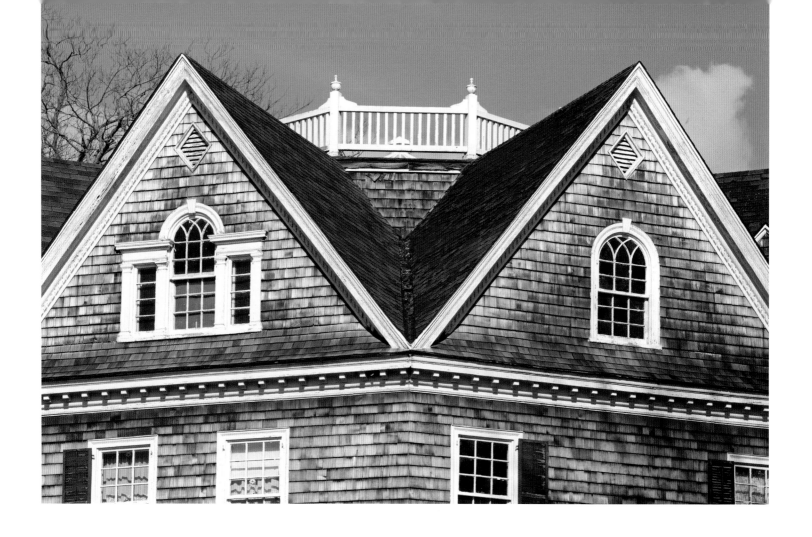

The gentle sweep of shingles over the main cornice helps to unify the composition and soften the massing. The proportions and details of the Palladian window are perfect.

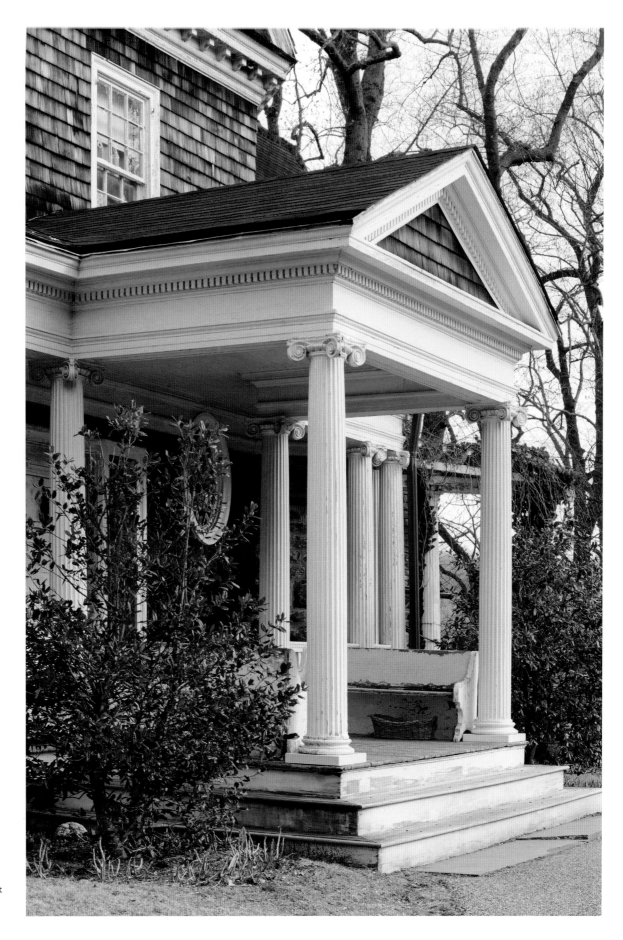

The continuous entablature that encircles the first floor extends to become the main entrance.

in foundations, walls, and chimneys was now presented as a domesticated building material rather than as an allegory of wilderness.

Set against relatively plain walls, the trim established the figurative character of the house. Classical moldings of exceptional intricacy and perfect proportions frame windows, doors, and roof edges. Porches defined by deep entablatures are supported by fluted columns based on Vitruvian orders. Colonial-inspired six-over-six sash illuminate bedrooms on the upper floors, while larger panes of glass provide water views from the living rooms. Exquisitely detailed Serliana on the third floor reinforce the major axes of the plan below. A pair of federal-revival elliptical sash flanks a matching door frame enclosing leaded-glass sidelights and a robustly paneled front door.

With few exceptions the interior reflects a subdued vernacular classicism that refers more to the partners' walking tours of New England than to the inventive finishes and details of their earliest houses. Walls and ceilings are for the most part plain plaster, with simple baseboards, crowns, and door casings. A system of pilasters frames panels of tapestry in the drawing room. The entrance hall is animated by the calligraphy of leaded glass at the vestibule, while the voluptuous newel post at the stair comes straight from colonial Newport.

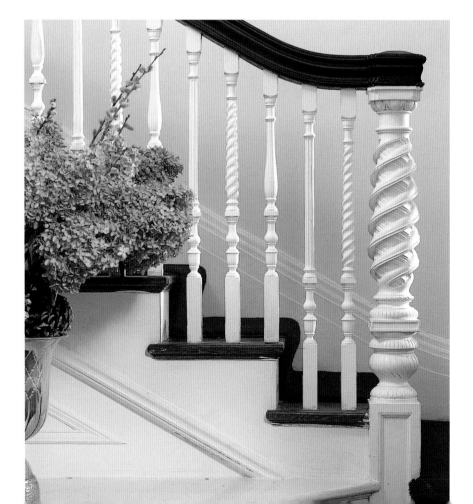

Most of the interiors relied on White's selection and arrangement of furniture for their full effect. The generous details of McKim's favorite Georgian stair needed only a coat of paint.

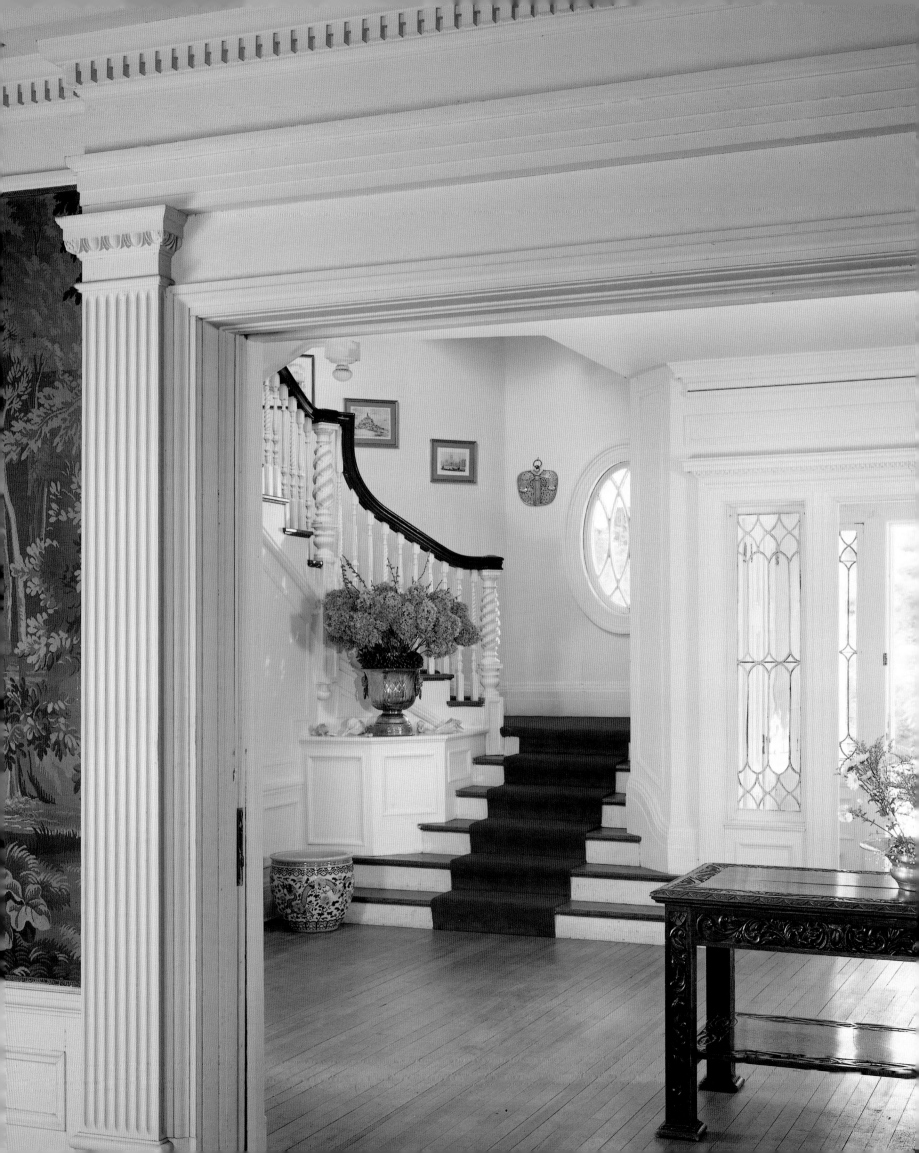

STUYVESANT FISH HOUSE

NEW YORK

1897–99

Mr. and Mrs. Stanford White were among one hundred guests at the Saint Valentine's Mardi Gras ball on February 14, 1899, given by Mrs. Stuyvesant Fish to inaugurate her new house at 25 East Seventy-eighth Street. The *New York Times* described the party as "the most original and unique entertainment given in the city," with details that included dancers swathed in electric lights powered by concealed batteries, individual valentines delivered by children dressed as cupids, a cotillion bracketed by dinner and supper (the latter at three o'clock in the morning), and party favors of live goldfish encased in crystal globes.

In characterizing Mrs. Fish's new house as "one of the handsomest in the city" with a "great ballroom admirably fitted for a large dance," the *Times* acknowledged the twin successes of structure's progenitors. Mamie Fish had built a town house worthy of her social ambitions and Stanford White had realized his vision for the physical appearance of New York City. He based the facades on Italian Renaissance prototypes, a lineage that informs the ornament of the entrance, balcony, and oeil-de-boeuf windows, the deep-set casements and robust copper cornice, and the golden palette of pale yellow roman brick and creamy limestone trim. White tempered his paradigm with historic and practical references to Georgian London: broken window surrounds inspired by the baroque churches of James Gibbs and an English basement protected by a service moat and sturdy iron fence.

The layout within was based around a white marble staircase that established a continuous and seamless architectural experience, connecting the front door to the second floor and creating the impression that Mrs. Fish's ballroom was the largest in the city. White retained Allard et Fils for the interiors and probably had a significant hand in them. The rooms replicate a Grand Tour across time and space: a variety of

The exceptional proportions and regular pattern of thin Roman brick contrast with the monolithic limestone trim and rich ornament of the exterior walls.

The facade suggests a house built for private entertaining, but it has a public character as well. Every component of its design is integral to the building's civilized and generous dialogue with the street.

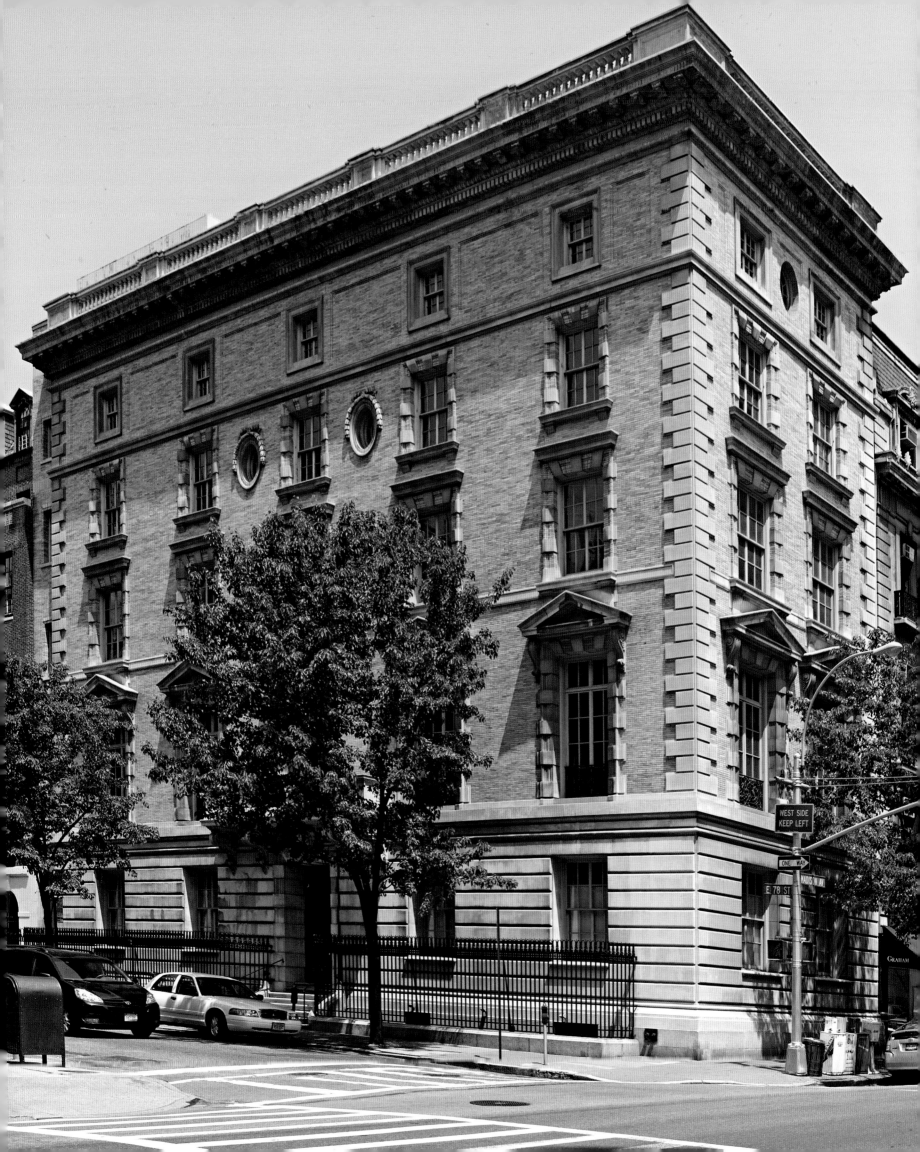

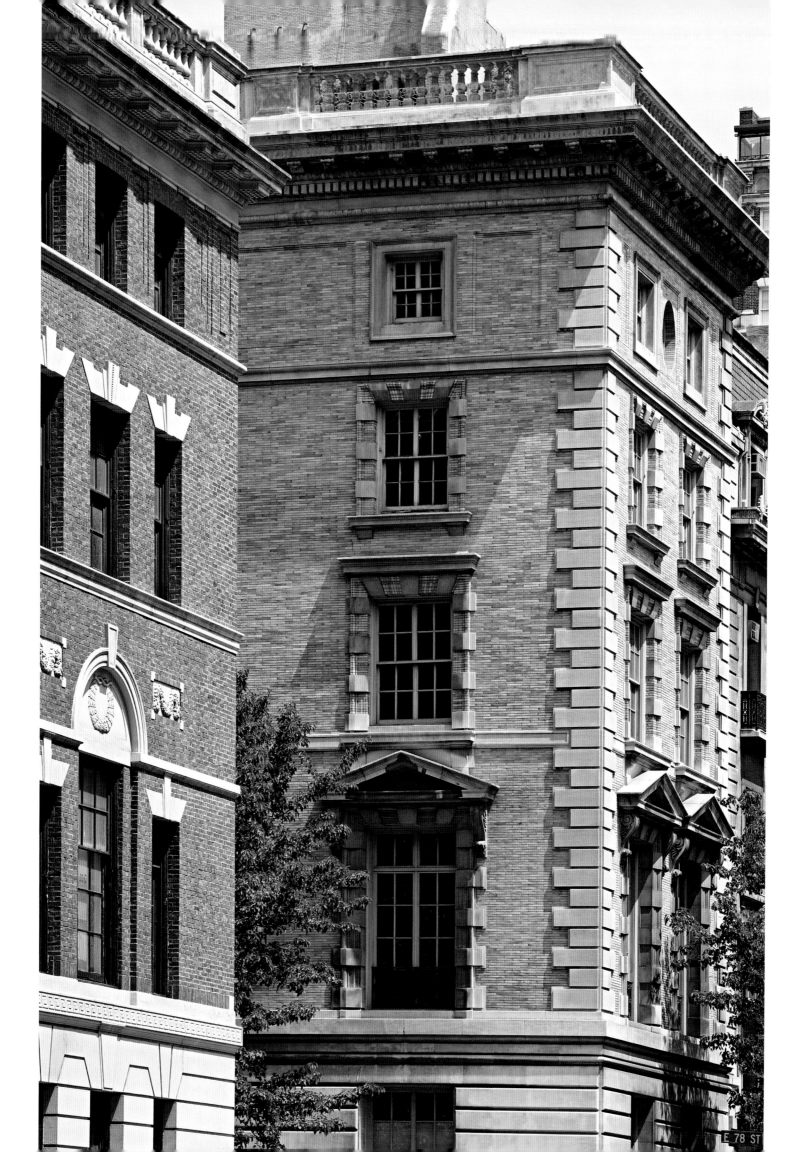

European settings from multiple centuries with an emphasis on eighteenth-century France, a touch of England, and a selection of late Victorian wallpapers. Interior design included furniture (the *Times* actually reported the delivery of the major pieces in September 1898), paintings, tapestries, and sculpture, plus an astonishing number of animal skins.

Two years after the completion of the Fish house, Charles McKim designed a house for Philip Rollins directly across Seventy-eighth Street. A counterpoint to White's florid adaptation of the Italian Renaissance, the Rollins house illustrates McKim's preference for a more sober reinterpretation of Italian Renaissance architecture based on the Georgian buildings of London and New England. The juxtaposition of the two houses illustrates the breadth of imagination and inspiration that White and his partners brought to bear on the challenge of designing for an emerging cultural capital. Twenty years later their accomplishment was appreciated by English critic C. H. Reilly who wrote that "Their work interpreted the Old World to the New in such a way that the New was able to enter for the first time into its full inheritance."

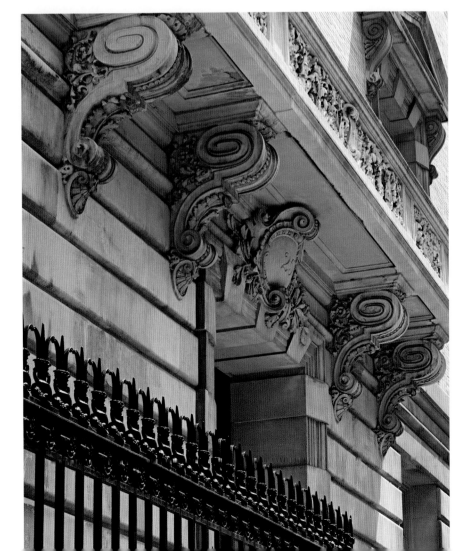

The cheerful palette and highly tactile surfaces form an amiable contrast to McKim's considerably more restrained town house for Philip Rollins across the street.

Within the context of an already saturated facade, White enriched the balcony over the front door. The spikes of the iron fence are intertwined with fish.

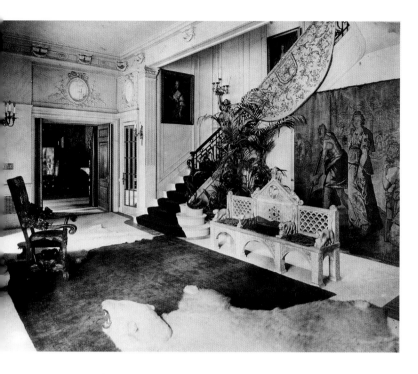

The corner location allowed for abundant light in all rooms, enhancing the palette of the entry, stair hall, and ballroom. White's interiors included plants and hunting trophies, but the number of polar bear skins is remarkable.

Preservation Society of Newport County

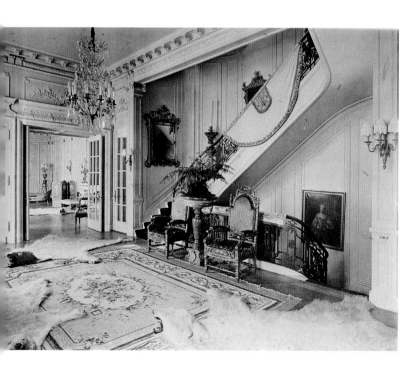

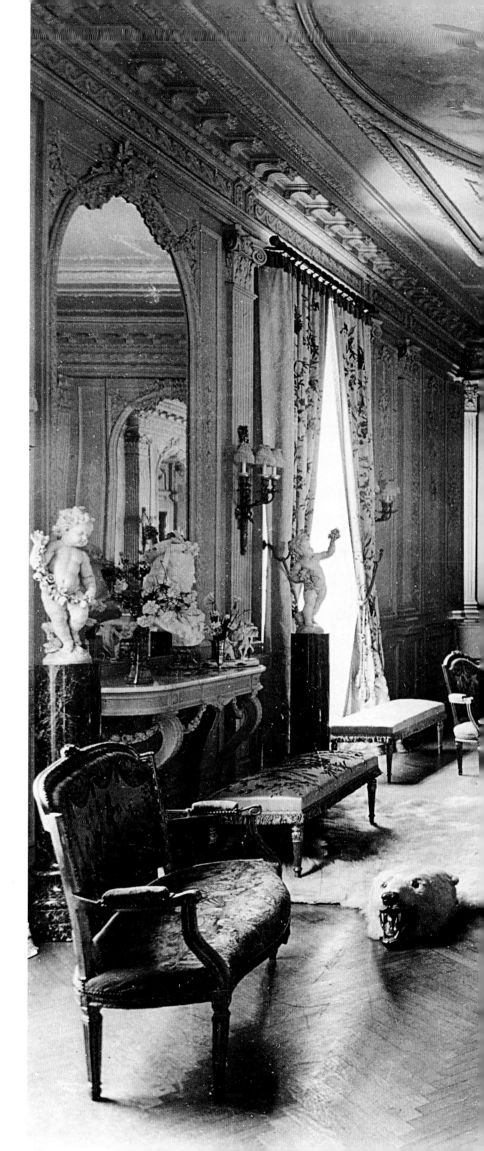

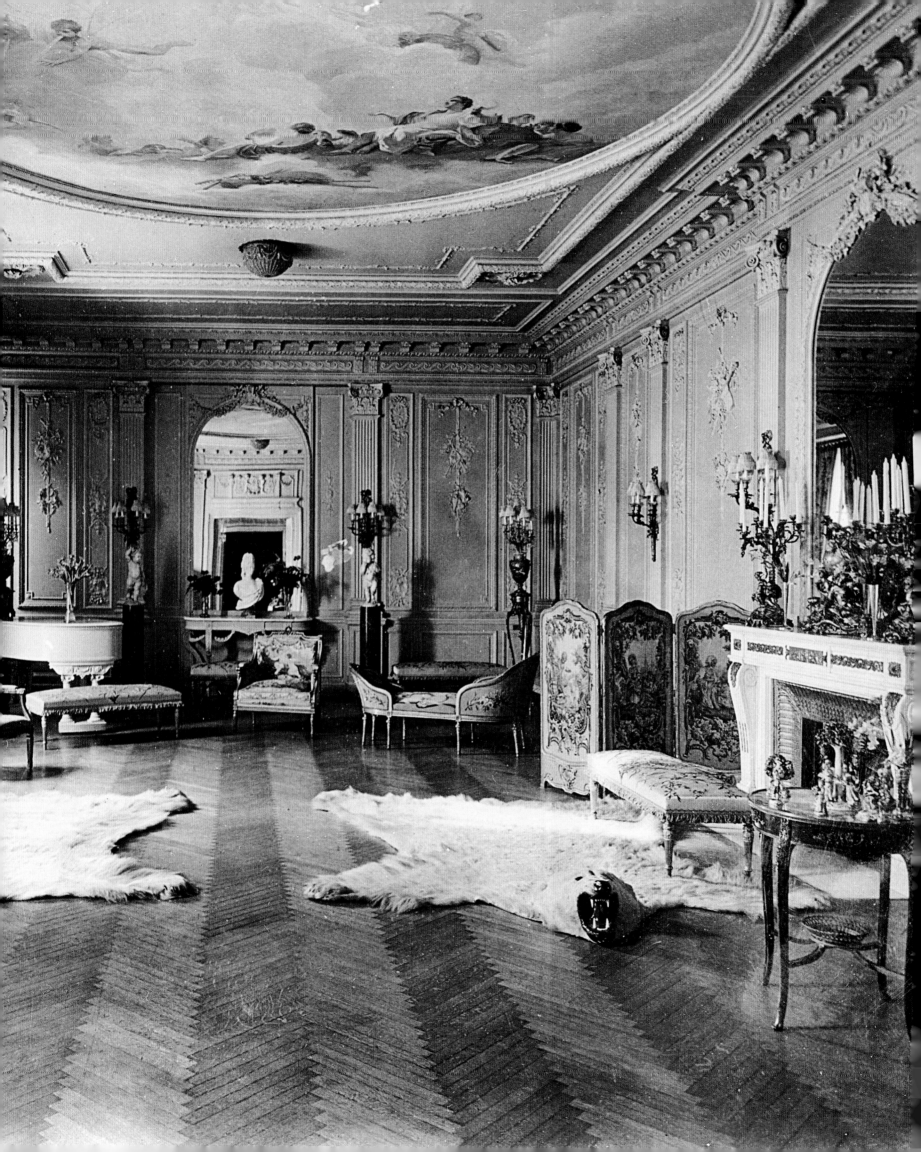

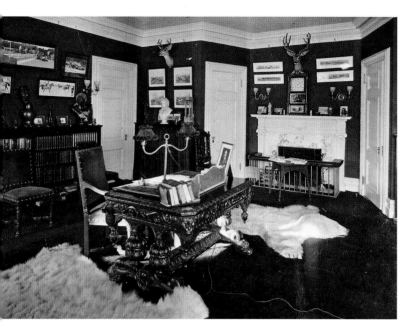

Sporting trophies in Mr. Fish's
study (above) overlook a desk
supported by giant dolphins;
Mrs. Fish's study (below) is
more feminine and appears
somewhat more comfortable.

Preservation Society of
Newport County

Mrs. Fish's bedroom was
celebrated for the great
medieval bed, which was
set on a platform under an
embroidered panel of a
sea serpent.

Preservation Society of
Newport County

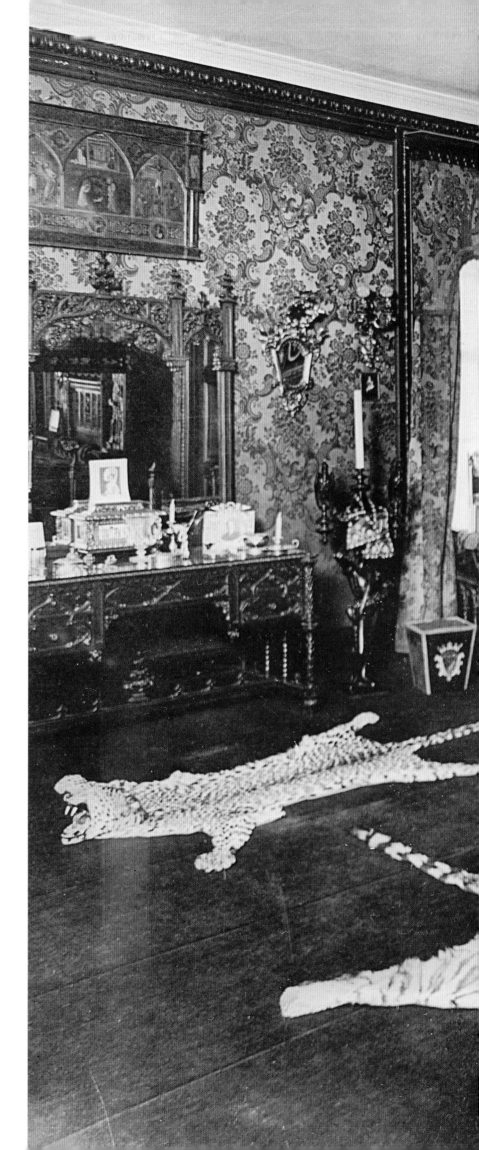

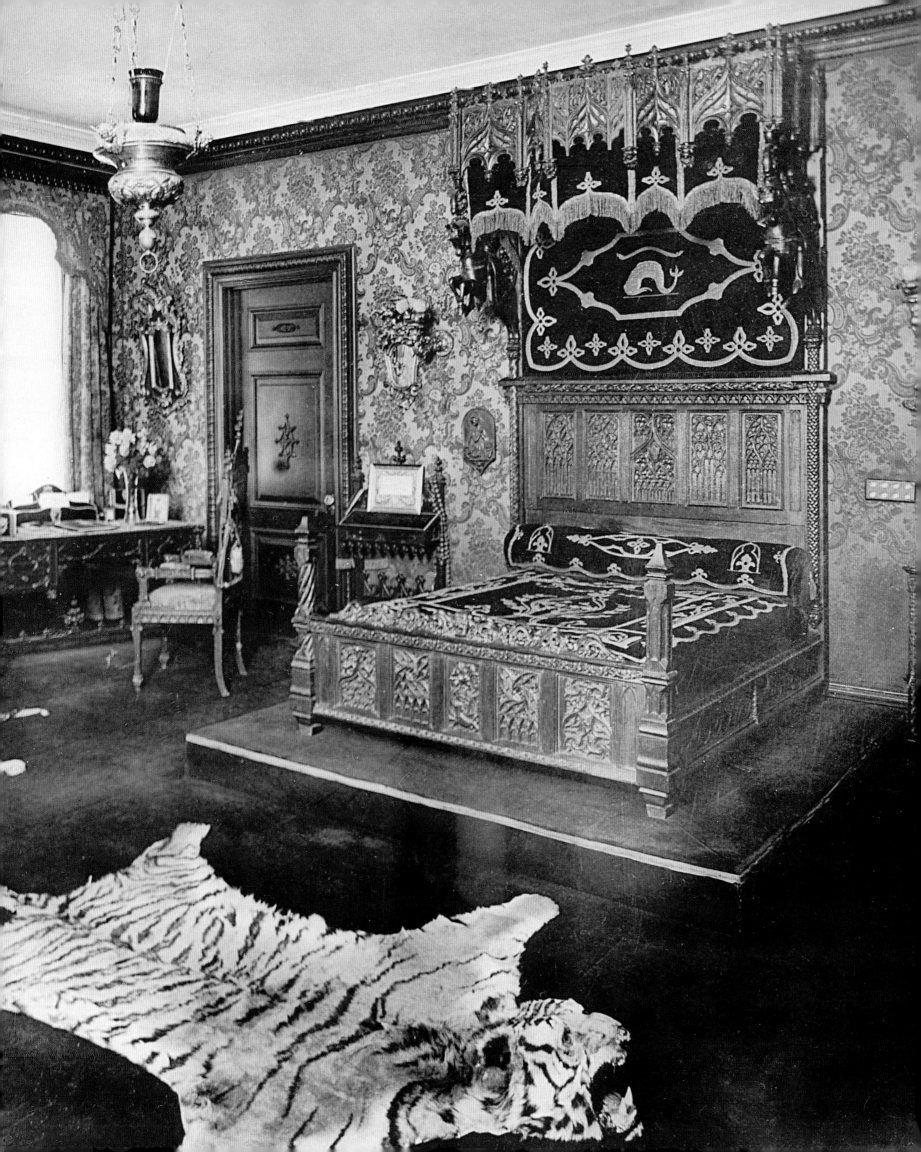

ROSECLIFF

My frau is coming on Friday to spend a week with Mrs. Clews and I am going on with her, returning Monday. I will bring your plan to you early Saturday morning.

The house works beautifully and you will have, I think, if you build it, quite the most livable and nicest house in Newport. The only thing that troubles me is that it is a more expensive plan than the old one and I do not see how it would be possible to build it (without the decorations of the three main rooms and the re-laying out of the grounds) for less than $250,000.

However the first thing to find out is whether the plan and design of the house are about what you want and we can go into the question of cost afterwards, so please do not make any engagements for early Saturday morning.

The implied animation of garden statuary mirrors the constant movement of clouds and whitecaps.

THIS LETTER of August 17, 1898, from Stanford White to Mrs. Hermann Oelrichs, describes a breakthrough in the schematic design of Rosecliff and illustrates the overlap of White's personal and professional lives. The document also alludes to the history of the project. Five years earlier, another architect had sketched a Spanish colonial villa for the site, a proposal that could not overcome the twin flaws of inappropriate image and insufficient ambition. By 1898 the level of architectural aspiration in Newport was approaching the stratosphere, and with the settlement of her silver-mining father's estate, Teresa Fair Oelrichs was one of the richest women in America.

Mrs. Oelrichs's goal was to build a house that would allow her to give the best parties of Newport's two-month season. The house had to dazzle, but it also had to accommodate a practical program that included nine principal bedrooms with private baths, vast kitchens, and ample

Gardens on the land side of the house emphasize nature subdued. The motif of nature abundant is picked up in the garlands decorating the spandrels of the arches.

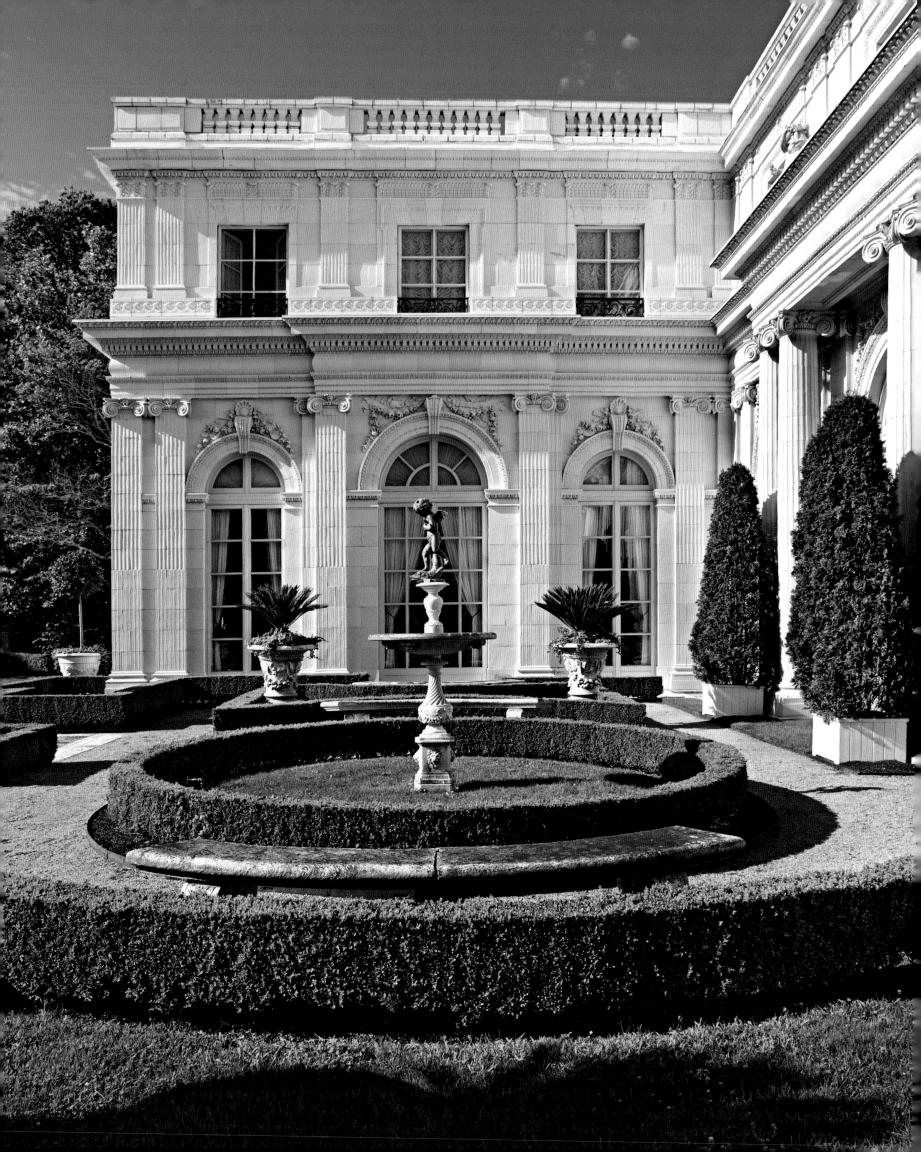

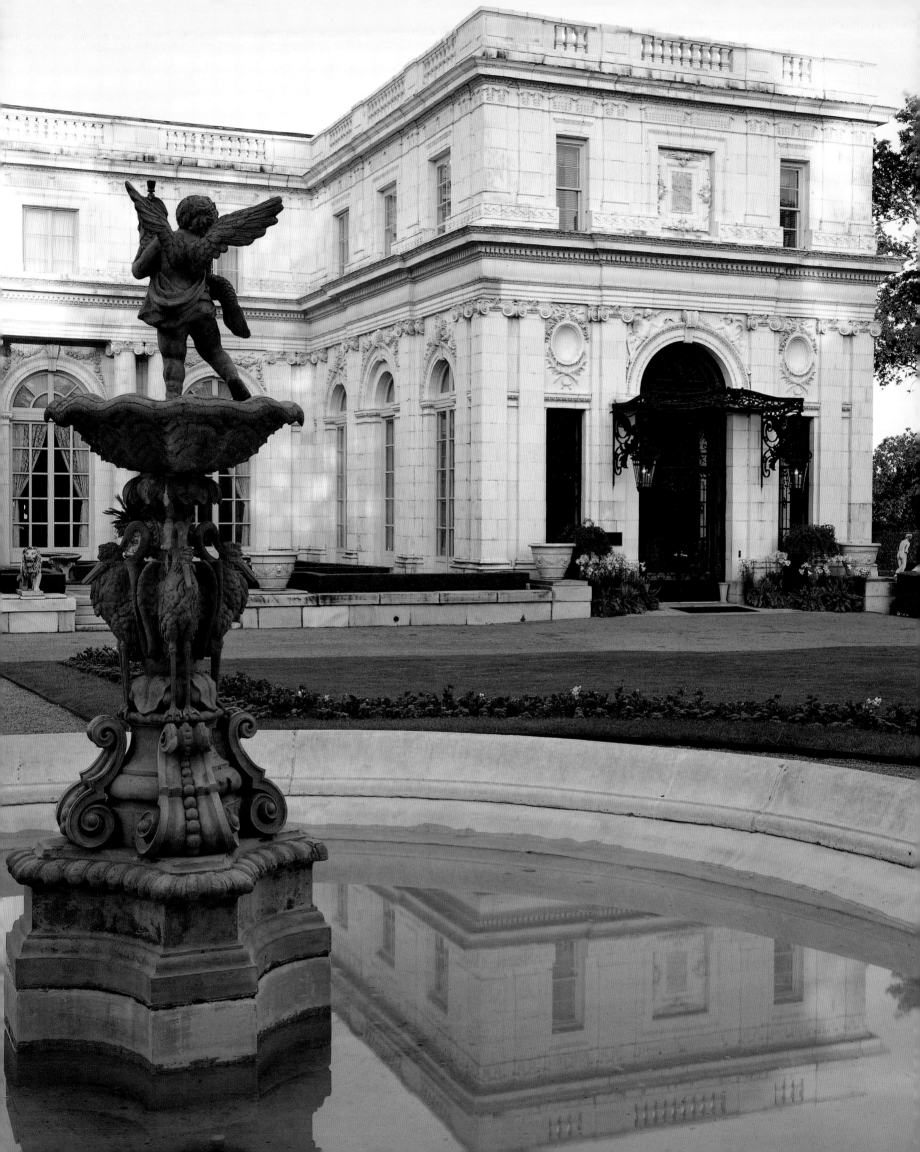

service spaces. It also had to resolve the geometry of a flag-shaped lot that connected ocean frontage to Bellevue Avenue via a narrow right-of-way.

The plan White would deliver that Saturday morning solved the problem at every level. The long driveway offered a view of the entire facade before arriving at a front door set at one end of the structure. The formal rooms on the ground floor unfold in a processional sequence that allowed guests to make a series of ever-grander entrances, culminating in the ballroom at the center. White would develop the design to include the entry hall's triumphal arch and rococo double staircase, and he would concoct the decorative scheme for the major rooms, collaborating with Allard on their execution. The slightly incongruous décor of the reception room reflects its reassignment to Allard after Mrs. Oelrichs learned of White's plan to incorporate a particularly expensive set of Beauvais tapestries.

For the image of the exterior, White transformed Louis XIV's one-story Grand Trianon into a four-story machine for entertaining, inserting a full floor of bedrooms between the orders of double pilasters and the continuous balustrade. The Trianon's pink marble was replaced by

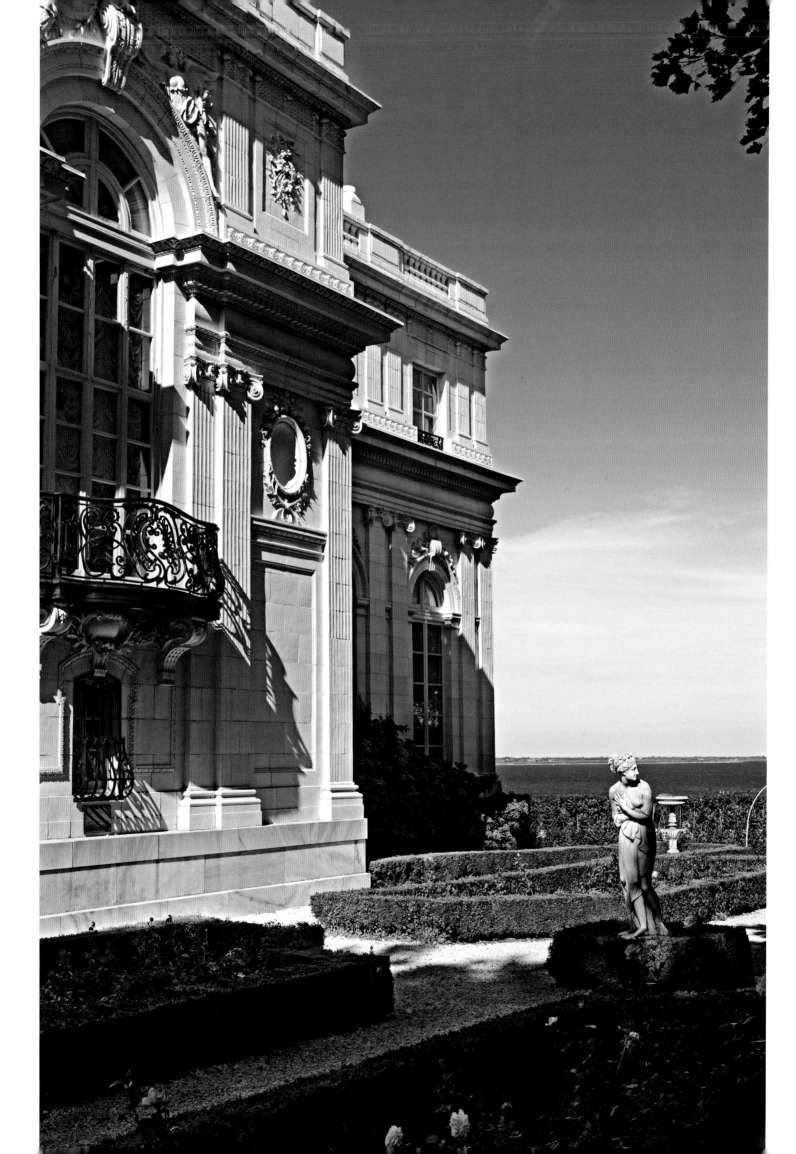

During the Newport season the exceptionally dense ornament and high relief of the south facade would complement the blooms in the Rose Garden. Like the walls of the house itself, the balustrade at the edge of the cliff was made of glazed terra cotta.

white glazed terra cotta, a building material that particularly interested Stanford White.

With the formal inauguration of Rosecliff in 1904, Mrs. Oelrichs commenced a series of legendary parties, and the house continues to stand at the pinnacle of White's portfolio. The extravagance of the project conceals a more prosaic aspect of his professional abilities. Construction of the house, less decoration and site work, cost about one thousand dollars less than Stanford White had predicted in the letter to his client.

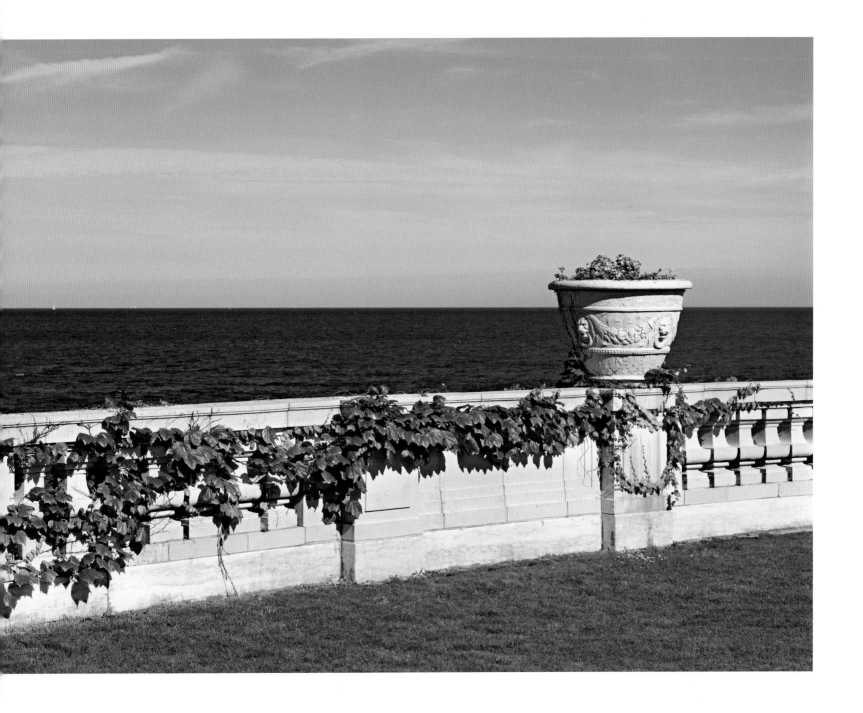

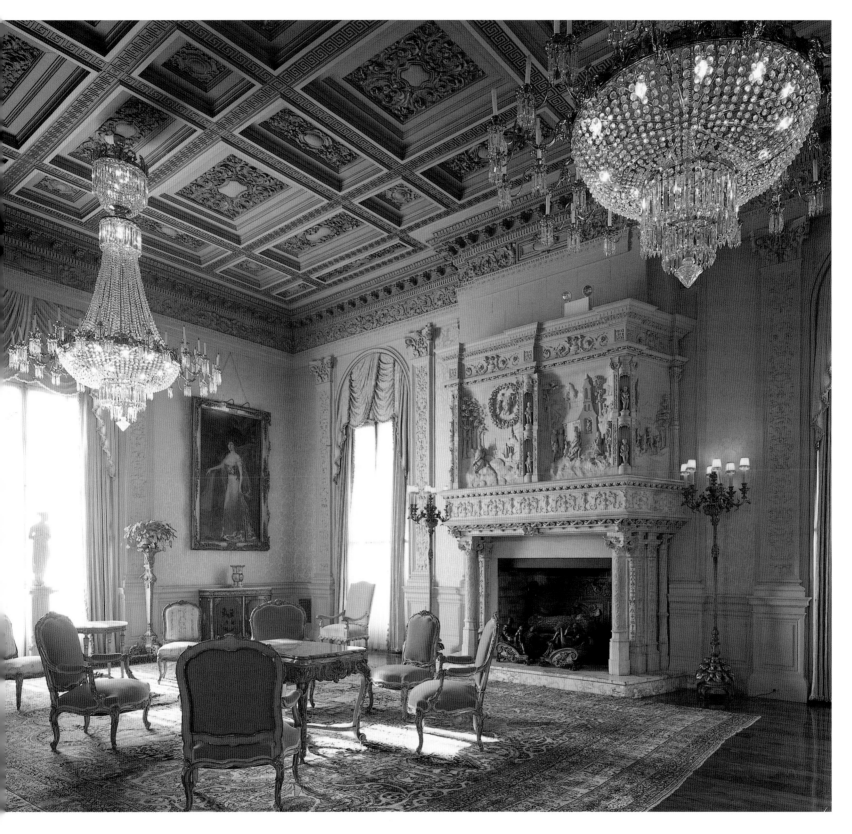

White's plan called for Tessie Oelrichs to receive guests in this room, but he did not design the room itself. Tessie assigned its decoration to Allard et Fils after a spat with her architect.

Tessie Oelrichs's ambition to be Newport's premier hostess must have received an immeasurable boost from the stair that Stanford White designed for her.

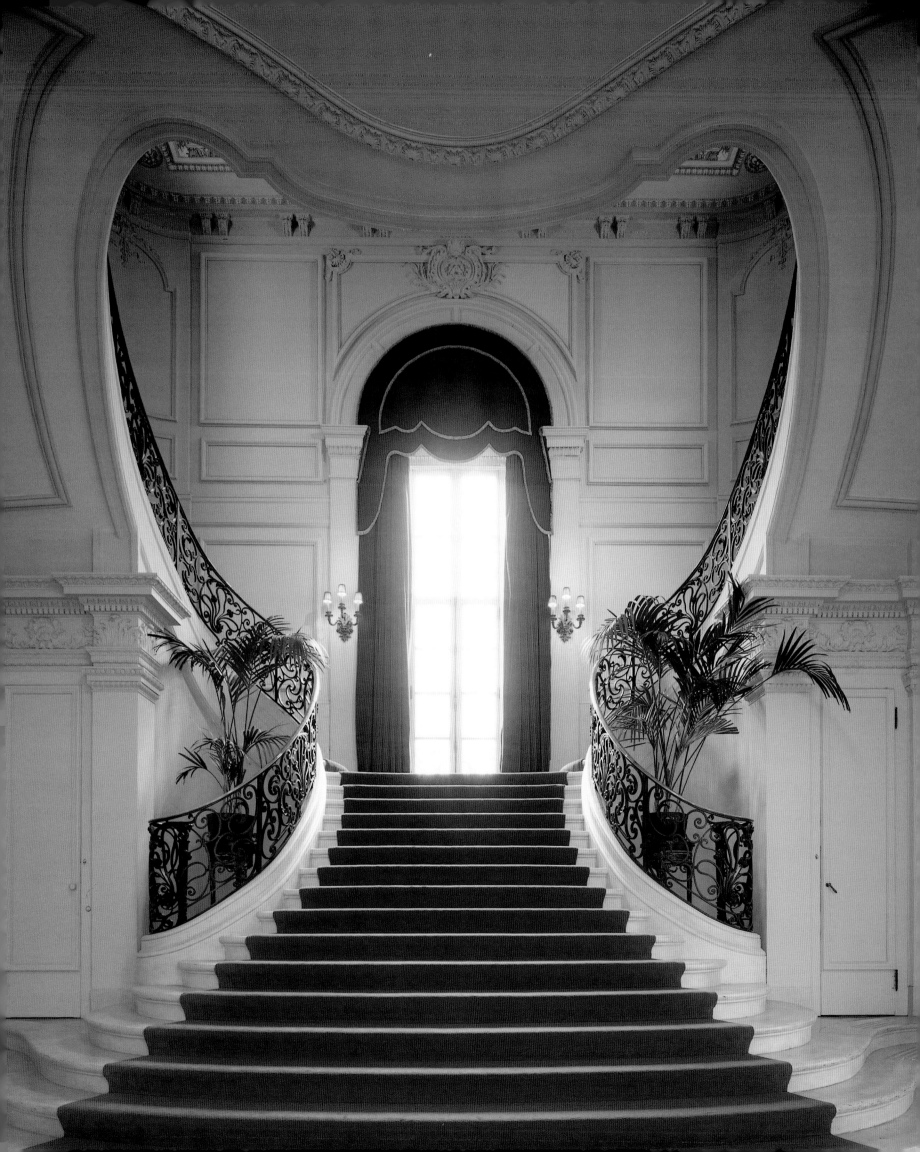

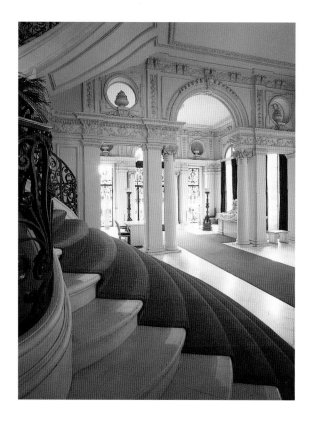

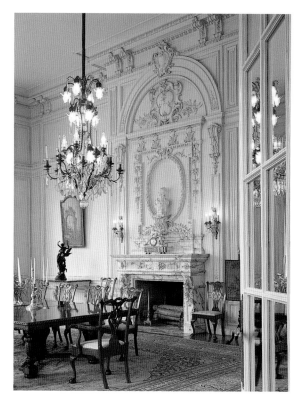

The processional nature of White's design is seen in details of passage and arrival, reaching its crescendo in the living room.

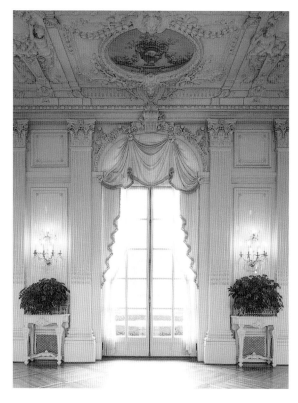

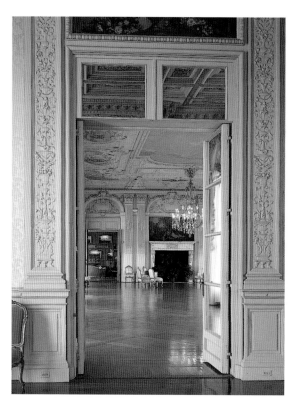

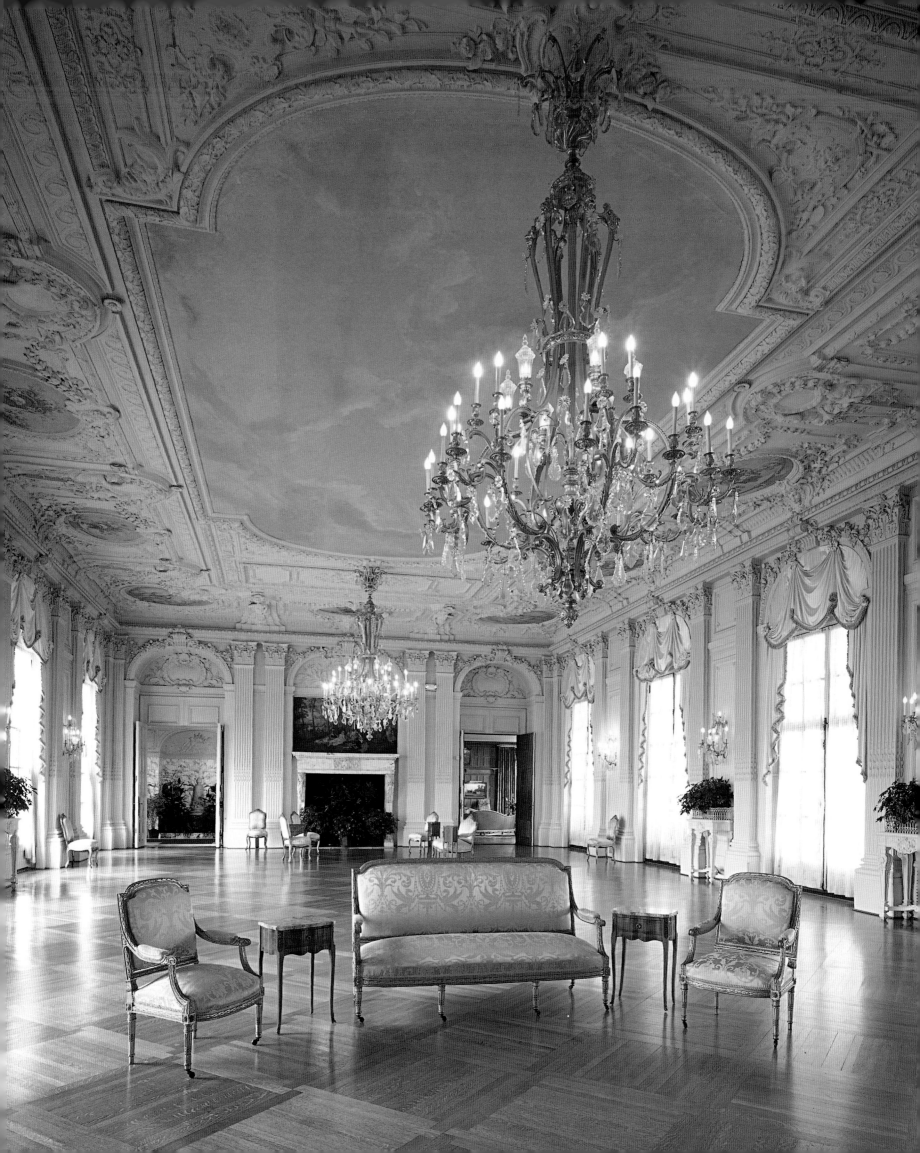

PAYNE WHITNEY HOUSE

NEW YORK

1902–07

*T*HE TOWN HOUSE for Payne and Helen Hay Whitney at 972 Fifth Avenue represents a confluence of superlatives. One of the most expensive private projects of White's career, it was also one of the best in every respect. Conceived and ultimately implemented over a five-year period untroubled by financial crisis, it benefited from the nearly unlimited resources of Oliver Payne, treasurer of Standard Oil, and his designated heir, namesake, and equally wealthy nephew Payne Whitney. Whitney was the son and, before the project reached the halfway mark, heir of streetcar king William Collins Whitney. The elder Whitney had been secretary of the Navy; Helen Hay's father had been secretary of state under two presidents. The ingredients for a project fueled by so much culture and prestige could not have been more potent.

The finished house illustrates White's ability with settings for elaborate social rituals and also with the patterns of family life. The main living floors were furnished with antiques that White acquired in the course of a European shopping trip with the Whitneys. Carved ceilings, gilded door surrounds, stone mantels, antique velvet, and princely accessories corroborate White's skill as a decorator as well as the extent of his contacts throughout Europe. The high Renaissance fittings speak to White's maturity, while the upholstery tacks that frame plain leather walls in Whitney's study connect this late work to the architect's earliest interiors. Mrs. Whitney's studio upstairs was finished with a frescoed ceiling and a floor of soft, warm Italian terra cotta tile, creating a lovely atelier in the heart of the family quarters.

White's ability to work with the best artists and craftsmen of the period is in evidence throughout the house. Allard was responsible for installing the imported fittings. John La Farge executed four stained-glass windows on the theme of the seasons. James Wall Finn, a skilled muralist who was assisting McKim at the time with Belle da Costa

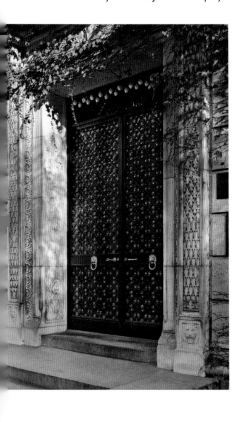

The front door with its foliate grilles and gilded pomegranates was fabricated by the W. H.. Jackson Company.

The commission entailed two houses, one for Henry Cook, who developed the block, and its neighbor to the south for the Whitneys.

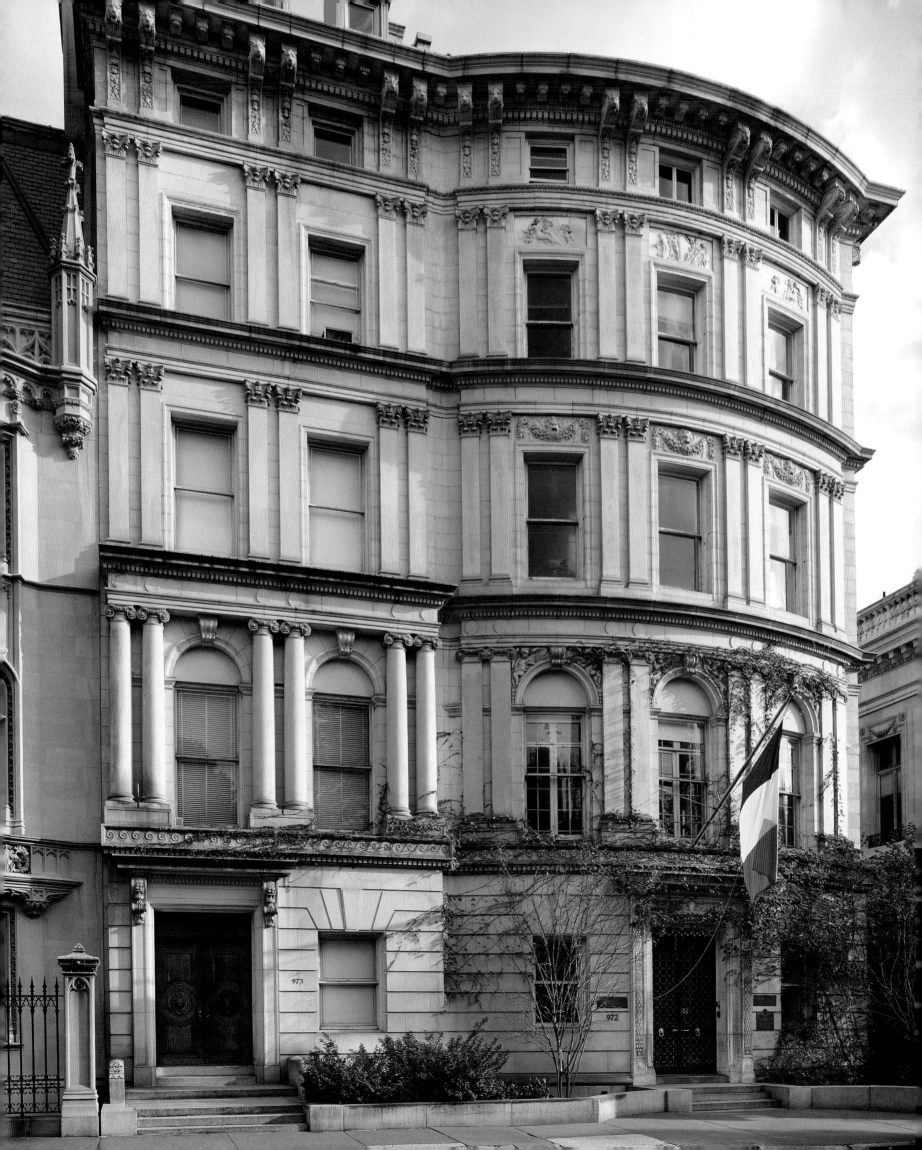

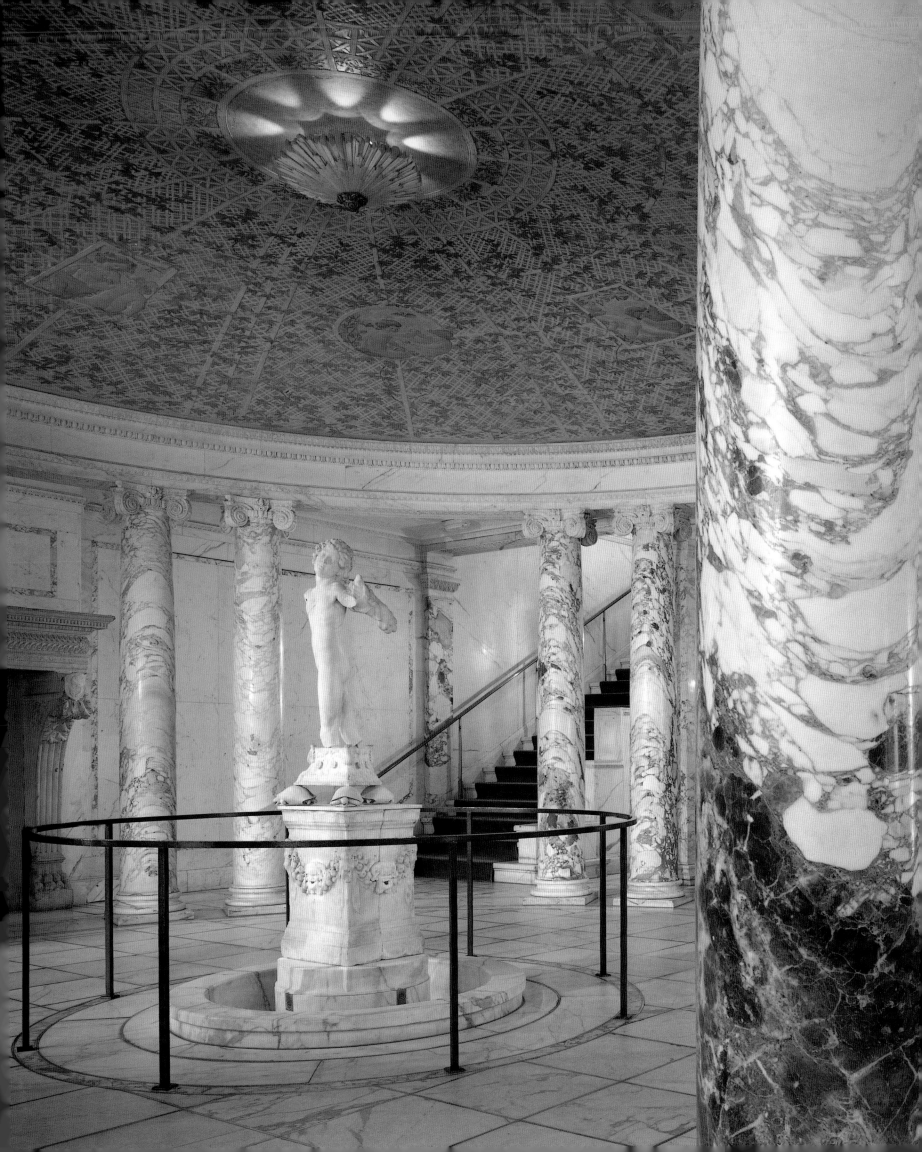

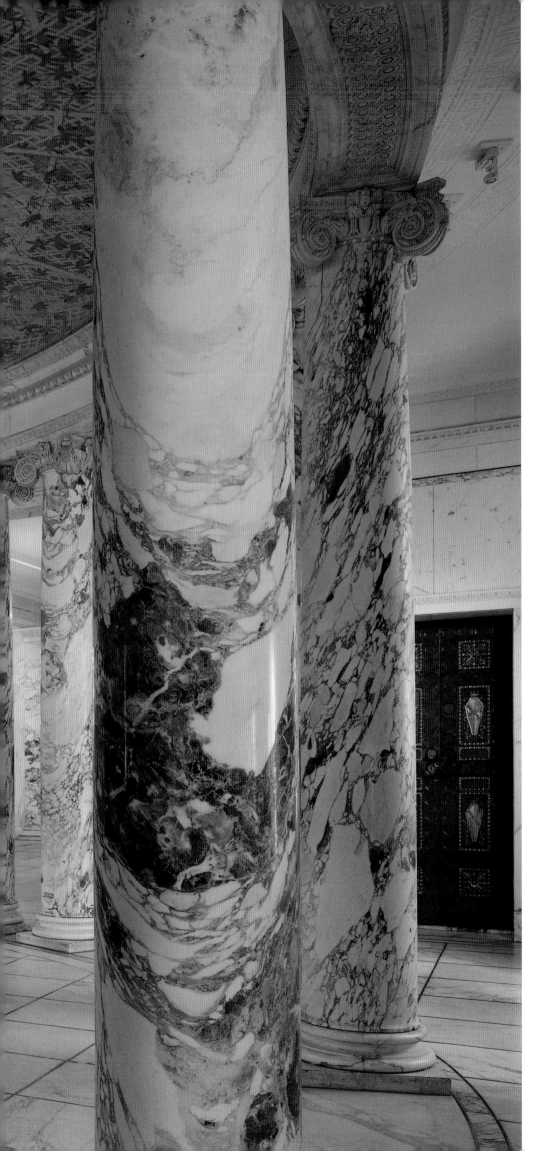

The circle of paired columns represents an unusual but effective plan device for the entrance hall. White also designed the fountain, the plaster relief ceiling, and the doors leading to the jewel-like Venetian Room.

A balustrade of giant marble risers recalls the geometry of White's stair design at Box Hill.

The south-facing windows of the second floor hall are reflected in the mirrored doors to the dining room.

Greene's office at Pierpont Morgan's library, painted the putti, trellises, and grapevines that decorate the ceiling of the entry hall.

Two aspects of the Whitney interior reveal the exceptional power and range of White's imagination. The mirrored reception room, a space designated for visitors to wait before being shown into Payne Whitney's study or led upstairs, is almost without precedent. White dissolved the boundary between architecture and decorative arts in a wash of reflected and refracted light over entire walls of gilded moldings rendered at the scale of a neoclassical pier glass and set below an openwork cornice of cloisonné roses. The delicacy and spatial ambiguity of the small chamber stand in contrast to the geometric clarity of the entrance hall with its circular entablature, shallow plastered dome, and ring of marble columns. White developed the hall around the peristyle to organize the patterns of arrival, departure, and waiting. The unusual architectural motif was inspired by the covered porch of the Villa Giulia. The Roman villa features a horseshoe-shaped arcade open on one side and covered by a continuous plaster vault decorated with motifs of trellises, vines, and infants. White transformed the model into a circular aedicule within a square room, using the screen of columns to accommodate multiple paths through the ground floor. White's temple encloses a fountain assembled from fragments of marble sculpture that he had accumulated, including the figure of a boy that is considered by some to be an early work by Michelangelo, an attribution that shows White as a connoisseur of art as well as a companion to artists.

The second floor hall at the time of the Whitneys' occupancy. The interiors were distinguished for the exceptionally high quality of the furnishings that White selected.

New-York Historical Society

White based the shallow dome of lattice panels and playful putti on the vaulted porch of the Villa Giulia in the Rome.

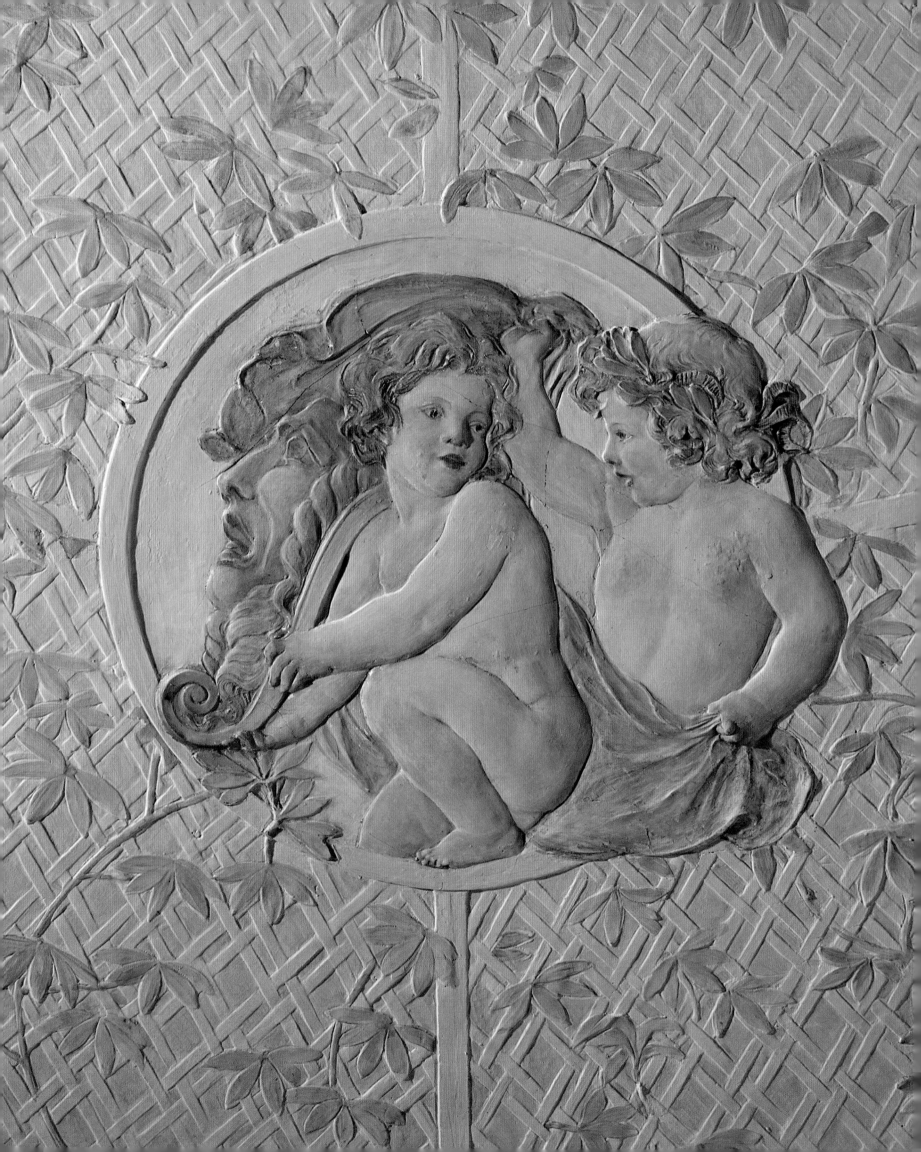

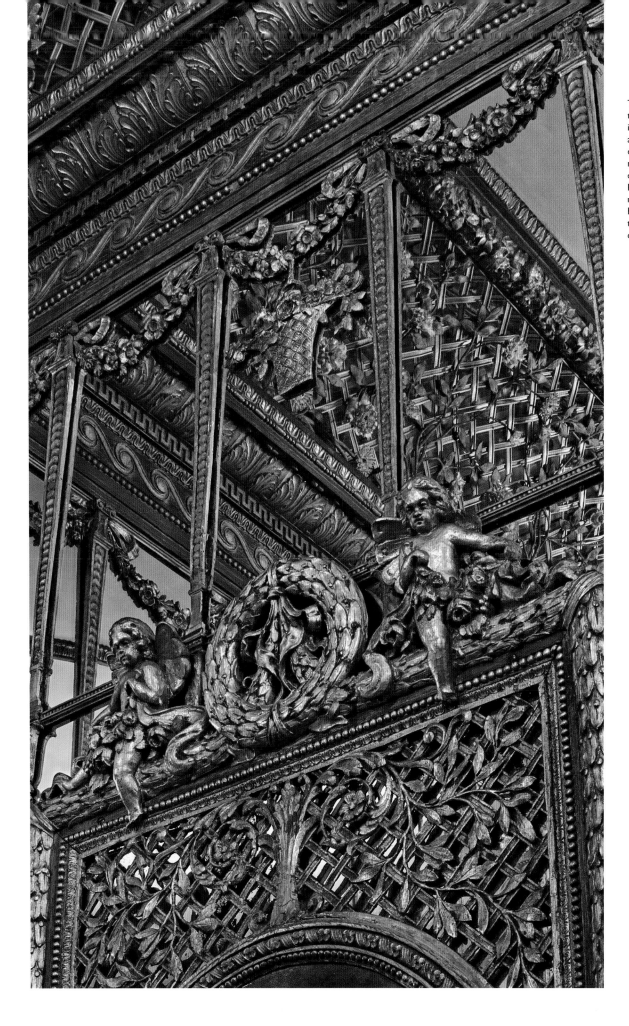

The Venetian Room represents the pinnacle of White's lifelong interest in the intersection of architecture and furniture design. The walls are based on neoclassical pier mirrors, but other sources range from High Renaissance moldings for the mantel and door casings to Bavarian rococo candelabra for the enameled flowers in the ceiling cove.

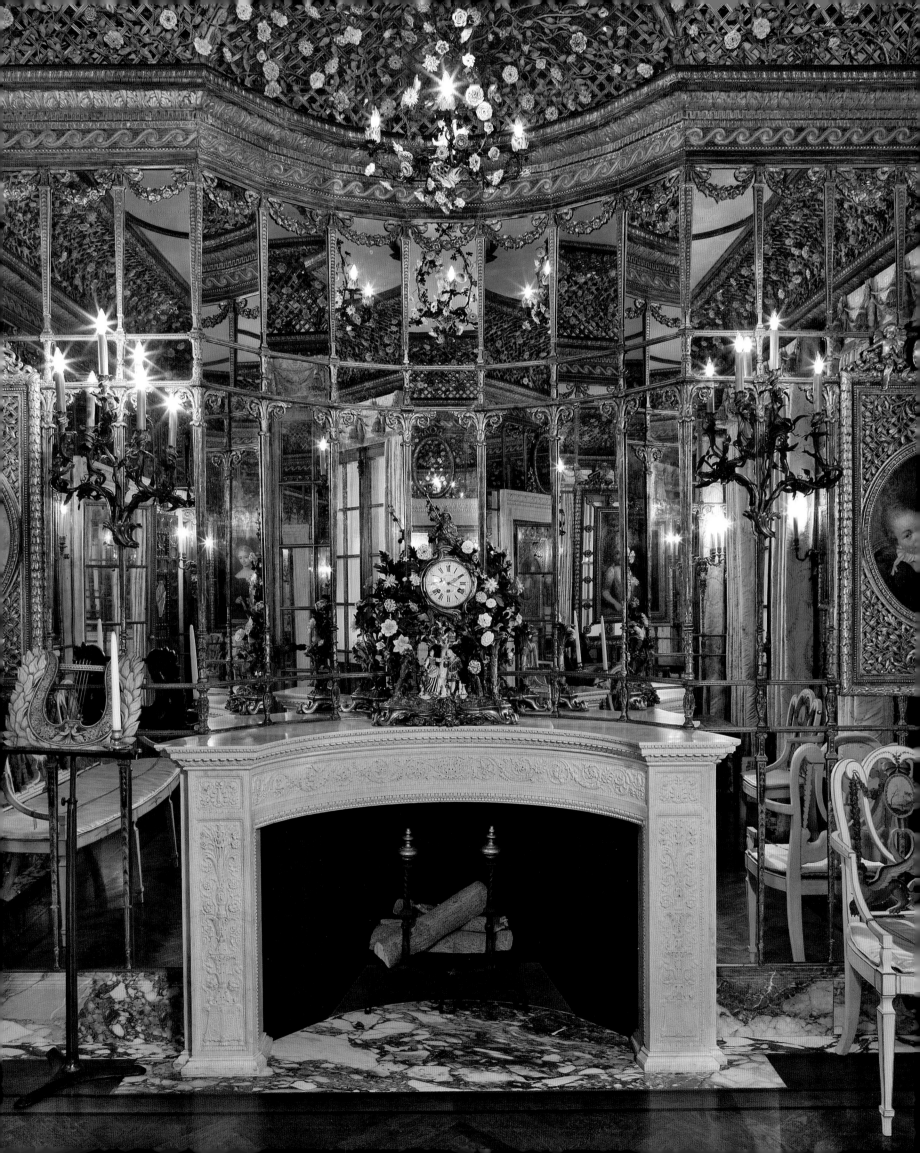

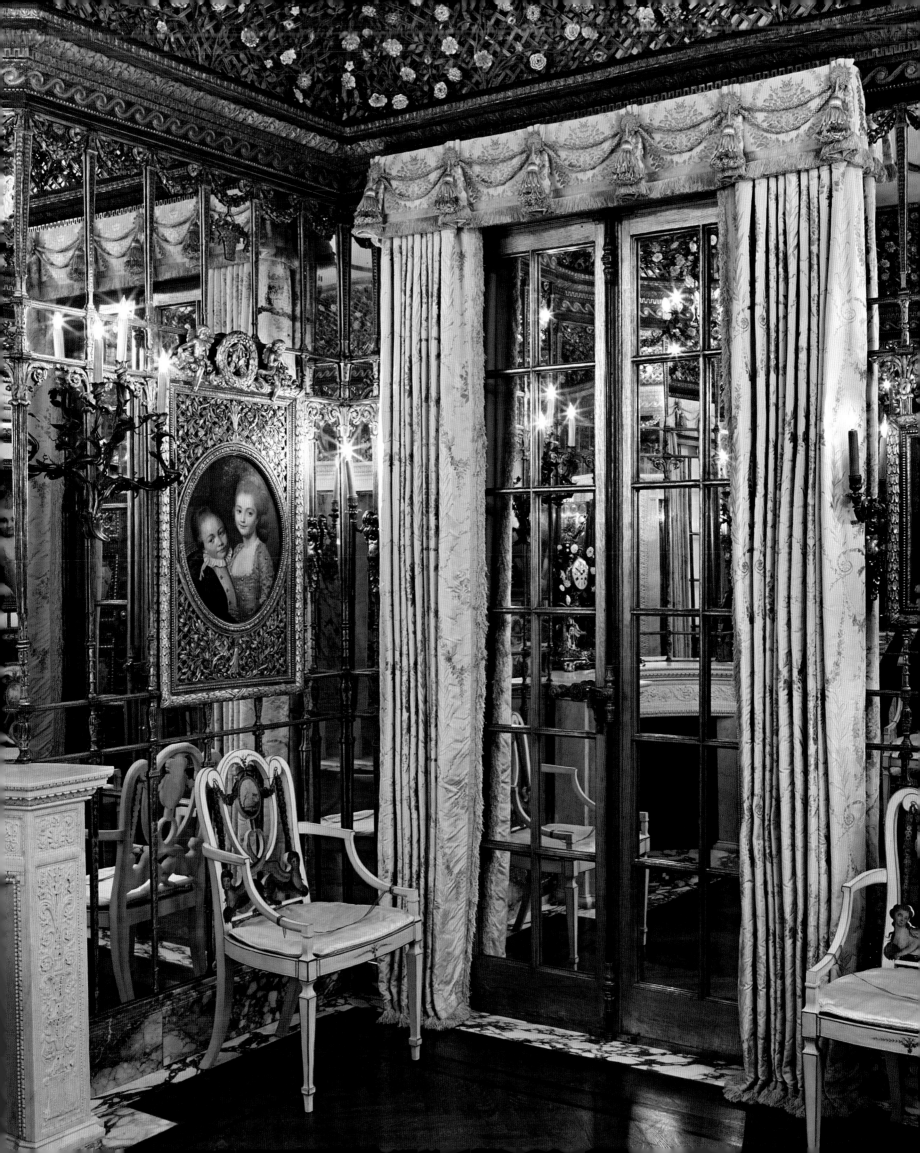

White's design included selection of the furniture, paintings, and window treatment as well as the veritable encyclopedia of individual molding profiles.

Architecture of Assembly

S TANFORD WHITE'S SKILLS AS architect, decorator, and ornamentalist—combined with his energetic and gregarious personality—found physical expression in the extraordinary environments he created for celebrations. His clients may have dictated the program and even specified the tone of the design, but it was his genius that created settings that came alive when they were occupied by groups of like-minded people.

The timing of his career provided ample opportunity to apply this talent. Post–Civil War wealth accompanied by increased leisure created a fertile environment for an architect like Stanford White. Increasingly elaborate social rituals demanded new settings ranging from Kingscote's dining room to Mrs. Stuyvesant Fish's ballroom. Tessie Oelrichs's Rosecliff, Robert W. Patterson's house in Washington, and John Jacob Astor's Ferncliff Casino were each designed specifically for entertaining.

The trend was not restricted to personal residences. Late-nineteenth-century hostesses also began to entertain in public settings. Mrs. Odgen Mills, chatelaine of Staatsburgh in the Hudson Valley, was the first to give a private dinner at Sherry's. Owned by restaurateur Louis Sherry, the hotel White designed on Fifth Avenue at Forty-fourth Street contained a great ballroom and a number of smaller private banquet rooms that were the settings for legendary parties, including one involving guests eating dinner on horseback. A broader range of festivities, including displays of more conventional equestrian skills, could be enjoyed at Madison Square Garden.

White's festive designs were not limited to architecture. He planned civic celebrations—New York's centennial tribute to George Washington's presidency and the celebration of the four hundredth anniversary of the

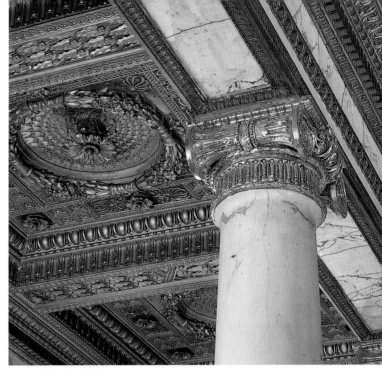
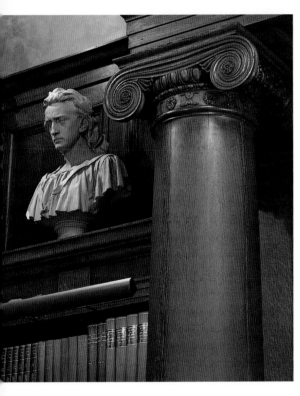
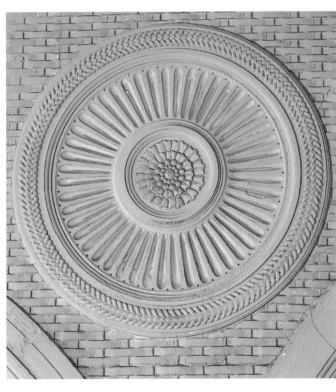
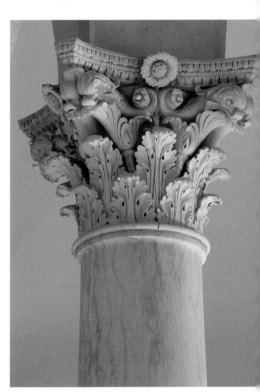

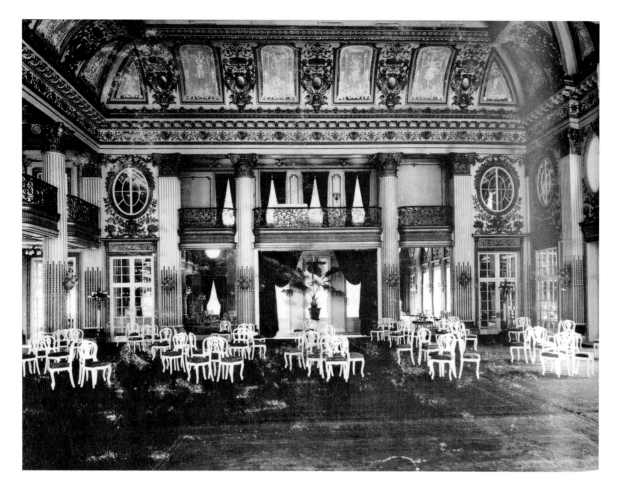

White collaborated with muralist James Wall Finn on the decoration of the main ballroom of Sherry's Hotel. The hotel's other settings for public and private entertaining included a second, smaller ballroom, private dining rooms, and a ground-floor restaurant.

landing of Christopher Columbus—and elaborate cultural events, ranging from the decoration of the Metropolitan Opera House in honor of Prince Henry of Prussia to "A Night in Venice," in which gondoliers poled their gondolas around the Madison Square arena. Family pageantry included a wedding reception at Rokeby in the Hudson Valley for Temple Emmett (brother of White's brother-in-law Devereux Emmett) and Alida Chanler.

White also designed private clubs, a building type that falls somewhere between houses and public buildings. Far more accessible than any residence and far more exclusive than Sherry's or the Garden, clubs represented a middle ground in which communal activities were merged with individual comfort. White's clubhouses would contain morning rooms, music rooms, dining rooms, card rooms, billiard rooms, and libraries, each of which displayed his ability to design settings that reinforced their social purpose. These spaces and activities were organized around plans

The ceiling of the Metropolitan Club library ingeniously conceals the asymmetry imposed by the carriage turn around. The central table and original bookshelf lights are impressively large.

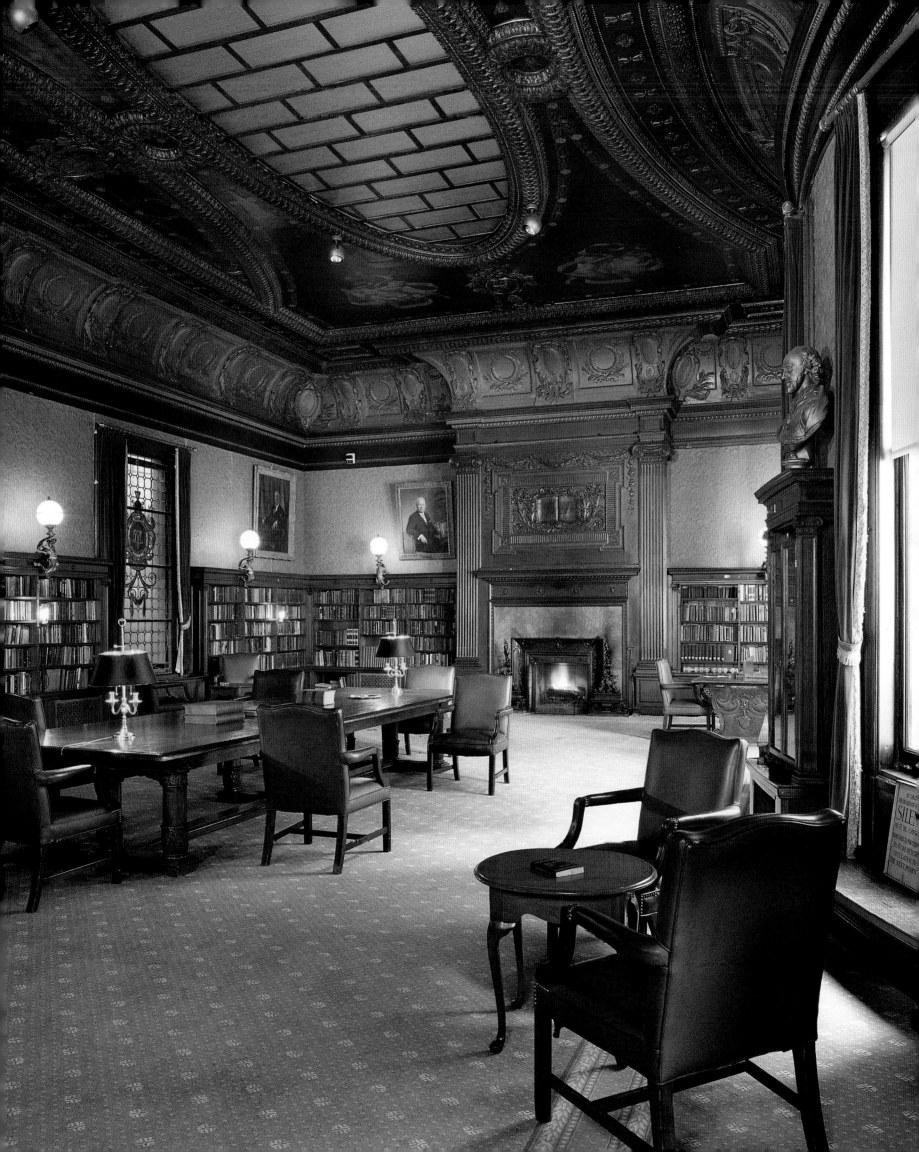

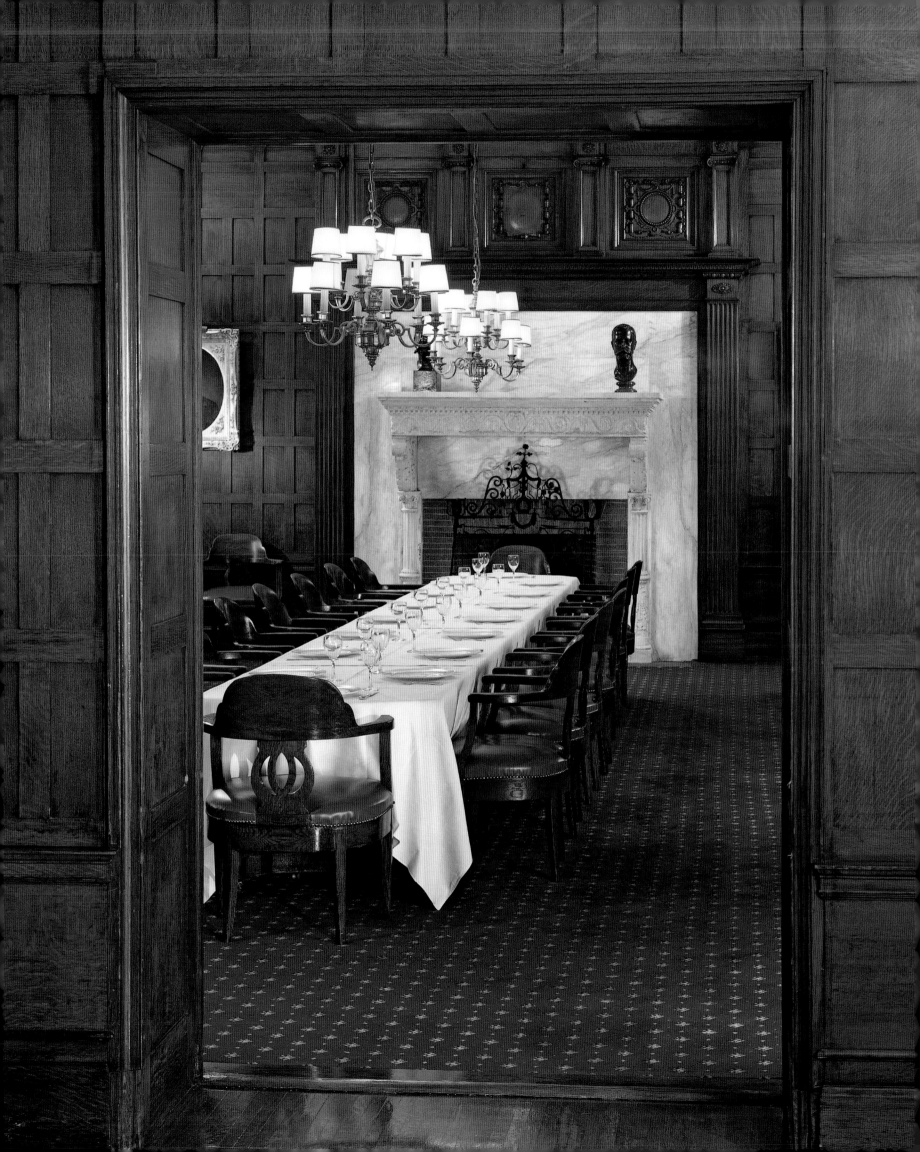

and sections that reflected a precise understanding of the requirements of their users, and they would be presented behind facades that maintained members' privacy while suggesting, with extraordinary subtlety, the unique culture of the institution that occupied it.

Clubs, in the sense that White would recognize, began in England as coffeehouses. By the second half of the nineteenth century, gentlemen's clubs were well established in London but they were still a relatively novel phenomenon in America. The Philadelphia Club was the first in the United States, founded in 1830 and housed in its own clubhouse by 1835. New York's first was the Union Club, founded in 1836. By the time White started practicing, clubs in the city included the Union League, the University Club, the Harvard Club, and the Century Association. Most initially occupied former town houses, but by the 1880s, rapidly increasing membership and the desire to accommodate every member in a single dining room transformed these organizations into clients for new, purpose-built structures.

Probably as a result of his father's Anglophile tendencies, White had an appreciation for the nuances of club life, from the expectation of companionship to the pleasure of its enjoyment through a spectrum of formal and informal social activities. It didn't hurt that clubs were selective—White may have had a common touch that allowed him to work with artisans, but he was a bit of a snob when it came to the class of humanity he dismissed as "bores." He also understood the program. Clubs offered opportunities for conversation in large groups as well as the intimacy of one-on-one encounters. They were settings for dining and drinking, for billiards and card playing, and for group singing, as well as the more subdued pleasures offered by a writing table stocked with club stationery or a single upholstered chair pulled up to a welcoming fire. They offered a retreat from both home and office, where a loyal and vigilant doorman protected members from each.

Stanford White was "clubable." Entertaining, attentive, and highly social, he was able to move easily among the rich, well-bred, and creative people that he considered friends. The *Social Register* of 1896 records his membership in ten clubs, but it is likely that there were others that the

The members dining room at the Century Association features a single long table, broad chairs, plain paneling, and a highly intimate scale.

The facade rises from a smooth base at street level to meet the sky with ornamental exuberance. White controlled the broad range of materials, surfaces, and shapes with a highly restricted color palette.

august publication did not deign to recognize. White is said to have belonged to as many as forty, an estimate corroborated by the stream of invitations he received to join a club, start a club, or "advise a group of fellows" about the idea of a club.

Each clubhouse White designed was tailored to the membership, and his architecture could express the specific aspirations, character, and self-esteem of a wide range of the population. The Metropolitan, which the newspapers called "the millionaire's club," was a congenial environment for White to meet with his wealthy clients. Its architecture could not have been more different from the Century Association, whose membership was limited to "artists, authors, and amateurs of the arts" and where White conferred with fellow architects or collaborators. Neither club looked anything like the Players, which had been established for the benefit of actors and was White's favorite club. He could relax there, for actors were neither his clients nor his competition. Many a note to White's closest friends would end with the implied invitation: "Tonight I dine at the Players."

Most of the clubhouses that White designed as well as joined were in Manhattan. Early in his career White became a member of the Tile Club, a loosely organized society of artists that would meet to smoke, talk, and paint tiles. Sometime after 1881 they occupied the parlor floor of

The Freundschaft Society occupied the southeast corner of Park Avenue and Seventy-second Street until 1911. Details on the facade anticipate the Century Association clubhouse that White designed three years later.

a small building behind a town house on Tenth Street. White designed the main room, which, given the limited resources of the group, involved more decoration than actual construction. White's first city clubhouse proper was designed in 1885 for the Freundschaft Society, an organization of German businessmen. White and his partners created a boxy three-story building that projected an image of sobriety to the outside world, while from an artistic and historical perspective it underscored the firm's

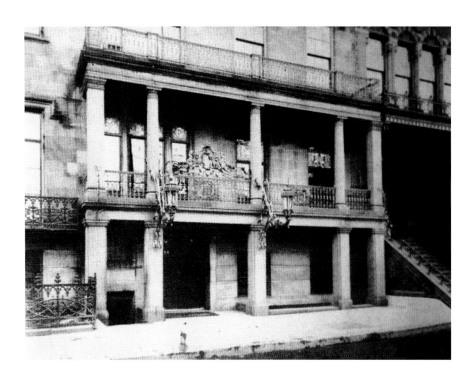

The unusual spacing of columns supporting the porch at the Players allowed White to dignify the off-center entrance and subordinate the irregular fenestration of the older town house.

struggle to replace the Romanesque idiom of H. H. Richardson with the architectural language of the Italian Renaissance.

White's next commission was for the Players, a creation of Edwin Booth, the legendary Shakespearean actor who had the misfortune of being the brother of Lincoln's assassin. In 1887 Booth decided to create a club that would permit his fellow actors, a group not normally counted among the city's most genteel classes, to mingle with artists, writers, and other reputable professionals. The status of the Players was enhanced by farsighted nominations—both Mark Twain and Grover Cleveland were persuaded to join at the outset. The image of the club also benefited from White's design, which maintained the character of a private house on Gramercy Park. The only hint of a more institutional purpose was the full-width balcony, which soon became a beloved perch for members.

By 1889 White must have begun to enjoy a reputation as a club architect. The Century Association, then located in a converted town house on East Fifteenth Street, acquired a lot on Forty-third Street and retained McKim, Mead & White. The Century membership included virtually every living American architect of any distinction beginning with Richard Morris Hunt, a member since 1855. Stanford White, who at thirty-six was by far the youngest of this distinguished cohort, would design the new clubhouse in collaboration with McKim, a fellow Centurian, and their gifted but antisocial assistant, Joseph Morrill Wells.

The Century's rooms satisfied members' requirements for generous accommodations in a homelike environment, while the facade is a testament to White's imagination, knowledge of precedent, and ability to transform historical models into original works of architecture. The

The scale and decoration of entry doors at the Players announce the semi-public incarnation of Edwin Booth's former residence.

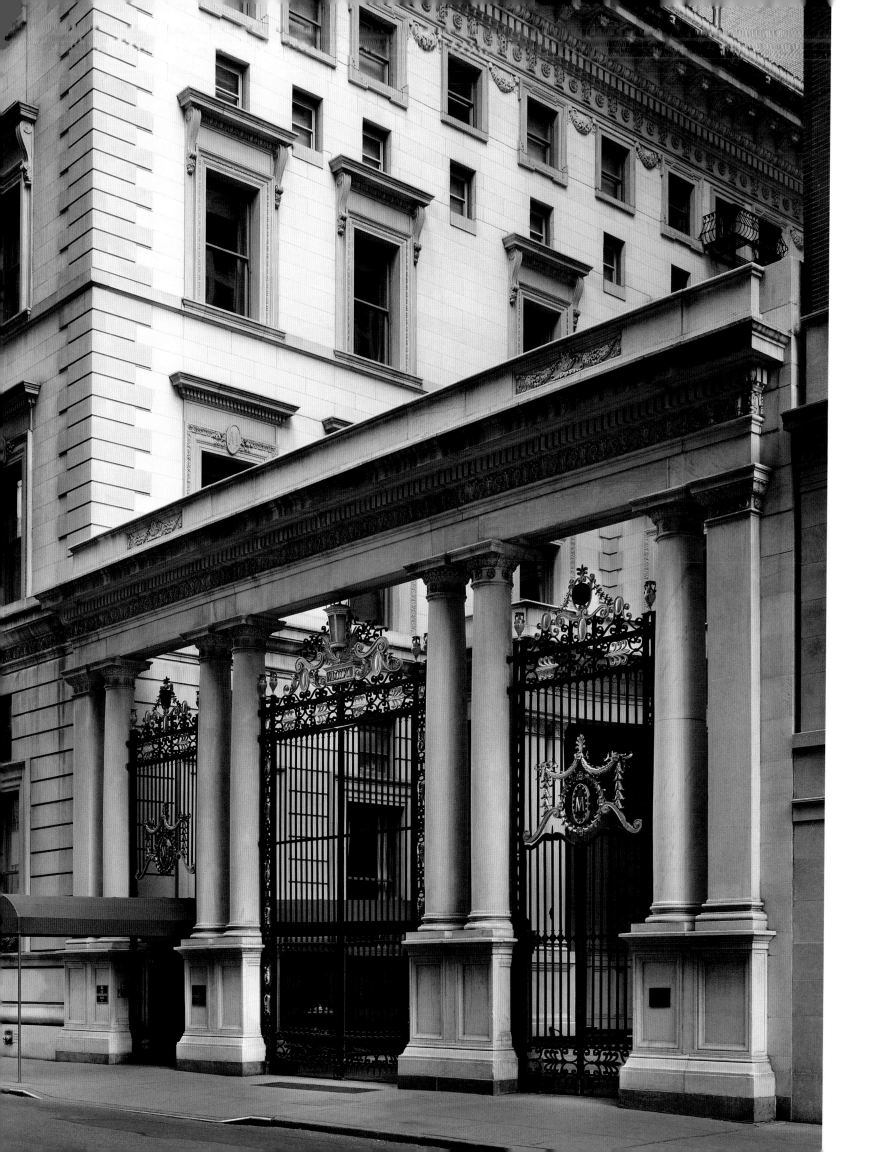

facade was based on the Palazzo Canossa in Verona. Layers of disciplined coursing alternate with eruptions of generous ornament, creating a composition that promised the pleasure of companionship and conversation.

The third of White's important designs for city clubs was the Metropolitan, a club famously founded in 1891 by J. Pierpont Morgan after a business associate was blackballed at the Union Club. White's design for the Metropolitan's facade suggested the wealth, power, and unflinching self-esteem of the membership. The architecture of the clubhouse shows that by 1893 White was firmly on a course to re-create in New York City the splendors of the Italian Renaissance. The commission itself is important as an example of his ability to work with large budgets to satisfy even larger egos, a skill he would employ in the next dozen years on his great country houses.

The Metropolitan's program called for the usual list of major and minor rooms, but twice as grand and twice as many as any other house committee could even imagine. In response to the evolving demands for member services, the program included bedrooms, a bowling alley, and even a space for bicycle storage. Dining was important in all of these clubs, and White made the Metropolitan Club's dining room a destination on the third floor, accessible by an intentionally discontinuous path that led past an impressive row of secondary rooms. Even the site was heroic. One hundred feet of frontage on Fifth Avenue allowed for rooms with unrivaled views of the street and the park beyond. A depth of almost half a block gave White the opportunity to add a gated forecourt to his portfolio of memorable processional spaces.

In 1903 White was retained to design a clubhouse for the Lambs, an association of actors and theater people that preceded the Players by fifteen

The Metropolitan Club illustrates a shift toward greater restraint using subdued ornament, flatter surfaces, and simpler massing. The gates screened the members' private carriage entrance.

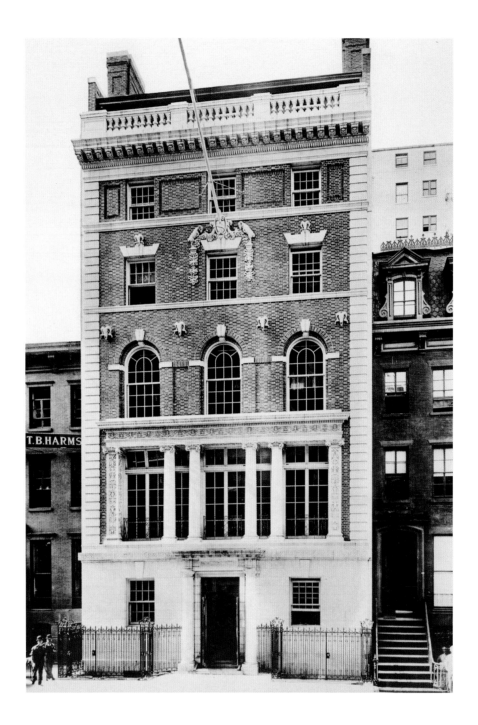

The second floor of The Lambs suggests a freestanding screen that appears to be completely detached from the bank of windows behind as well as the brick wall above, giving the facade remarkable depth.

years. White was a Lamb, and he was well aware of the acting profession's reputation for social eccentricity. White's facade for the new clubhouse on West Forty-fourth Street combined Georgian and federal-revival elements to project a strictly businesslike character, as if to emphasize the orderly nature of the membership rather than its artistic and presumably extremely entertaining qualities. The presence of a theater on the second floor is only grudgingly acknowledged on the street elevation; facades of Broadway theaters promised much greater levels of entertainment.

In 1904 White began work on two city clubs with highly specific memberships. The Harmonie Club had been founded in 1852 as the *Gesellschaft Harmonie* by German-speaking New Yorkers with an appreciation for singing, dining, and bowling, as well as a collective vision of a club for family use. In 1905 the club acquired a midblock parcel on Sixtieth Street and hired Stanford White, possibly as a result of the commission from the Freundschaft Society twenty years earlier.

White's facade for the new clubhouse had to express the deep fraternal bonds of the membership, recall the lyrical activities that had given them so much pleasure in the past, and most particularly avoid competing with

White overlaid Doric, Ionic, and Corinthian orders on the facade of the Harmonie Club to establish three levels of scale within the two-part composition.

The upper half of the Harmonie Club, with its exceptionally enriched frieze and interlocking major and minor orders, is fully visible only from the Metropolitan Club across the street.

(or becoming overwhelmed by) the Metropolitan Club directly across the street. His model was the Palazzo Canossa, a solution he had used fifteen years earlier for the Century. This time a taller clubhouse on a narrower lot required him to transform the palazzo's horizontal composition into a vertical one, but the Harmonie retains the Century's same basic organization as two monumental stories. The modesty of the Harmonie's tall, smooth base establishes a foil to the ornamental swagger of the Metropolitan Club's gates. Pedestrians who looked at the upper floors of the Harmonie were rewarded with a cornucopia of terra cotta ornament.

White faced a different challenge when he had to express the culture and character of the Colony. The club had been established in 1903 by a set of well-connected society women, including Pierpont Morgan's daughter Anne and Charles T. Barney's daughter Helen, who enlisted her father to supervise the construction. To suggest a combination of high purpose and good breeding, White gave the clubhouse a federal revival facade based on eighteenth-century Tidewater precedents. The central entrance is particularly rich in its combination of materials, details, texture, and color. Fragments of broken glass pressed into wet mortar joints add a touch of sparkle to the entrance and connect the architecture of the Colony Club to White's earliest designs.

Increasingly annoyed that all of the clubs they belonged to shut down around midnight, Stanford White and a few of his equally fast-living friends started the Brook. The clubhouse was to be open twenty-four hours a day; according to the club's motto over the mantel, the Brook would "run forever." It would also shift its course. In 1903 White remodeled an existing town house for the club on East Thirty-fifth Street. Two

years later it moved, and White remodeled a second house on Fortieth Street, giving it a sober, almost civic image that was unexpected for a club with such a private purpose.

Outside New York, White designed a range of entertaining and sports buildings in the newly emerging summer resorts and suburban enclaves. Work on the Newport Casino began just after White arrived in September 1879. The casino transformed the architecture of America's eastern seaboard and established the reputation of the young firm, but its

The broad central doorway, slender cast-iron columns, and attenuated windows of the Colony Club animate the Madison Avenue streetscape with their unusual proportions. Damask-like patterns appear in the brick facade and parapet railing above.

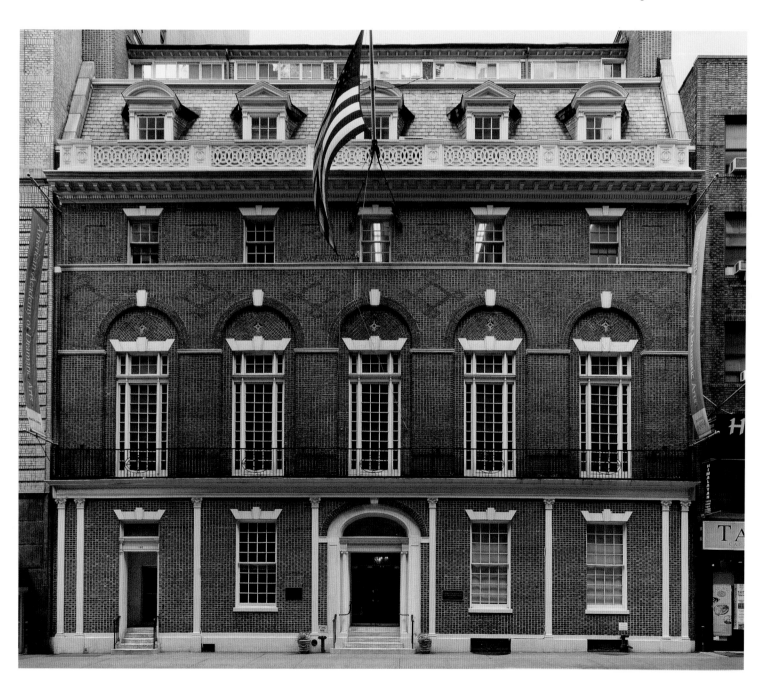

significance lies in more than just a new architectural style. The club was intended to be enjoyed by women as well as by men, an anomaly among nineteenth-century institutions. The connection between site, program, and design was expressed in the distinction between the decorous and responsibly urban street facade and the cheerful, inviting informality of the interior court.

The Short Hills Music Hall in New Jersey may have been the first commission that White brought to the young firm. Short Hills was a planned community, established as a weekend and summer vacation retreat an hour away from New York City. The music hall was conceived by developer Stewart Hartshorn as a true community center rather than a private club, albeit for a community limited to buyers or renters of Hartshorn's properties.

White designed the music hall as a boldly asymmetrical collage of gable and tower set on a rubble stone base. The barnlike massing of the main block suggested generous and inherently flexible spaces within, an appropriate image for an assembly building without a specific program. The Music Hall's cheerful and inviting spirit was expressed by the asymmetrically placed tower and cocked roof, supported by a single, banner-like bracket.

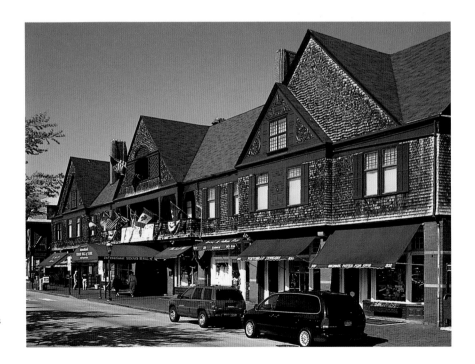

The ornamental relief and scenographic overlay of gables on the main facade of the Newport Casino shows White's interaction with McKim in their first collaboration.

The Narragansett Casino of 1883 reflected a similarly ambitious plan on the part of its developers, including Louis Sherry, to appeal to the more informal (and less prosperous) summer population across the bay from Newport. The program for this more democratic casino featured a veritable catalogue of social spaces, including a restaurant and cafe; dining, card, and billiard rooms; a theater with a full backstage; and a circular space labeled "Palm Room." Connected stone towers spanned the shore road, enclosing an open-air cafe and establishing a municipal image for the private casino that made Narragansett appear to be a one-club town.

Some of White's clubhouses were designed to support active forms of exercise, such as the Brooklyn Riding and Driving Club, designed in

Stone towers and a
monumental arch enclose
the main shore road at the
base of the Narragansett Pier
Casino. The design is said to
have been initiated by White
and completed by McKim.

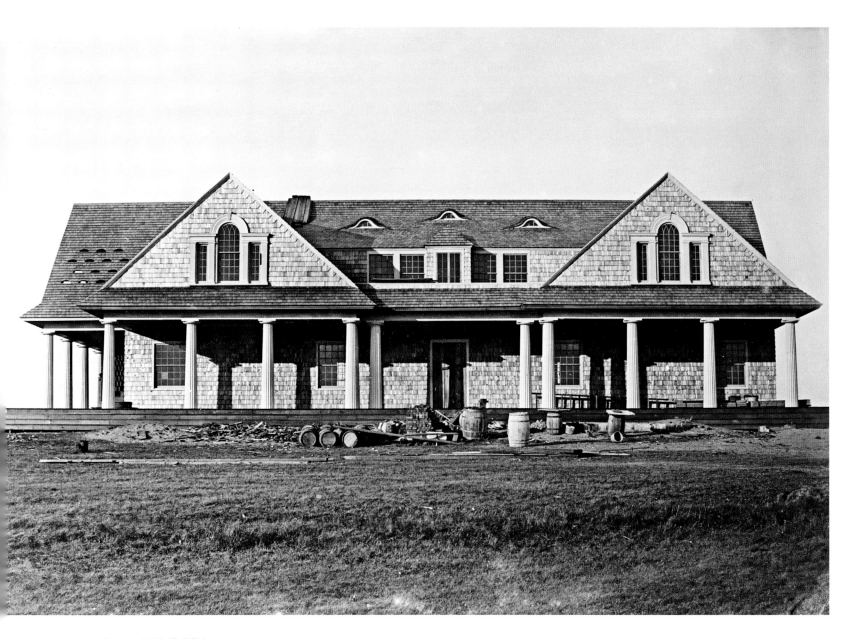

Shinnecock Hills Golf Club during construction. A tight pattern of openings in the roof created a sparkle of light over the west-facing porch.

collaboration with Sidney V. Stratton. Golf, imported to the United States in 1875, was becoming an increasingly popular sport, and White had arranged the open fields around his own country house to accommodate a nine-hole course. Further east, the Shinnecock Hills Golf Club was founded in 1891 by four summer residents of Long Island's South Fork, and as two of them had been clients of the firm, White was asked to design the clubhouse. With no obvious precedents for the building type, the architect took his cues from the extraordinary site, a rolling landscape with distant views of the sea. Except for barns and windmills, the clubhouse would have been the only structure for miles. White

combined the simplest of elements—gables, shed dormers, continuous porches, and baseless fluted Tuscan columns—and the simplest materials—plain shingles and white trim—to evoke the spirit of Arcadia. The details illustrated his emerging regional vocabulary of colonial moldings and six-over-six sash, while delicate federal-revival Palladian windows elevated the structure above the vernacular buildings that had inspired it.

One of White's most interesting designs along the country club model was completed in 1902 for a private client, John Jacob Astor IV, on the grounds of Ferncliff in the Hudson Valley. Astor's casino, intended for the entertainment of weekend guests in all kinds of weather, included an indoor tennis court, an indoor swimming pool, and squash courts, as well as a main hall so large that it that could easily accommodate an entire country ball, all enclosed in a pavilion based on the Grand Trianon at Versailles.

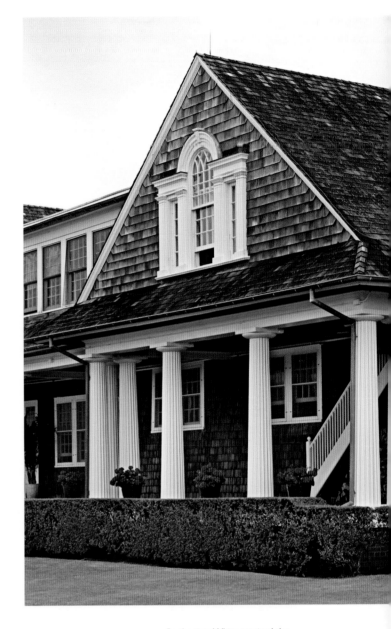

By the time White received the commission for the Shinnecock Hills, he had begun to replace the exuberance of his early shingle designs with a more subdued classical vocabulary emphasizing balance, proportion, and literate details.

McKim was the partner in charge of the firm's work at the 1893 World's Columbian Exposition in Chicago, but White must have had a hand in the planning and design of the New York State Pavilion. The massing and elevations were based on the Villa Medici in Rome; the structure itself contained meeting and assembly rooms wrapped around large central halls on two levels, plus a rooftop garden from which visitors could overlook the entire fairgrounds. The holiday image and welcoming interiors of the pavilion suggest the participation of Stanford White, and by the end of the five-month exposition it had become one of the fair's most popular buildings. Since 1894 its monumental Venetian chandelier has decorated the main hall of the Metropolitan Club.

Overleaf: The scale, proportions, and rhythms of Ferncliff Casino allow the architecture of Versailles to fit into the landscape of the Hudson River Valley.

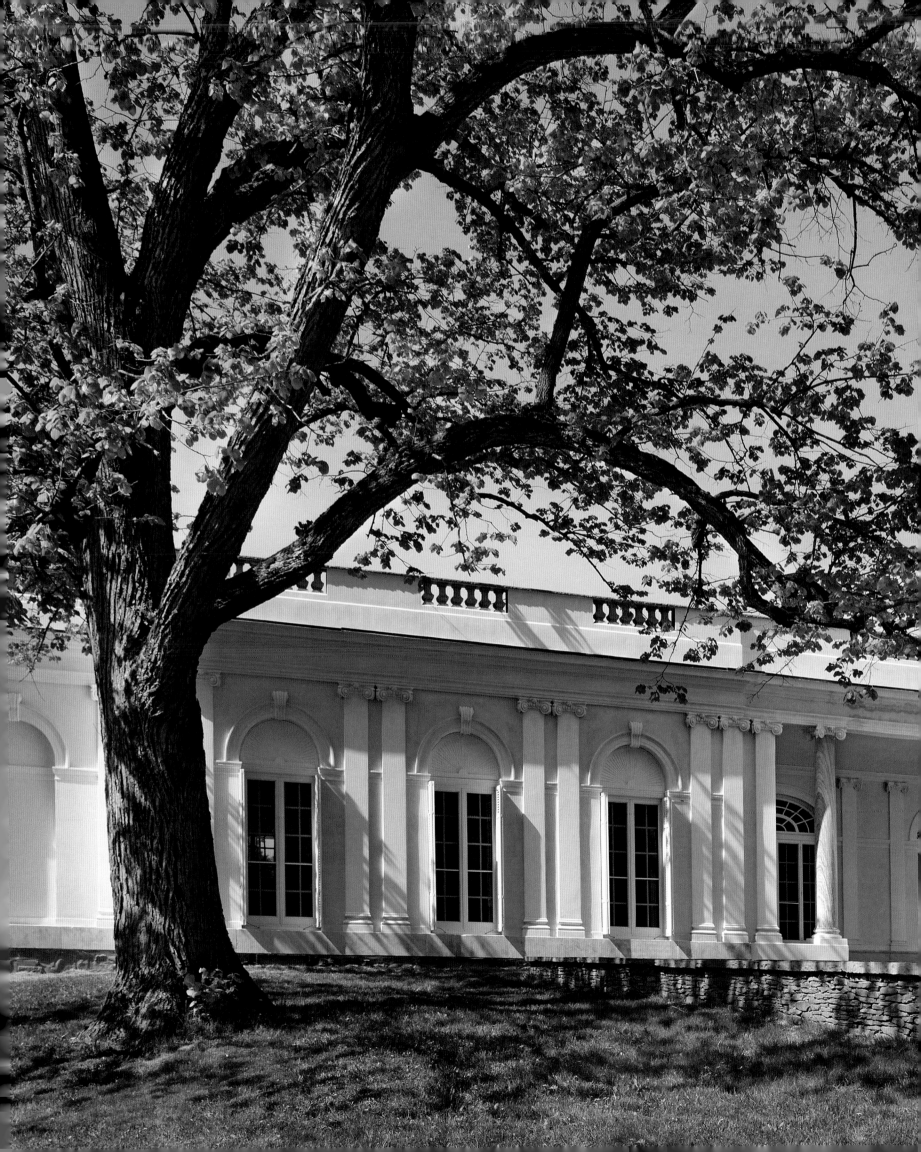

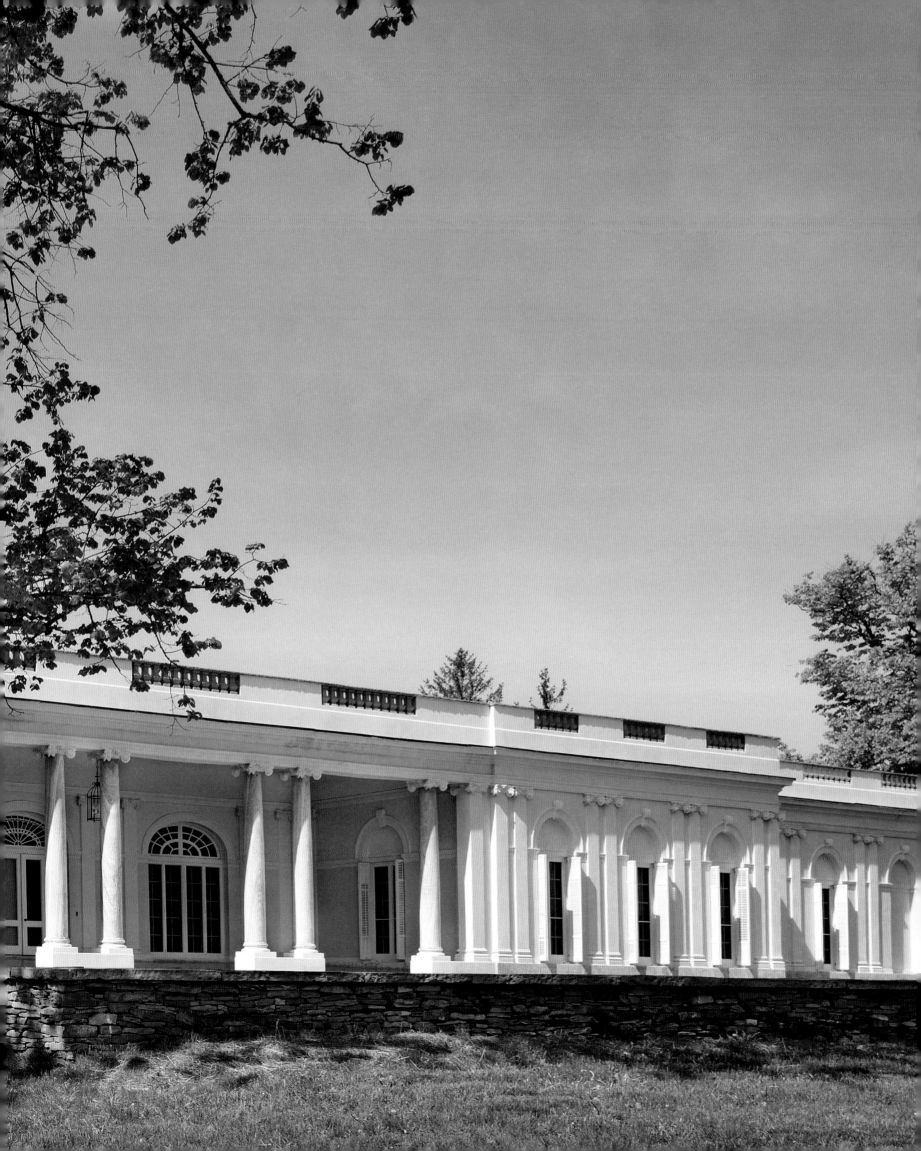

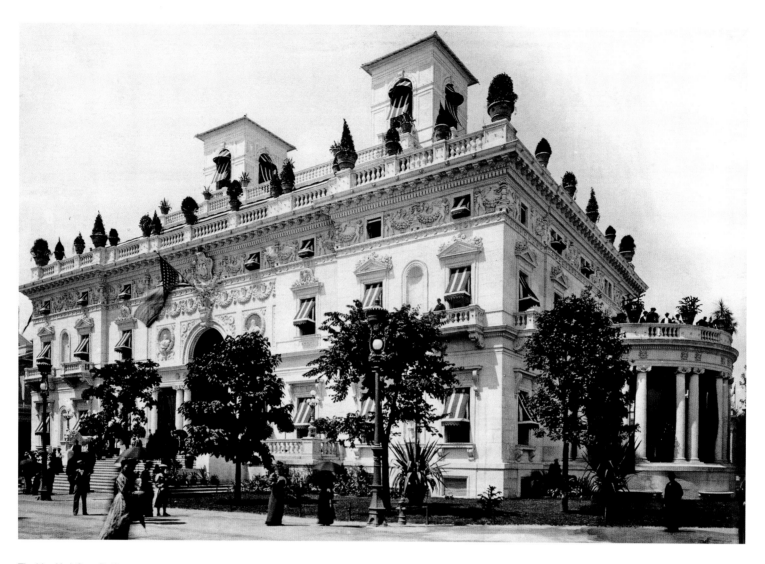

The New York State Pavilion at the Chicago Exposition dominated a street of replica landmarks that included a copy of Philadelphia's Independence Hall. The profusion of ornament, from stucco swags over the entrance to huge flowerpots on the roof suggests that White had a hand in the design.

The same year that the World's Columbian Exposition opened, White began work on his most severely classical design, the Cullum Memorial at West Point. Funds for the building had been a bequest from a former commandant to house artifacts of military campaigns, but the interior plan, with multiple meeting rooms on the ground floor and a large ballroom above, implied a more sociable program. The architectural expression of the memorial, both inside and out, shows how White could adapt his vocabulary to create a dignified social space for an important but atypical population. In retrospect, the Cullum Memorial marked a significant turn in White's portfolio toward a more restrained classicism.

White's talent for creating rooms and buildings as pleasurable settings for assembly has always been recognized, and the delight of occupying these spaces has helped to ensure their survival. A number of

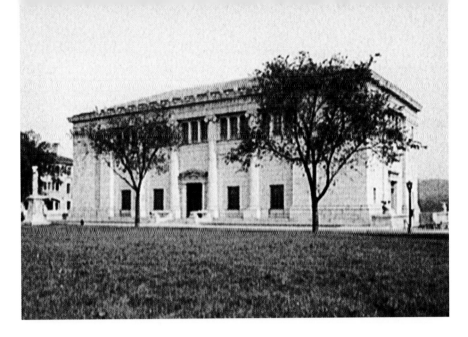

The sober public face of West Point's Cullum Memorial did not rule out animated effects within. The intricate screen of Greek crosses is dissolved by the wash of daylight, a characteristic of White's work from the very beginning.

Library of Congress

designs that were originally conceived for other programs have been successfully transformed into social spaces. Houses for Charles Osborne, Mary Garrett, Robert Patterson, and Elliott Shepard are now private clubs; his villa for Percy Alden served as a union retreat for more than forty years before returning to private hands. Great spaces in other houses continue to serve a social purpose, albeit a more public one, including the Payne Whitney house, Henry Villard's house, and James Breese's Music Room. In some cases the current use overcomes conventional logic. Stanford White could not have imagined dancing in the Bowery Savings Bank, and no one could have predicted that the New York Life Insurance Company's clock tower at 346 Broadway would become a setting for receptions and art exhibits. The successful transformation of a banking hall into a ballroom and a storage attic into a gallery suggests that even the most practical of White's designs was conceived with an exceptionally full measure of delight.

NEWPORT CASINO THEATRE

NEWPORT, RHODE ISLAND

1879–80

*W*ITHIN one month of its opening in 1880, the *New York Times* declared the Newport Casino to be "the leading attraction of the season . . . a success in every sense of the word." The following spring the paper stated that "the Casino proves to be an institution long needed" and then proceeded to identify every family arriving in Newport for the season, a roll that anticipated many McKim, Mead & White clients over the next twenty years. The spectacular growth of the firm's practice can be even more tangibly linked to the list of casino directors: seven of the original sixteen would commission at least one building from the casino's architects. Stanford White could not have chosen a more strategic venue to begin his career.

The overall plan of the casino and the Bellevue Avenue facade are

Dowelled screens, basketweave strips, and pebbledash panels signal White's contributions to the firm's first major commission.

The bell-shaped cap on the clock tower recalls Alden Villa, the casino's exact contemporary. The lamps flanking the entrance reappear on the Boston Public Library.

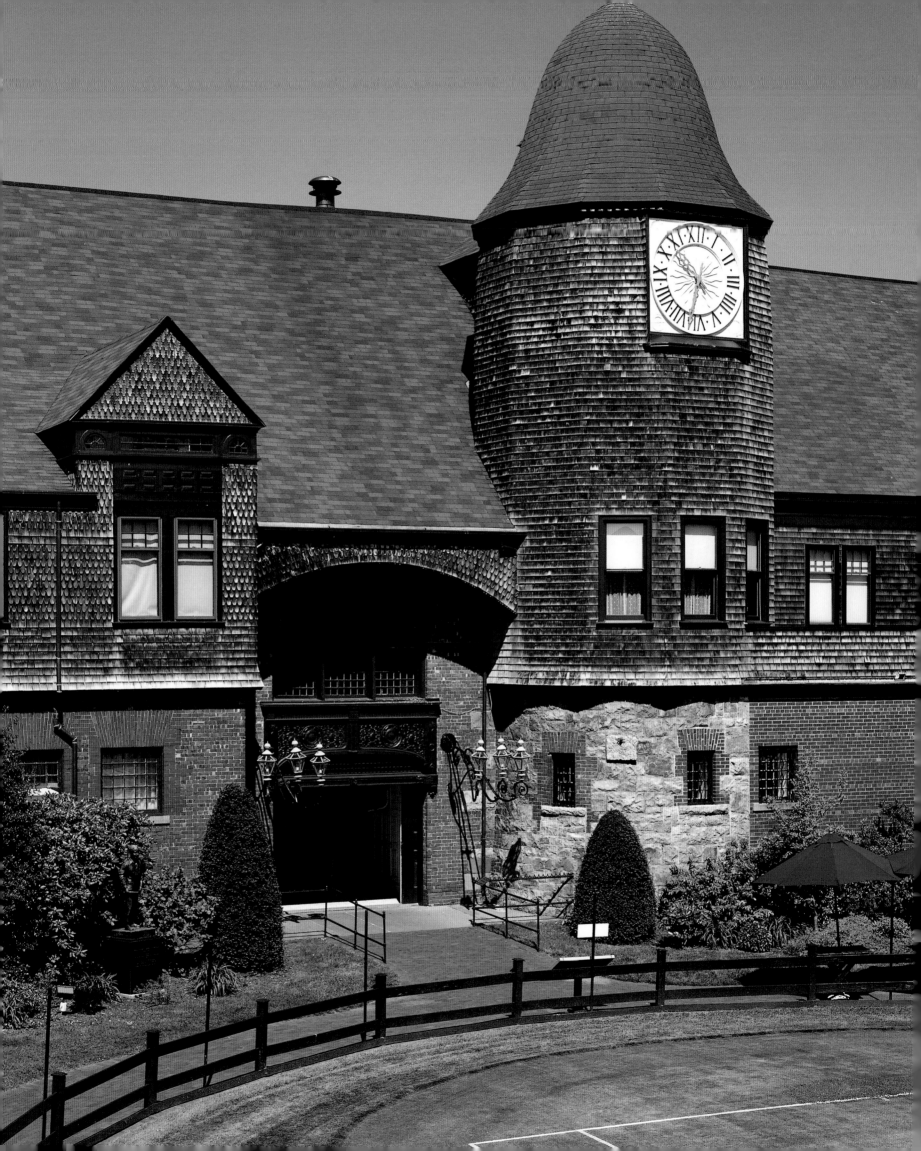

A delicate cornice with a frieze of scallop shells surrounds the entire hall of the theatre. The stencil pattern of the arch and the reeded basket-weave are unique to the proscenium.

generally attributed to McKim; the courtyard, exterior details, and interiors are considered the work of Stanford White. Over the course of a frantically busy first winter, White also designed the club rooms, with their mixture of aesthetic movement details, finishes, and colors, and the Casino Theatre, a four-hundred-person assembly room. From the very first season the theatre was heavily used by members and regularly covered by the press as a setting for biweekly dances; professional productions of drama, comedy, and light opera; and occasional amateur theatricals, including plays written by (and sometimes starring) casino member Julia Ward Howe. Sunday evening concerts of "sacred music" were an attempt to circumvent puritanical attitudes that was not appreciated by Newport's clergy. While the casino normally closed for the season in October, the theatre was reopened at least once for a spectacular New

The walls of the lower story were given a relatively plain treatment that allowed the audience to become the ornament at floor level, an approach that must have been particularly effective when the room was used for dances.

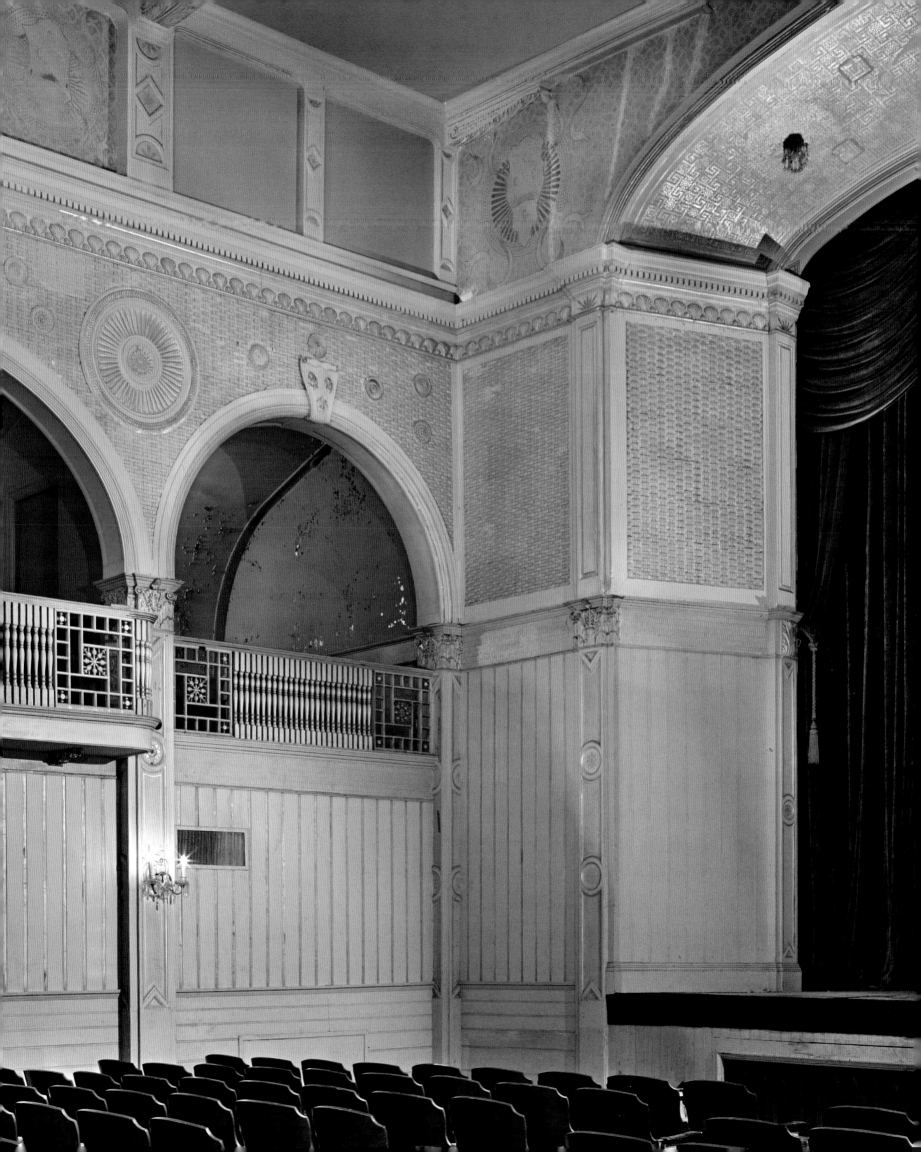

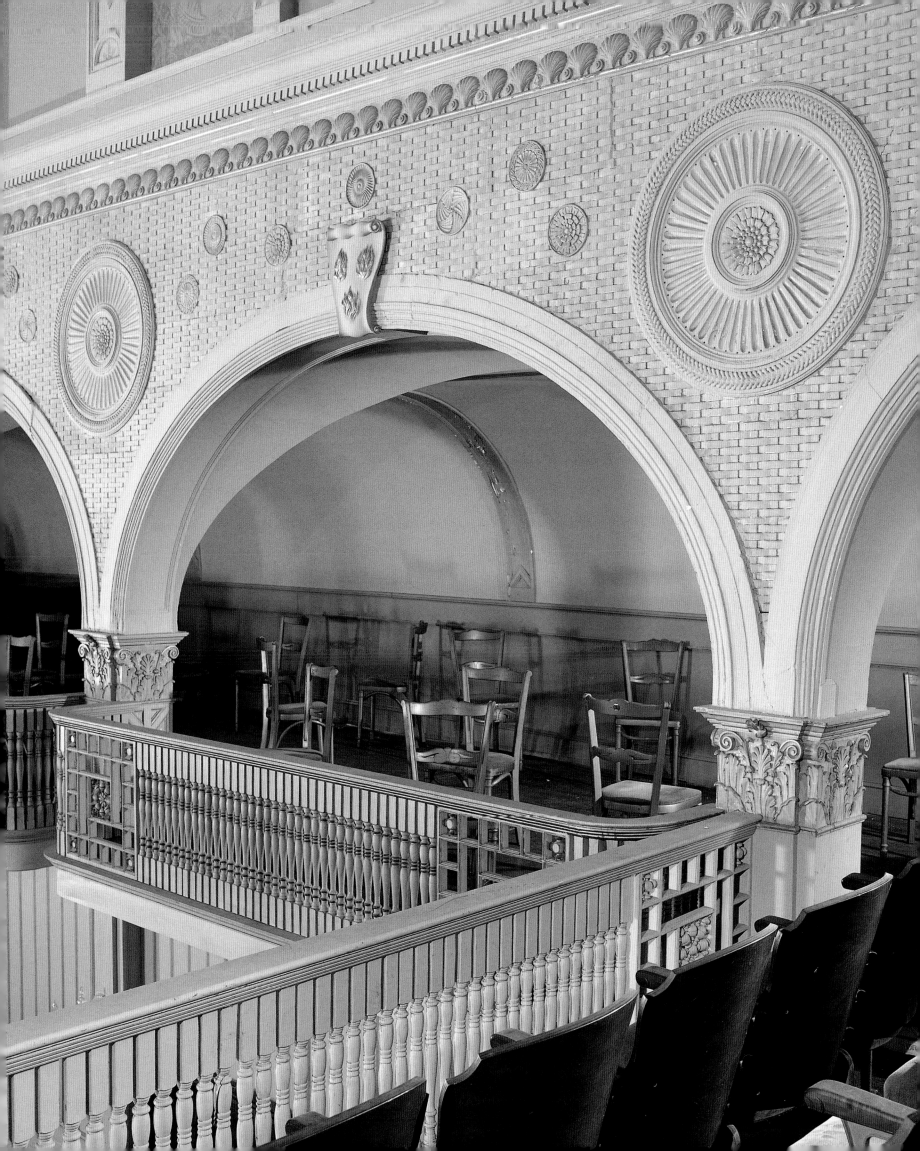

Plaster cast medallions and basket-weave panels of the upper walls match those of the library at the Seventh Regiment Armory, which White completed the same year.

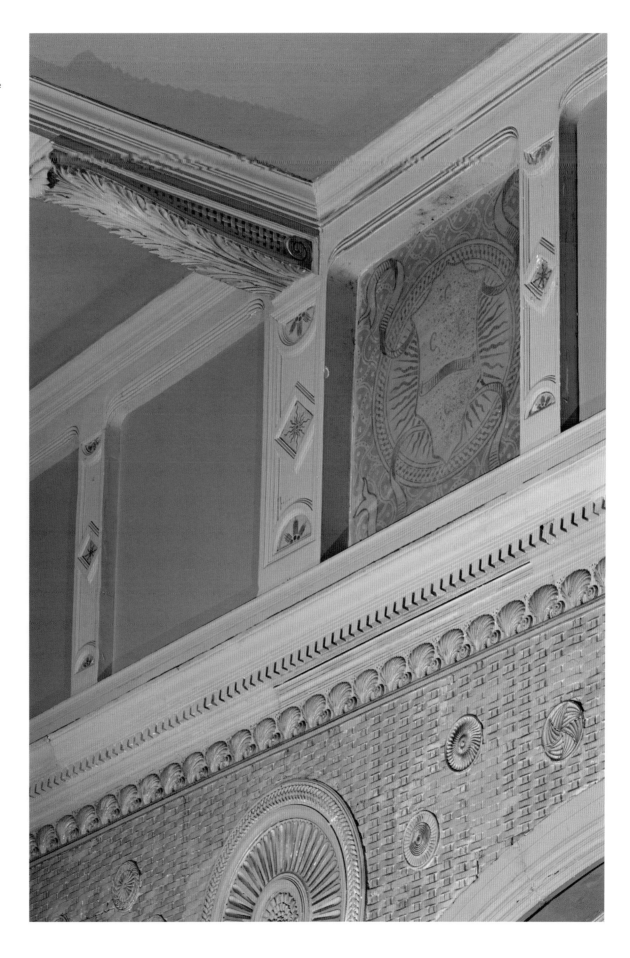

The interiors do not follow any established style; White combined references to multiple periods with original decorative patterns.

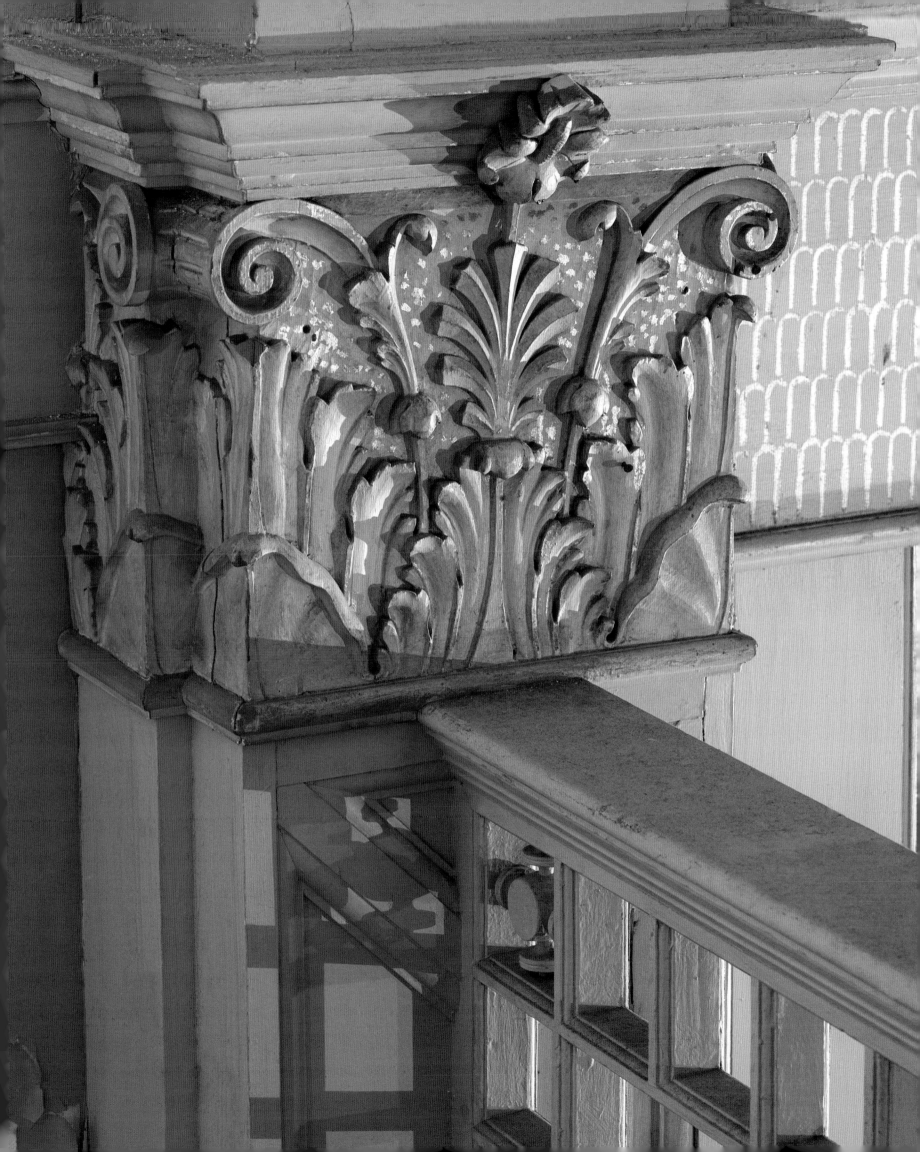

Year's Eve ball in 1884.

The theatre was realized as a simple shingled box set at the rear of the casino property, separated by the width of a single tennis court from the court-tennis building. The two buildings were joined by a bi-level porch facing the main part of the complex and trimmed with the casino's signature lattice screens. The balconies provided lobby space for intermissions, spectator viewing for lawn-tennis matches, and, according to the *Times* reporter, a popular site for flirting between dances.

The interiors of the Casino Theatre illustrate the best of Stanford White's imagination, his appreciation for the European architecture he had just spent a year sketching, and his earliest collaborations with Richardson, McKim, and Tiffany. A ceiling subdivided by a grid of beams springs from a continuous cornice set three-quarters up the wall, the basic organizing device of White's earliest designs for important rooms. Giant arches with Renaissance casings and baroque keystones flank the two long sides of the hall, supported by an order of square columns and Corinthian capitals. Balconies pinched between arches project into the main volume of the space. On Monday and Thursday nights townspeople could pay one dollar to sit on the balcony and watch casino members dancing on the floor below.

The decorative motifs combined characteristic aesthetic movement details with White's more personal vocabulary. Woodwork was enriched with Jacobean and Italian Renaissance moldings. Circular medallions in two sizes were superimposed on a faux basket-weave under a frieze of scallops and spiral shells. Rows of Georgian spindles on the balconies alternated with Chippendale panels inset with Moorish scrollwork.

The color scheme was as lighthearted as the architecture: gold emblems surrounded by light blue panels covered the ceiling and upper walls. Ivory-painted woodwork was accented with splashes of gold. The balcony walls closest to the proscenium were finished in the same metal color, one of a series of similar effects that would eventually inspire the critic Mariana Griswold Van Rensselaer to suggest changing the name of the firm to "McKim, Mead, White & Gold."

Up close the carving and gilding has the character of theatrical makeup, but its overall effect on the room was magical. The pattern of fish scales appears in many of White's early designs.

THE PLAYERS

*F*ROM AN architectural perspective, the adaptation of 16 Gramercy Park South from residential to institutional use is remarkable for the degree of complexity that Stanford White was able to introduce in an existing row house. Working within the confined geometry of two party walls, he created settings for a host of fraternal activities in an intricate combination of spaces, which range from large to small, grand to informal, and festive to contemplative. The transformation is also significant for the degree of intimacy that the architect preserved within a semipublic building.

The clubhouse had always possessed a domestic scale. Constructed in 1847, the house had been purchased in 1888 by Edwin Booth, the first great American actor, to share with his fellow actors as a place for lounging, dining, and reading, with bedrooms for transients. Stanford White, who had not yet established a reputation as a club architect but who had altered a number of houses in the neighborhood, got the commission in August 1888.

White removed the tall brownstone stoop, relocating the entrance to

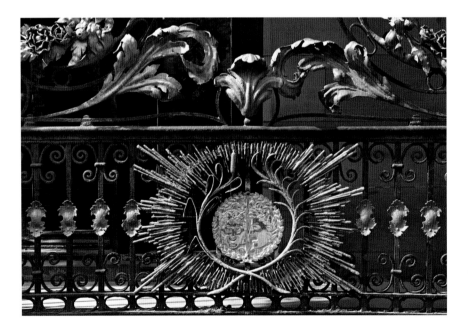

Gilding on hammered metal gives the balcony a triumphal air.

The Renaissance mantel and massive ironwork suggest princely power within a domestic setting.

244

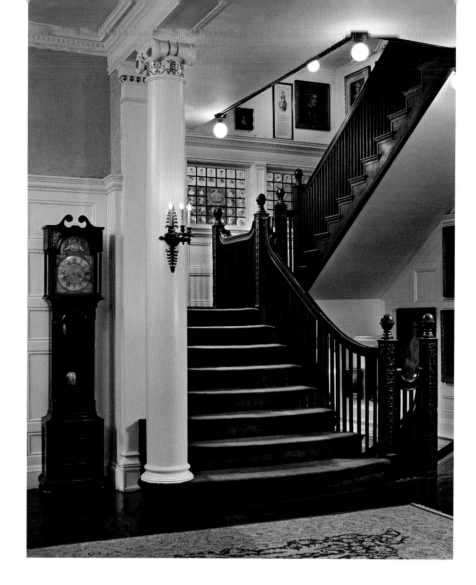

At the Players, even the staircase is allowed to make a dramatic entrance.

the lower level, a strategy that would become his standard approach for town house renovations. Given the building's new institutional use, the intervention made perfect sense, since it removed the cloakroom facilities from the *piano nobile*, liberating the best floor for formal club use. With the low ceiling height of a brownstone basement, White's compact entry hall has far more charm than space, but it somehow manages to accommodate a porter, coats, umbrellas, and packages, as well as a box for incoming mail that, for a variety of reasons, members might prefer not to receive at home. A newel post carved with a bust of William Shakespeare guarded a narrow staircase with access to the upper floors.

The miniaturized entry establishes a foil to the central hall half a flight above, which is far grander than one might expect. White forced the scale of the hall by introducing an exceptionally broad staircase to the upper floors, subdividing the space with columns that emphasize the high ceilings, and installing a palazzo-sized mantel. The other spaces on

A mask of Apollo decorates the ceiling of a sitting room raised to accommodate the vestibule below.

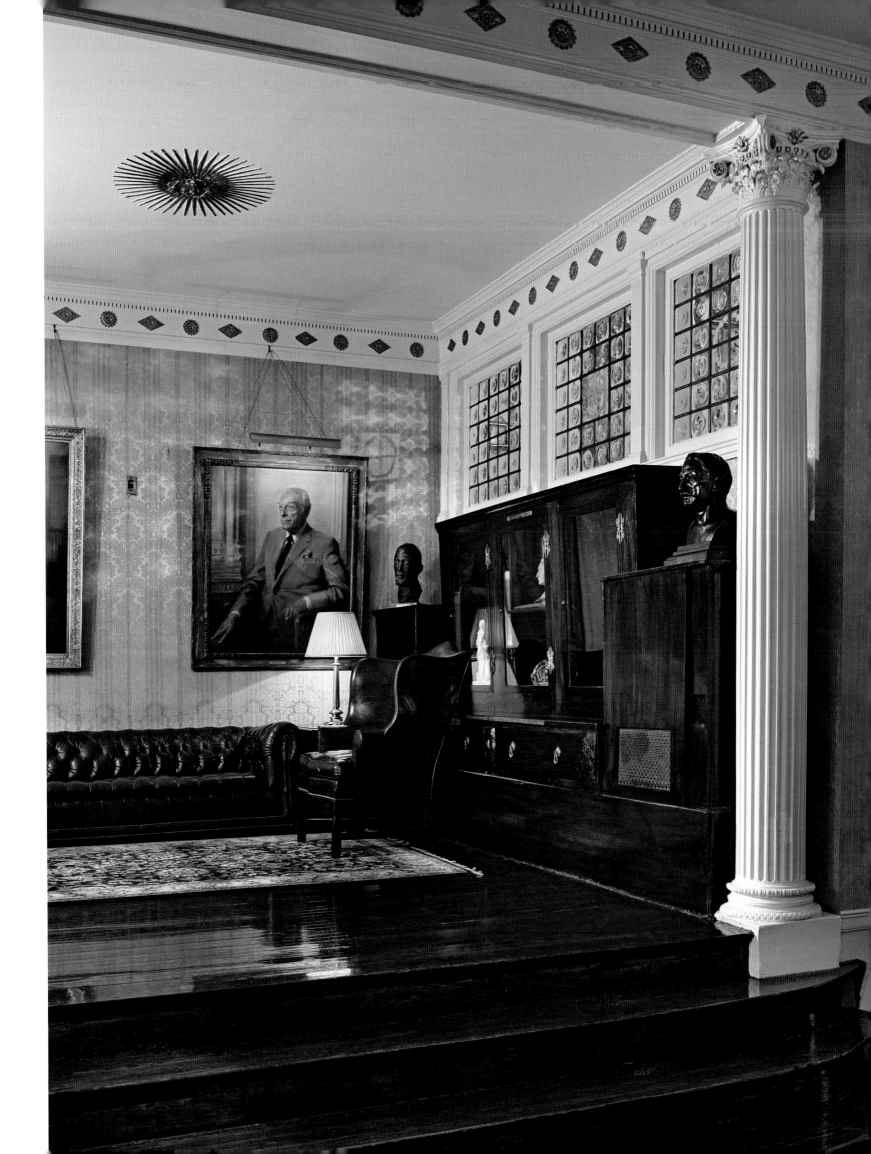

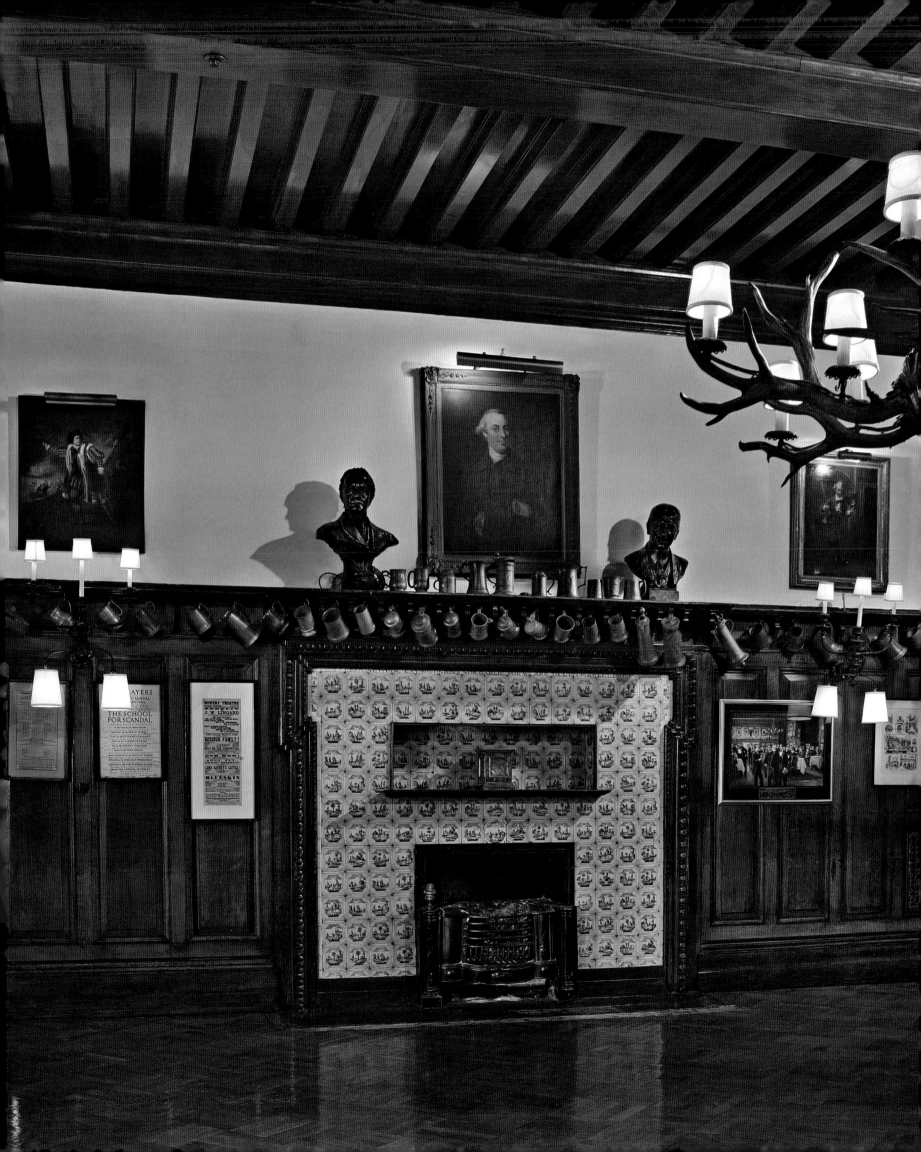

While the bust of Shakespeare honors England's Renaissance, the robust woodwork throughout the club recalls English architecture from the medieval to the baroque.

The tiled mantel and its matching twin bracket the ends of the original dining room. The built-in niche above the fireplace is typical of the firm's early designs.

the second floor possess a more intimate scale. The club dining room in the rear is framed by twin fireplaces with Delft-tile surrounds, and a pair of small, connected lounges overlooks Gramercy Park. One of these is raised a few steps to accommodate the entry below. The grand staircase assumes more appropriate dimensions to lead upstairs to a library and card room. On the fourth floor, Booth retained a suite of rooms overlooking the park.

With the stoop removed, White added a continuous balcony at the second floor, affording the actors a protected outdoor vantage point from which they could drink or dine while surveying—as if in a private box at the theater—the civilized streetscape of Gramercy Park.

THE CENTURY ASSOCIATION

NEW YORK

1890–91

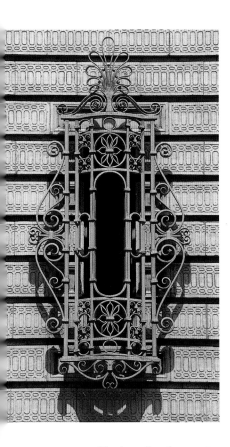

The decoration of terra cotta walls and iron grilles seems to be inspired by embossed leather book covers more than by traditional building materials.

*T*HE CENTURY ASSOCIATION had been incorporated "for the purpose of promoting the advancement of art and literature by establishing and maintaining a library, reading room, and gallery of art." To that noble program the 1889 House Committee planning the new clubhouse added a congenial roster of spaces for eating, drinking, and playing billiards. The character of each activity would inform its location as well as its degree of accessibility. A top-lit art gallery stretching across the rear of the lot was set over an appropriately subterranean billiard room. The gallery opened off a landing near the entrance so that artist-members could exhibit their work to an invited public without violating the clubrooms above. The three-story route through the building terminated in the sacred precincts of the dining room and the library, a two-story space that housed all of the literature that Centurions could be expected to read or write.

The architecture of the clubhouse is full of slight irregularities, highlighting the differences between McKim's paradigm of clarity in processional architecture and White's infatuation with its subtleties. The misalignment of cross-axes introduces an underlying informality to suites of individually grand rooms, a strategy that may reflect the members' request that the new clubhouse be "home-like." The second-floor hall—with its broad, twin staircases, its screen of monumental columns with gilded bronze capitals, and its imposing niches for classical statuary—is the most formal and imposing of the interiors, but it introduces a second and unexpectedly grand entrance hall a full floor above the actual front door. The scale becomes increasingly intimate during the ascent through the building, an effect that the architects reinforced by disconnecting the stair leading to the third floor from the stair down to the first. The interior decor evolves in parallel, from the sturdy mosaic floor of the lobby to the comfortable wood paneling of the library and dining room. In general,

The original rendering illustrates the open loggia (since enclosed), a full row of granite bollards (since removed), and finials on top of the upper balustrade (possibly never built). Half of the elaborately framed oculus windows at the fourth floor opened onto the kitchen.

The Century Association

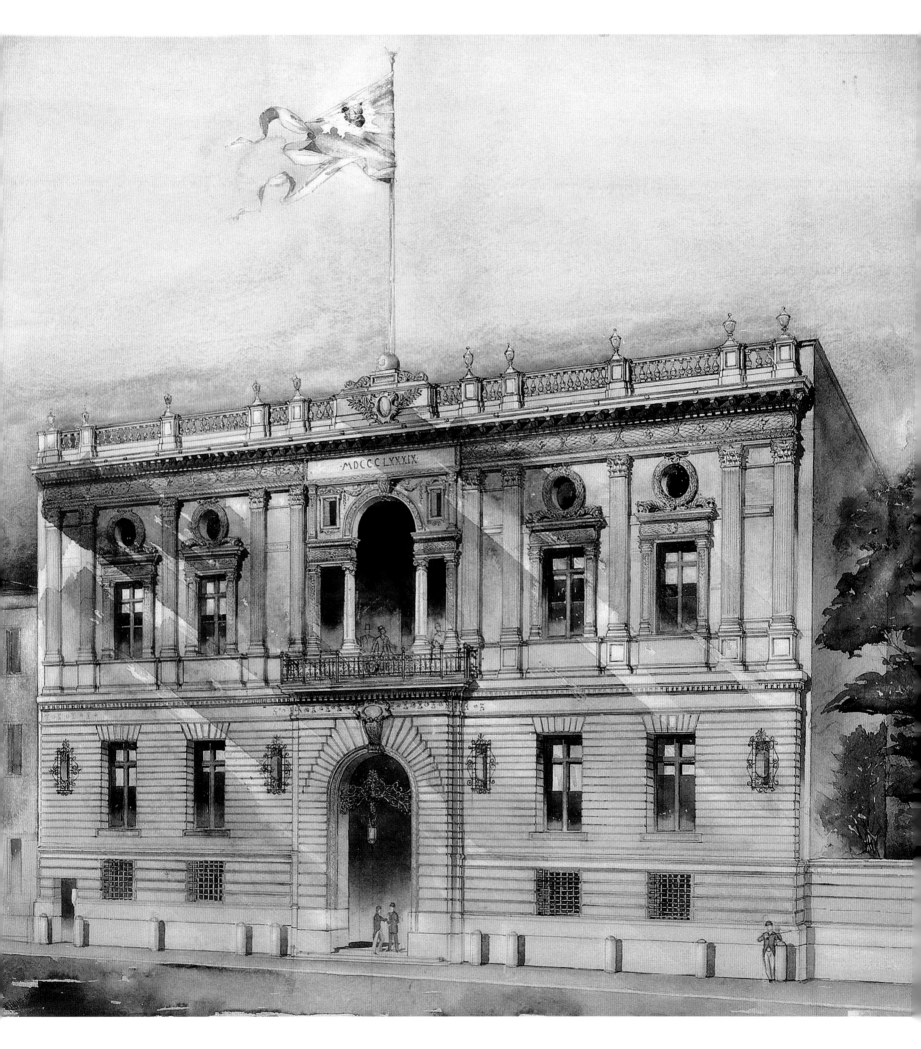

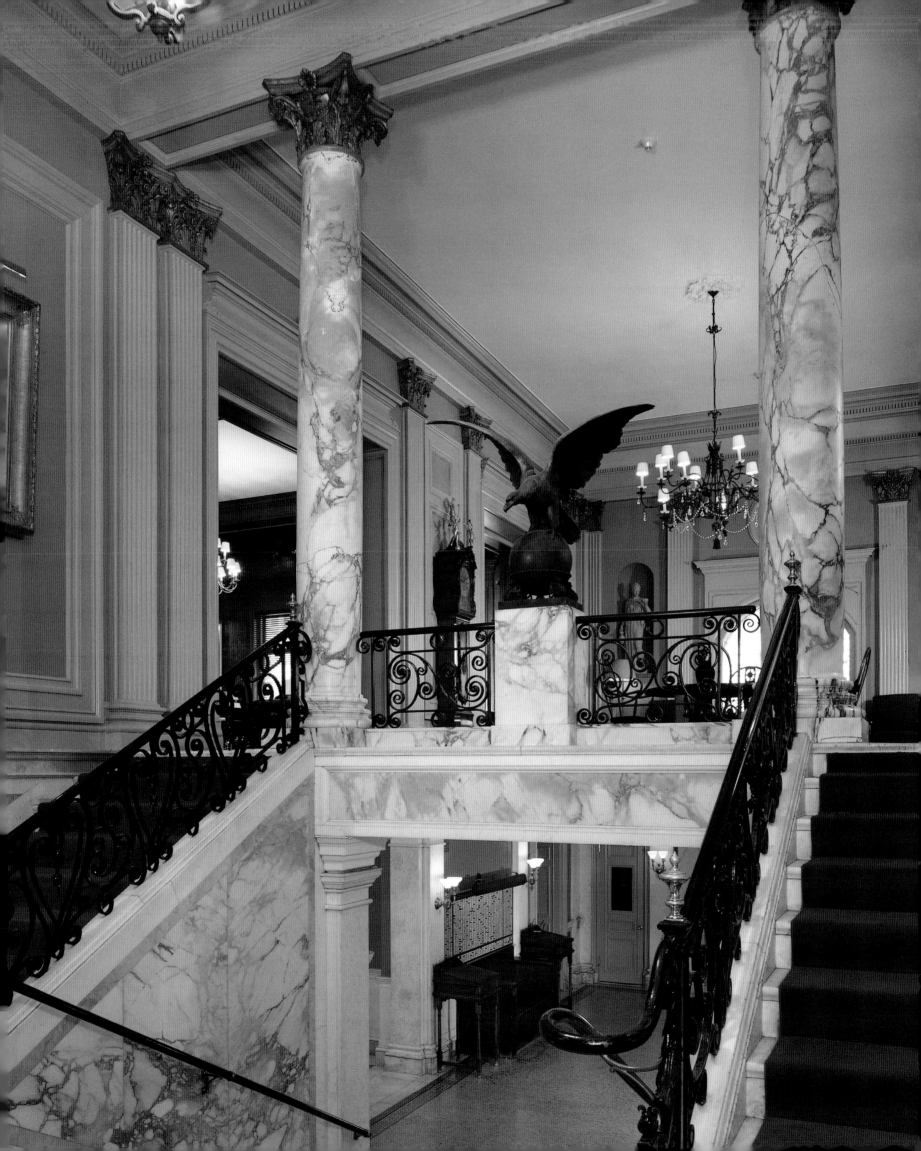

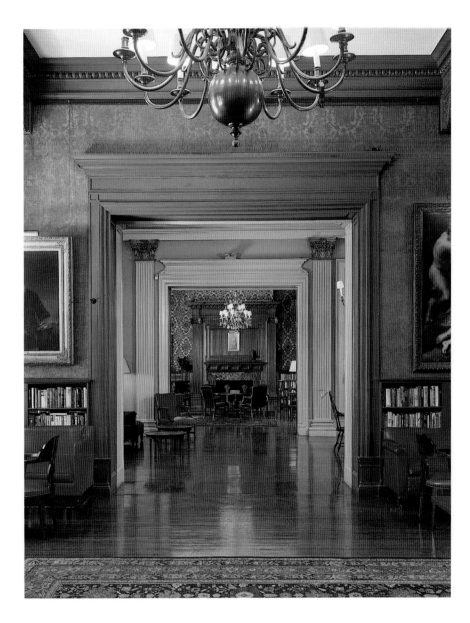

The main club rooms on the second floor are characterized by oversized openings and an impressive ceiling height. The paneled surround of the fireplace in the music room extends the enfilade of doorways.

Marble on the walls of the lower staircase becomes a screen of freestanding columns, making the stair an element that both separates and connects the entry below and the private realm above.

the decor of the clubhouse is characteristic of White's transitional period, when an increasingly classical vocabulary was gradually replacing the inventions of his early interiors but without the high level of restraint that distinguished his mature designs.

White based the principal facade on the Palazzo Canossa in Verona, a precedent that allowed him to express four floors of program as a monumental two-story structure. Strong bands of horizontal layering rise with progressively richer surfaces, culminating in a high floor of exceptionally figurative windows topped by a densely embroidered frieze, cornice, and balustrade. White collaborated with Joseph Morrill Wells on the details of the elevation, which is saturated with the rich textures,

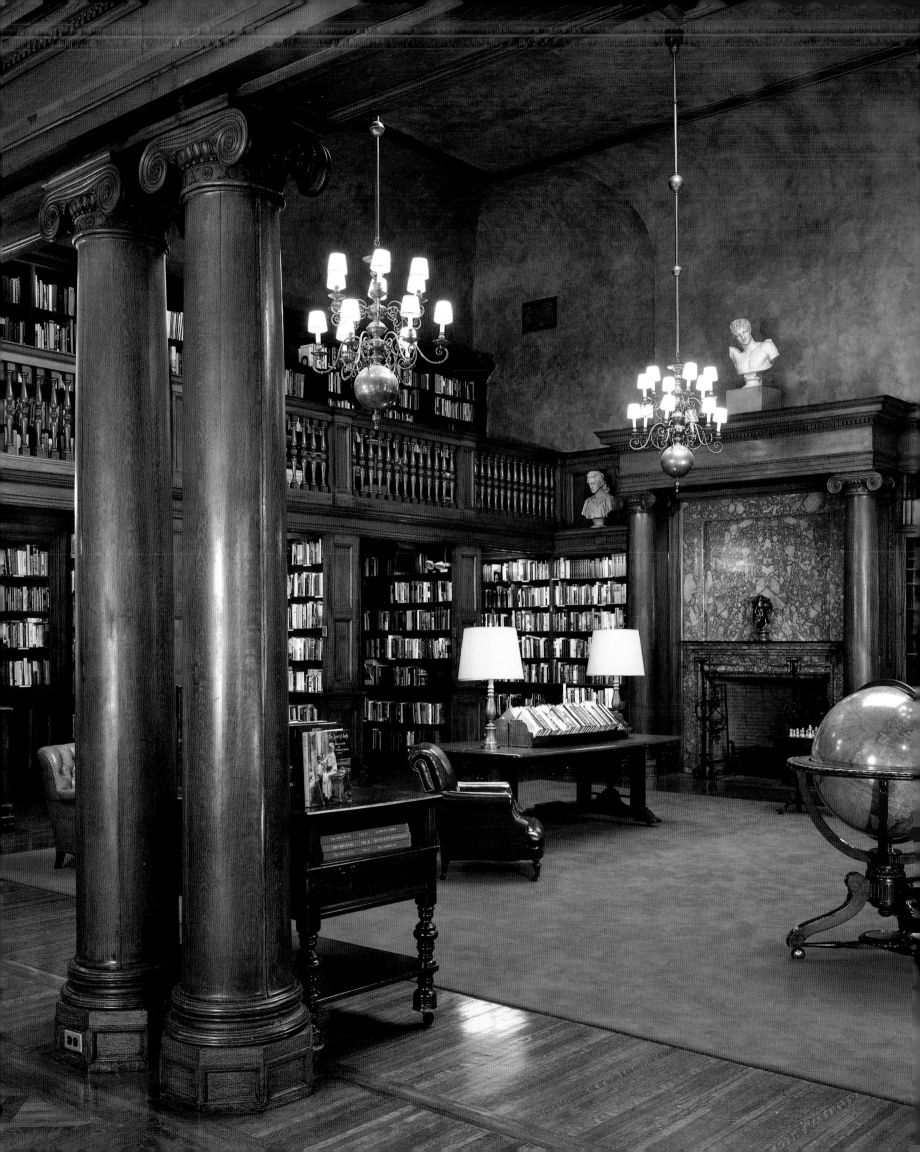

The Century's facade was inspired by Palazzo Canossa and the manner in which multiple floors in the high basement are subordinated to enhance the *piano nobile*.

The library depends on the bookcases and mantels for both ornament and scale. Half of its volume consists of empty air and smooth plaster surfaces.

materials, and colors that White used throughout his career—elaborate ironwork, figurative marbles, and expressive rustication, presented in a palette dominated by pale yellow, ivory, and cream.

The texture of the walls was achieved not with stone—which is limited to smooth granite at street level—but with architectural terra cotta. The commission arrived in a period when White was experimenting with terra cotta to animate the exterior of Madison Square Garden and other commercial structures. The Century facade shows his ability to control the nearly unlimited freedom offered by that material.

METROPOLITAN CLUB

I prefer individually these plans to any I have yet seen. They do not embrace some of the grand features that yours do but for practicability I think they will answer every purpose. I have worked long and hard on them for the past week.

White balanced the formidable mass of the clubhouse with a significant volume of open space, screened by an exceptionally transparent gate.

*I*N THE COURSE of his career Stanford White wrote many similar letters, but it must have been quite a shock to receive this one. The January 31, 1892, letter from Paris was accompanied by plans for a new clubhouse based on a *hôtel particulier*. Regardless of the merits of the proffered design, the document created a dilemma. White had been working on another scheme for more than six months, and construction had been underway since September. The writer was William K. Vanderbilt,

The impressive size and projection of the cornice become evident in comparison with the windows below, but the scale is carefully controlled so that it does not overwhelm.

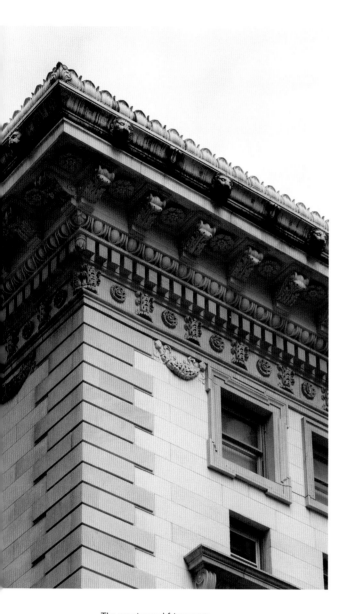

The cornice and frieze were adapted from the Palazzo Farnese in Rome, while the balcony, lanterns, and other details were inspired by less specific Italian Renaissance models.

founding member of the Metropolitan Club, one of the world's richest men, and an individual who could expect his suggestions to be treated as commands.

In this case the architect was well protected. White's scheme had the support of three key members who were also clients of long standing: J. Pierpont Morgan, founder and first president of the Metropolitan Club and the largest stockholder in the Madison Square Garden Corporation; William Watts Sherman, cofounder of the club and White's client since his Richardson days; and Robert Goelet, chair of the Building Committee and friend and faithful patron of Stanford White.

The Metropolitan Club had been founded less than a year earlier by a group of New York's wealthiest citizens seeking an environment where they could meet their peers in splendor and comfort. Within months the founders had acquired a large parcel of land at the corner of Sixtieth Street and Fifth Avenue, hired an excavation contractor, and selected Stanford White as their architect. The building was expected to be expensive, and White fulfilled all expectations with one of his best designs.

The club's program specified a living room spanning the Fifth Avenue frontage with windows overlooking Central Park. White created a matching dining room on the third floor, collaborating with Gilbert Cuel on the decoration. The library was assigned to Herter Brothers, but White alone was responsible for the main hall, a space more than forty-five-feet high, with floor, columns, and walls rendered in white marble. Book-matched slabs framed by a grid of matching marble establish the scale of the tall, smooth walls. With the exception of W. H. Jackson's black ironwork and Maitland Armstrong's stained-glass windows, virtually every remaining surface, including panel moldings, column capitals, and elaborately coffered ceiling, was gilded.

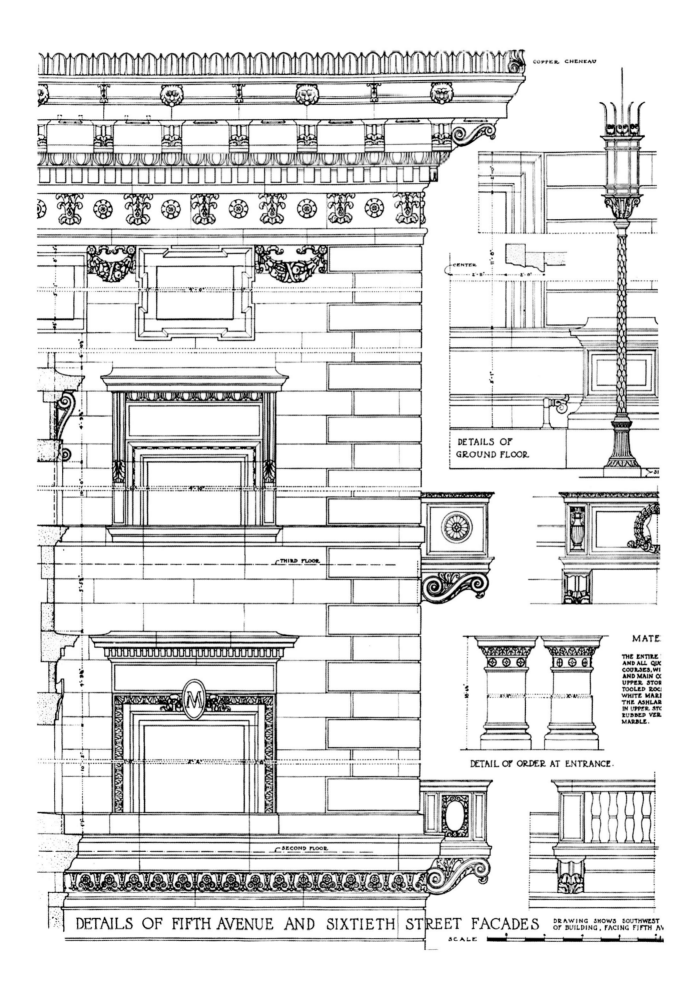

COPPER CHENEAU

CENTER

DETAILS OF
GROUND FLOOR

THIRD FLOOR

SECOND FLOOR

MATE

THE ENTIRE
AND ALL QUO
COURSES, WI
AND MAIN CO
UPPER STOR
TOOLED ROC
WHITE MAR
THE ASHLAR
IN UPPER STO
RUBBED VER
MARBLE.

DETAIL OF ORDER AT ENTRANCE.

DETAILS OF FIFTH AVENUE AND SIXTIETH STREET FACADES DRAWING SHOWS SOUTHWEST
OF BUILDING, FACING FIFTH AV

SCALE

259

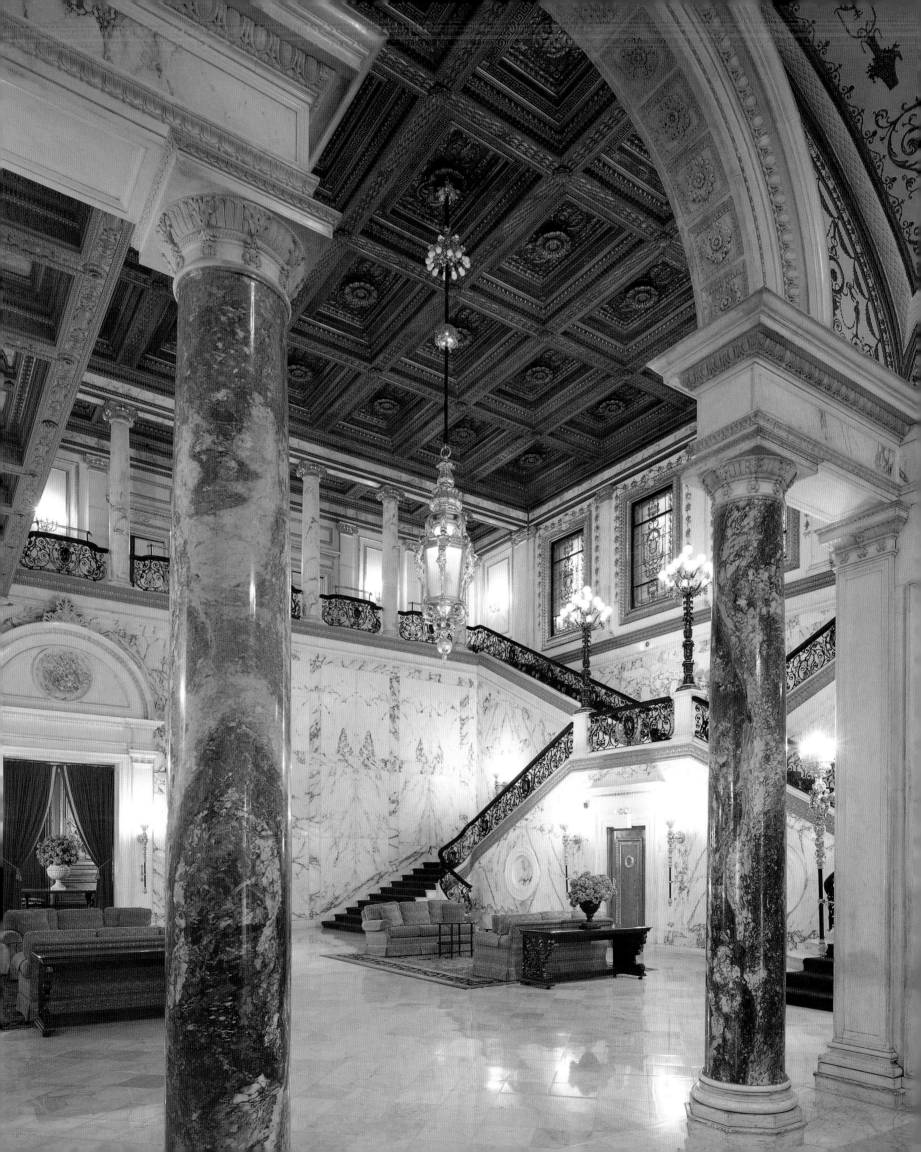

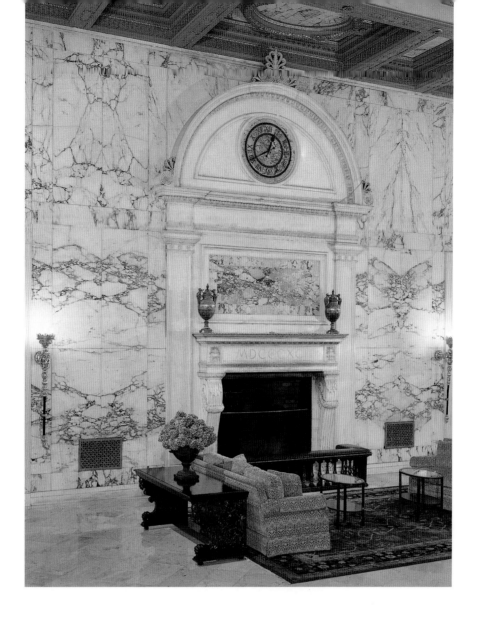

The decoration of the main hall combines High Renaissance opulence with the simpler geometry of the cinquecento. Slabs of veined marble on the walls are organized within a nearly invisible grid.

The white marble exterior projected the same level of power but with considerably more sobriety. White based the elevations on general Renaissance prototypes. The frieze alluded specifically to the Palazzo Farnese in Rome, but the overall image of the building relates to the London clubs of Charles Barry and Decimus Burton. Because the clubhouse had to command the open spaces of Central Park and Grand Army Plaza, White deliberately overscaled the projecting cornice.

At the eastern end of the property, White set an open, convex courtyard, the building's most original feature and the private club's most generous contribution to the streetscape. The rear corners of the baroque volume were filled with two entrances—one for members, and a second leading to a dining room reserved for women. The courtyard and its activities were protected from the street by a decorative screen consisting of a full marble entablature and elaborate wrought-iron gates.

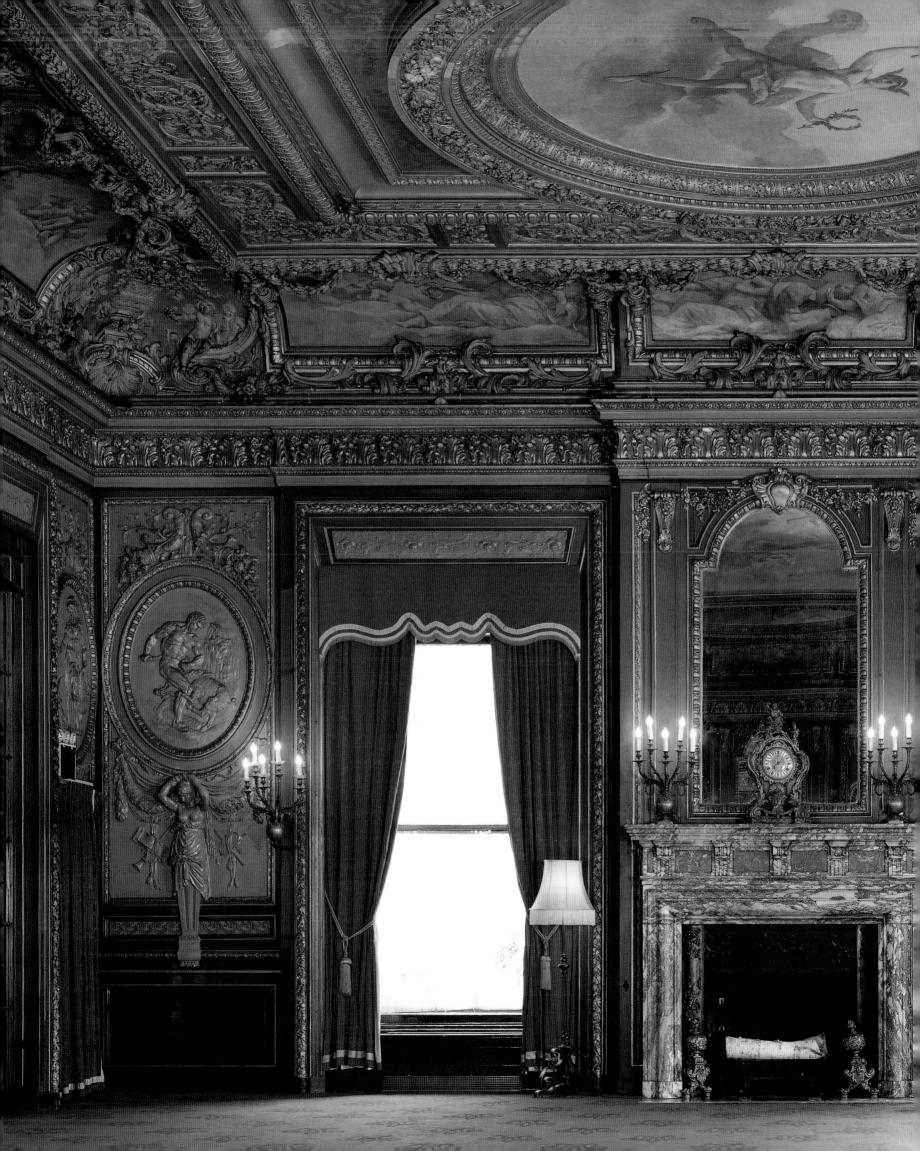

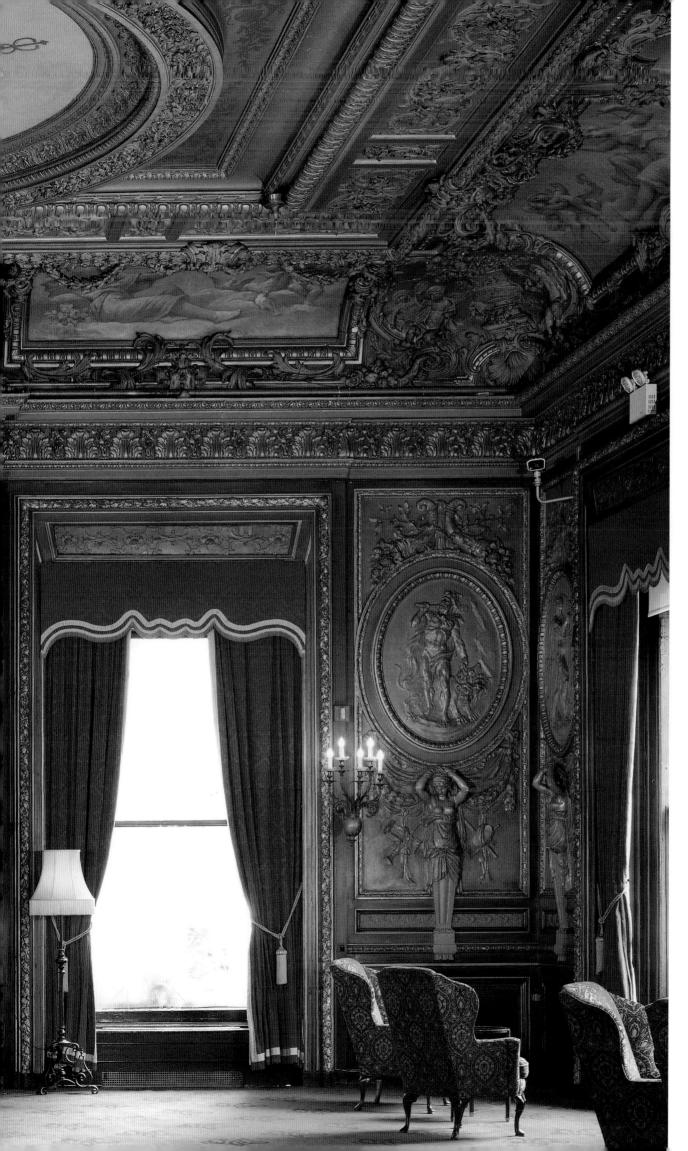

The west lounge on the first floor features allegorical panels celebrating the Labors of Hercules. The height of the sconces and female figures acknowledges the human scale of the members.

263

FERNCLIFF CASINO

RHINEBECK, NEW YORK

1902–04

*I*N MARCH 1902 John Jacob Astor IV retained Stanford White to design a playhouse for Ferncliff, the Astor country seat in Dutchess County. Satisfying the architectural needs of America's most fortunate citizens had presented Stanford White with extraordinary opportunities, but the very rich were not a class noted for their patience, and White had to get something down on paper quickly. To impose some degree of architectural coherence on Astor's unique program, White borrowed a solution that seemed to be working well in a parallel commission.

White had quickly resolved the arrangement of interior spaces and

The original plans called for a rooftop viewing pergola accessed by this stair. The alternating spindles connect the banister to the firm's colonial revival designs.

Arched doorways establish a powerful rhythm on the four walls of the central hall while the combination of clear glass and mirrored panes obscures the physical limits of the monumental space.

264

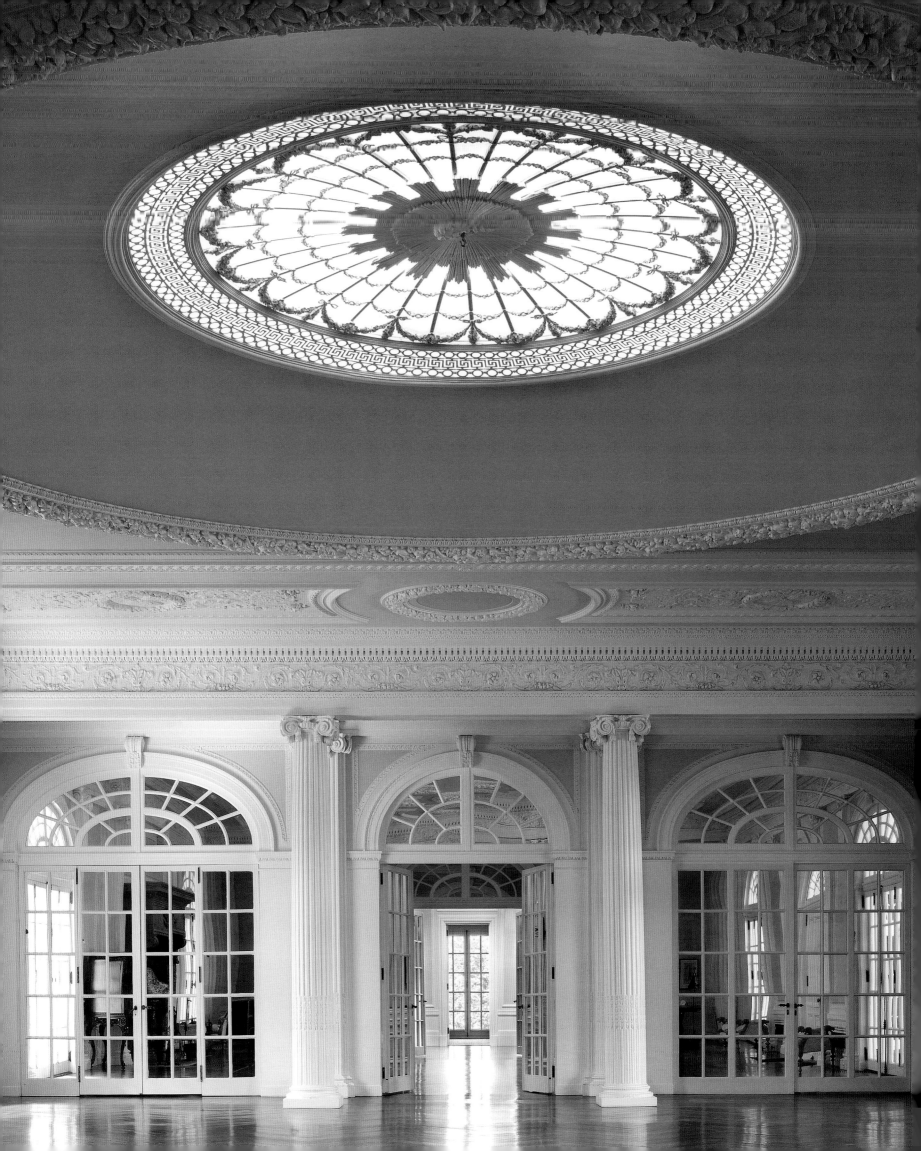

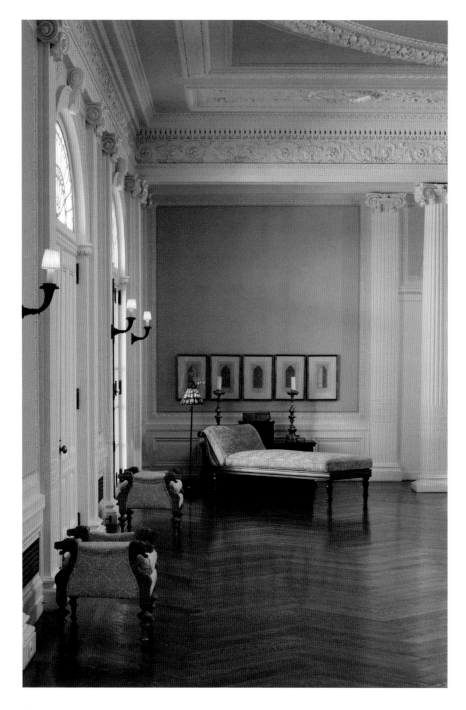

The sumptuous ornament of
the central hall is largely limited
to the cornice and ceiling.

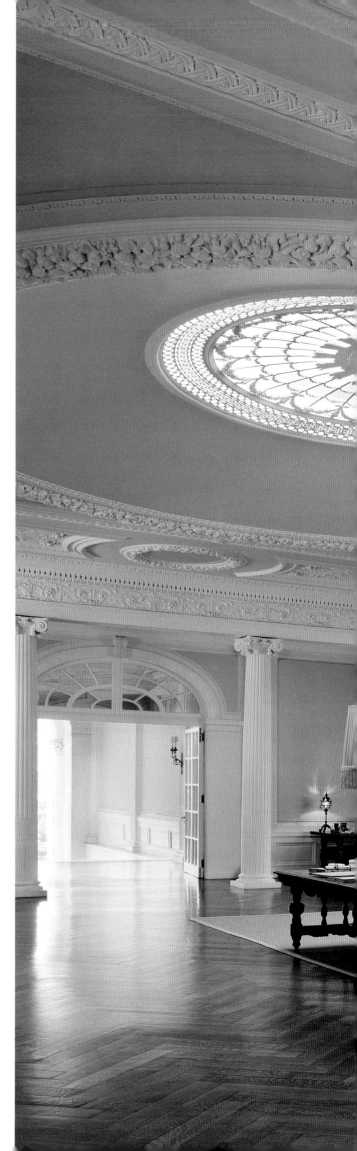

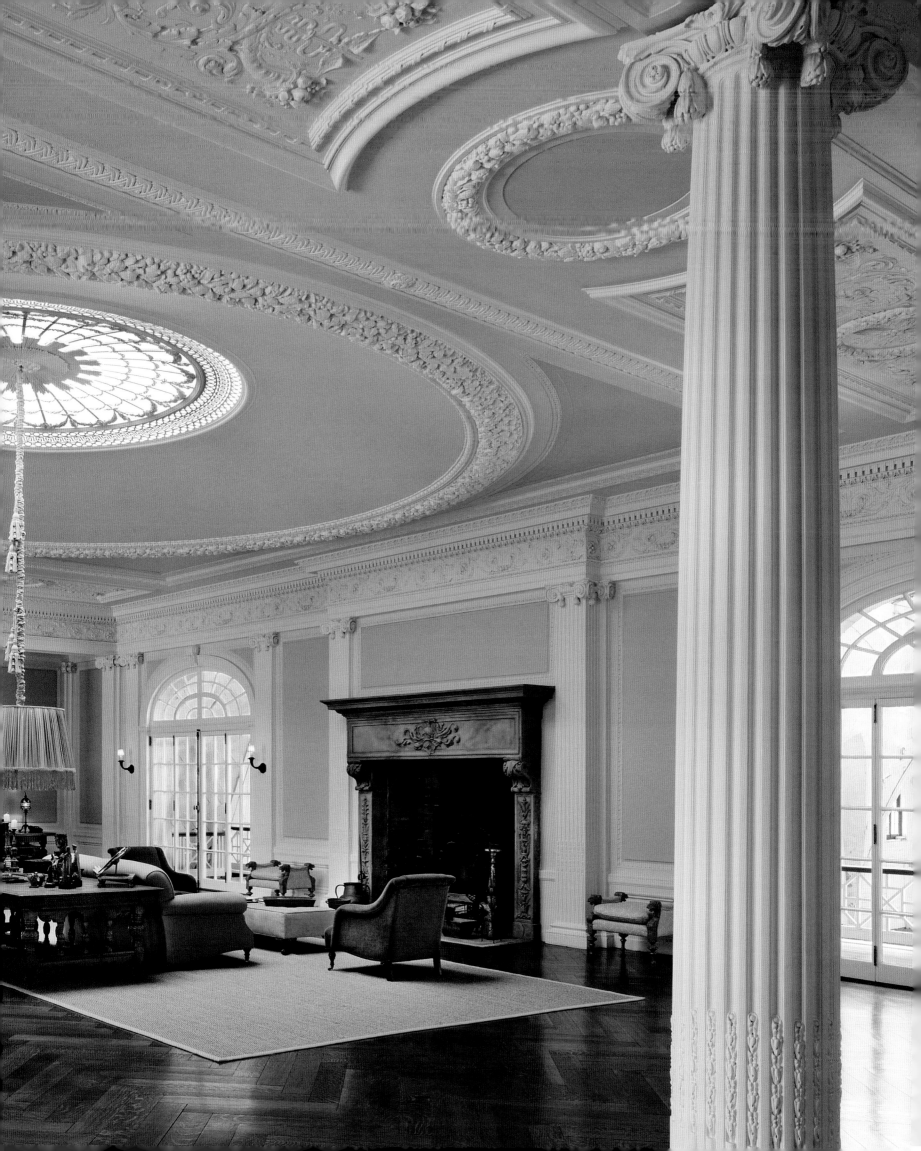

French Ionic capitals reflect the festive spirit of the central hall.

the model for the elevations—design and documentation of the casino were completed in less than three months. The plan for the great central hall presented a more difficult problem, one that was similar to the Payne Whitney house at 972 Fifth Avenue that White was designing at precisely the same moment. In both structures the entrance hall had to establish a note of high drama, undiluted by the ancillary spaces and asymmetrical circulation patterns that actually made the plans work. In the case of the Ferncliff Casino, the entry hall also had to adjudicate

The swimming pool is approached from a higher level, presenting an enticing view of the water itself.

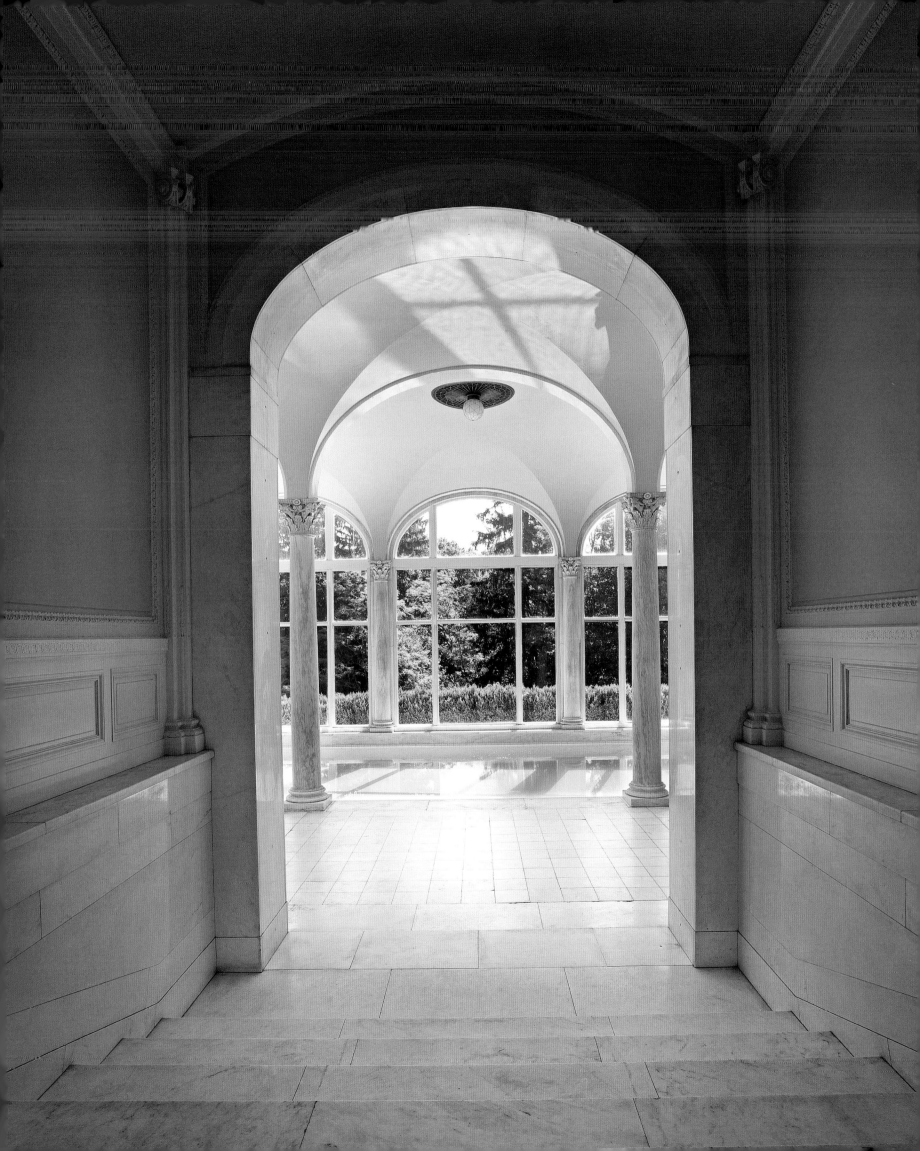

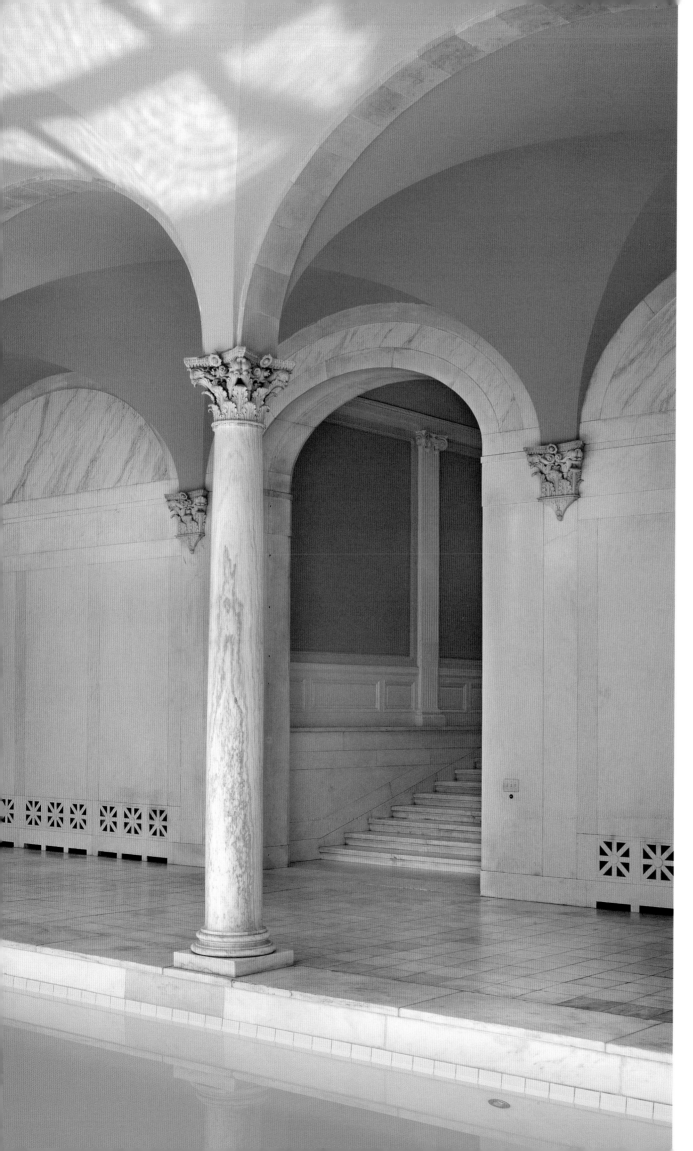

The emphasis in the pool is on hard, smooth surfaces, with limited ornamental touches. The marble for the columns is Cippolino, the walls are Danby. The infill at the arches is faux painted.

White designed the terra cotta capitals in a Corinthian order featuring pairs of dolphins at the corners.

between the vast size of an indoor tennis court and the more intimate scale of the rooms. The earliest drawings show the hall resolved with a circular peristyle that White transposed from the ground floor of the Whitney house. The circular motif must have been a placeholder; the Ferncliff plan was ultimately resolved with a screen of freestanding, fluted Corinthian columns set parallel to the end walls. The screens conceal the hall's subtle asymmetries and reconcile its multiple scales, all within the constraints of a strictly orthogonal geometry. Still, echoes of the Whitney house reverberate in the enormous shallow dome in the middle of the ceiling.

The commission displays White's skill at identifying and modifying existing models. The casino plan was original, tailored specifically to Astor's program, while the decorative references embraced a range of precedents from ancient Rome and the Italian Renaissance to Robert Adam and New England. The extraordinary interiors reflected the combination of eclecticism, erudition, breadth, delicacy, and sheer energy that characterized White's designs. The technology, including the gravity ventilation system, structural vaulting, and operable skylights, was up to the minute.

Astor's program was assembled into a building in which exterior elevations were based on the Grand Trianon, constructed by Louis XIV as a retreat from the formal protocol of the palace. White recognized other similarities between the Versailles pavilion and the site overlooking the Hudson River. The Trianon was a one-story building with a large floor area, and Astor's program had to enclose forty thousand square feet, mostly on a single level. White appropriated the Trianon's balustrade, cornice, arches, and paired pilasters to give scale and rhythm to his long, low walls. As an extra benefit, the link connecting the Trianon's separate wings became the model for a covered outdoor vestibule that allowed Astor to park his automobiles out of the rain. The choice of precedent also enabled White to exploit the Trianon's more ineffable qualities for the benefit of his client, in this case by associating the House of Astor with the Bourbon dynasty.

The skylight over the tennis court could slide open in warm weather, while fabric shades originally provided sun screening. The Guastavino Company was responsible for the engineering and construction.

CHAPTER FIVE

CHAPTER FIVE

Public Buildings

STANFORD WHITE's portfolio of institutional and public buildings reflects the prosperity, cultural expansion, and national pride of the last quarter of the nineteenth century. More than any other architect of the period, White shaped the image of the new commercial and cultural institutions and commemorative monuments, designing banks and churches, luxury retail spaces, hotels, and office buildings, as well as university campuses and industrial complexes. The most famous of these was, of course, Madison Square Garden, a building that symbolized a new social paradigm of public entertainment.

In scale and scope the Garden transformed the streetscape of Manhattan, its exotic turrets rising above the roofline of the surrounding buildings and its three-hundred-foot tower dominating the skyline. More significantly, the pale cream color of the full-block building revolutionized the palette of the city. The materials and decorative scheme were equally significant for White, whose later buildings incorporated the same smooth surfaces of light-colored roman brick and rich ornament in carved limestone or molded terra cotta. This combination is seen in buildings as diverse as the Stuyvesant Fish house, the Judson Memorial Church, the Century Association clubhouse, the Cable Building, the IRT power house, the Hotel Imperial, and Gould Library and the academic buildings of the University Heights campus of New York University.

Stanford White is generally acknowledged as an arbiter of taste for newly wealthy individuals, and his designs for commercial clients played a similar role in establishing the image of emerging and expanding businesses. Confronted with architectural competition from the tower Richard Morris Hunt designed for the *New-York Tribune*, James Gordon Bennett Jr. commissioned White to design a new building for the *New*

W. Louis Sontag Jr.
Madison Square Garden, c. 1895.
Watercolor on paper
24 by 17½ inches.

Museum of the City of New York

The IRT Power House incorporates White's palette of light-colored Roman brick and terra cotta ornament, here worked into rough panels in keeping with the industrial purpose of the building.

York Herald on a trapezoidal site he had acquired at Thirty-fifth Street and Broadway between the fashionable precinct of Madison Square and the seamy theater district. Bennett elected to distinguish his building by specifying that it could be no more than two stories, a space constraint that White resolved by locating the presses below grade. For the building's image, White selected a northern Italian Renaissance precedent, the Loggia del Consiglio in Verona. To minimize the irregularity of the site, he wrapped the building with an elegant arcade based on that of the Loggia, adapted the alternating bays and panels on the second story, and added a rich projecting cornice at the roofline. The whole was described by *Scientific American* as "an object of varied and surpassing beauty...a crystallized dream of art."

The rapid accumulation of wealth spawned new financial institutions

to expand and protect personal fortunes. Foremost among these were life insurance companies and savings banks, both looked upon with some suspicion by the clients they hoped to attract. At the same time, these businesses began to recognize the potential of multistory buildings in conveying prosperity and trust as well as providing a revenue stream from tenants. The challenge for the architect was to adapt the traditional palazzo form and classical detailing associated with the Renaissance Italian banking fortunes to the American business paradigm. White experimented with this idea in the late 1880s and early 1890s, using a variety of configurations, materials, and textures on the facades of eight- or nine-story office buildings. For the Goelet Building at Twentieth Street and Broadway, he changed the proportions of the tripartite facade, expressing the first three stories as a tall arcade and minimizing the attic, and clad the whole in red and orange brick with limestone trim and textured brick panels. At the Judge Building diagonally across Broadway, pairs of monumental arches, enclosing two and three stories of windows and interrupting the stringcourses, introduced a new verticality to the facades, which were executed in light brick enriched with terra cotta.

On the facade of the Goelet Building panels of patterned brick animate the rectilinear window arrangement. The abstraction of the design is unusual in White's early work.

A copper balustrade above a literate classical cornice marks the third floor of the New York Life Insurance Building. White designed a clock tower for the top of the building, which was in turn crowned with a sculptural group by Philip Martiny.

White returned to a more straightforward adaptation for the Cable Building at Houston Street and Broadway, where the base, *piano nobile*, and attic were stretched over multiple stories but clearly delineated by stringcourses. Clad in yellow brick with terra cotta ornament and topped with a massive projecting copper cornice, the Cable Building is his most successful resolution of the problem.

Between 1894 and 1899, White undertook the reconfiguration of the New York Life Insurance Building at 346 Broadway. As a first step, a twelve-story building was constructed at the rear of the site and subsequently, eight stories were added to the original 1870s building to make a coherent office block. The interior of the original building was gutted to accommodate a new banking hall and executive offices, and the exclusive

The Cable Building was designed as offices above a vast basement full of machinery that controlled the cable car system owned by the Metropolitan Traction Company, a syndicate in which White's friend and client William C. Whitney was a partner.

Rendering of the State Street
Savings Bank, Detroit, a
commission that came to White
through the noted art collector
Charles Lang Freer, a patron
of Whistler and Dewing.

Merchants Club occupied the top floor. A colossal order of Corinthian columns marked the entrance, while a monumental clock and a sculpture by Philip Martiny of four figures of Atlas supporting a latticed globe were incorporated in a tower on the roof. The frieze below the projecting cornice incorporated the New York Life monogram within a laurel wreath, while other company motifs were carved on cartouches at the corners of the second floor. These symbols of authority and power left no doubt about the position of New York Life in the financial world.

For the Bowery Savings Bank, White invoked the authority of ancient Rome, with pedimented porches marking the entrances on Bowery and Grand Street. On the interior, the banking hall featured monumental Corinthian columns supporting a gilded coffered vault and a monumental skylight. In contrast, the Detroit Savings Bank was a chaste marble pavilion with a recessed entrance marked by Ionic columns, not unlike the entrance facade of the Whittemore Memorial Library in Naugatuck, Connecticut; the Orange Free Public Library in New Jersey; and the Walker Art Gallery at Bowdoin College in Maine. It was McKim who

brought this idea to its highest expression at the Morgan Library in New York, but as Leland Roth notes, the Detroit Savings Bank marked "a new, more settled phase for White."

A comparable assurance characterized White's final bank commission, the Knickerbocker Trust Company at Fifth Avenue and Thirty-fourth Street. Charles T. Barney, the bank president and White's financial adviser, and the directors were forced to abandon a more ambitious thirteen-story project but elected to proceed with the four-story base. Monumental Corinthian columns supported a deep and richly ornamented frieze below a projecting cornice and balustrade, creating an impressive cube that successfully held the prominent corner.

This section of Fifth Avenue, formerly home to Mrs. Astor's house

At the Knickerbocker Trust Company White superimposed a gigantic order over walls of glass, combining dignity and functionality.

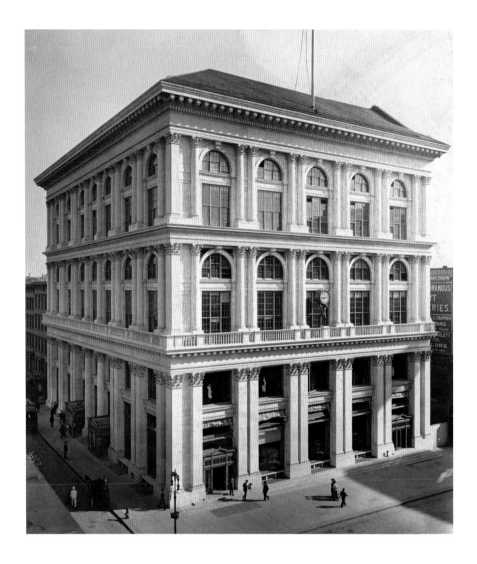

and ballroom and the white marble mansion of A. T. Stewart, the source of Bessie White's inheritance, was rapidly developing as a fashionable shopping area in the early 1900s. That transformation was complete with the relocation of Tiffany & Company from Union Square to 409 Fifth Avenue at the corner of Thirty-seventh Street, the highest point of Murray Hill. Inspired by the Venetian Palazzo Grimani, clad in white Dover marble, and articulated with Corinthian pilasters and columns, the new Tiffany building was indeed the palace its president Charles T. Cook had demanded.

The great fortunes of the late nineteenth century generated an unprecedented level of philanthropy, funding new cultural, educational, and religious institutions in cities along the East Coast. McKim, Mead & White garnered many of these important commissions, notably McKim's

gates for Harvard University, the Boston Public Library, Boston Symphony Hall, the Brooklyn Museum, later additions to the Metropolitan Museum of Art, and branch libraries for the New York Public Library.

Early in their careers both McKim and White worked with H. H. Richardson on Trinity Church in Boston. It can be said that White learned to be an architect while working on Trinity Church, and those lessons informed his entire career. The American Renaissance ideal of a group of artists working in collaboration with an architect found its first expression there, but equally important was the ideal of reinterpretation of precedent to make a new architecture. The tower of Trinity was based on the tower of the cathedral at Salamanca in Spain, a building Richardson knew from a photograph sent to him by John La Farge. Having selected Salamanca, Richardson turned the photograph over to White, who changed the rectangular footprint to a square and added a story of arched

Lovely Lane Methodist Church, Baltimore. The lancet windows in the tower were arranged in a cruciform pattern and illuminated at night.

At Judson Memorial Church White applied a wealth of texture and ornament to the forms of Tuscan architecture.

openings below dormers and an octagonal roof that echoed the original.

For his first independent church commission, Baltimore's First Methodist Episcopal Church, more familiarly known as Lovely Lane, White selected the rough stone and rounded forms of Romanesque architecture. The tower recalls that of the basilica of Santa Maria at the monastery of Pomposa, a small town north of Ravenna. On the interior there are references to Sant'Apollinare in Classe and the tomb of Galla Placidia, but the complex geometry of the oval plan of the sanctuary topped by a shallow dome came from the young architect's imagination.

Ultimately, in connection with his final and most important church commission, the Madison Square Presbyterian Church, White set forth his views on appropriate styles for church architecture. Maintaining

that the Gothic "belongs absolutely and only to the Roman Catholic Church," he proposed that the "simple forms of early Christian religion," and those of the Reformation and of colonial America, be used for Protestant churches.

White used a Tuscan model for the Judson Memorial Church on Washington Square in New York. Like Lovely Lane and the later Madison Square Presbyterian Church, the church building was part of a larger complex. Here a basement floor with deep rustication and guilloche-patterned terra cotta unifies the composition. The church is located one level above the street, a simple undecorated basilica with stained-glass windows by John La Farge. The tower rises beside the hooded entrance, a Tuscan campanile in form but with the characteristic open arcades filled in with windows and blind openings set behind multiple arched layers.

Church commissions bracketed White's career, with two late works completed after his death: the brilliant Madison Square Presbyterian Church and the modest Trinity Episcopal Church in Roslyn, New York, commissioned by Katherine Duer Mackay, the chatelaine of Harbor Hill. Despite differences in ambition, the two buildings show White at the height of his powers, skillfully blending a range of unexpected materials to create an image and spirit that infused the space. At Trinity White drew on English pilgrimage halls of the thirteenth and fourteenth centuries, a precedent he considered appropriate for Anglican traditions. The exterior is clad in overburned brick laid in courses of stacked headers, an irregular surface that modulates the severity of the form. A tall, buttressed gable extending above the roof to become a bell tower dominates the composition. Inside, massive ash beams support the roof, leaving the nave column-free. As at Judson, the interior is simple, with stained glass attributed to Tiffany (and others) contrasting with the wood and unornamented plaster.

On Madison Square, encroaching office buildings challenged White to design a church that could hold its own in the new density of the streetscape. As at the Knickerbocker Trust, the use of monumental Corinthian columns on a low building created a formal mass with significant impact. In contrast to the bank, where the facade was articulated by alternating

Like St. Paul's in Stockbridge, the ceiling of the nave of Trinity Church in Roslyn is supported by massive beams. The finish of the oak woodwork matched the interior of Harbor Hill.

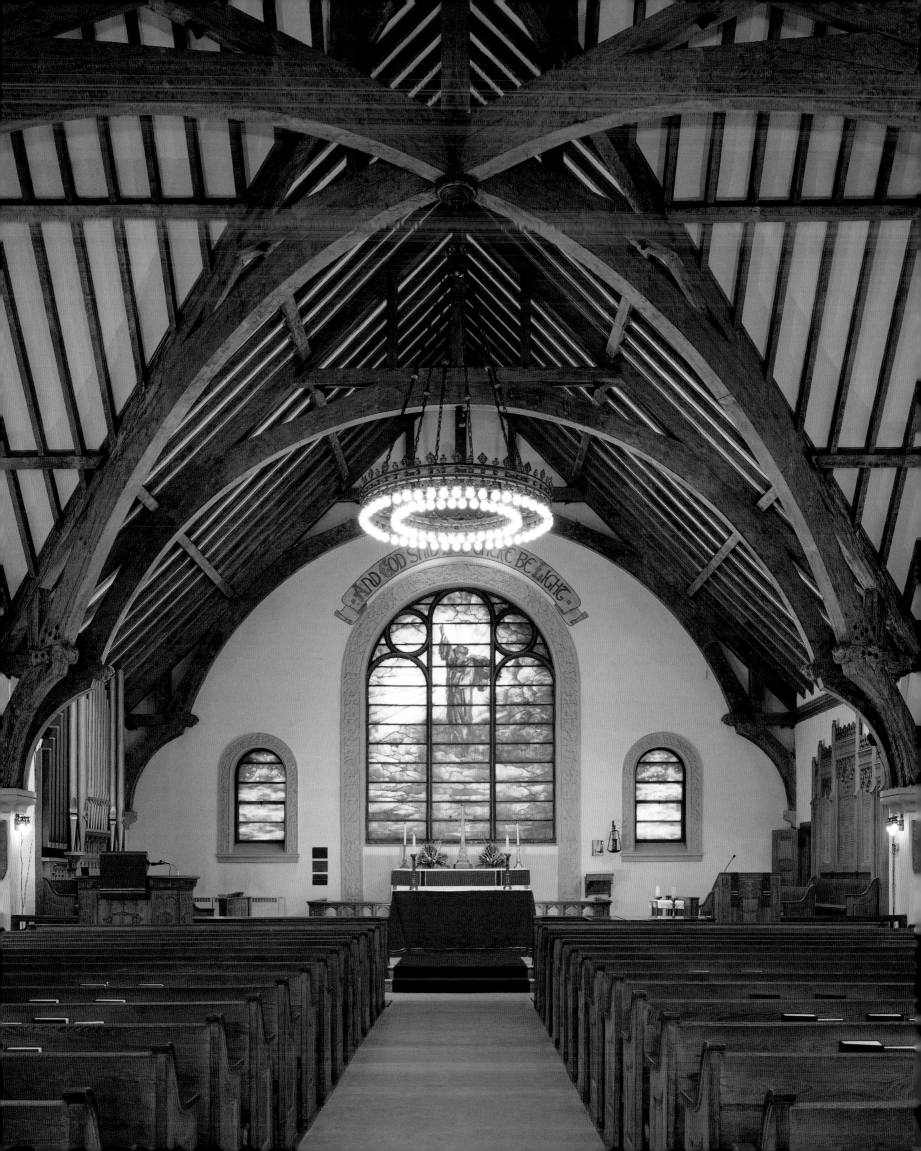

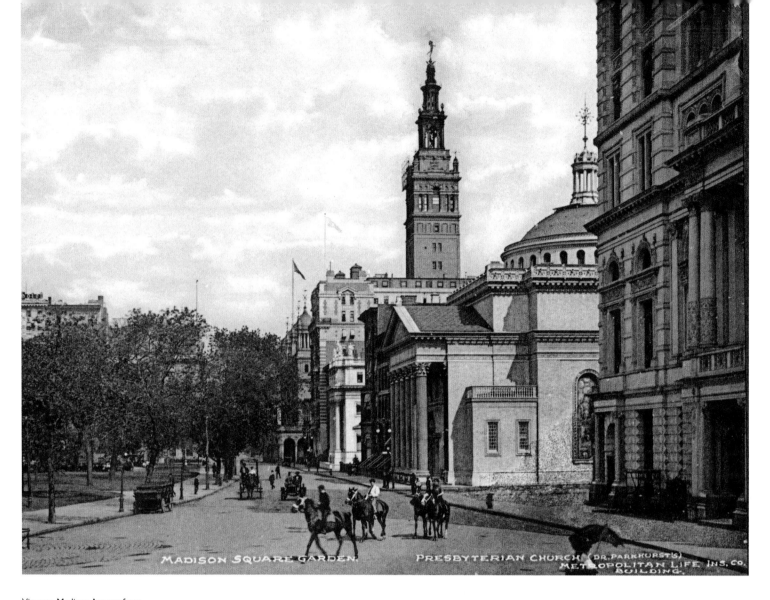

View up Madison Avenue from
Twenty-third Street to the
Madison Square Presbyterian
Church with the tower of
Madison Square Garden in
the distance.

Museum of the City of New York

white marble columns and dark, recessed bays, White introduced both color and surface texture to the church. Smooth, green granite columns contrasted with the patterned brick and complemented the green tile dome above.

For a little more than a decade, Madison Square Garden and Madison Square Presbyterian Church together animated Madison Avenue between Twenty-fourth and Twenty-seventh streets. Comparison of the two reveals the evolution of White's work from the late 1880s to the early 1900s. Both were clad in light-colored brick with terra cotta ornament, but the almost reckless combination of motifs at the Garden became more disciplined at church. The foliate ornament at the Garden, incorporating garlands and cornucopias, was replaced by a more sober vocabulary of literate classical detail. In the end, both buildings gave way to the increasingly prosperous life insurance industry. Madison Square Presbyterian Church

Terra cotta ornament at the Madison Square Presbyterian Church (above) incorporates classical and early Christian elements in a disciplined rhythm, in contrast to the overall patterns and heraldic details at Madison Square Garden (below).

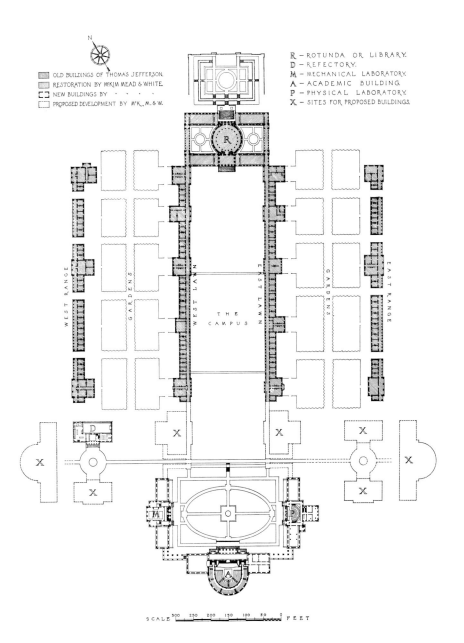

The McKim, Mead & White campus plan for the University of Virginia shows the firm's three buildings flanking a terrace facing the Rotunda at the head of the Lawn

was demolished by Metropolitan Life in 1919, and Madison Square Garden by New York Life in 1925.

Educational buildings and campus plans form a small but significant aspect of Stanford White's work. The earliest, the gymnasium for what became Goucher College, grew out of his successful collaboration with John Franklin Goucher on Lovely Lane Methodist Church. Built of the same rough-hewn local granite, the gymnasium faces the church and parish house across a narrow street. Before White's academic building was completed in 1891, classes were held in the chapel of the church. The classroom building was also executed in granite, but by the time White

designed the president's house, he had adopted his signature materials—pale roman brick and limestone trim.

A fledgling institution within an urban street grid, Goucher had no defined campus plan. Circumstances were entirely different with Columbia University, New York University, and the University of Virginia, established institutions that commissioned new buildings and campus plans from Charles Follen McKim and Stanford White. All three projects date from the mid-1890s, following the World's Columbian Exposition in Chicago where McKim, Mead & White achieved national prominence. The architects were certainly already known to the president and trustees of Columbia and New York University, but McKim's role in Chicago and Stanford White's position as impresario of the New York celebration must have raised the firm's profile as institutional architects. White would also have intersected with NYU in connection with the Washington Arch commemorating the centennial of the first presidential inauguration.

For the new NYU campus in Fordham Heights overlooking the

White rebuilt the Rotunda, replacing the wooden dome with one of Guastavino tile and adding a portico on the north facade to match Jefferson's original on the south.

Harlem River, White developed an axial plan with a domed building to serve as library, chapel, and museum at the head. The precipitous site required a visual frame for the building, which White provided though the device of an embracing ambulatory filled with busts of scientific and cultural leaders known as the Hall of Fame of Great Americans. The library and flanking Hall of Languages and Hall of Philosophy were clad in buff-colored brick, with restrained limestone trim in keeping with their sober educational purpose.

The formality of the academic quadrangle derived from the earlier campuses of Union College in Schenectady, New York, by Joseph-Jacques Ramée and the "academical village" laid out by Thomas Jefferson for the University of Virginia. Among the first American universities to be consciously planned, these campuses were characterized by a "careful balance between building masses and open spaces, hierarchical composition, focus, and coherence and harmony in expression" that McKim and White sought to emulate in their own campus work.

Jefferson's Rotunda, completed in 1817, was already a national icon when a disastrous fire destroyed the wooden dome and gutted the interior on October 27, 1895. Both John M. Carerre of Carerre & Hastings and William Rutherford Mead immediately offered their respective firms' services in restoring the building. The project expanded in response to a master plan submitted by the university faculty calling for the rebuilding of the Rotunda as a library only and the construction of additional classroom buildings. The rector and board of visitors approached Shepley Rutan and Coolidge as well as Carrere & Hastings and McKim, Mead & White to submit separate proposals for the restoration and the new construction. Ultimately all three firms agreed that the same architects should handle both aspects of the job, and McKim, Mead & White was selected in early 1896.

Stanford White took charge of the project, arriving in Charlottesville on January 28 for a site visit. "I have seen his plans. They are wonderful and I am scared to death," he confided to the mural painter Edward Simmons on his return. McKim, Mead & White developed two schemes for each aspect of the commission. For the Rotunda, one option was a meticulous

Built to commemorate the centennial of Washington's inauguration as President, the Washington Arch is replete with symbols of American democracy. Washington is portrayed as a general by Hermon A. McNeil on the east pier and as a statesman by Alexander Stirling Calder on the west pier.

restoration, maintaining the interior divisions required for classroom uses, with the addition of a portico on the north facade, an unbuilt element of Jefferson's design. The alternate and final scheme opened up the interior to a single, domed volume consistent with the new library use. Two sites were proposed for the new classroom buildings, a cluster to the west of the lawn and a new terrace with three buildings at the foot of the lawn facing the Rotunda. White argued for the cluster scheme, which would have no impact on Jefferson's design or the view to the Blue Ridge Mountains, but the board of visitors selected the terrace scheme."

To minimize the intrusion, all three buildings were built into the

slope, with only one of their three stories visible from the lawn. Brick was closely matched to that of the original pavilions, and the classical trim restrained to subordinate the new construction to the old. Open pergolas connected the buildings at the terrace level, preserving a sense of the view. In spite of these strategies and the fact that the scheme was the client's choice, White has consistently been accused of mutilating the campus that he described as "the most exquisite and perfect group of collegiate buildings in the world."

During the same period, philanthropy combined with national pride to create a wealth of public monuments honoring such military heroes as David Glasgow Farragut, Robert Gould Shaw, and William Tecumseh

Four ceremonial columns and two Tuscan-style pavilions mark the entrance to Prospect Park from Grand Army Plaza.

Sherman and commemorating events as diverse as the centennial of George Washington's inauguration and the tragedy of the English prison ships, when more than eleven thousand colonial soldiers were believed to have died during the Revolutionary War.

White's design for the base and setting of the Farragut statue established his reputation as an architect for monuments, and his visibility as impresario of exhibitions and lavish entertainments at Madison Square Garden made him New York's choice for public celebrations as well. To commemorate the centennial of Washington's inauguration, the city planned a three-day festival focused on Washington Square. The decorative wooden arch White designed proved so popular that its patron, William Rhinelander Stewart, proposed a permanent version to be funded by public subscription. The graceful marble arch, loosely modeled on the

Exuberant foliate ornament enriches the columns at the Fifteenth Street entrance to Prospect Park.

Arch of Titus in Rome, now marks the southern end of Fifth Avenue. Its rich sculptural program, replete with iconography related to Washington and portraits of him as general and as president, exemplifies the ambition of public monuments to honor American history and leadership and to connect it to ancient traditions.

In Brooklyn, White was invited to redesign Grand Army Plaza and the main entrance to Prospect Park. Four Doric columns, crowned with eagles by Frederick W. MacMonnies, were installed, complemented by lighting standards, balustrades, and pavilions. Working with MacMonnies, White reconfigured John Duncan's Soldiers and Sailors Arch to a more harmonious proportion and added the triumphal *quadriga* on the top and

sculptural groups of army and navy on the pedestals facing the park.

Stanford White's last public work, completed after his death, was the Prison Ship Martyrs Monument in Fort Greene Park. The site, one of the highest points in Brooklyn, overlooked Wallabout Bay, where the troops had perished in the holds of English ships. Broad stairs lead up the terraced hill to a simple fluted Doric column that was originally crowned with a tripod and eternal flame. The austerity of the design is entirely appropriate to the monument, but it also reflects the restraint of White's last projects, where the exuberance and plasticity of the early work has been abstracted and absorbed into a purely formal composition.

Prison Ship Martyrs Monument,
White's final public work.

LOVELY LANE METHODIST CHURCH

BALTIMORE, MARYLAND

1883–87

\mathcal{J}OHN FRANKLIN GOUCHER, Methodist minister and missionary, and founder of Goucher College, was the client for Stanford White's first church, Lovely Lane in Baltimore.

Recognized within the Methodist administration as a determined builder, Goucher was selected as pastor with the specific mission of building a new church to replace a crumbling meetinghouse and to commemorate the centennial of Methodism in America.

Well traveled and well married to the daughter of a prominent Baltimore family, Goucher would certainly have been aware of the growing reputation of McKim, Mead & White and perhaps would have been personally familiar with White's residential projects in Baltimore for Ross W. Winans and the Garrett family. Whatever the connection, Goucher commissioned White without competition, and with equal single-mindedness acquired land on north St. Paul Street, somewhat outside the city center. The public was skeptical, referring to the project as "Goucher's Folly" and the "Cathedral in the Cornfield."

White based his design on early Christian precedents, drawing on the form of the tower of the basilica of Santa Maria, a ninth-century Romanesque structure within the Abbey of Pomposa, just a few miles north of Ravenna. The complex consists of the main sanctuary, with a chapel and meeting rooms behind, and a parish house running the length of the two worship spaces. The exterior is executed in rough-face granite quarried locally at Port Deposit. Broad steps lead to arcaded porches on the east and north facades of the main sanctuary.

Basilica of Santa Maria, Abbey of Pomposa, Italy.

In Baltimore, the tower of Santa Maria is transported to an urban setting, where it marks the corner of St. Paul and Twenty-second streets.

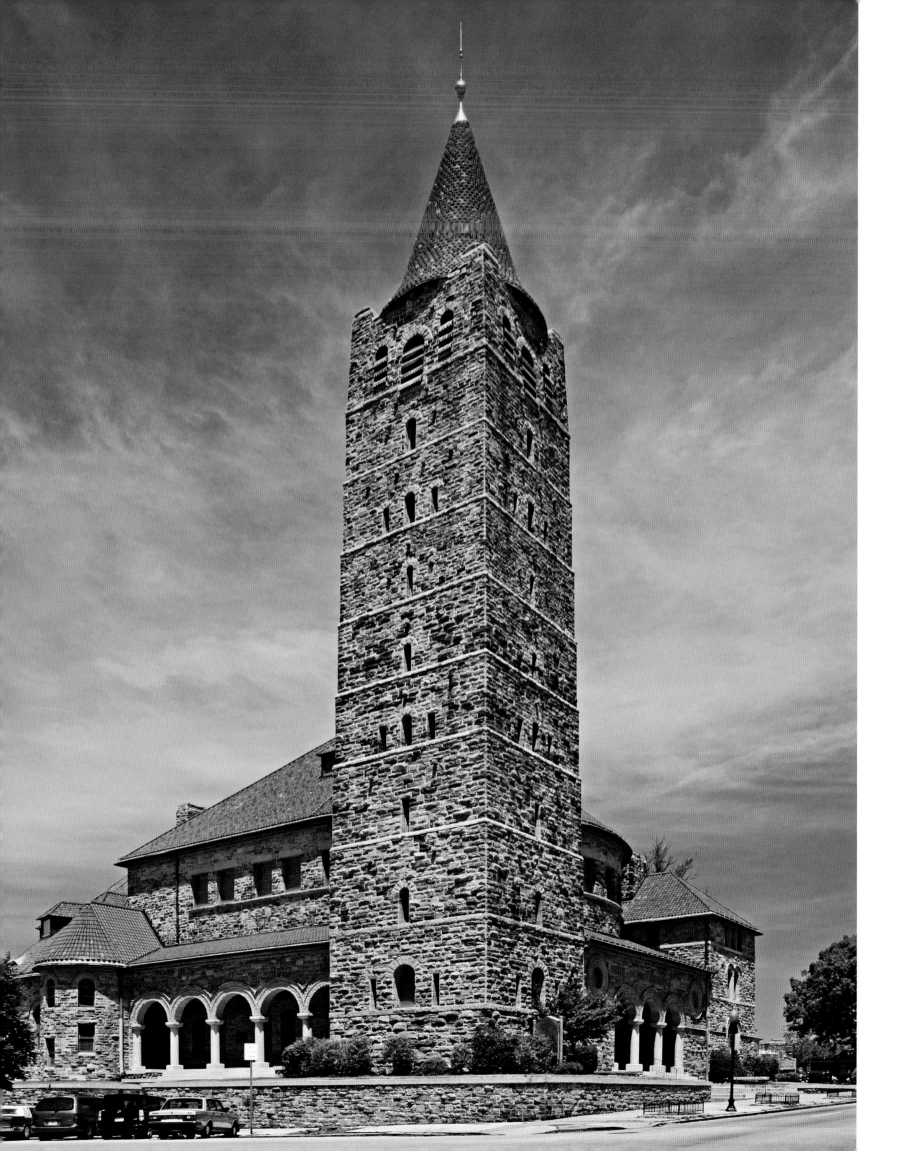

Arcaded porches surround the nave on the north and east facades. Openings are articulated with the same rough-hewn stone.

Overleaf
Highly polished wood
and smooth walls in
the sanctuary contrast
with the rough stone
of the exterior.

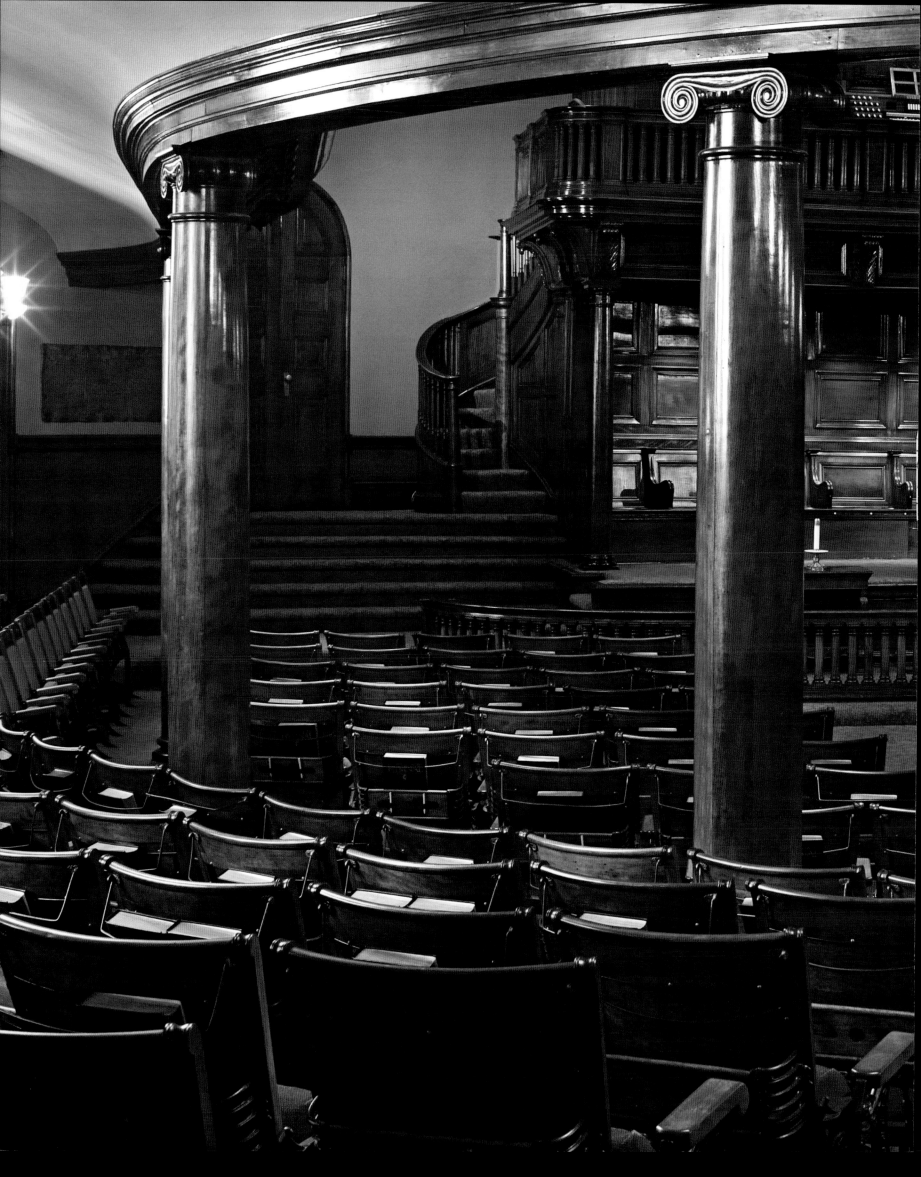

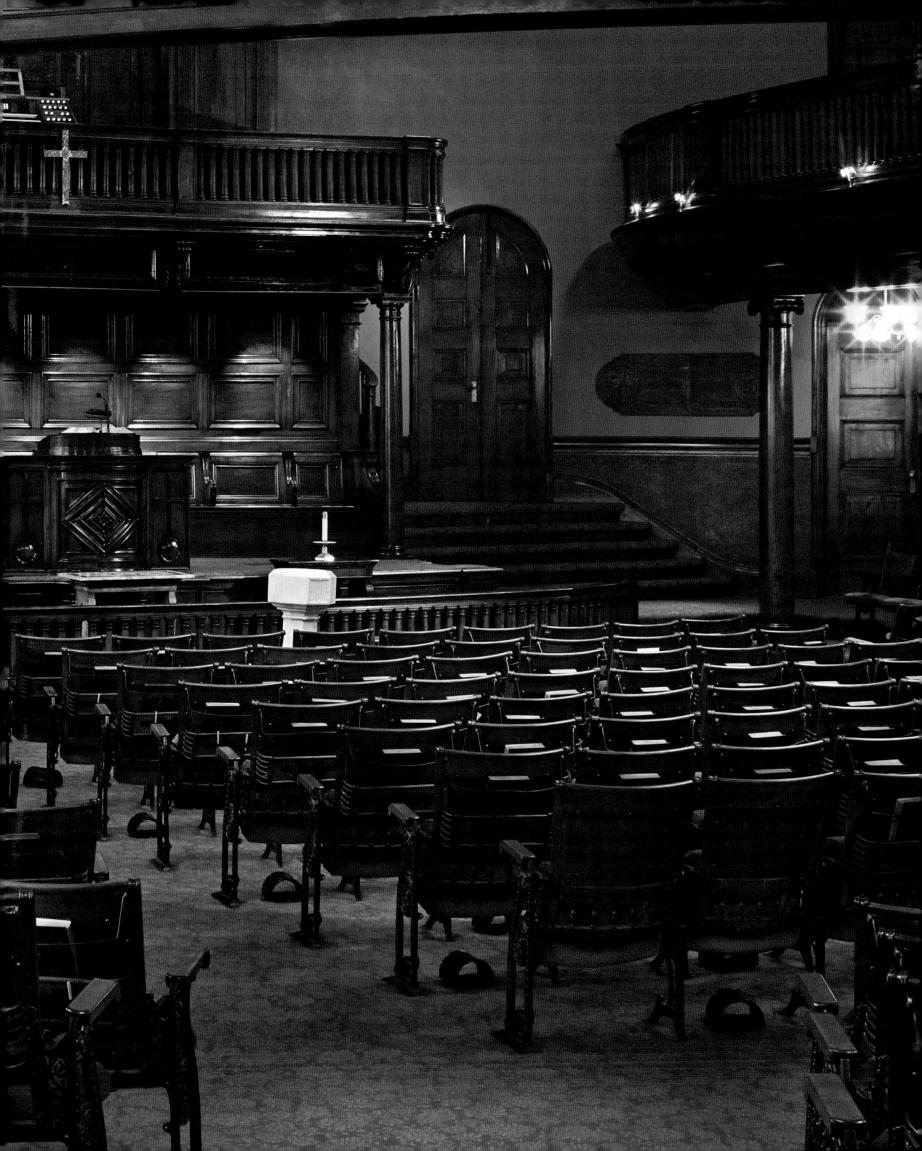

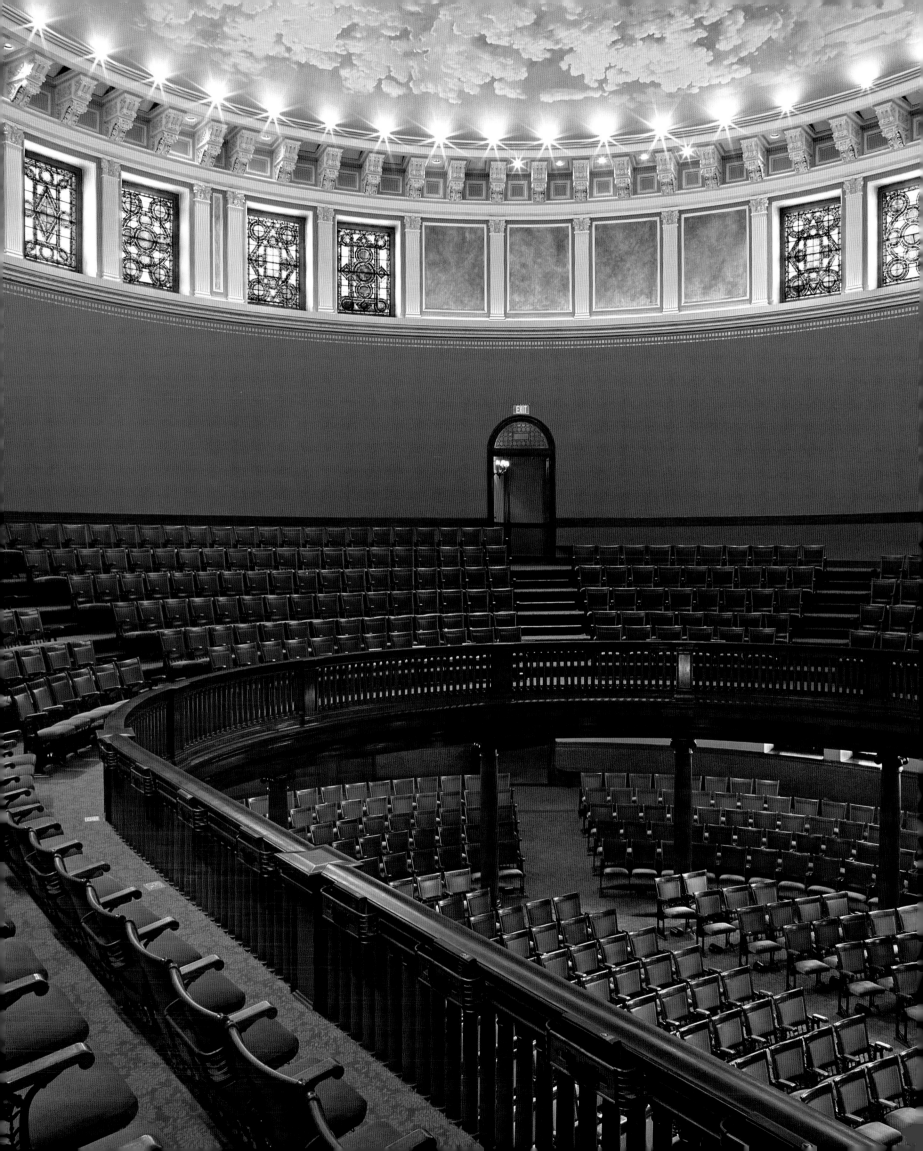

In spite of the monumentality of the form, there is no principal entrance to the church. Instead the east porch has three doors that open directly into the back of the sanctuary; doors at either end of the porch open into vestibules in the tower and the parish house, each with doors to the sanctuary. This absence of formal circulation characterizes the plan, which is laid out as a series of spaces connected by vestibules and passages.

In contrast to the rough exterior, the sanctuary exudes warmth and comfort in a simple palette of terra cotta and highly polished black birch. Dominating the space is a shallow dome painted to record the night sky as it appeared on the date of the dedication of the church in 1887, said also to be the same configuration as that in Judea at the birth of Christ. At the cornice, 340 gas jets created a circle of flame that evoked that at San Vitale in Ravenna. Seats, upholstered in fabric imported from Belgium, were arranged in a horseshoe, creating an intimate setting within easy range of the preacher.

Montgomery Schuyler discussed Lovely Lane in his first series of articles for the new journal *Architectural Record* in 1891. While admiring the skill of the architect in resolving the geometry of the curves of the sanctuary with the rectilinear parish house and tower, he was disappointed in the exterior treatment, considering the "masses so powerful that they would have borne a much higher elaboration than they have received." He was particularly critical of the lack of resolution at the top of the tower, where "a hood seems to have been dropped down on an unfinished tower."

The powerful form and detailing of this wrought-iron hinge convey the craftsmanship of the building as a whole.

Overleaf
The chapel behind the sanctuary was also used as classroom space for the Women's College of Baltimore, which subsequently became Goucher College.

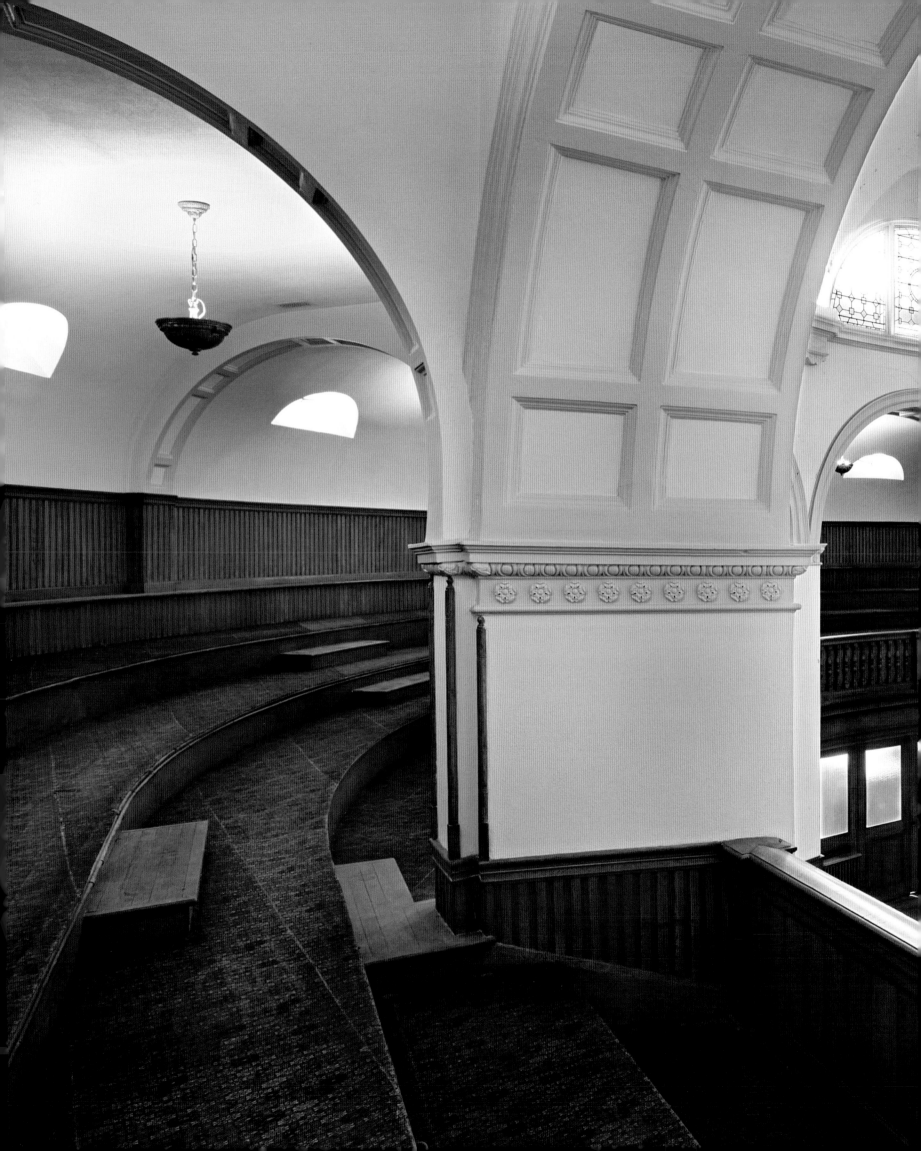

MADISON SQUARE GARDEN

NEW YORK

1887–90

*I*N THE LATE nineteenth century, Madison Square Garden dominated the New York skyline, its tower visible from vantage points throughout the city and beyond. The building, which occupied the full block from Twenty-sixth to Twenty-seventh streets and Park to Madison avenues, incorporated a vast amphitheater, two performance spaces, a roof café, and a restaurant. This program of varied entertainments captured the imagination of Stanford White, who designed the form and exterior ornament and orchestrated the interior decor, even including uniforms for the staff. The result was the epitome of the architecture of festivity that established White as the architect of pageantry and ceremony in the city.

White's greatest achievement, however, was the skillful combination of the disparate parts of the program into a coherent whole. Separate entrances for the amphitheater and the theaters allowed simultaneous performances, while the tower apartments and roof café could be accessed independently. An arcade surrounded the building, protecting patrons in inclement weather and unifying the structure at street level.

The main mass of the building was sixty feet high, rising to a colonnade of Ionic columns supporting a balustrade animated by domed tourelles. Smooth, buff-colored roman brick walls were enriched with a terra cotta stringcourse and window surrounds, culminating with an elaborate Palladian window at the center of the Park Avenue facade. Above and below, a profusion of terra cotta ornament in virtually every motif ever devised covered the arcade, balustrade, and tourelles. The principal feature, however, was the tower on Twenty-sixth Street, which White had modeled on the Giralda in Seville and crowned with Augustus Saint-Gaudens's bronze figure of Diana.

The interiors were among the most successful of the firm's designs for performance space. The luxuriously appointed Garden Theater, with

The intricate Moorish ornament of the Giralda tower in Seville was adapted for Madison Square Garden.

On Madison Avenue, the main block of the building continued the cornice line of its neighbors, with domed tourelles as a transition to the height of the tower.

Corbis

a sloped orchestra and a graceful, horseshoe-shaped balcony, was praised for its "unusual air of joyousness combined with refinement." Its curtain was based on Boldini's *Parc au Versailles*, a painting in White's collection. The concert hall on the second floor, intended for light, popular music, was decorated in Louis XVI white and gold. A flat floor allowed the space to be used for banquets, dances, and ceremonial events as well as concerts; Helen Gould, donor of the Gould Library designed by White for New York University, received the chancellor's certificate for completion of the University Law Class for Women at the NYU commencement exercises in the concert hall in 1895.

Terra cotta ornament on Madison Square Garden incorporated virtually every known motif, appropriating even the "fishscale" surface executed in wood at the Church of the Atonement in Quogue, New York, and at the Tilton House in Newport.

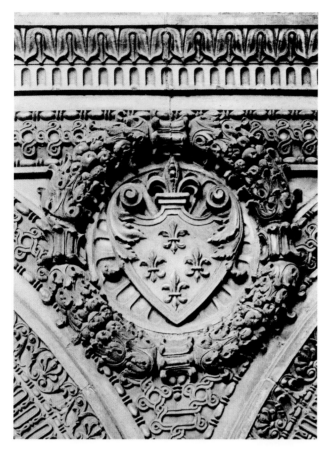

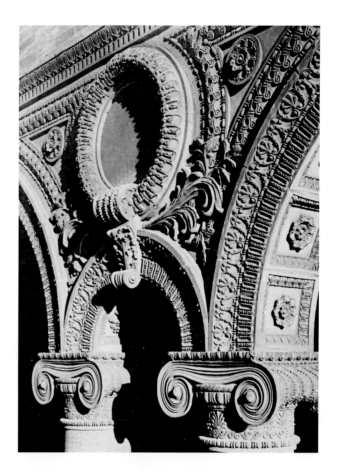

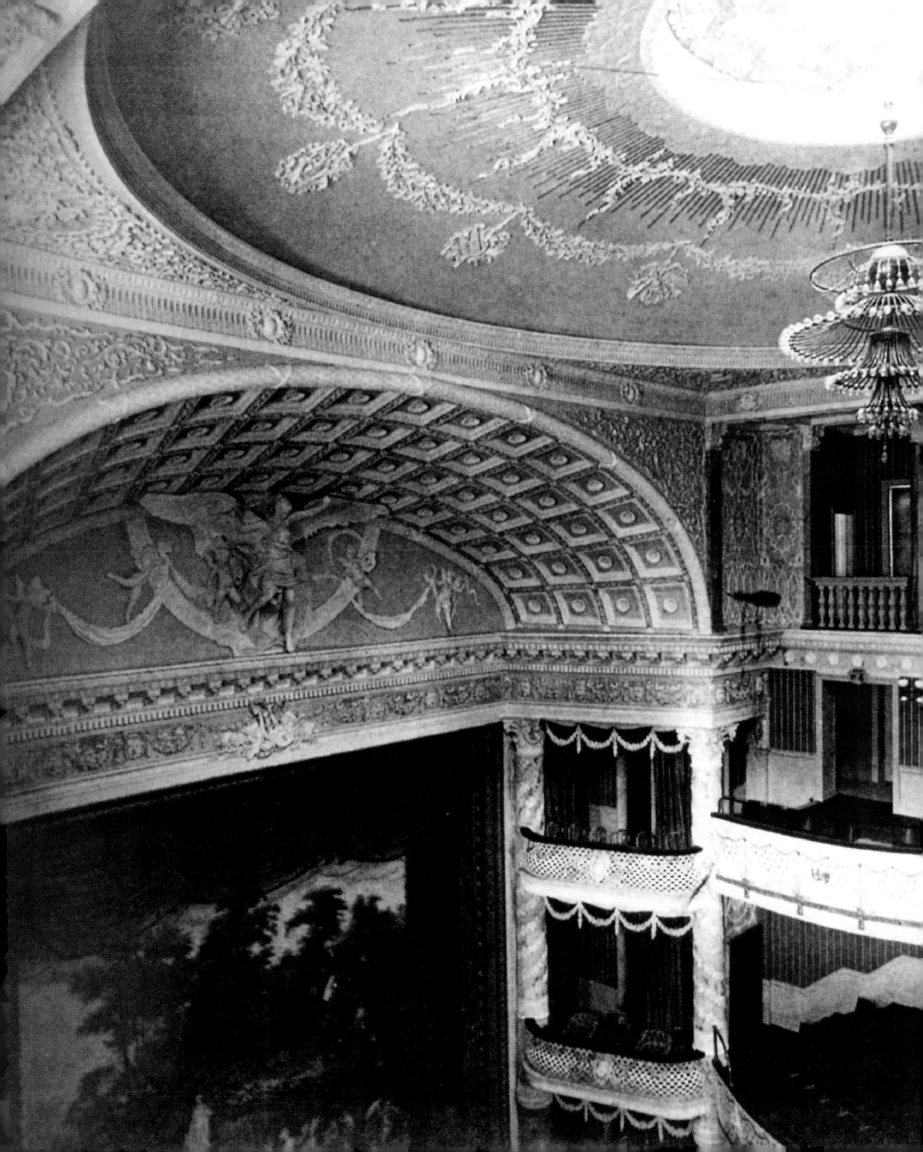

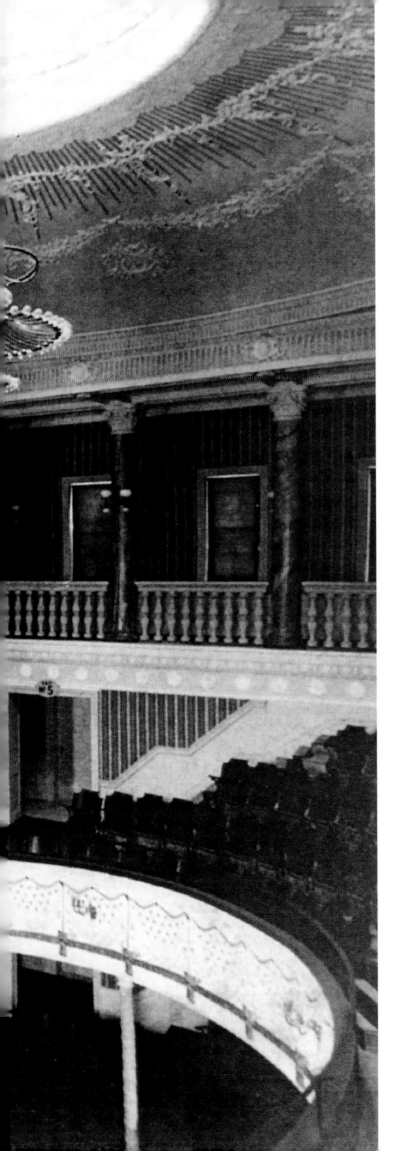

Madison Square Garden was frequently the setting for elaborate costume balls.

Corbis

Graceful curves, festive ornament, and a cream and gold color scheme made the Garden a more sophisticated version of the Casino Theatre completed in Newport a decade earlier.

Avery Architectural and Fine Arts Library, Columbia University

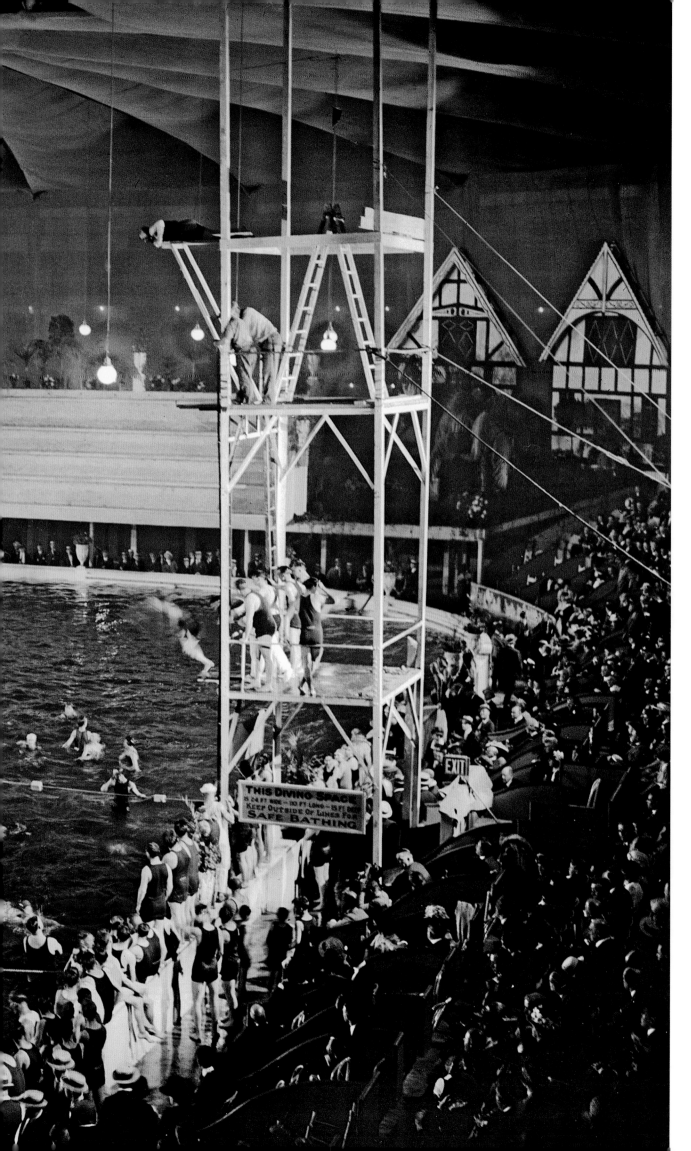

The arena could be flooded
as it was for the famous
Night in Venice and here for
a swimming competition.

Corbis

317

The amphitheater, also intended as an exhibition space, could seat eight thousand. The vast interior was dominated by a web of cream-colored trusses spanning 167 feet, with an operable skylight over the center. In the evening the room sparkled with light from incandescent bulbs lining the trusses. The National Horse Show was an annual event, and the *New York Times* regularly reported on exhibitions and performances, including a Fairyland for Children, where the ancient streets, castles, churches, and marketplaces of Old Nuremburg, "the home of toys," were re-created in "a realistic manner" and at full scale.

Madison Square Garden was greeted with great enthusiasm at its opening in 1890. The architecture critic Mariana Griswold Van Rensselaer could not imagine the city without it: "Nothing else in all New York has done so much to dignify, adorn, and enliven its neighborhood; nothing else would be so sorely missed by all New Yorkers were ruin to overtake their dearest architectural possessions."

The rooftop café provided *plein air* entertainment on summer evenings.

Corbis

The National Horse Show, an annual event at Madison Square Garden, was a highlight of the New York social season.

Corbis

"JAPAN BY NIGHT" MADISON SQ.

HERALD BUILDING

NEW YORK

1890–95

*T*HE HERALD BUILDING stood on a trapezoidal site at the intersection of Broadway, Sixth Avenue, and Thirty-fifth Street, known today as Herald Square. Now embedded in the public consciousness through the George M. Cohan song "Give My Regards to Broadway" ("Remember me to Herald Square"), the area was on the fringes of the city in 1890, when James Gordon Bennett Jr. decided to move the offices of his newspaper uptown.

Bennett, certainly one of the wealthiest and most flamboyant of McKim, Mead & White's clients, had previously commissioned the Newport Casino and the yachts *Namouna* and *Lysistrata*. An avid sportsman, he is said to have introduced polo to America. His vision for the Herald Building was a replica of the Doge's Palace in Venice. In a masterful demonstration of client management, White agreed with the notion

The main entrance was recessed behind the arcade and a porch with apisal ends.

By 1910, the surrounding buildings had begun to cast shadows across Broadway and the Sixth Avenue elevated train was in service.

Corbis

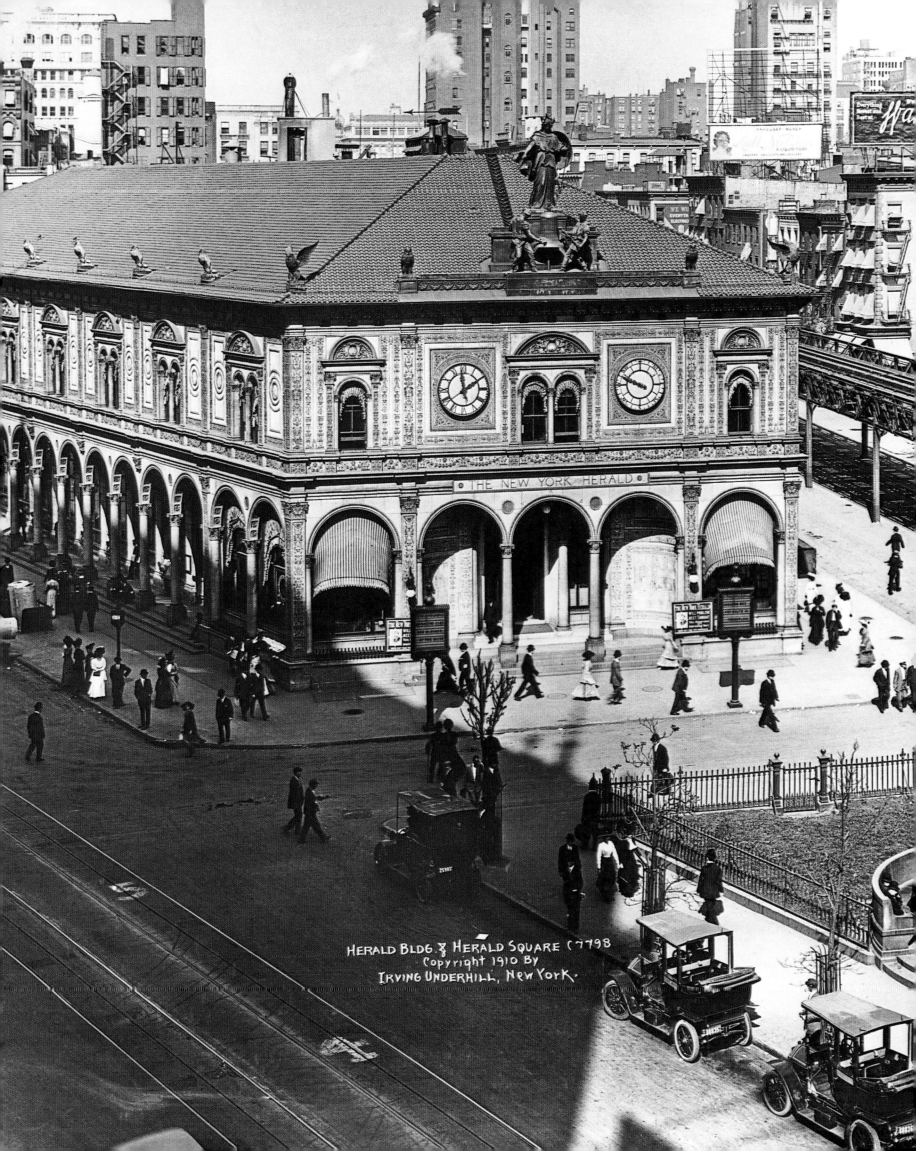

HERALD BLDG. & HERALD SQUARE C7798
Copyright 1910 By
IRVING UNDERHILL, New York.

The Broadway facade incorporated the delicate arcade and paired windows of the Loggia del Consiglio. In New York, terra cotta ornament replaced painted decoration on the second floor and owls rather than herms guarded the roofline.

of the Venetian model but redirected Bennett to the Loggia del Consiglio in the Piazza dei Signori in Verona.

White's design was equally masterful, enclosing the newspaper's printing plant and editorial offices in a two-story arcaded structure embellished with panels of yellow and buff terra cotta. The principal entrance facing Thirty-fifth Street was marked by a sculptural group of Minerva and two bell ringers who sounded the hours on the large clock to the west of the windows of Bennett's second-floor office. On the interior, a circular lobby ringed with monumental columns created a serene moment before giving way to small offices and tight circulation that resulted from

In plan, orthogonal editorial offices contrast with the irregular geometry of the city department, the press room, and the delivery room.

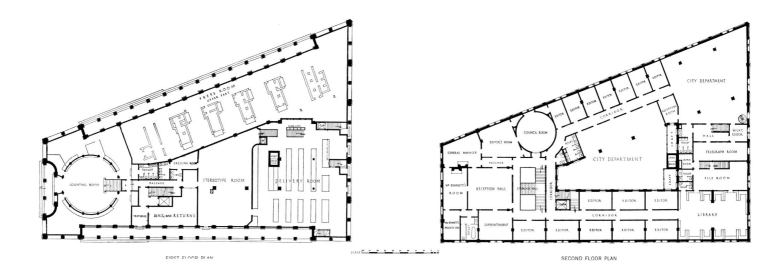

FIRST FLOOR PLAN

SECOND FLOOR PLAN

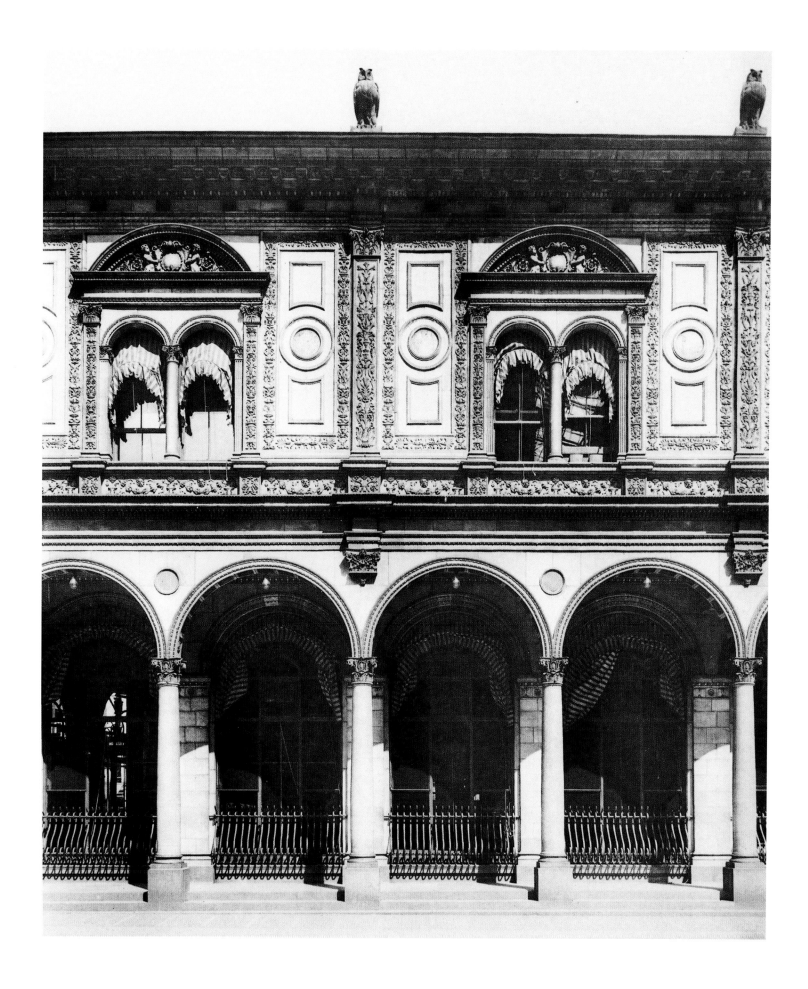

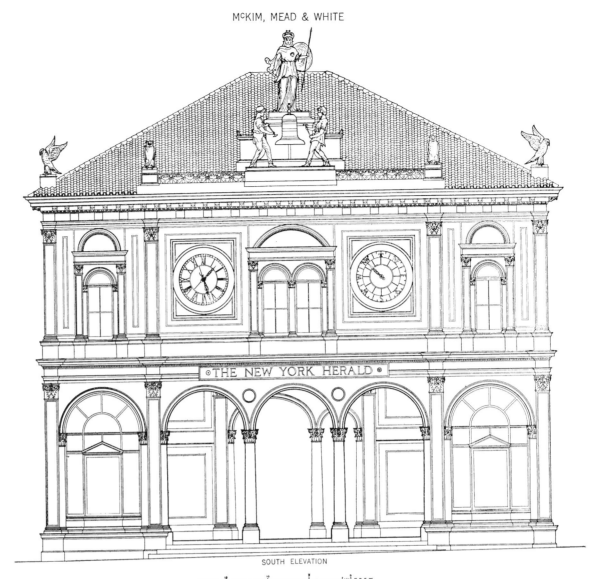

THE NEW YORK HERALD

SOUTH ELEVATION

SCALE F E E T

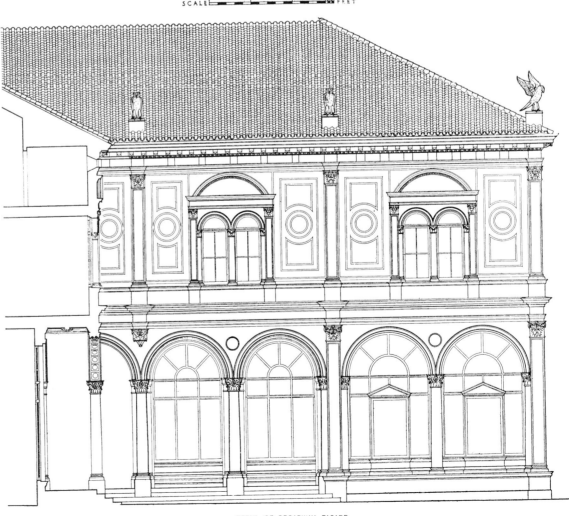

324

DETAIL OF BROADWAY FACADE
NEW YORK HERALD BUILDING, NEW YORK CITY.
1894

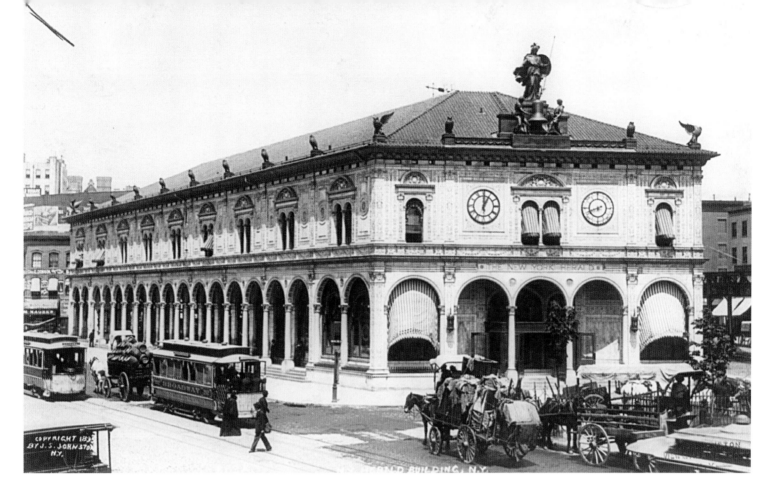

the shape of the site. A marble dado and a screen of brass spindles and miniature Ionic columns separated the offices from the lobby. Massive printing presses were located below grade, and, in a gesture that supported Bennett's commitment to popular journalism, the arcade on Broadway was glazed to allow the public to literally watch the news being made. At night, the electrified eyes of twenty-six owls, Bennett's personal symbol, winked in the darkness.

Like Madison Square Garden, the Herald Building demonstrates White's extraordinary skill with both ornament and organization. As Leland Roth notes, the two buildings "established White's ability as an organizer of competing functional demands and a master of ornamental embellishment." Within the firm, the Herald Building was held in high esteem; McKim described it as "the highwater mark of this office in design."

Windows overlooking the press room invited passersby to watch the latest edition of the *New York Herald* in production.

GOULD LIBRARY, NEW YORK UNIVERSITY

Ｎ EW YORK UNIVERSITY first approached Stanford White in 1892 with an ambitious scheme for a new campus in the Fordham Heights section of the Bronx. White responded immediately with a plan for relocating, stone by stone, the iconic Town and Davis building on Washington Square to the site. After these preliminary investigations, the project was put aside during a funding crisis precipitated by the death of Jay Gould, the major donor. Discussions were also in progress regarding the potential merger of NYU and Columbia University.

By 1893, however, it was clear that the two institutions would remain independent and that both would move uptown, Columbia to the land formerly occupied by the Bloomingdale Asylum and tactfully renamed Morningside Heights, and NYU to the former Mali estate high above the Harlem River. Columbia appointed Charles Follen McKim as its architect. Having determined that the cost of relocating the Town and Davis building would be equivalent to that of constructing five new

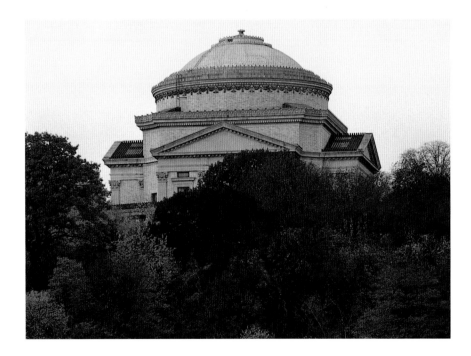

View of Gould Library from Highbridge Park in Manhattan.

The pedimented porch and dome of Gould Library recall the form of the Rotunda at the University of Virginia, but the materials are White's characteristic yellow roman brick with limestone trim.

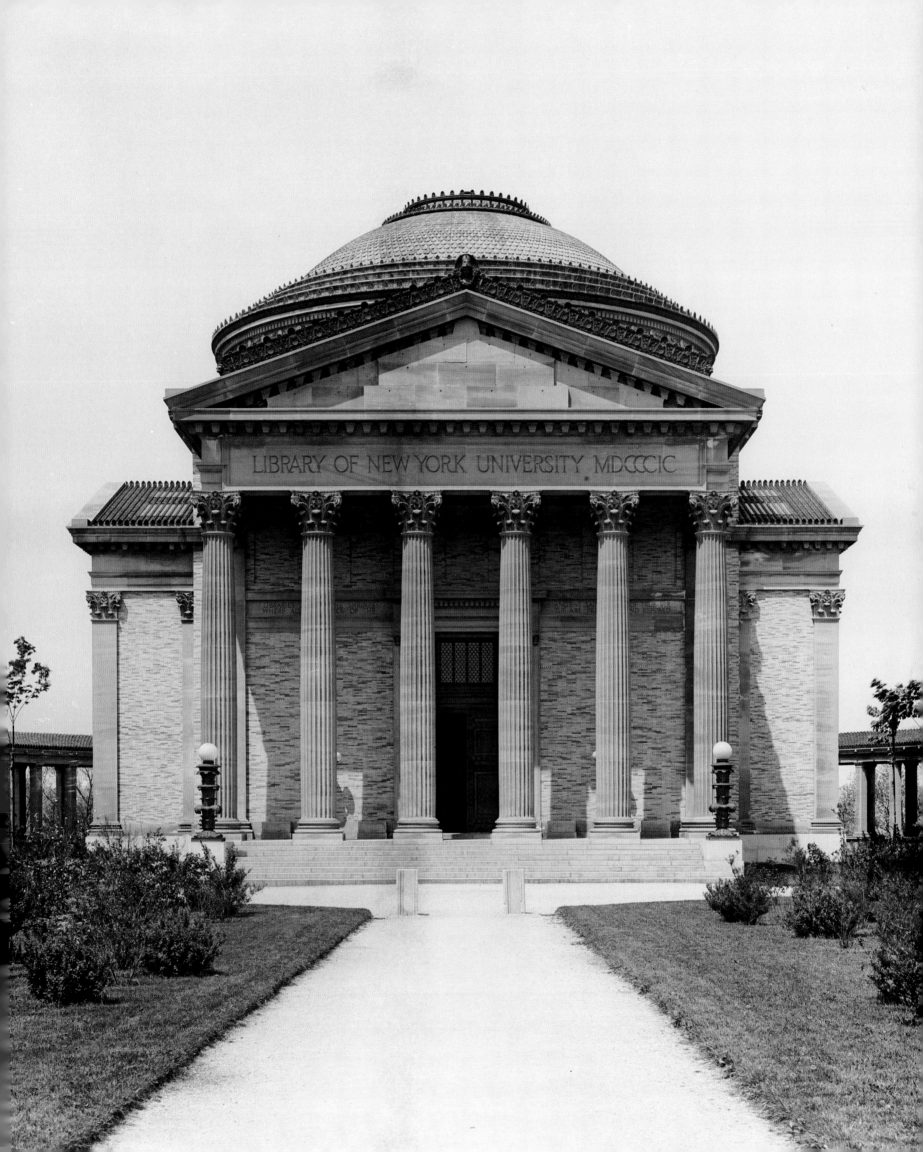

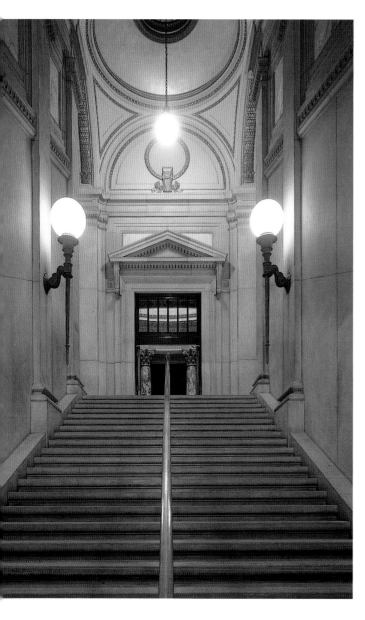

The monumental stair leading to the main reading room was based on one of White's youthful travel sketches.

The austerity of the exterior gives way to a profusion of color and materials in the main reading room.

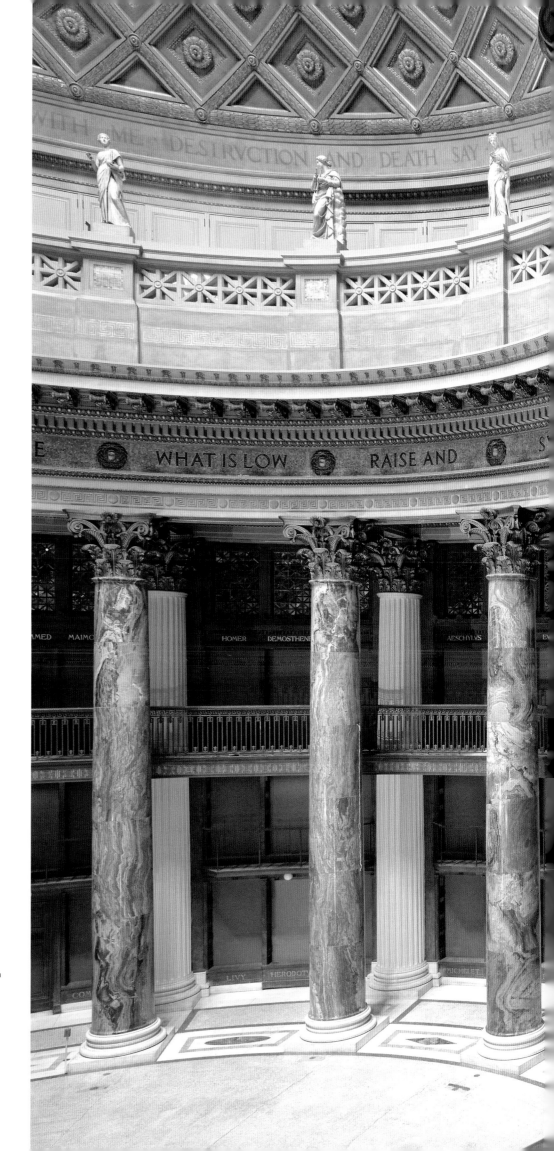

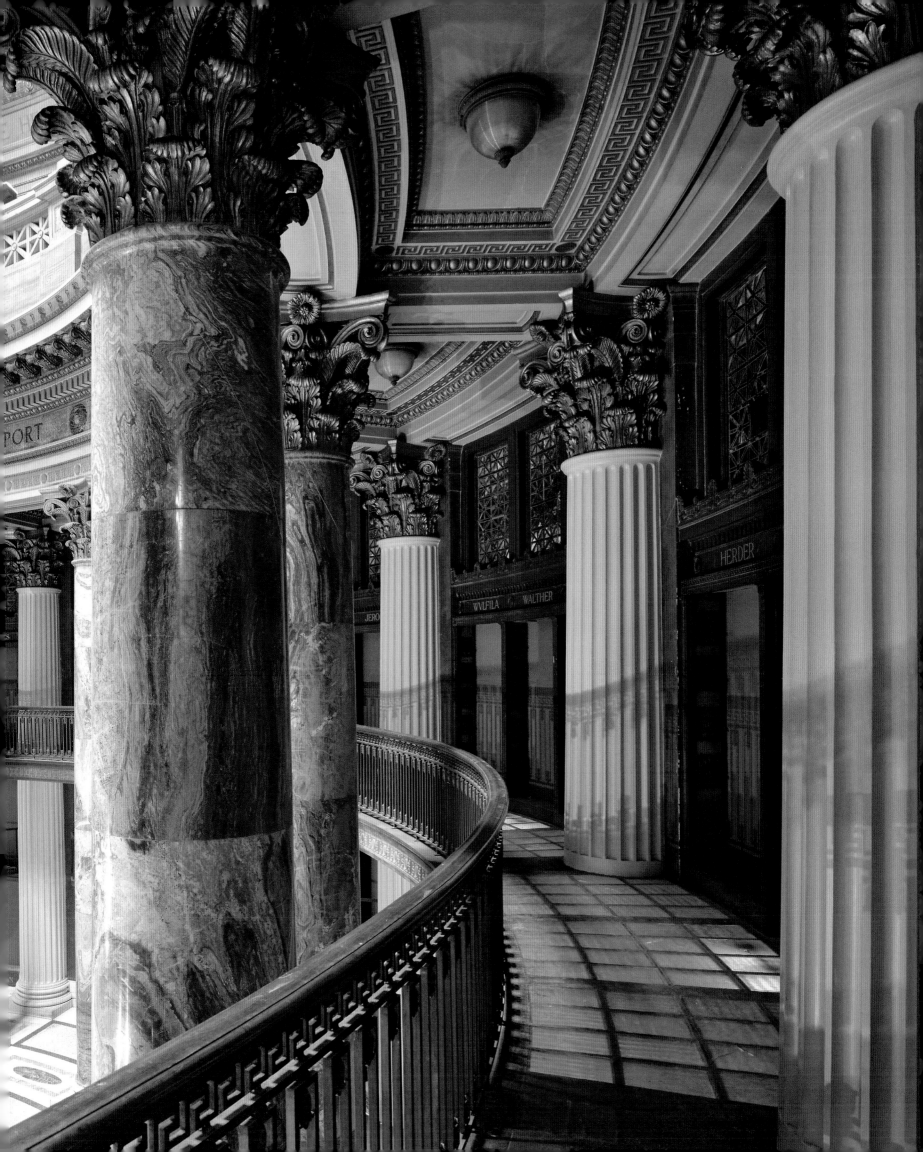

Bronze doors given in memory of Stanford White in 1921.

buildings, NYU returned to White for sketches for an entirely new campus. The development of these projects provides an opportunity to compare the approaches of the two partners.

Both White and McKim adapted the axial planning of the World's Columbian Exposition. White's version was more literal, with Gould Library sited at the head of the lawn and classroom buildings on both sites oriented to the lawn and perpendicular to the library, much as the Administration Building and exhibition halls had addressed the basin in the Court of Honor. All the NYU buildings were clad in buff-colored roman brick with limestone trim, a uniform palette similar to the White City in Chicago. In contrast, McKim surrounded Low Library with pavilions clad in brick as a foil to the limestone of the library. On the interiors, the aesthetic preferences of the two architects are clear. White's interest in compression and release is evident in the relatively long and narrow staircase that opens into the dramatic, three-story, skylit rotunda. A circle of sixteen green Connemara marble columns (the most beautiful marble in the world, according to White), enriched with gilded Corinthian columns, animates the space. Stained-glass panels glow behind the second-floor balcony with sunlight filtering through the skylight of the coffered dome. At Low, the coffered dome is solid, with more even light admitted through thermal windows on all four sides, and the sixteen columns are arranged in a square with solid piers at the corners. The effect is monochromatic and austere, in comparison with the rich polychromy at Gould.

Gould Library, which also accommodated the university chapel and museum, was one of four buildings completed by McKim, Mead & White. Several others were built along the lawn according to White's plan, but the full extent of the master plan was not executed.

The Hall of Fame of Great Americans, part of White's original scheme, surrounds the building and links to the Hall of Languages and the Hall of Philosophy. Bronze busts honor statesmen, inventors, writers, artists, and scholars.

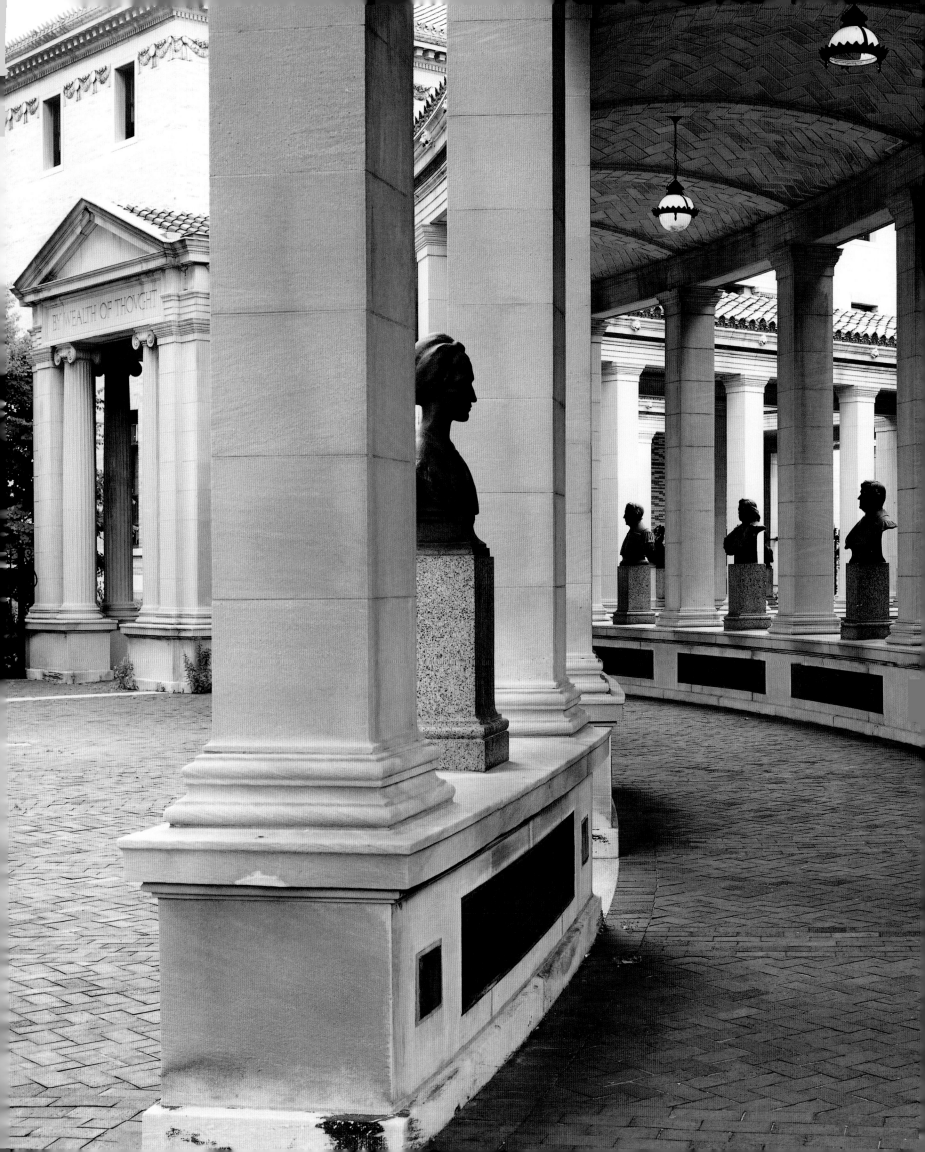

MADISON SQUARE PRESBYTERIAN CHURCH

NEW YORK

1903–6

*C*ONSIDERED Stanford White's masterpiece, the Madison Square Presbyterian Church stood at the north corner of Twenty-fourth Street facing Madison Square. The commission included the church itself and a parish house with meeting rooms and facilities for the parish's extensive community service programs. The congregation was led by the Reverend Charles H. Parkhurst, one of the city's most outspoken reformers, organizing and leading the campaign that ultimately defeated Tammany Hall, and a vestry of political and cultural leaders including

The main door has an elaborate surround incorporating both figural and foliate motifs. Metal studs outlining the panels recall the much earlier doors at the Players and Alden Villa.

Museum of the City of New York

The Madison Square Presbyterian Church was a colorful building, with green granite columns across the porch and a brilliant green tile roof supporting a gold cupola. Glazed blocks in green, yellow, and blue were incorporated in the Madison Avenue facade, the first use of colored glazes on architectural terra cotta.

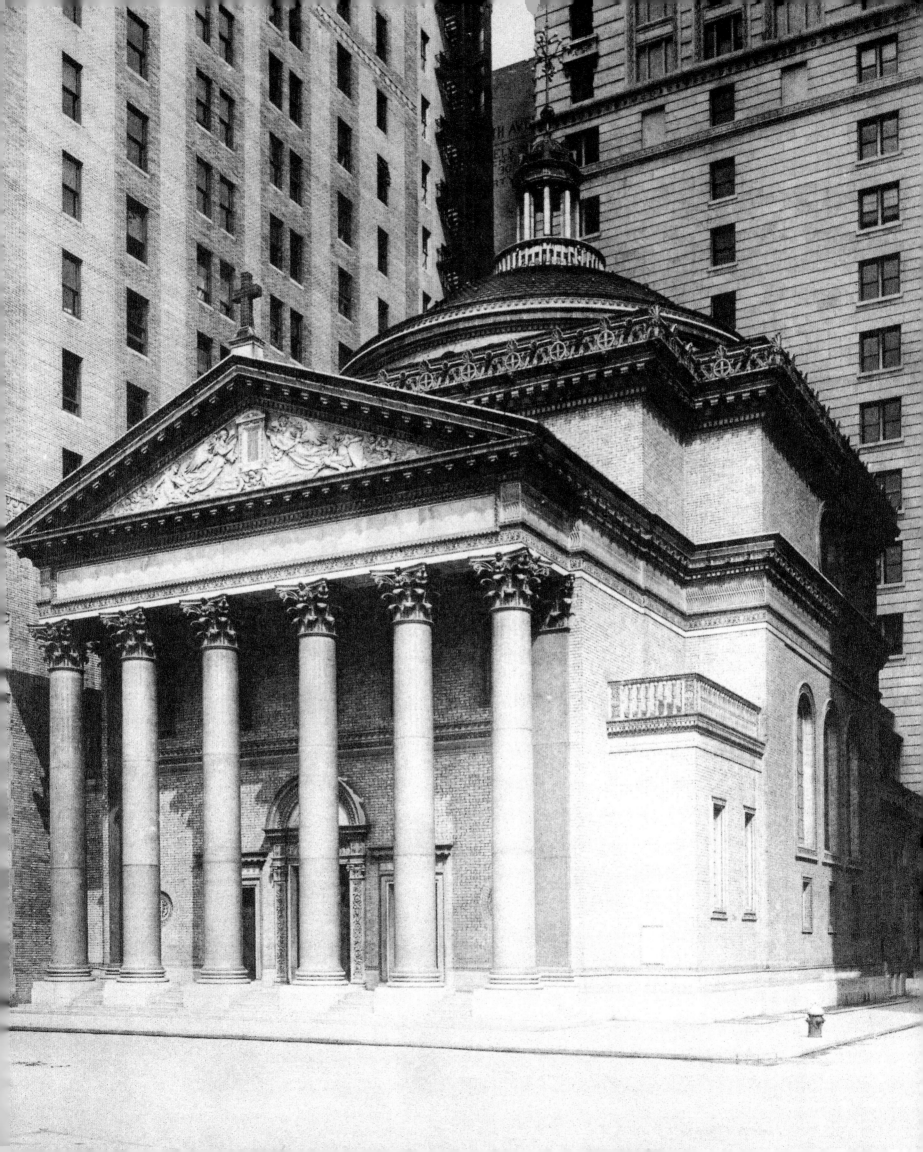

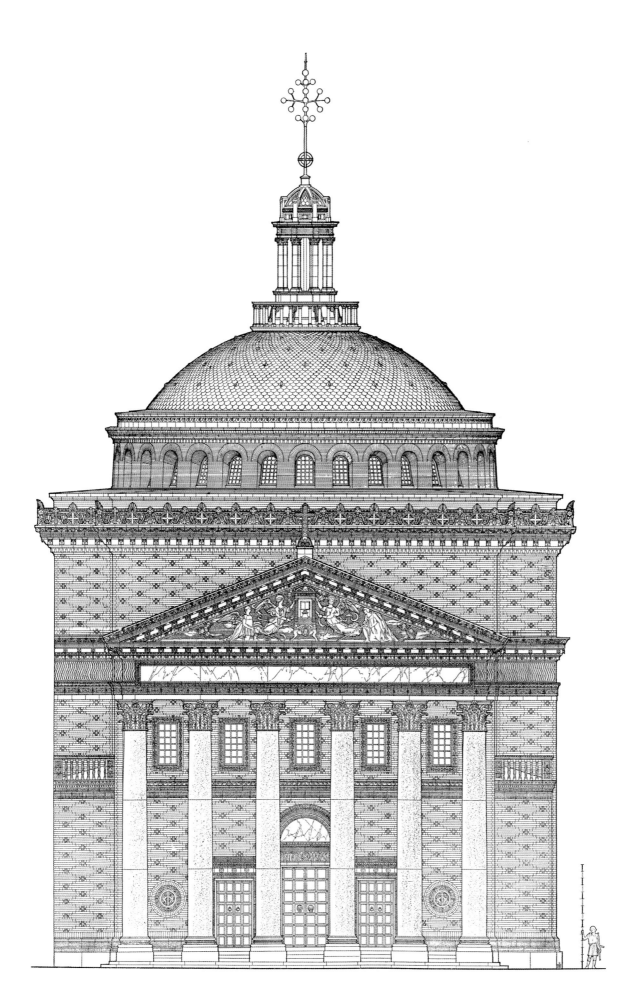

The elevation shows the overall decorated surfaces, in keeping with the Byzantine tradition, juxtaposed with a classical sculptural group in the pediment.

This roundel incorporates stylized animal and plant forms in a geometric pattern inspired by the Celtic tradition.

Robert W. de Forest, president of the Metropolitan Museum of Art, and the noted collector Arthur Curtiss James.

In keeping with his mature designs, White seemingly effortlessly combined a Greek cross plan with a shallow Guastavino dome and a pedimented temple front. The exterior was clad in cream-colored roman brick set in running bond, overlaid by diaper patterns of headers stamped with Greek crosses in relief. Green granite columns with polychrome Corinthian capitals, a dome covered in green and yellow glazed tiles

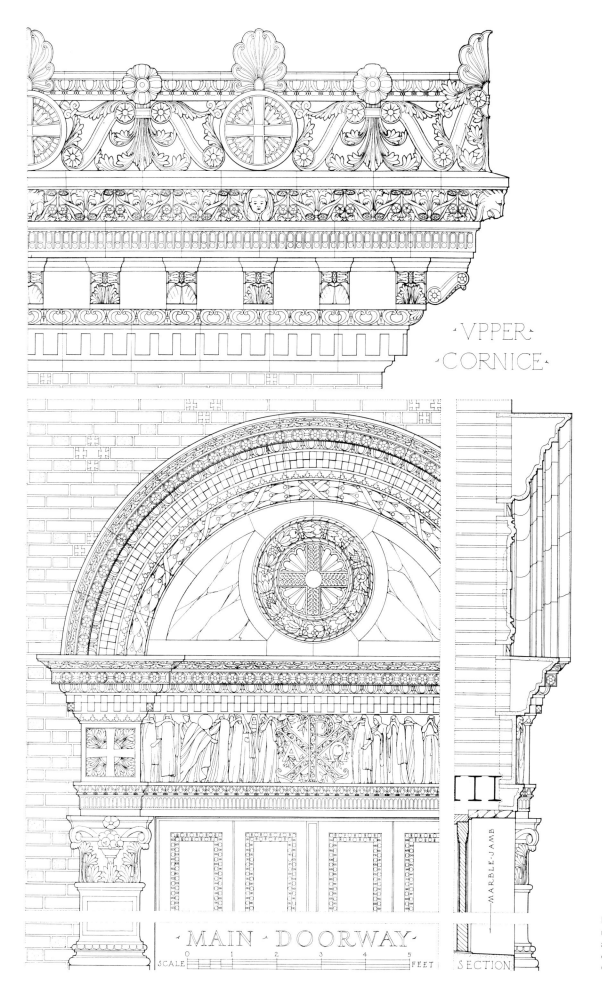

·VPPER·
·CORNICE·

·MAIN·DOORWAY·

SCALE 0 1 2 3 4 5 FEET

MARBLE·JAMB

·SECTION·

Both the cornice and the
main doorway were executed
as drawn, with the exception
of the roundel with the
Greek cross.

336

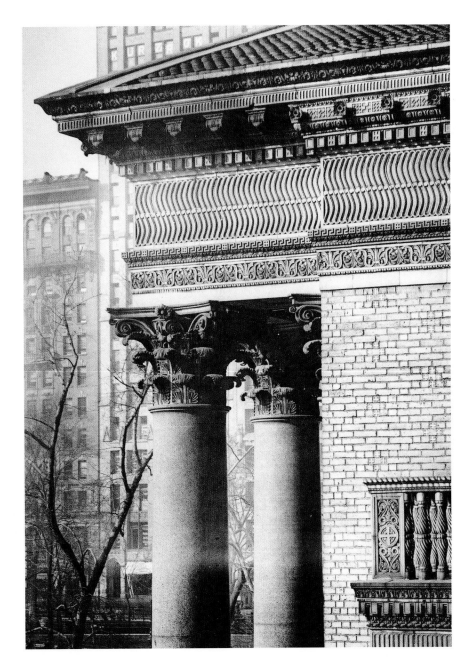

The frieze is filled with strigilation, a curvilinear pattern found on ancient Roman sarcophagi that White reinterpreted as an architectural motif.

topped by a golden lantern, and disciplined explosions of ornamental detail executed in polychrome glazed terra cotta brought the relatively austere building to life.

On the interior, a shallow dome, covered in shimmering gold mosaic and encircled by arched windows of clear glass, rested on four sharp pendentives. The overall spirit was Byzantine, featuring intricate mosaics, Tiffany windows, silk fabrics, exotic pendants, and pews and woodwork in silvery gray Quaker oak. Louis Comfort Tiffany was a member of the

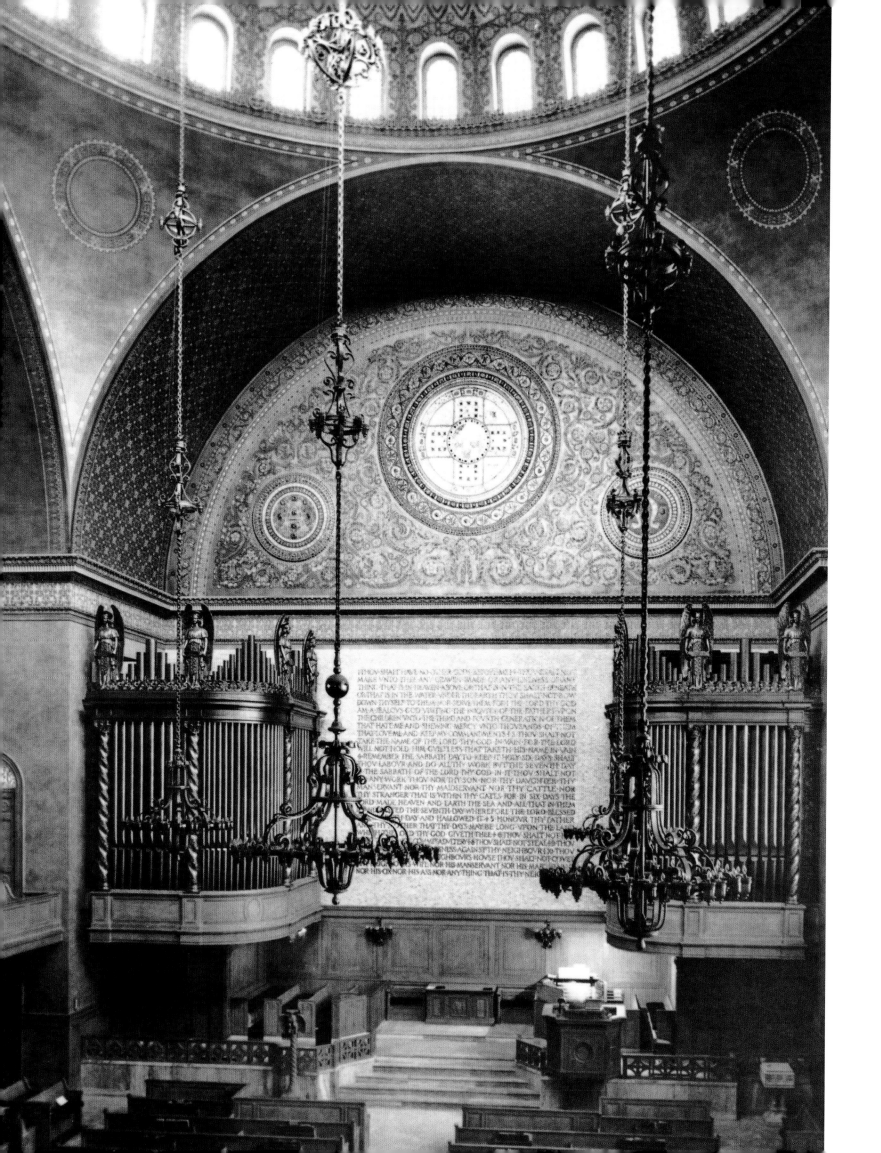

Tiffany's windows engage the architecture at two scales, mirroring the overlapping circles and cruciform of the plan while contributing color, texture, and detail to the interior.

The forged iron chandeliers, evoking White's earliest collaboration with Tiffany at the Seventh Regiment Armory, were reinstalled in the First Presbyterian Church on Fifth Avenue when the congregations merged in 1919.

building committee, and his studios supplied many of the interior finishes and fittings.

The choice of a domed Byzantine form was described by the *New York Times* as a "bold departure in style," a solution to the problem of building a church on a site "backed by a fifteen-story skyscraper with the possibility of a similar building on one side and a 600-foot tower across the street." Convinced that a traditional Gothic church with a tall spire would be overwhelmed by that setting and that the early Christian style was more suited to the Protestant denominations, White persevered. As the critic John Jay Chapman wrote, the church "was a Byzantine jewel that brought you to a full stop of admiration."

TIFFANY & CO.

NEW YORK

1903–6

*I*N 1893 Charles L. Tiffany reassured a *New York Times* reporter that rumors of the venerable jewelry store moving uptown to Fifth Avenue and Thirty-fourth Street were unfounded, adding that he intended to finish his business life in the Tiffany building on Union Square. Nine years later, and only a few months after Tiffany's death, Charles T. Cook, his successor as president of the firm, announced the purchase of the corner lot at Fifth Avenue and Thirty-seventh Street. In the intervening decade, the great mansions that had lined Fifth Avenue were demolished and replaced by new financial and luxury retail establishments.

The premier jewelers in the country, Tiffany & Co. supplied gems to the most fashionable socialites, produced trophies for elite sporting events, and garnered awards for tour-de-force designs at international exhibitions. For the World's Columbian Exposition, the firm assembled

Canaletto, *Venice: Palazzo Grimani*, c. 1756–68.

The National Gallery, London

White's adaptation of the Palazzo Grimani allowed for abundant glazing at all levels. The marble at street level was recently replaced.

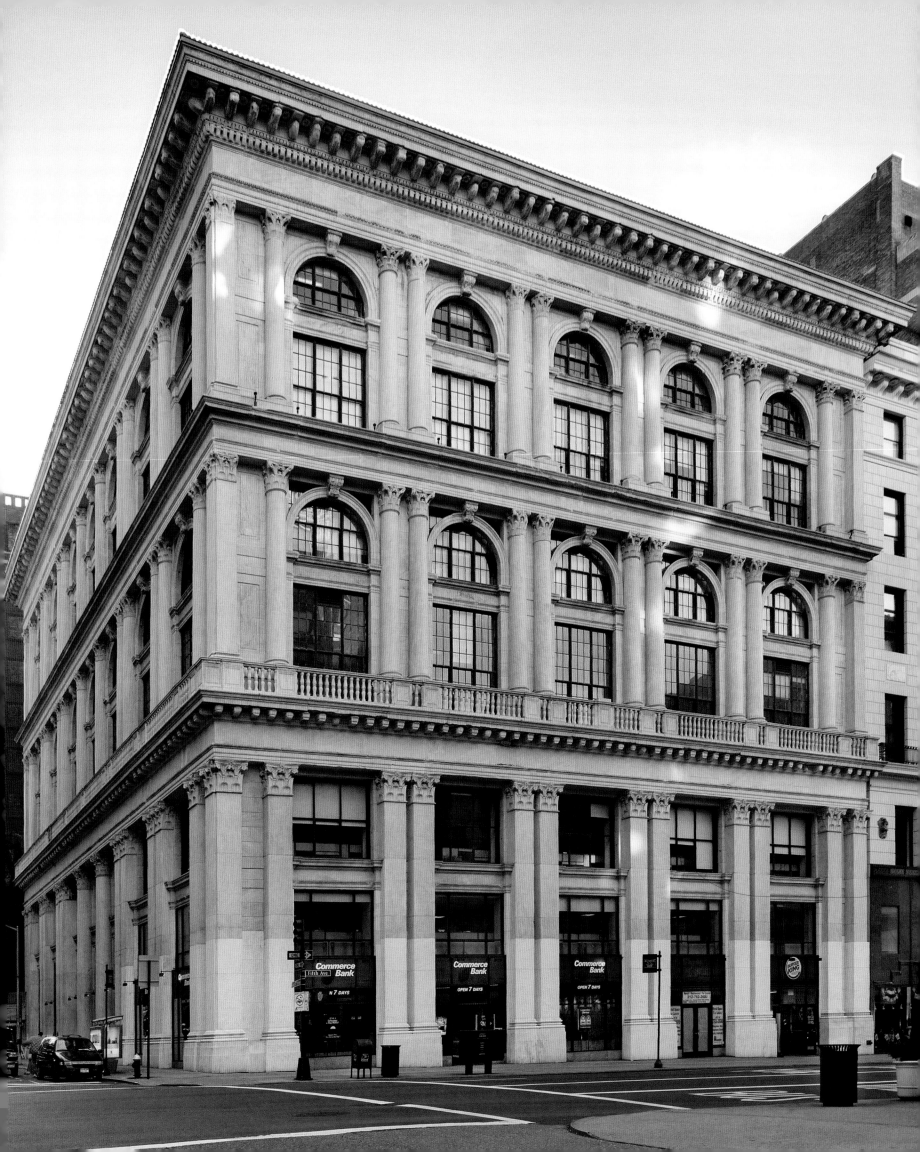

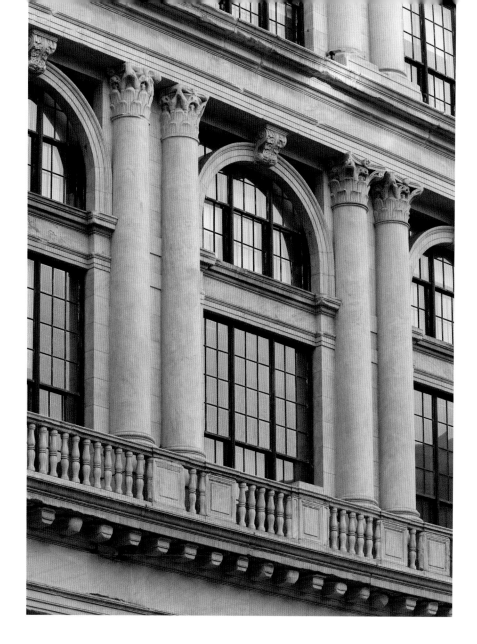

The non-structural corner between the arch and its rectangular frame, called a spandrel, was left open to increase the amount of glass in the layer behind.

what the *New York Times* described as "jewelry of wondrous design." More than one thousand pieces were created, including a foulard designed to resemble a piece of Spanish lace and composed of one thousand diamonds, one thousand emeralds, and several large yellow sapphires. In June 1903 Tiffany & Co. commissioned Stanford White (a loyal customer) to design a new headquarters worthy of its stature on the Fifth Avenue site.

Once again, White turned to the Veneto for inspiration, basing his design on the sixteenth-century Palazzo Grimani by Sanmicheli in Venice. White retained the tripartite organization of the Grimani facade, inserting two stories within each horizontal division and a full seventh floor beneath the hipped roof. The result was, according to Henry James, "A great nobleness of white marble . . . with three fine arched and columned stages above its high basement, within the conditions of sociable symme-

try." By sociable symmetry, James was referring to the cornice line at four to seven stories established by the McKim, Mead & White buildings along Fifth Avenue, beginning with the Knickerbocker Trust at Thirty-fourth Street, including the Gorham Building at Thirty-sixth Street and the University Club at Fifty-fourth Street, and culminating with White's earlier marble palace, the Metropolitan Club at Sixtieth Street.

Entrances at both ends of Tiffany's Fifth Avenue facade opened onto a double-height space with polished purplish-gray German marble columns supporting an elaborately coffered ceiling. Intricately inlaid teak showcases displayed the Tiffany wares. At the rear of the store, elevators enclosed in steel cages rose through the building to displays of bronzes on the second floor and tableware on the third. Services, including photography and engraving, were on the fourth floor, with work areas for diamond cutters and polishers and goldsmiths on the fifth. Clocks and leather goods occupied the sixth floor. At the top of the building, beneath

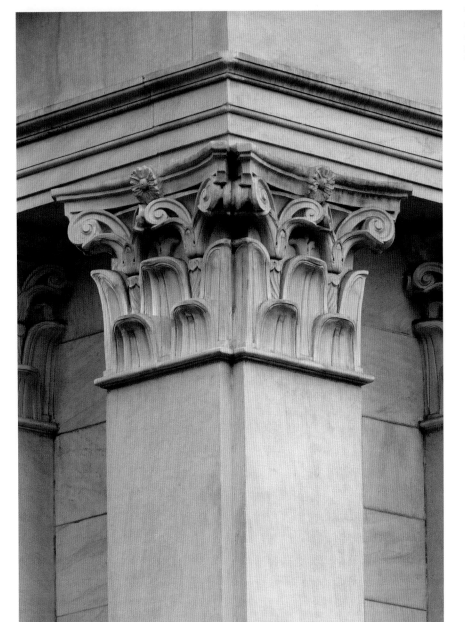

The leaves in the Corinthian capitals are curiously undeveloped, suggesting an interest in abstraction that characterized White's late designs.

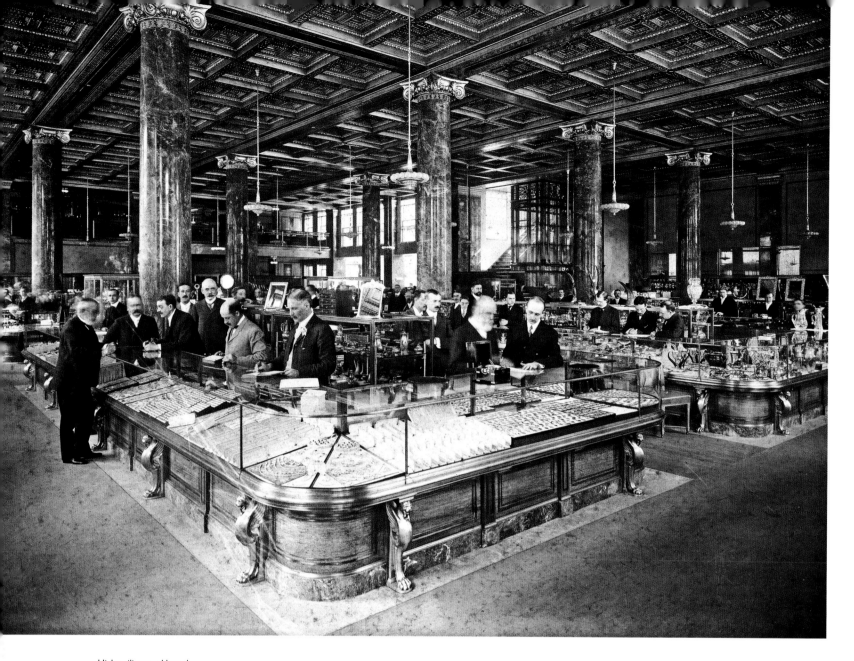

a skylight in a shallow Guastavino dome, was a full-floor exhibition space.

Tiffany & Co. was fully satisfied with the building, asserting that it "unquestionably reaches the highest mark of artistic excellence up to the present time." Beyond the aesthetic achievement, the building also speaks to White's interest in structural expression. The steel frame allowed him to incorporate large glass windows at the street level and to replace the traditional masonry spandrels with glass on the upper floors. This interest in technical experiments, first seen in the subfloor ventilation system at Lovely Lane Church and the silently retracting roof of the arena at Madison Square Garden, was characteristic of White, who was also captivated by the sparkle of electricity and the speed of the automobile.

The main stair incorporates a number of White's favorite motifs—exedra, giant risers, and mythical beasts—wrapped around a bronze elevator cage.

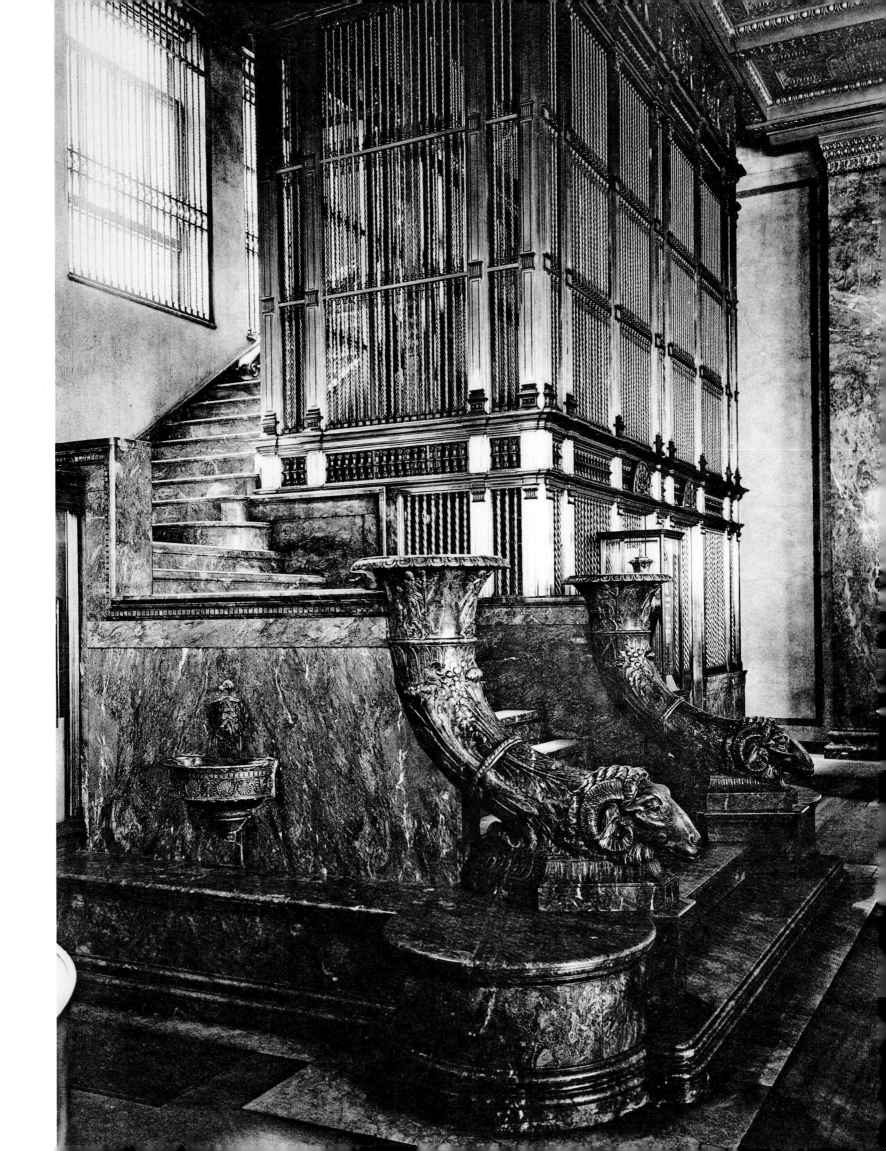

NOTES

PROLOGUE

p. 6 "He was a personality of enormous power"
Quoted in Orick Johns, "Stanford White's
Genius Survives City's Change," *New York
Times*, March 25, 1925.

p. 8 "draw like a house afire"
Quoted in Leland Roth, *McKim, Mead & White
Architects*, 56 n49.

p. 9 "My general health is perfectly good"
Stanford White, letter to Robert Goelet,
December 23, 1892. Letter book 7:40, Avery Fine
Arts and Architectural Library, Columbia
University.

CHAPTER 1

p. 16 "I work all day…"
Stanford White, letter, December 16, 1897.
Letter book 19, Avery.

p. 22 "after nearly fifty years I am still living
there."
Bessie White, unpublished memoir, 6. Aline
Saarinen papers, Archives of American Art.

p. 50 "When there was music, they seemed to
listen and vibrate."
Mrs. Winthrop Chanler, *Roman Spring:
Memoirs*, 257.

p. 54 "it is quite unlikely that it will be matched
in value or importance by any other private
collection."
New York Times, November 28, 1907.

CHAPTER 2

p. 58 "a council chamber where other men could
meet"
Charles Baldwin, *Stanford White*, 115.

p. 62 In 1892 he wrote to Sargent
Stanford White, letter to John Singer Sargent.
Letterbook 6:361. Avery.

p. 64 "I thought he was making a finial for your
tower."
Quoted in Paul Baker, *Stanny: The Gilded Life of
Stanford White*.

p. 64 "The Veterans have steered clear of con-
ventionalisms"
*The Veteran's Room, Seventh Regiment N.G.S.N.Y.
Armory*. Pamphlet privately printed 1881;
reprinted 1979, 13.

p. 67 "His royal highness Mr. Villard"
Stanford White, letter to Bessie Springs Smith,
nd [October 1883]. Published in Claire Nicolas
White, ed., *Stanford White: Letters to His Family*,
130.

p. 68 "The beginning of any good work that we
may have done"
Quoted in Baker, 338–39.

p. 68 "I know that it cannot be left in other
hands without great danger."
William Rutherford Mead, letter to McKim,
December 19, 1887. Published in Charles Moore,
The Life and Times of Charles Follen McKim, 65.

p. 69 "I send you a tracing."
Stanford White, letter to McKim, December 28,
1892, Letter book 7:68, Avery.

p. 69 "Then did McKim 'go fishing.'"
Albert Randolph Ross, "Stanford White as
those trained in his office knew him,"
Brickbuilder, December 1906: 246.

p. 71 "the finest piece of architecture in France"
Stanford White, letter to Alexina Mease White,
August 30/September 1, 1878. Published in
Stanford White: Letters to His Family, pp. 48–54.

p. 73–74 "I would really like here a thoroughly
quiet severe and architectural treatment of
these sculptures"
Stanford White, letter to Frederick
MacMonnies. Letter book 8:190. Avery.

p. 79 "You've got a good thing. Why don't you
stick to it?"
Stanford White, letter to Augustus Saint-
Gaudens, December 17, 1879. Dartmouth
College Library. Published in *Stanford White:
Letters to His Family*, 98.

p. 82 "Greek, Moresque, and Celtic, with a dash
of Egyptian, Persian, and Japanese"
Quoted on Park Avenue Armory Conservancy
Website. www.armoryonpark.org.

p. 102 "from Paris to Petersburg."
David Lowe, *Stanford White's New York*, 118.

p. 104 according to Maitland Armstrong
Quoted in Lowe, 119.

p. 109 "one of the supreme achievements in
American stained glass art"
Lowe, 112.

CHAPTER 3

p. 112 "women who want closets!"
Stanford White, letter to Augustus Saint-
Gaudens, October 17, 1879. Dartmouth College
Library. Published in *Stanford White: Letters to
His Family*, 94.

p. 170 "I must insist that you place more men
there and drive the work day and night until
completion"
Stanford White, letter to Herter Brothers,
November 1892, Letter book 6:297, Avery.

p. 172 "I send you plans of your house and a per-
spective"
Stanford White, letter to Kate Wetherill,
November 13, 1893. Letter book 8:213, Avery.

p. 180 "great ballroom admirably fitted"
New York Times, February 15, 1899.

p. 183 "Their work interpreted the Old World
to the New"
C. H. Reilly, *McKim, Mead & White*.

p. 188 "My frau is coming on Friday"
Stanford White, letter to Tessie Oelrichs,
August 17, 1898. Letter book 20:380, Avery.

CHAPTER 4

p. 236 "the leading attraction of the season"
New York Times, September 8, 1880.

p. 243 "McKim, Mead, White & Gold"
Mariana Griswold Van Rensselaer, "Madison
Square Garden," in David Gebhard, ed., *Accents
as Well as Broad Effects: Mariana Griswold van
Rensselaer Writings on Architecture, Landscape,
and the Environment, 1876–1925*, 90.

p. 256 "I have worked long and hard on them
for the past week."
Quoted in Paul Porzelt, *The Metropolitan Club of
New York*, 40.

CHAPTER 5

p. 278 "a crystallized dream of art"
Quoted in Baker, 214–15.

p. 283 "a new, more settled phase for White."
Roth, 241.

p. 287–88 "belongs only and absolutely to the
Roman Catholic Church"
Quoted in Baldwin, 236.

p. 294 "careful balance between building
masses"
Roth, 204.

p. 294 "I have seen his plans"
Quoted in Roth, 197.

p. 296 "the most perfect group of collegiate
buildings in the world."
Stanford White, Notes on the University of
Virginia, undated typescript. New-York
Historical Society.

p. 307 Montgomery Schuyler discussed
Montgomery Schuyler, "The Romanesque
Revival in America," *Architectural Record*,
October–December 1891.

p. 318 "Nothing else in all of New York"
Mariana Griswold Van Rensselaer, "Madison
Square Garden," in Gebhard, ed., *Accents as Well
as Broad Effects*, 82.

p. 325 "master of ornamental embellishment"
Roth, 171.

p. 325 "the highwater mark of this office in
design"
Quoted in Baker, 215.

p. 339 "bold departure in style"
New York Times, October 14, 1906.

p. 339 "a Byzantine jewel"
Quoted in Baldwin, 235.

p. 340 "jewelry of wondrous design."
New York Times, April 9, 1893.

p. 342 "conditions of sociable symmetry"
Henry James, *The American Scene*, 138.

p. 344 "unquestionably reaches the highest mark
of artistic design"
Quoted in Baker, 365.

SELECTED BIBLIOGRAPHY

The American Renaissance, 1876–1917. New York: Brooklyn Museum, 1979. Essays by Richard Guy Wilson, Dianne H. Pilgrim, and Richard N. Murray.

Andrews, Wayne. *Architecture, Ambition, and Americans: A Social History of American Architecture.* New York: The Free Press, 1947, 1964.

Baker, Paul. *Stanny: The Gilded Life of Stanford White.* New York: The Free Press, 1989.

Baldwin, Charles. *Stanford White.* New York: Dodd Mead, 1931. Reissued in paperback with an introduction by Paul Goldberger by Da Capo Press, 1971.

Blake, Channing. "Architects as Furniture Designers," *The Magazine Antiques,* May 1976, 1042–1047.

Broderick, Mosette Glaser, and William C. Shopsin. *The Villard Houses: Life Story of a Landmark.* New York: Viking Press, 1980.

Chanler, Mrs. Wintrhop. *Roman Spring: Memoirs.* Boston: Little Brown & Co., 1934.

Cowles, Virginia. *The Astors.* New York: Knopf, 1979.

Craven, Wayne. *Stanford White: Decorator in Opulence and Dealer in Antiquities.* New York: Columbia University Press, 2005.

Curran, Frances, ed. *Trinity Church: One Hundred Years 1869–1969: A Centennial History.* Privately printed.

Fowler, Dorothy Ganfield. *A City Church: The First Presbyterian Church in the City of New York 1716–1976.* New York: First Presbyterian Church in the City of New York, 1981.

Gebhard, David, ed. *Accents as Well as Broad Effects: Mariana Griswold van Rensselaer Writings on Architecture, Landscape, and the Environment, 1876–1925.* Berkeley: University of California Press, 1996.

James, Henry. *The American Scene.* New York: Penguin Books 1994.

Jordy, William. *American Buildings and Their Architects: Progressive and Academic Ideals at the Turn of the Twentieth Century.* New York: Anchor Books, 1976.

Lessard, Suzannah. *The Architect of Desire: Beauty and Danger in the Stanford White Family.* New York: Dial Press, 1996.

Logan, Andy. "That was New York: The Palace of Delight, " *The New Yorker,* February 27, 1965, 41ff.

Lowe, David Garrard. *Stanford White's New York.* New York: Doublday, 1992.

McKim, Mead & White. *A Monograph of the Work of McKim, Mead & White 1879–1915,* 4 vols. New York: The Architectural Book Publishing Co., 1915–20. Reissued in one volume with an introduction by Leland Roth by Benjamin Bloom, Inc., 1973. Reprinted by the Arno Press, 1977.

Meyer, John W. "The New York Work of Stanford White," *Museum of the City of New York Bulletin* V:5 (March 1942), 46–52.

Moore, Charles. *The Life and Times of Charles Follen McKim.* Boston and New York: Houghton Mifflin Company, 1929.

New York City Landmarks Preservation Commission. Designation Reports for The Century Association, Gould Library at New York University (now Bronx Community College), Metropolitan Club, Washington Memorial Arch.

Parks, Janet, and Alan G. Neuman. *The Old World Builds the New: The Guastavino Company and the Technology of the Catalan Vault.* New York: Avery Architectural and Fine Arts Library and Wallach Art Gallery, Columbia University, 1996.

Peck, J. Cornelius. *Stanford White at Cornwall: A Shavian Connection to American Queen Anne Architecture.* New Hope, PA: Peck Publishing Group, 2007.

Portzelt, Paul. *The Metropolitan Club of New York.* New York: Rizzoli International Publications, 1982.

Reilly, C. H. *McKim, Mead & White.* London: E. Benn Ltd, 1924.

Roth, Leland M. *The Architecture of McKim, Mead & White, 1870–1920: A Building List.* New York: Garland Publishing, 1978.

———. *America Builds: Source Documents in American Architecture and Planning.* New York: Harper & Row, 1983

———. *McKim, Mead & White Architects.* New York: Harper & Row, 1983.

Saarinen, Aline. "The Splendid World of Stanford White," *Life* 61 (September 16, 1966), 87–108.

Stern, Robert A. M, Gregory Gilmartin, and John Montague Massengale. *New York 1900: Metropolitan Architecture and Urbanism.* New York: Rizzoli International Publications, 1983.

Stern, Robert A. M., Thomas Mellins, and David Fishman. *New York 1880: Architecture and Urbanism in the Gilded Age.* New York: Monacelli Press, 1999.

The Veteran's Room, Seventh Regiment N.G.S.N.Y. Armory. Pamphlet, privately printed 881, reprinted 1979.

Weber, Bruce. *Homage to the Square: Picturing Washington Square 1890–1965.* New York: Berry-Hill Galleries, 2001.

Wecter, Dixon. *The Saga of American Society.* New York: Charles Scribner's Sons: 1937.

White, Claire Nicolas, ed. *Stanford White: Letters to His Family.* New York: Rizzoli International Publications, 1997.

White, Lawrence Grant. *Before the War: Memories of the Years 1887–1914.* Unpublished memoir.

———. *Sketches and Designs of Stanford White.* New York: The Architectural Book Publishing Company, 1920.

White, Samuel G. *The Houses of McKim, Mead & White.* New York: Rizzoli International Publications, 1998.

———, and Elizabeth White. *McKim, Mead & White: The Masterworks.* New York: Rizzoli International Publications, 2003.

Wilson, Derek. *The Astors 1763–1992: Landscape with Millionaires.* New York: St. Martin's Press, 1993.

Wilson, Richard Guy. *McKim, Mead & White, Architects.* New York: Rizzoli International Publications, 1983.

Wodehouse, Lawrence. "Stanford White and the MacKays." *Winterthur Portfolio* 11, 1976, 229–33.

ACKNOWLEDGMENTS

FOR MORE than a hundred years since his death in 1906, Stanford White has been the subject of intense scrutiny from biographers and critics who have attempted to reconcile his talent and architectural accomplishment and his evident social position with the reckless management of his personal and financial affairs. In roughly chronological order, these writers include Lawrence Grant White, Charles Baldwin, Aline Saarinen, Leland Roth, Richard Guy Wilson, Lawrence Wodehouse, Mosette Broderick, Paul Baker, David Garrard Lowe, Suzannah Lessard, Claire Nicolas White, and Wayne Craven. Each of them provides an important dimension to the work and life, and we are most fortunate to have these sources.

Stanford White's correspondence, preserved at Avery Fine Arts and Architectural Library, Columbia University, allows the architect to speak for himself, creating a vivid image of bristling energy, generosity, humor, and contrition for missed obligations.

The task of navigation through the extensive archives at Avery and at the New-York Historical Society was greatly simplified by Janet Parks and Marilyn Kushner, respectively. Paul Miller graciously provided access to the properties of the Preservation Society of Newport County. We also appreciate the assistance of the rights and reproductions departments at those institutions and at the Museum of the City of New York.

Our greatest debt is to the building owners, who have been so generous with their knowledge and their time. We are especially grateful for the enthusiasm and hospitality of Kathy Hammer and Arthur Seelbinder, Kip and Caija Kelly, and Daniel White and Betsy Hussey-White.

For their support of this project and our two earlier books, we thank our friends in publishing: Douglas Curran, Stacee Lawrence, Charles Miers, Gianfranco Monacelli, Andrea Monfried, David Morton, Nicolas Rojas, Abigail Sturges, and Solveig Williams.

It has truly been a pleasure to collaborate once again with Marcus Ratliff and Amy Pyle and with Jonathan Wallen and Lester Ali. Together they have created a magnificent book.